D0850616

The
MAGAZINE CENTURY

Mediating American History

David Copeland
General Editor

Vol. 9

PETER LANG
New York • Washington, D.C./Baltimore • Bern
Frankfurt • Berlin • Brussels • Vienna • Oxford

DAVID E. SUMNER

The **MAGAZINE CENTURY**

American Magazines Since 1900

PETER LANG
New York • Washington, D.C./Baltimore • Bern
Frankfurt • Berlin • Brussels • Vienna • Oxford

Library of Congress Cataloging-in-Publication Data

Sumner, David E.
The magazine century: American magazines since 1900 /
David E. Sumner.
p. cm. — (Mediating American history; vol. 9)
Includes bibliographical references and index.
1. American periodicals—History—20th century. I. Title.
PN4877.S86 051'.08209034—dc22 2010016329
ISBN 978-1-4331-0494-7 (hardcover)
ISBN 978-1-4331-0493-0 (paperback)
ISSN 0085-2473

Bibliographic information published by **Die Deutsche Nationalbibliothek.**
Die Deutsche Nationalbibliothek lists this publication in the "Deutsche
Nationalbibliografie"; detailed bibliographic data is available
on the Internet at http://dnb.d-nb.de/.

Cover images reprinted with permission of Time Inc.,
National Geographic Society, and New York Magazine

The paper in this book meets the guidelines for permanence and durability
of the Committee on Production Guidelines for Book Longevity
of the Council of Library Resources.

Table of Contents

Preface

A Focus on Innovators and Innovation

How do you write a history of magazines when at least 20,000 magazines are published in the U.S. according to the latest 2008 numbers?[1] I have asked myself that question over and over as I researched and wrote this book. Each magazine has its own history and dozens of well-known magazines have had entire books written about their histories. The problem gets more complicated because an estimated 100,000 American magazines have been published at one time or another in the last century. Experts estimate that more than 80 percent of all new magazine launches last less than three years. Many once-great magazines, such as *Life* or *Woman's Home Companion*, were successful for decades only to succumb to changing times. If I wrote a page on every magazine published at any time between 1900 and 2000, I could have a 100,000-page book. Therefore, I would like to outline the parameters of this book.

First, I have limited it to the best-known consumer magazines. The term "consumer magazines" refers to those that anyone can subscribe to or purchase at newsstands. Therefore, it will not include business-to-business or "trade" magazines or those published by organizations, professional associations, colleges and universities or special interest groups. Even when limiting the scope to consumer magazines, there are at least 9,000 magazines to write about.

Second, I chose to focus on innovative magazines, editors and publishers. Within each decade, I looked for publishers and editors who established successful magazines and did something different or better than their competitors. They discovered a new business model, a new niche, a new editorial formula, or other-

wise found a way to publishing success in a competitive business environment. Generally that means the highest-circulation magazines, but not necessarily. Many small-circulation, but notable magazines are included within these pages.

Third, I wanted to write the history of magazines within the context of American history, not as isolated entities devoid of larger social and economic trends. Therefore, the book is organized chronologically by decades. Previous books about American magazine history were structured according to sectors and niches. Each structural approach has advantages and disadvantages. I chose to write about some magazines that illustrated or reflected the trends of each decade. I also wrote about "magazines that made the news" in all news media—whether for laudable reasons or because of scandals, lawsuits and controversies. This book contains the good news and the bad news.

Fourth, I chose magazines that reflected or illustrated larger trends taking place within American society. For example, the women's movement brought the launch of magazines such as *Ms,* and the civil rights movement contributed to the success of *Black Enterprise* and *Essence.* The focus on sex and celebrity that began during the 1970s brought the success of *People, Us Weekly, National Enquirer* and *Entertainment Weekly* and many similar titles.

Fifth, I chose to focus on magazines that are still published and with which modern readers will be familiar. I will discuss a few once-great magazines that are no longer published, such as *Literary Digest* and *Life.* The extinct magazines that I chose to write about were historical because of their impact on society or they were in some way innovative in their time.

It seems most prefaces end with the glowing accolades to the author's spouse who supported him or her through every trial while putting up with prolonged absences from family duties. I have already expressed those sentiments to my wonderful wife, Elise, so that I could refrain from boring the readers. I offer a special thanks to Ball State University, which provides duly-chosen faculty members with paid sabbaticals or "special assigned leave" as we call it. Without this leave during the fall semester of 2009, I could not have written this book. Special thanks also to the editors and staff at Peter Lang Publishing, Inc. in New York who made this author's job easy. This international company based in Geneva, Switzerland, donates its profits to international children's charities, which gave me an added incentive to give you—the readers—my very best work.

DAVID E. SUMNER
WWW.PROFESSORMAGAZINE.COM

Note

1. *The Magazine Handbook 2009–2010* (New York: Magazine Publishers of America, 2009), www.magazine.org/advertising/handbook/Magazine_Handbook.aspx.

The Magazine Century

"This is the redeeming strength of all magazines today—attitude. The magazine engages its reader and holds him because it shares with him a certain point of view."

HAROLD HAYES, *ESQUIRE* EDITOR (1963–1973)

Between 1900 and 2000, the growth of magazines exploded as their number increased from about 3,500 in 1900 to 17,815 in 2000—a 509 percent increase. American population increased from 76 million in 1900 to 291 million in 2000—a 382 percent increase. This growth of magazines exceeded population growth by 127 percent. Consequently, there was one magazine for every 21,700 Americans in 1900, but by 2000, that figure was one magazine for every 16, 300 Americans.

Henry R. Luce, who founded *Time, Life* and subsequently the largest magazine publishing company of the 20th century, coined the phrase "The American Century" in a famous *Life* magazine editorial on February 7, 1941. Americans faced the dark shadows of war as the German army marched across France and began bombing raids on London. Luce argued that the time had arrived for America to assume its proper leadership role as the world's dominant power: "The world of the 20th *Century*, if it is to come to life in any nobility of health and vigor, must be to a significant degree an *American Century*."[1]

By using the term "American century," Henry Luce did not mean increasing its economic or military power, but offering to the world a benevolent source of ideals, freedom and material resources:

America as the training center of the skillful servants of mankind, America as the Good Samaritan, really believing again that it is more blessed to give than to receive, and America as the powerhouse of the ideals of Freedom and Justice—out of these elements surely can be fashioned a vision of the 20th Century to which we can and will devote ourselves in joy and gladness and vigor and enthusiasm.

While Luce introduced the term "the American century" into public discourse, whether it was or should be called "the American century" is still being debated by scholars.[2] It was, however, a *magazine century* and an *American magazine century* without a doubt. The typical American read about .42 magazines per month in 1920. By 2000, that figure had more than tripled and the typical American read about 1.30 magazines per month. Those figures were derived by comparing the total circulation of A.B.C.-audited magazines* with total population. More details about these figures are revealed in Table 1.

By 2000, the United States was publishing 9,478 consumer magazines—almost three times the number published in the United Kingdom, which ranked second.

Table 1

Year	Magazine Circulation and Readership Per Person 1920–2005		
	Monthly Circulation	U.S. Population	Readership per person
1920	44,095,000	105,710,620	0.42
1925	54,176,000	115,832,000	0.47
1930	78,844,000	122,775,046	0.64
1935	75,974,000	127,250,000	0.60
1940	94,817,000	131,669,275	0.72
1945	121,240,000	132,137,000	0.92
1950	146,974,508	150,697,361	0.98
1955	173,126,045	164,302,000	1.05
1960	189,172,231	179,323,175	1.05
1965	213,573,145	194,303,000	1.10
1970	244,735,073	203,302,031	1.20
1975	249,983,461	215,973,000	1.16
1980	280,741,959	226,545,805	1.24
1985	323,887,115	238,466,000	1.36
1990	366,111,872	248,709,873	1.47
1995	364,896,329	263,044,000	1.39
2000	378,918,978	291,421,906	1.30
2005	362,281,559	296,329,000	1.22

Source note: These figures include magazines belonging to the Audit Bureau of Circulations, which represent the largest and best-known consumer magazines, but less than 10 percent of the total number of published magazines. Actual readership figures are probably higher.

with 3,174 consumer magazines. Japan, Germany and France held the third, fourth, and fifth spots, respectively (see Table 2). The data comes from Federation of the International Periodical Press in London, which publishes annual magazine data from more than 40 countries.

Why did magazines grow?

Table 2

Top Ten Publishers of Consumer Magazines		
Rank	Country	Consumer magazines
1	United States	9,478
2	United Kingdom	3,173
3	Japan	2,457
4	Poland	2,126
5	France	1,250
6	Argentina	930
7	Italy	863
8	Czech Republic	840
9	South Korea	756
10	Canada	715
Source: Federation of the International Periodical Press, London		

If you want to skip the theory and move to the big story, then you can turn to the next chapter now. However, the concluding pages of this chapter will create a theoretical framework for the century that offers some explanations as to why magazines experienced such expansive growth. Five times since the 20th century began, skeptics have predicted the decline or demise of magazines. First, after World War I when automobiles first became popular and inexpensive, some people felt the time people spent driving would hurt magazine reading and the magazine business. Second, when commercial radio stations flourished in the 1920s, some thought radio would steal all the advertising from magazines as people stopped reading them. Third, the Golden Age of movies during the 1930s again convinced the skeptics that magazines had a dim future as the public became fascinated with this new medium. Fourth, television's introduction and its mushrooming growth in the 1950s again made people wonder whether magazines could survive. The demise of such icons as *Collier's*, *Look*, and *Life* in the late 1960s convinced many that magazines were doomed.[3] Finally, the introduction of the Internet during the 1990s again brought

out the "death of print" chorus to sing its eulogy to magazines.

Only four books cover any general history of American magazines and they offer limited explanations for the success of magazines. Theodore Peterson's *Magazines in the Twentieth Century,* was published in 1964. Professor Peterson attributes the success of magazines to "the increase in population, the redistribution of purchasing power, the advances in education, and the increase in leisure time."[4] Professor David Abrahamson focused on the growth of magazines in the two decades after World War II in his book, *Magazine-Made America: The Cultural Transformation of the Postwar Periodical.* Professor Abrahamson analyzes the proliferation of special interest magazines launched after World War II along with the decline of mass market general interest magazines. His theory is that the economic prosperity and growth in leisure time enabled the growth of special interest magazines.

John Tebbel and Mary Ellen Zuckerman covered the first 250 years of American magazines with *The Magazine in America 1741–1990,* which was published in 1991.

Tebbel and Zuckerman did not attempt any analysis of why magazines grew. Richard Ohmann's *Selling Culture: Magazines, Markets and Class at the Turn of the Century* (1996), focused on the two decades between 1890 and 1910 to analyze why magazines expanded so rapidly in this century. Professor Ohmann credits magazines for their singular role in creating a mass culture and shared sense of identity, values and experiences among Americans. Writing from an admitted Marxist theory of hegemony, Ohmann argues that the success of magazines grew as a direct result of capitalist expansion and need for manufacturers to create new markets of readers for their burgeoning line of products. So they turned to magazines to create a mass culture, whet readers' appetites for new products and experiences, and find new markets for their goods and services. In Ohmann's view, magazine readers were pawns in the hands of larger forces seeking to use and manipulate them for their own materialistic ends.

Professor Ohmann's Marxist framework fails to recognize the freewill and autonomy of magazine readers in choosing content that is useful to their lives. American consumers drove the growth of magazines because magazines met their needs. Despite this limitation, Ohmann's analysis is the most comprehensive anyone has yet attempted. In positing a theory of magazine expansion, both he and Professor Abrahamson made connections between a large number of technological, economic, social and cultural forces and events that came together to produce the growth in American magazines during the 20th century.

A good theory, whether rooted in the physical or social sciences, is simple in its eloquence and powerful in its ability to explain a large number of phenomena.

Richard Brown points out that it offers an appealing explanatory power to historians:

> For in an era when general history is becoming less and less comprehensible owing to the increasing specialization of scholarship, an interpretive framework that promises to integrate a wide range of historical phenomena...deserves scrutiny. An idea that helps to explain the connections among events in economic, political, social and intellectual history can be vitally important for our understanding.[5]

The Magazine Century will introduce two theories about why American magazines grew so rapidly during the 20th century. First, the expanding number of mass media inventions—radio, movies, television—served to whet the appetite for new sources of information that magazines provided. This expanding range of interests created a demand for larger numbers of special interest magazines and a declining market for general interest magazines. This will be called the "expansion of interests" theory.

Second, two concurrent trends in magazines during the 20th century form the "popularization of content" theory. Technological innovations and increased reliance on advertising as a revenue source made magazines gradually cheaper to consumers. As the century progressed, advertisers picked up more and more of the tab. Consequently, the intellectual and literary content of magazines declined as they reached wider and wider audiences. Toward the end of the century, the content of mass market magazines had become increasingly focused on celebrities, sex, lifestyles, and very individualized leisure pursuits. Magazines ceased to be a public forum of ideas and became focused on content that allowed individuals to follow very personalized interests. These two trends result in what this author calls the "popularization of content" theory.

The expansion of interests

Magazines are not a printed product that people buy and read simply because they enjoy magazines in and of themselves. They are valuable to consumers only because of the information they provide. In the case of magazines, Marshall McLuhan is not correct because the medium is not the message. The message is the message that the medium conveys. As people became interested in more topics, places, pursuits and issues, then they needed more magazines to report on those interests.

Professor Benjamin Compaine introduced this concept of the expansion of interests. He said that television's exposure of the public to new ideas, places, and interests helped spur magazine growth: "Just as book publishers have learned that

a successful movie spurs book sales, so magazine publishers have learned to take advantage of television. The popularity of television spectator sports has stimulated sales for magazines and fast-breaking news on television has created opportunities for deeper analysis and perspective from the newsmagazines," he explained.[6] People buy magazines only for the information they provide—specifically because of their interest in a particular type of subject matter that the magazine writes about. Therefore, magazines grew because of the increasing ranges of people's interests that expanded exponentially throughout the 20th century. The inventions of the telephone, the airplane, radio, motion pictures, and later television broke down the barriers that divided a globe and widely expanded people's interests in reading about new cultures, vocations, avocations, as well as national and international cultural and news events. As the century progressed, air travel and international travel were no longer limited to the wealthy. Far from limiting the expansion of magazines, new forms of mass media, travel and communication had the opposite effect of increasing the demand for magazines.

Professor Peterson acknowledges this concept without expanding it in detail. "Why was the magazine industry able to grow in the face of such competition?" he asks. He offers this answer:

"One good guess, and there is some documentation to support it, is that each new medium has stimulated rather than diminished use of the existing media. Book publishers learned that a Hollywood dramatization of a book spurred rather than harmed the sale of copies."[7]

This expanding (and fragmenting) range of people's interests resulted in a transition from high-circulation, general interest magazines at the beginning of the century to small-circulation, niche magazines by the end of the century. While this trend is widely noted by many magazine observers, the evidence shows that it began early in the century—not after the advent of television. General interest magazines began falling by the wayside early in the century as many special interest titles were launched to serve niche interests in the American public, especially during the 1940s. Early examples of specialized titles were *Scientific American*, founded in 1845, *Popular Science* (1872), *Sports Afield* (1887), *National Geographic* (1888), *Outdoor Life* (1898), *Field and Stream* (1895), and *Motor Boating* (1907). Table 3 provides a sample of fifty leading hobby and special interest magazines launched prior to 1950 and still published today.

Almost four times as many general interest magazines ceased publishing before 1950 as after 1950. Table 4 gives a list of twenty-five general interest magazines that ceased publishing before 1980 and nineteen that folded before 1950.

Table 3

Date	Magazine
	50 Special Interest **Magazines Launched Between 1845 and 1950**
1845	Scientific American
1863	Armed Forces Journal
1867	American Naturalist
1872	Popular Science
1885	American Rifleman
1886	Progressive Farmer
1886	Sporting News Magazine
1887	Sports Afield
1895	Field and Stream
1898	Outdoor Life
1899	Technology Review
1900	Natural History
1901	House & Garden
1902	Successful Farming
1902	Popular Mechanics
1903	Motor: Covering the World of Automotive Service
1903	Hounds and Hunting
1904	Horticulture: Gardening at its Best
1907	Motor Boating
1908	Sea: America's Western Boating Magazine
1912	Motorcyclist
1913	Art in America
1913	American Scientist
1913	Architecture
1914	Golf Illustrated
1916	Dog World
1916	Aviation Week & Space Technology
1920	Scott Stamp Monthly
1922	German Shepherd Dog Review
1922	The Ring: The Bible of Boxing
1922	American Gardener
1925	Arizona Highways
1926	Dance Magazine
1926	Camping Magazine
1927	Flying
1929	Model Airplane News
1931	American Cowboy
1934	Model Railroader
1936	Opera News
1936	Ski Magazine
1937	American Artist
1937	Chronicle of the Horse
1937	Popular Photography
1939	Salt Water Sportsman
1940	Trains

Table 3 *continued*

Date	Magazine
1941	*Trailer Life*
1942	*Organic Gardening & Farming*
1944	*Fishing & Hunting News*
1947	*American Motorcyclist*
1943	*Hot Rod Magazine*
1950	*Prevention*

Table 4

25 General Interest Magazines That Ceased Publishing Between 1900 and 1980		
Magazine	Founding	Termination
Arena	1889	1909
Lippincott's Magazine	1866	1916
Leslie's Weekly	1855	1922
The Independent	1848	1928
The Dial	1880	1929
Everybody's Magazine	1899	1929
Munsey's	1889	1929
McClure's	1881	1929
Century Illustrated Monthly	1881	1930
Smart Set	1890	1930
World's Work	1900	1932
Outlook	1867	1932
The Delineator	1873	1937
Literary Digest	1890	1938
Scribner's Magazine	1887	1939
Pictorial Review	1899	1939
North American Review	1815	1940
Forum	1887	1940
Littell's Living Age	1844	1941
American Magazine	1876	1956
Collier's	1888	1956
Coronet	1936	1961
Look	1937	1971
Life+	1936	1972
American Mercury	1924	1980
+Relaunched as monthly 1972–2000		

The popularization of content

The explosive growth of manufacturing and advertising has made magazines gradually cheaper and thus expanded their circulation to more and more Americans. The decrease in magazine prices from "expensive" to "inexpensive" and often free has been fueled by a gradually increasing reliance on advertising revenue. According to a 1963 article in the advertising trade magazine *Printers' Ink*, "The largest single influence in causing magazines to prosper was the power of advertising to stimulate the purchase of goods America was capable of producing. This coincided with the era of mass production and as a result advertising, in the modern sense, awoke like a sleeping giant and affected the growth of magazines tremendously."[8] Between 1900 and 2000, magazines generally became a *business enterprise* instead of a *literary enterprise*. Magazines became defined not as much by their content but by the demographic character of their audiences.

In 2001, a study in the *Journal of Advertising Research* pointed out that magazine color advertising rates increased 136 percent (inflation adjusted) between 1980 and 1998. During the same period, inflation-adjusted single copy magazine cover prices increased by only 11 percent. More surprising, however, is that the average price of a magazine subscription declined in inflation-adjusted dollars. While the published subscription price increased from an average of $14.49 to $26.04, the actual price of a magazine subscription for consumers declined by 9.2 percent in inflation-adjusted dollars between 1980 and 1998.[9]

By 2000, the cover price of most magazines was essentially "zero" for those with Internet access. The business model of a low cover price introduced in the 1890s by *Munsey's, McClure's* and *Cosmopolitan* has continued to evolve in the same direction. Readers benefited from a continually decreasing price for content while advertisers paid a continuously increasing price to reach those readers.

Instead of a "general interest" appeal, magazines became defined by people's interests. If enough people become interested in a subject, then someone soon launched a magazine to cater to those interests. However, a component of the special-interest magazine is the special-audience magazine. A special-interest magazine, which has readers of all ages, genders and ethnic backgrounds, focuses on a particular subject that all of them are interested in. A special-audience magazine, on the other hand, is directed at readers in one segmented age, gender or ethnic grouping. Within that segment, the type of content varies. Women's magazines or Hispanic magazines, for example, may contain articles about health, food, fashion or entertainment. Both special-interest and special-audience magazines became more predominant as the century progressed and reflected this move away from general interest magazines.

"Publishers became a dealer in consumer groups as well as a dealer in editorial matter," as Professor Peterson said.[10] All it took to publish a magazine was a sufficiently sizeable group of people with a niche interest and a group of advertisers producing products catering to that niche.

While everyone has heard the aphorism "Information wants to be free," its original context is overlooked. Chris Anderson, editor of *Wired* and author of *Free: The Future of a Radical Price*, credited the phrase to Peter Samson of MIT's Tech Model Railroad Club in 1959.[11] Twenty-five years later, "All information wants to be free" was published as rule three in "Seven Principles of the Hacker Ethic" in the book *Hackers: Heroes of the Computer Revolution* by Steven Levy. Stewart Brand, creator of the *Whole Earth Catalog* gave it a definitive context at a 1984 conference of computer hackers in Fort Cronkhite, California. Brand re-stated rule three in a way that has since characterized the transforming age of digital media:

> On the one hand, information wants to be expensive, because it's so valuable. The right information in the right place just changes your life. On the other hand, information wants to be free, because the cost of getting it out is getting lower and lower all the time. So you have these two fighting against each other.[12]

The cost of "getting it out" has indeed become lower and lower ever since the invention of the printing press, the invention of computers, and the invention of the Internet. But the cost of creating intellectual property—the cost of paying salaries to editors and writers—continues to rise and creates the thorny conundrum faced by newspaper and magazine publishers today.

All of this has resulted in a general decline in the intellectual level of magazine content as it reached more mass market audiences. If a newspaper or magazine had to reduce its staff because of reduced revenue, then the amount of time spent in producing its content must necessarily decline. The quality of its intellectual property will also decline. This broad statement is obviously not true of many fine magazines still published today, but it does characterize industry trends as a whole.

The most popular mass-market magazines of the 1890s, such as *Munsey's*, *McClure's*, and *Cosmopolitan*, more closely resembled today's *The New Yorker* or *The Atlantic Monthly* than current popular mass-market magazines such as *People*, *National Enquirer*, or even *Reader's Digest*. Features were often eight to ten pages long, the topics were sophisticated, the print was small, and pages were text-heavy with a few scattered photos. Magazine readers of the late 1890s were more highly educated and sophisticated in their literary interests than the great majority of magazine readers today. In *Magazines in the Twentieth Century*, Professor Peterson said, "…Advances in education increased the number of Americans who could read and write, but schools were not producing the sort of educated reader that the best nineteenth century magazines were edited for."[13]

While space can't allow reprinted articles from early magazines, Table 5 below helps to illustrate this change. Lengthy articles on these topics would not likely appear in popular mass-market magazines today, such as *Reader's Digest, Ladies' Home Journal,* or *People.*

Table 5

Three Examples of Magazine Feature Articles in 1900
These articles were chosen as representative of typical feature articles from three of the most popular, highest-circulation magazines in 1900: *Ladies Home Journal, Munsey's,* and *McClure's*
"The Passion Play This Year" by Ida Shaper Hoxie, *Ladies Home Journal,* June 1900, pp. 7–8. Approximately 4,500 words in 6-point type on 2 large pages with 9 small photos taken in Oberammergau. This article describes an overview of the Oberammergau (Germany) Passion Play, including its history, a detailed description of its physical setting in the Bavarian Alps, its plot and its actors. A sidebar includes a detailed outline of what occurs in each of 18 scenes in the play.
"The Panama Canal" by Henry Harrison Lewis, *Munsey's Magazine,* June 1900, pp. 361–370. Approximately 2,400 words in 9-point type including 9 photos taken in Panama. This article describes the failed efforts to build the Panama Canal, which was not completed until 14 years later. It describes "the present conditions and future prospects of the great ditch started so disastrously in 1880 by Ferdinand de Lesseps—the Advantages of the Panama Route, and the plans of the new company organized to prosecute the work."
"Governor Roosevelt—As An Experiment. Incidents of Conflict in a Term of Practical Politics," by Lincoln Steffens, *McClure's,* June 1900, pp. 109–112. Approximately 3,050 words in 9-point type on 4 pages with no photos or graphics. This article, which was published near the end of Theodore Roosevelt's term as governor of New York, critically examines his performance as governor and assesses his prospect for nomination as the Republican vice presidential candidate in the 1900 election.

In the early 1900s, magazines looked like small versions of books. At the end of the century, magazines looked like television screens. In his classic work, *Amusing Ourselves to Death: Public Discourse in an Age of Show Business,* Professor Neil Postman made this same point. Postman argued that America has moved from a print-centered culture in the 19th century to an entertainment-centered culture in the late 20th century. While more printed material is available today than at any previous time in history, Postman argued that until the late 19th century, "Printed matter was virtually all that was available.…Public business was channeled into and through print, which became the model, the metaphor, and the measure of all discourse."[14]

This trend is illustrated among magazines by the rise of the celebrity-sex-entertainment niche that began with *TV Guide* in 1953, *People* in 1974 and *Us Weekly* in 1977. In 1985, Jann Wenner, publisher of *Rolling Stone,* bought *Us Weekly* and later

said, "Call it what you want—gossip journalism, celebrity journalism, human-interest journalism. By any name, this has become the dominant theme in journalism…."[15] Although these magazines had origins in the pulp magazines and movie magazines in the 1930s, their ascendance into mainstream magazine culture began in the 1950s.

Postman argued that magazines have also influenced television and that the process is two-way. "New and successful magazines, such as *People* and *Us*, are not only examples of television-oriented print media," he says, but they have influenced television news content. "Whereas television taught the magazines that news is nothing but entertainment, magazines have taught television that nothing but entertainment is news."[16]

One notable exception to this trend was the "New Journalism" movement of the 1960s, which produced some of the finest writing of the 20th century. The most notable magazines producing this new genre of literary nonfiction were *Esquire, The New Yorker, Harper's,* and *New York.* Those same magazines and a few more have managed to preserve that literary tradition in varying degrees. Chapter eight covering the 1960s will discuss these magazines and the genre in greater detail.

National Enquirer originated as the *New York Evening Enquirer* newspaper in 1926, but Generoso Pope, Jr. purchased it, re-named it *National Enquirer* in 1957, and gave it the reputation for which it became known. In 1979, Pope launched another tabloid, *Weekly World News,* and in 1984 Rupert Murdoch introduced *The Star.* Table 4 offers circulation data and founding dates for 10 of these leading tabloid and celebrity magazines. Their combined circulation of 14.5 million is about 40 percent more than the combined 10-million circulation of ten leading news and opinion magazines: *Time, Newsweek, U.S. News & World Report, The Economist, The Week, Harper's, The Atlantic, The New Republic, The Nation,* and *National Review.*

Table 6

Leading Celebrity, Tabloid and Entertainment Magazines				
Magazine Title	Launch year	Subscription Sales	Single Copy Sales	Total 2008 Circulation
Entertainment Weekly	1990	1,701,153	50,437	1,751,590
In Touch Weekly	2002	64,419	834,492	898,911
Life & Style Weekly	2004	10,189	461,969	472,158
National Enquirer	1957	271,275	620,100	891,375
Ok! Weekly	1993	341,759	490,417	832,176
People	1974	2,127,384	1,472,149	3,599,533
Star Magazine	1984	571,525	617,096	1,188,621
TV Guide	1953	2,942,230	155,291	3,097,521
Us Weekly	1977	1,011,018	796,669	1,807,687
Total Paid Circulation				14,539,572

Source: Ken Sonenclar, *Lost in Transition: The Revolution in Celebrity Media* (New York: desilva + phillips, LLC, March 2009). Accessed at www.mediabankers.com, August 26, 2009.

Hugh Hefner founded *Playboy* in 1953, Bob Guccione started *Penthouse* in 1965, and Larry Flynt launched *Hustler* in 1974. The influence, however, was not limited to the "skin magazine" sector for which *Playboy* is most famous. In the spring of 1972, Joseph E. Scott and Jack L. Franklin reported in *Public Opinion Quarterly* the results of a survey of magazine content from 1950 to 1970. Their goal was to determine how much the "sexual revolution" had changed popular magazines in terms of sexual references, such as articles about abortion, homosexuality, masturbation, adultery, and other forms of extra-marital sex. Using a sample of seven magazines—*Reader's Digest, McCall's, Life, Look, Saturday Evening Post, Time and Newsweek*—they discovered that the number of sex references increased 82 percent from 1950 to 1960 and 111 percent from 1950 to 1970. Even accounting for a slight decline in total number of pages among these magazines, the ratio of references to sex per page was .18 in 1950, .27 in 1960 and .42 in 1970.[17]

Ten years later Professor Scott updated the same study using the same magazines, except for *Look*, which had stopped publishing. He found the same continuing trend: "The number of references to sex continued the same pattern observed for previous decades. The number of sex references increased 83 percent from 1950 to 1969, 16 percent from 1960 to 1970 and 68 percent from 1970 to 1980. The ratio of references to sex per page is not only higher for 1980 than the previous years, the increase is greater from 1970 to 1980 than for any previous decade," he wrote.[18] Another study published in the *Journal of Sex Research* found that even *Playboy* centerfolds had become more "explicit" between 1953 and 1990.[19]

Citing other research, Scott concluded that the sexual content of these magazines was not the cause of America's changing sexual habits, but that the reverse was true: "It appears reasonable to interpret these increases as a simple reflection of the fact that there has been a gradually increasing acceptance of and more open mindedness about the subject."

Magazines mirror American culture. They do not shape it. A few influential magazines may influence small segments of opinion leaders. But magazines emerge and evolve to meet the demand for changing public interests and tastes. Professor Scott adds this supporting fact: "That magazines such as *Playboy* and *Penthouse* have circulations in 1980 larger than *Time* and *Newsweek* and are listed among the top twelve periodicals published in the United States seems to add weight to this conclusion."[20]

Succeeding chapters will explain how magazine publishers and editors sensed the changing nature of American interests and rose to create vehicles that filled the information needs of those interests. It begins with the stories of Cyrus Curtis, Frank Munsey, Samuel McClure and John Walker during the 1890s and how they created the business formula for the modern magazine. It continues by telling the sto-

ries of the most successful editors and publishers of the early 20th century and its succeeding decades. The 20th century was a colorful, fun-filled century for magazines—complete with public controversies, legal disputes, dismal failures, and spectacular successes. It was the magazine century.

Notes

1. Henry Luce, *Life*, February 7, 1941, quoted in *Diplomatic History* 23, 2 (Spring 1999): 159–172.
2. "The American Century: A Roundtable," *Diplomatic History* 23, 2 (Spring 1999): 159–172.
3. Benjamin M. Compaine, *Who Owns the Media? Concentration of Ownership in the Mass Communications Industry* (White Plains, NY: Knowledge Industry Publications, Inc., 1982), 169.
4. Theodore Peterson, *Magazines in the Twentieth Century* (Urbana: University of Illinois Press, 1964), 55.
5. Richard D. Brown, *Modernization: The Transformation of American Life, 1600–1865* (New York: Hill and Wang, 1976), 19.
6. Benjamin Compaine, "The Magazine Industry: Developing the Special Interest Audience," *Journal of Communication* 30, 2 (Spring 1980): 98–103.
7. Peterson, *Magazines in the Twentieth Century*, 52.
8. "Selectivity: Magazines' Uncommon Strength," *Printers' Ink, The Weekly Magazine of Advertising and Marketing*, June 14, 1963, 268.
9. David E. Sumner, "Who Pays for Magazines—Advertisers or Magazines?" *Journal of Advertising Research*, 41, 6 (November–December 2001): 61–67.
10. Peterson, *Magazines in the Twentieth Century*, 45.
11. Chris Anderson, *Free: The Future of a Radical Price* (New York: Hyperion Books, 2009), 94.
12. Ibid., 96.
13. Peterson, *Magazines in the Twentieth Century*, 144.
14. Neil Postman, *Amusing Ourselves to Death: Public Discourse in the Age of Show Business*, 20th Anniversary ed. (New York: Penguin Books, 1985, 2005), 41.
15. Edwin Diamond, "The New Gossips," *New York*, May 13, 1985.
16. Postman, *Amusing Ourselves to Death*, 112.
17. Joseph E. Scott and Jack L. Franklin, "The Changing Nature of Sex References in Mass Circulation Magazines," *Public Opinion Quarterly* (Spring 1972): 81.
18. Joseph E. Scott, "An Updated Longitudinal Content Analysis of Sex References in Mass Circulation Magazines," *The Journal of Sex Research* 22, 3 (August 1986): 387.
19. Anthony F. Bogaert, Deborah A. Turkovich and Carolyn L. Hafer, "A Content Analysis of 'Playboy' Centrefolds from 1953 through 1990: Changes in Explicitness, Objectification and Model's Age," *The Journal of Sex Research* 30, 2 (May 1993): 135–139.
20. Scott, "An Updated Longitudinal Content Analysis of Sex References," 391.

The 1890s

The Emergence of Modern Magazines

Today it would be called a recession or maybe a depression, but in the 1890s it was called the "Panic of 1893," the worst economic crisis to hit the U.S. until that time. Historians said it was caused by a "railroad bubble." By 1890, railroads were overbuilt with 70,000 miles of track, which were poorly financed. That led to bankruptcy filings by leading railroad companies followed by a series of bank failures. Unemployment climbed from 3 percent in 1892 to more than 18 percent in 1893 and didn't drop to less than 10 percent until 1899. One historian described the period this way:

> All around were breadlines of hungry men, without a nickel in their pockets....Prices fell. Banks closed. Farm mortgages were foreclosed. Ready cash was not to be had. The government itself was dangerously short of funds, and its credit was not good.[1]

In the midst of this panic when most magazines sold for 25 cents or more, Samuel S. McClure launched *McClure's* in June 1893 at the cover price of 15 cents. John Brisben Walker, editor of *Cosmopolitan*, dropped its price in July to twelve and a half cents. In October, Frank Munsey dropped the price of *Munsey's* from twenty five to ten cents. Within a few months, all three were selling for ten cents. Other magazines followed. By the beginning of the 20th century, most magazines sold for ten or fifteen cents per copy and a dollar for a year's subscription.

By 1897, *McClure's* circulation increased to 260,000, *Cosmopolitan's to* 300,000, and *Munsey's* to 700,000—surpassing all competitors.[2] In 1903, *Ladies' Home Journal* was the first American magazine to reach a million subscribers. Their publishers stumbled into the economic formula that changed the business model of American magazines. It was simple: sell magazines for less than the cost of publishing them, attract a huge circulation, and sell ads to manufacturers willing to pay most of the costs to reach those readers by advertising their products. By selling their magazines for much less than the cost of production, they found profits in the high volume of advertising that the resulting large circulations attracted. Up until this time, magazines depended primarily on circulation revenue, while advertising played a minor role in both content and revenue.

In her memoir *Always in Vogue*, Edna Woolman Chase, a *Vogue* editor from 1895 to 1952, gave Frank Munsey the most credit for originating this concept:

> Munsey, even more than his great colleagues Curtis and McClure, is responsible for the prosperity of the magazine publishing industry in America, for it was he who formulated what seemed at the time a preposterous theory, although now all our popular magazines are built upon it; namely, to sell your magazine at a good deal less than it costs you to make it.[3]

Magazines become *the* national medium

After magazines began decreasing their prices, magazine circulation tripled between 1890 and 1905. In 1865, about one monthly magazine was published for every ten people. By 1905, that ratio grew to three copies for every four people.[4] "It was a happy time for magazines, that last decade of the nineteenth century, and fortunes were in the making as publishers reached persons who had seldom if ever before bought magazines," wrote Professor Theodore Peterson in *Magazines in the Twentieth Century*.[5]

Magazines became *the* national medium of communication and the only way to reach America's surging population with a message or a product. Magazines defined popular culture for more than thirty years until radio, motion pictures, television and the Internet followed to join in that role. By the early 20th century, magazines were "not only a regular form of entertainment, a source of pleasure for a national audience of readers, but a potent and powerful force in shaping the consciousness of millions of Americans,"[6] wrote Matthew Schneirov in *The Dream of a New Social Order*.

Several historical events came together at the right time to create the circumstances for magazines to become the first national mass medium.

- The completion of the first cross-country railroad in 1869 made a nation-

al distribution of magazines geographically feasible.

- Rotary web presses replaced the slow flatbed presses. Richard M. Hoe (1812–1886) invented the rotary printing press, which enabled pages to be printed on continuous rolls of paper through high-speed presses at a speed of ten times that of the sheet-fed presses that preceded them.
- The invention of halftone engraving made it possible for magazines to publish photographs using $20 halftones instead of $300 woodcuts that were limited to hand-drawn illustrations.
- The price of paper manufacturing decreased substantially after wood replaced cloth.
- Demand for advertising surged with the growth of manufacturing. Between 1850 and 1910, for example, the average manufacturing company increased its production output by nineteen times and the number of its employees by seven.[7] New products like Coca Cola and Ivory Soap had become household names.
- Congress stimulated the growth of magazines by creating second-class mailing privileges for magazines, which decreased the cost of mailing from three cents per pound in 1874 to two cents in 1879 and one cent by 1885.[8] Then it added free postal delivery to rural areas, which increased the number of rural free delivery routes from forty-four in 1897 to 25,000 in 1903. There was a widespread feeling at the time that much of the misunderstanding between North and South arose from the lack of a national press that reached all parts of the nation. Part of the rationale behind's Congress' move to lower postal rates was to help fill this void and encourage the publishing of magazines and a national exchange of ideas.[9]

In 1893, *National Geographic*, a five-year-old academic journal for geographers and members of the fledgling National Geographic Society was still struggling to find its popular niche. *Saturday Evening Post*, although aiming at a middle-class audience, was near bankruptcy. *Ladies' Home Journal* under its legendary editor Edward W. Bok was starting to grow. Other magazines like *Scribner's, Century*, and *Harper's*—similar in content to today's *The New Yorker* or *The Atlantic* were influential among the elite, but limited in popular appeal. Into this mix came *McClure's, Munsey's, and Cosmopolitan*, which in 1893 had a vastly different content and audience than today's *Cosmopolitan*.

Samuel S. McClure and *McClure's*

Samuel S. McClure (1857–1949) was a gifted editor with an uncanny knack for discovering promising writers and packaging their content in an affordable magazine.

He founded *McClure's* in 1893 as an inexpensive illustrated monthly. Each issue contained articles on exploration, science, trains, and interviews and personality profiles. By 1900, *McClure's* boasted a circulation of 370,000, larger than any other monthly except *Munsey's*. In 1902, it initiated the muckraking movement. It began with Ida M. Tarbell's expose of monopolistic practices of the Standard Oil Company, which ran for two years and culminated in her book *History of the Standard Oil Company*. Lincoln Steffens' series on municipal government corruption and Ray Stannard Baker's articles on labor union racketeering and railroads made *McClure's* the muckraking leader.

McClure immigrated to this country from Ireland with his mother in 1866 when he was nine years old. They settled near relatives in northern Indiana. He worked his way through Knox College in Galesburg, Illinois, and graduated in 1882. He found his first job in Boston working for bicycle manufacturer Colonel Albert Pope teaching customers how to ride a bicycle. Pope, however, soon discovered his literary talents and asked the young McClure to become the founding editor of *Wheelman*, the company's bicycling magazine. McClure admitted he was not an avid magazine reader until he became its editor:

> When I was in college, I had never read magazines. They were too expensive to buy. It always seemed remarkable to me that a man could ever feel rich enough to pay thirty-five cents for a magazine.[10]

After two successful years, McClure left *Wheelman* with his new bride to seek his publishing fortunes in New York. After a year working as a printer's assistant for *Century* magazine, McClure started the country's first newspaper syndicate in November 1884. Describing it in his autobiography, he said:

> My plan, briefly, was this: I could get a short story from any of the best story writers then for $150. I figured that I ought to be able to sell that story to 100 newspapers throughout the country at $5 each.[11]

McClure went on to spend nine years building a highly successful syndication business. He traveled extensively around the country recruiting well-known writers, including Robert Louis Stevenson, Arthur Conan Doyle, and Rudyard Kipling, and syndicated their material to newspapers, mostly Sunday supplement magazines.

With the syndicate's eventual success, McClure decided to start a new magazine with a fifteen cent cover price aimed at readers who could not afford the typical twenty-five and thirty-five cent price of magazines. Determined to create an appealing and affordable popular magazine, McClure traveled again to search for authors and material. The launch was delayed by the market panic of 1893. He described the moment when he first realized the extent of the crisis. He was visit-

ing a Chicago newspaper editor who subscribed to his syndication service. McClure asked the editor for payment for the previous month's articles.

"Money, oh no! We can't give you any money. Look out there!" said the editor. "He pointed to a window, and I looked out. Down below I saw a crowd in the street, masses of people seething from curb to curb before a building. The building was a bank. That was the first I saw of the panic of 1893. And the first number of the new magazine was not yet off the presses," McClure wrote.[12]

Nevertheless, some of his influential friends had confidence in McClure and invested enough money in the magazine to get it started. The inaugural issue in May 1893 contained this unsigned announcement:[13]

> ## PRICE, 15 CENTS A COPY.
> ## SUBSCRIPTION, 1.50 A YEAR
> The price of this magazine marks a radical departure in the history of American magazines. This price is possible on account of the connection of the magazine with the Newspaper Syndicate established by S.S. McClure.
>
> Many stories by famous authors, and frequently special articles, will be secured from the newspapers and afterwards be republished in the magazine, with new and splendid interviews.

That issue, however, sold only 8,000 of its 20,000 printed copies. "The 8,000 that were sold brought in $600 but the paper and printing had cost thousands," McClure wrote.[14] By December 1894, however, circulation had reached 40,000 before surging during the next twelve months to 250,000 by December 1895.

The magazine struggled for a year until McClure discovered Ida M. Tarbell, whose skillful articles contributed immensely to the magazine's success. After her series on "The Life of Napoleon" was published in 1894, circulation rose from 40,000 to 80,000. After "The Life of Lincoln" series was published in August 1895, it went from 20,000 to 250,000, enabling the magazine to make its first profits in 1896.[15]

McClure also hired Witter Bynner as poetry editor and former actress Viola Roseboro as the fiction editor, who went on to discover the writers O. Henry and Willa Cather. In so doing, McClure was the first publisher of a general interest magazine (other than a women's or children's magazine) to hire women as full-time writers and editors.

McClure was among the first editors to seek out particular types of content

instead of sifting through the manuscripts that came in and choosing the topics that seemed most interesting. McClure disliked this passive role of an editor. In 1897, he told the *New York Tribune*, "A magazine should represent the ideas and principles of one man or a group of like-minded men" and "have a single purpose all through." He believed in "supervising the treatment of a topic to make it just right for our use….That is the reason why I or some of my assistants always collaborate with the author of a great feature."[16]

Finally, McClure was astute enough to pay writers a steady salary instead of for the number of words they produced. "I decided therefore to pay my writers for their study rather than for the amount of copy they turned out—to put the writer on such a salary that it would relieve him of all financial worry and let him master a subject to such a degree that he could write on it."[17] He noted that Ida Tarbell spent five years writing the fifteen articles in the Standard Oil series, which cost the publisher about $4,000 each.

Like most magazines until the turn of the century, *McClure's* clustered all of its advertising at the back of the magazine. Advertisers in one of its 1896 issues included Mason and Hamlin pianos and organs, Woodbury's facial soap, Edison phonographs, Wilbur's Cocoa, the Scientific Suspender Company, Parcheesi games, Rapid Writer fountain pens, and several typewriter manufacturers.

In January 1903, *McClure's* published the issue that launched the muckraking movement. Ida Tarbell wrote her third article about the Standard Oil Company ("The Oil War of 1872"), Ray Stannard Baker wrote on labor issues in the mining industry ("The Right to Work: The Story of Non-Striking Miners"), and Lincoln Steffens wrote "The Shame of Minneapolis," an expose of the city's widespread corruption. This last story was part of Steffens' series "The Shame of the Cities." McClure later said that this issue grew out of no special plan to launch a movement, but resulted, instead, from "merely taking up in the magazine some of the problems that were beginning to interest people a little before newspapers and other magazines took them up."[18]

Muckraking, however, was not a great financial success for *McClure's*, and circulation grew slowly during the early 1900s. In 1905, McClure earned his last profit on the magazine. McClure sold the magazine after several top writers, including Ida Tarbell, Ray Stannard Baker and Lincoln Steffens, left after a dispute with him. These writers formed a conglomerate to purchase the *American Magazine*, formerly *Frank Leslie's Illustrated Monthly*, for $360,000.[19] *McClure's* went on to survive a series of owners, editors, closings and revived start-ups for the next twenty-four years until March 1929 when it was merged with *The Smart Set*.[20]

Frank A. Munsey and *Munsey's*

If Samuel McClure was the talented literary publisher who learned how to succeed in business, Frank Munsey was the businessman who learned how to succeed in publishing. Frank A. Munsey (1854–1925) is credited with the idea of using new high-speed printing presses to print on inexpensive paper to mass produce affordable magazines aimed at working- and middle-class readers who didn't read the "high brow" magazines of the time. Although launched in 1889, *Munsey's* magazine was losing money until he dropped its price to ten cents in the October 1893 issue—three months after *McClure's* was launched with a fifteen cent cover price.

A Maine native, Munsey moved to New York in 1882 to start *Golden Argosy*, a boy's adventure magazine. *Golden Argosy* was, in the words of one historian, "an adolescent version of what would later become *Munsey's* with features on the glamour of city life, inspirational stories of small-town boys who struck it rich, and an assortment of serialized fiction." The very first issue contained the first installment of a serial by Horatio Alger called, "Do or Dare: A Brave Boy's Fight for a Fortune."[21]

In 1889, he founded *Munsey's Weekly*, a 36-page magazine, designed as "a magazine of the people and for the people, with pictures and art and good cheer and human interest throughout." Although it reached 40,000 copies per week for a while, its circulation and revenue declined, forcing him to reduce it to a monthly in 1891.

When the panic of 1893 struck, however, Munsey found himself facing $100,000 in debts and two failing magazines. Feeling desperate, in September 1893 he decided to take a risk by dropping the price to ten cents. To announce his decision, he purchased a large ad in the New York *Sun*, which read:

> At ten cents per copy and at a dollar a year for subscriptions, *Munsey's* will have reached that point below which no good magazine will ever go, but to which all magazines of large circulation in America must eventually come. The present low price of paper and the perfecting of printing machinery make it possible to sell at a profit a magazine at these figures—as good a magazine as has ever been issued, provided it is not too heavily freighted with advertisements.[22]

That move dramatically increased circulation from 40,000 to 500,000 in six months. By 1897, *Munsey's* circulation reached 700,000, surpassing *McClure's* 260,000 subscribers, and *Cosmopolitan's* 300,000.[23] Frank Munsey wrote, "Four months ago the circulation of *Munsey's* compared with that of giants in the field was extremely modest, but today *Munsey's* is King."[24] This announcement appeared in the October 1894 issue:

MUNSEY'S MAGAZINE, Vol. XII, No. 1, October 1894 (p. 111).

THE PUBLISHER'S DESK

The Record of a Year; or, Prophecy vs. History

One year ago, the management of this magazine because the subject of somewhat wide discussion; the object, indeed, of ridicule by the "wise." The occasion of this discussion, this ridicule, was the announcement, more or less forcefully stated, that as good a magazine as had ever been made could be made and published profitably at ten cents a copy or one dollar a year, and that these were the figures at which MUNSEY'S would thereafter be sold. The move was so unprecedented; it involved such an overturning, such a breaking away from established prices, from hide bound conventionality, that these wise ones whose imagination never swings loose, shrugged their shoulders with a contemptuous smile for the quixotic management that should undertake anything so completely ridiculous....THIS WAS PROPHECY; HERE IS HISTORY:

We opened the fall campaign last year with an edition of 20,000 for October. We open the fall campaign this year with an edition of 275,000 for October, thus making a net gain for the year of 255,000. An increase of over a quarter of a million in the circulation of a magazine in a single year is without precedent in the whole history of publishing....

And this announcement appeared in the next issue:

MUNSEY'S MAGAZINE, Vol. XII, No. 2, November 1894 (p. 111).

300,000 STRONG

We have got there—300,000 strong. These are the figures that we have reached this month. They are great big figures—greater by more than 100,000 of any other magazine in the world. And this is the work of but a single year.

A record like this means something. It means that in the people find the magazine they want—a magazine built on the lines of human interest—and that its price is right. The day has gone by for old war prices.

MUNSEY'S is surging forward at a terrific pace....Our average monthly gain for the year beginning October, 1893, and ending September, 1894, was 21,250 copies. And now that we have entered on the second year, the pace is getting hotter, decidedly hotter.

Frank Munsey earned another dubious honor. When he revamped and repositioned *Argosy* in 1896 as a cheap fiction magazine, he launched new genre of magazines that transformed American magazines for the next fifty years. Munsey's *Argosy*, containing action and adventure tales, was considered the pioneer among the "pulp magazines," so-named after the inexpensive paper made from pulpwood scraps they were printed on. Munsey had a simple maxim, "The story is worth more than the paper it is printed on." Aimed at a working-class population, the ten-cent pulps quickly earned a reputation as being sensationalist, violent, exploitative and sexist. The pulps fell generally into six content categories: sex-oriented, science fiction, horror, crime-detective, western, and action-adventure.

"They catered to basic needs in the male psyche because their market was almost solely focused on the U.S. male: his aspirations to be 'red-blooded' and a 'he-man,' and to have a life of action and adventure in which beautiful women fell easily into his arms, and even his bed," wrote Peter Haining in *The Classic Era of American Pulp Magazines*.[25]

Nevertheless, some of the century's best writers got their start in writing for them, including Isaac Asimov, Ray Bradbury, Max Brand, Edgar Rice Burroughs ("Tarzan" creator), Earl Stanley Gardner ("Perry Mason" creator), and Zane Grey. *Argosy's* success inspired more pulp launches by Munsey, including *All Story Magazine*, *The Cavalier* and *The Scrap Book*. Within the next thirty years, more than 300 pulp magazines were started by various publishers. The pulps reached their peak during the 1920s and 1930s and began to decline during the 1940s with wartime paper restrictions and changing public tastes.

Frank Munsey was an entrepreneur who owned at various times eighteen newspapers, ten magazines, and a grocery store chain. He also wrote five novels. He made enemies, however, by buying and closing competing newspapers and magazines. He was not a magazine publisher but a "magazine manufacturer," one rival said.[26] One biographer wrote of him, "So quick was he to destroy not only the creations of his own imagination but various newspapers which he bought to suppress in order to increase the power and influence of others he possessed that the phrase 'Let Munsey kill it' became current newspaper slang whenever a daily was reported in distress."[27]

When he died in 1925, he owned the New York *Sun*, one of the city's three largest dailies, the *Evening Telegram* and three magazines: *Argosy All-Story Weekly*, *Munsey's Magazine*, and *Flynn's Weekly Detective Fiction*. A lifelong bachelor, his estate was appraised at $19,747,687—about $260 million in today's money—most of which he left to New York's Metropolitan Museum of Art.[28]

John Brisben Walker and *Cosmopolitan*

After the June 1893 launch of *McClure's* at fifteen cents, Samuel McClure expected to have the monopoly on inexpensive magazine prices for at least a year. In July, however, John Brisben Walker (1847–1931) cut the price of *Cosmopolitan* from twenty-five cents to twelve and a half cents. *Cosmopolitan*, founded in 1886 as a hybrid of a conservative literary monthly and general interest magazine, was in its first eighty years quite different in content from the "sex manual" that some critics describe it as today. The magazine was failing during its first three years until Walker purchased it in 1889 and turned it around.

John Brisben Walker brought a diverse, interesting background into publishing. After attending the U.S. Military Academy, he served as a military adviser in China from 1868 to 1870. He returned to America and built an iron manufacturing plant in the Kanawha Valley of West Virginia. After making a fortune in iron manufacturing, he lost most of it in the financial panic of the 1870s. Turning to journalism, he became managing editor of the *Pittsburgh Telegraph* in 1876 and three months later took a similar position at the *Washington Chronicle*. After the *Chronicle* was discontinued, Walker purchased 1,600 acres of land near Denver and developed a highly successful alfalfa ranch. After selling the ranch for a large profit, he returned to New York in 1889 and purchased the failing *Cosmopolitan* magazine from Joseph N. Hallock.[29]

For the next six years, he published a wide variety of fiction and articles on public affairs, consumer issues and society by such well-known writers as Rudyard Kipling, Jack London, Robert Louis Stevenson, and Mark Twain. Besides its fiction, *Cosmopolitan* adopted a service emphasis. Some of its articles helped readers choose a profession, purchase a house, buy and prepare the right kind of foods, and stay healthy. One friendly critic said of Walker, "He has introduced the newspaper ideas of timeliness and dignified sensationalism into periodical literature."

Walker sought to straddle the boundaries between "dignity" and "sensation," as one of his contemporaries put it.[30] *Cosmopolitan* found a niche between the more populist content of *Munsey's* and the more sophisticated approach to celebrity interviews and features taken by *McClure's*. *Cosmopolitan* was, in the words of one historian, "A combination of…the quality magazine's emphasis on cultural uplift with to the independent newspaper tradition of political education to the sensational newspaper's focus on personality and human interest."[31]

Magazine historian Frank Luther Mott wrote: "Of the three *McClure's* was the best all-round magazine; *Cosmopolitan*, though perhaps as stimulating and vital, lacked something on the literary side; and *Munsey's*, with its excellent variety, made much of its appeal on a somewhat lower intellectual level than the others."[32]

Walker engaged in several projects that garnered public and media attention for

him and the magazine. His plan to launch the "Cosmopolitan University" was the most ambitious. In the August 1897 issue, he announced his free correspondence school. "No charge of any kind will be made to the student. All expenses for the present will be borne by *Cosmopolitan*. No conditions, except a pledge of a given number of hours of study." Walker appropriated $150,000 for the project and recruited a president and faculty members. Within six weeks, 4,000 students had enrolled and the number continued to grow. After two years, Walked admitted that the university could not handle the demand, and he was forced to substantially reduce its enrollment and scope.[33]

After making an unsuccessful race for Congress, Walker built an automobile plant and became the first president of the American Manufacturers Association. By 1905, Walker had become so involved in automobile manufacturing and other ventures that he gave little attention to *Cosmopolitan*. Walker sold *Cosmopolitan* in 1905 to newspaper magnate William Randolph Hearst (1863–1951), whose company has owned the magazine ever since.

Cyrus Curtis: *Ladies' Home Journal* and *Saturday Evening Post*

Cyrus Curtis (1850–1933) published the *Ladies' Home Journal* and *Saturday Evening Post* from the 1890s through the first three decades of the 20th century when they became the country's two highest-circulation magazines. *Ladies' Home Journal* was the first magazine to reach a million paid subscribers in 1903 and by 1920 was the most valuable magazine property in the country. Circulation of the *Post* reached one million by 1908 and two million by 1913.

Curtis hired two young men who became two of the most successful and beloved American magazine editors: Edward William Bok (1863–1930) and George Horace Lorimer (1867–1937). Bok edited *Ladies' Home Journal* from 1889 to 1919 and Lorimer edited *Saturday Evening Post* from 1899 to 1936.

Curtis started his publishing career at the age of fifteen in his hometown of Portland, Maine, when he founded *The Young American*. After the great Portland fire of 1866 destroyed both his home and printing business, he moved to Boston and started a weekly business magazine, *People's Ledger*, which he published from 1872 to 1876 when a fire again destroyed his business. Undaunted by setbacks, he heard that publishing and printing costs were much cheaper in Philadelphia. So he moved there with the hopes of re-entering the business. After selling advertising for *The Philadelphia Press* for several years, he received a $2,000 gift from his sister and brother-in-law, which he used to launch a weekly called *The Tribune and Farmer* in 1879.

Table 1

<div>

Cyrus H.K. Curtis
Publications Founded or Purchased

Founded Publications
- *Young American*. Portland, Maine. April 5, 1865.
- *People's Ledger*. Boston, Mass. 1872.
- *Tribune and Farmer*. Philadelphia, Penn. 1879.
- *Ladies' Home Journal*. Philadelphia, Penn. February 16, 1883.
- *Country Gentleman*. Philadelphia, Penn. 1911.
- *Public Ledger*. Philadelphia, Penn. 1920.

Purchased Publications
- *Saturday Evening Post*. Philadelphia, Penn. 1897.
- *Philadelphia Public Ledger*. Philadelphia, Penn. 1913.
- *Philadelphia Press*. Philadelphia, Penn. 1919.
- *Philadelphia North American*. Philadelphia, Penn. 1919
- *New York Evening Post*. New York, New York. 1923.
- *Philadelphia Inquirer*. Philadelphia, Penn. 1930.

</div>

In an effort to expand its readership, Curtis started a "Women at Home" department in *The Tribune and Farmer*. Curtis wrote it, but one night at home he asked his wife, Louisa Knapp Curtis, to proofread it. After reading it, she criticized it, which irritated Mr. Curtis. "I suppose you could do it better," he told her, to which she replied, "yes." After she took over this department, reader response was huge and circulation increased dramatically.

Seeing this new found success, Curtis decided to give up *The Tribune and Farmer* and create a new magazine out of his wife's column. "Call it, oh, call it 'The Ladies' Journal,'" he told the typesetter. The typesetter thought it would be nice to put an oval illustration of a home between "Ladies" and "Journal." The cut turned out to be so poor, that Curtis decided to go ahead and call it *Ladies' Home Journal*, which he launched with the first issue on February 16, 1883.[34]

Curtis wisely turned the editing of *The Ladies' Home Journal* over to his wife, Louisa, while he focused on building circulation and advertising revenue. In a year, it had 25,000 subscribers. It had soon surpassed in circulation and revenue its primary two competitors, *Good Housekeeping* (established in 1885) and *The Ladies' Home Companion* (established in 1873).

Curtis actively went out in search of advertisers and asked for $200 a page during the journal's first year. With his experience selling ads for *The Philadelphia Press*, he understood the crucial role advertisers could play in a magazine's success. In a

speech to a group of advertisers, he revealed his understanding of the new emerging magazine business model:

> Do you know why we publish the *Ladies' Home Journal?* The editor thinks it is for the benefit of the American woman. That is an illusion, but a very proper one for him to have. But I tell you; the real reason, the publisher's reason, is to give people who manufacture things that American women want and buy a chance to tell them about your products.[35]

As a result of strong advertiser support, Curtis was able to give subscribers an incredible bargain. One of his innovations involved "clubbing." While his normal subscription price was fifty cents per year, Curtis offered a group price of $1 a year for a "club" of four women, meaning each paid only twenty-five cents for a year's subscription. Some magazines of the late 1800s charged twenty-five cents for a single issue, while the typical subscription price ranged between $1.50 and $4 per year.

Edward W. Bok and *Ladies' Home Journal*

Mrs. Curtis edited the magazine until Edward W. Bok (1863–1930) was named editor in 1889. Bok built the magazine into one of the most successful magazines of the era. By the century's end, it reached the highest circulation of any magazine—860,000 subscribers.

A native of Holland who came to this country at the age of six with his family, Bok became a household name during his thirty years as editor. Shortly after he retired, he wrote his autobiography, *The Americanization of Edward Bok*, which won the Pulitzer Prize in 1921. Bok led crusades on behalf of his readers' interests. He played a crucial role in the fight for pure food legislation and exposed the frauds of patent medicine advertisers and banned them from the magazine. He ran an explosive series on the need for more public education about venereal disease. Although hundreds of readers protested by cancelling their subscriptions, Bok never relented or apologized.[36]

Edward Bok later recalled that Cyrus Curtis had issued three general directives for his magazine staff:

- To his editors: give the public the best. It knows. The cost is secondary.
- To his circulation men: Keep the magazines before the public and make it easy for the public to get them.
- To his advertising men: We know we give advertisers their money's worth, but you must prove it to them.[37]

One of his Curtis' early decisions in establishing an advertising policy was to reject

questionable advertising, such as fraudulent cure-alls and get-rich-quick schemes, which were very popular at the time. In its twenty-fifth anniversary issue in 1908, Edward Bok claimed these magazine "firsts" for *Ladies' Home Journal*.[38]

- First popular magazine of large circulation to sell at ten cents a copy and $1.00 a year
- First magazine to introduce a monthly change of cover design
- First magazine to refuse questionable advertising such as fraudulent cure-alls and wildcat investment schemes
- First magazine to introduce color printing and pioneer in the use of two-color, three-color and four-color printing.

George Horace Lorimer and *Saturday Evening Post*

In the summer of 1897, two men walked into Cyrus Curtis' office and told him about the death of the owner of the *Saturday Evening Post*. The unprofitable magazine had only 1,800 subscribers, and many of those were in arrears. "His only heir is a sister," said one of the men, a lawyer for the estate, "and she will not put up the money to get out this week's issue. You are the only man I can turn to for money."

Mr. Curtis talked to the men about the magazine's fate and then made an unexpected offer: "I will give you one thousand dollars for the paper, type and all," he said. The offer was accepted. Curtis knew about the magazine's long history, which traced back to the *Pennsylvania Gazette* published by Benjamin Franklin from 1728 to 1765. "From 1728 to the date of the Curtis purchase each issue had regularly appeared with the exception of a few issues missed during the period of the Revolution when the British were occupying Philadelphia, and when the publisher was with the Continental Congress," said Walter Fuller, president of Curtis Publishing, in a 1948 address to the Newcomen Society.[39]

In 1898, after a two-hour interview in Boston, Curtis hired George Horace Lorimer (1867–1937), a young reporter on the *Boston Post* as literary editor of his new magazine. Lorimer had read about Curtis' purchase of the *Post* and wrote him to apply for a job. Curtis subsequently sailed to Europe to ask Arthur Hardy, a former managing editor of *Cosmopolitan*, to become the *Post*'s editor. Because of some confusion in their schedules, Curtis missed seeing Hardy in Europe. So he cabled George Horace Lorimer and told him to put his name as editor-in-chief on the masthead of the next issue. Upon his return from Europe, Curtis was so impressed by Lorimer's work that he made him the permanent editor. Lorimer, who was thirty-one at the time, was to remain in that position for the next thirty-seven years.

Both Edward Bok at the *Ladies' Home Journal* and George Horace Lorimer at

the *Saturday Evening Post* took their magazines to unprecedented success and became two of the best-known editors in magazine history. Lorimer published works by some of the best fiction and nonfiction writers of the time, including Stephen Crane, Jack London, F. Scott Fitzgerald, Sinclair Lewis, and William Faulkner. By 1902, *Post* circulation had climbed to 315,000 and by 1906, it reached a million. By 1928, it climbed to three million subscribers.

The *Saturday Evening Post* under Lorimer appealed to the growing middle class in America and emphasized traditional virtues. Its inspirational approach made it the most successful magazine of the first half of the 20th century. Just prior to the Great Depression, the 272-page issue of December 7, 1929, weighed two pounds, carried 214 pages of advertising, and earned $1.5 million in ad revenue. *A Short History of the Saturday Evening Post,* published by Curtis Publishing in 1927, said this of Lorimer:

> Mr. Lorimer had certain personal assets of extraordinary value which few, if any, other editors possessed. He had lived in three widely separated sections of the country. He had done business or hunted or fished or climbed mountains in nearly every state….He had an intimate knowledge of sectional resources, interests, industries, likes, dislikes and modes of thought. He was able to visualize his own country and his own people; to perceive their greatness, their virtues, their faults and the stupendous possibilities which lay…ahead of the American nation.[40]

The *Post* declined in the 1930s when Lorimer vigorously opposed Franklin Roosevelt and his New Deal. He once told a friend, "I'll fight this New Deal if it's the last thing I ever do." Lorimer never seemed to grasp the wide popularity of Roosevelt among his readers. As a result, the magazine's political partisanship took its toll on circulation for a while.

Curtis had an uncanny knack for choosing outstanding editors, supporting them with the personnel and equipment they needed, and then leaving them alone to do their jobs. He approved Bok's request for a new $800,000 color printing press without hesitation. In one of his few attempts to influence content, Curtis questioned a short story Lorimer was planning to publish by saying, "My wife doesn't think it's a very good piece to be in the *Post*." Lorimer replied, "I'm not editing the *Saturday Evening Post* for your wife." Curtis said no more, and the piece ran. He once said, "I would no more think of telling him how to run it, what to print and what not to print, then I would think of telling Commodore Bennett how to run the *New York Herald*."[41]

Cyrus Curtis, with help from Bok and Lorimer, built the Curtis Publishing Company into one that dominated magazine publishing for the first half of the century. "Together they had built the Curtis Publishing Company into a giant that for a time took in $2 out of every $5 spent on national advertising in magazines, and

in so doing had contributed immensely to the development of the low-priced, mass-circulation periodical," said Professor Theodore Peterson in *Magazines in the Twentieth Century.*[42]

Effects of advertising

All five of these magazines profited from the growing industrial economy and expanding use of advertising. Prior to the 1890s, leading magazines snubbed their noses at advertising and relied upon circulation as their primary source of revenue. The most commonly cited figures for all magazines show a 128 percent increase in advertising revenues between 1890 and 1904. That amounts to an 18 percent rise in the proportion of the GNP represented by advertising.[43]

The growth of advertising had two major effects on magazines between 1900 and 1920. First, the Audit Bureau of Circulations was established in 1914 to monitor and verify circulation figures for advertisers. In the scramble for high circulation that low-priced magazines unleashed, some publishers padded their figures while others sought to maintain secrecy. Advertisers pressured magazine publishers to join and cooperate with the new bureau in providing accurate and reliable figures. Today, most leading magazines belong to the Audit Bureau of Circulations, based in Schaumburg, Illinois, and it remains the leading industry source for accurate circulation figures.

Advertising's other effect was in improving the design and graphical appeal of magazines. In 1896, Edward Bok, editor *of Ladies' Home Journal,* was the first to move advertising from its segregated section at the back of the magazine. Before long, most magazines were running editorial matter alongside advertisements. Most companies had their advertisements professionally designed by agencies. Their visually attractive advertisements stimulated editors to improve the graphic presentation of their editorial material. Since many advertisers placed color advertisements, their display stimulated the use of color in the graphic design and presentation of articles.

The swinging pendulum

Since the late 1800s, magazine publishers have had to straddle the fence between seeing themselves as a *business endeavor* and a *literary endeavor.* Most magazines have had to sell themselves to two audiences: first to readers and then to advertisers. This conundrum of "literature versus business" has always tilted to one side or the other depending on the nature of the magazine and its publishing organization. It continues to display itself in the recurring "church versus state" ethical conflicts that

occur when advertisers pressure editors for content and coverage that favor their products. Nevertheless, the magazine model tilted towards the "literature" side until the 1890s when the pendulum began to swing. The economic crisis of 1893 forced S.S. McClure, Frank Munsey and John Brisben Walker to seriously examine the business models for their magazines. Up until then, only the upper-middle and educated classes could afford the 25- and 35-cent cover prices and high subscription prices of most magazines. These editor-publishers forged the transition era between magazines-as-business and magazines-as-literature. The pendulum continued to swing throughout the 20th century as magazines became more "business" in purpose and less "literary."

Notes

1. George Britt, *Forty Years—Forty Millions. The Career of Frank A. Munsey* (New York: Farrar and Rinehart Co., 1935), 88.
2. Matthew Schneirov, *The Dream of a New Social Order: Popular Magazines in America, 1893–1914* (New York: Columbia University Press, 1994), 11.
3. Edna Woolman Chase and Ilka Chase, *Always in Vogue* (Garden City, NY: Doubleday, 1954), 67.
4. Richard Ohmann, *Selling Culture: Magazines, Markets and Class at the Turn of the Century* (New York and London: Verso, 1996), 29.
5. Theodore Peterson, *Magazines in the Twentieth Century*, 2nd ed. (Urbana-Champaign: University of Illinois Press, 1964), 11.
6. Schneirov, *The Dream of a New Social Order*, 5.
7. Peterson, *Magazines in the Twentieth Century*, 4.
8. Robert Stinson, "McClure's Road to *McClure's*: How Revolutionary Were the 1890s Magazines?" *Journalism Quarterly* 47 (1970): 256–262.
9. Walter D. Fuller, "The Life and Times of Cyrus H.K. Curtis," Address to the Newcomen Society, New York, February 19, 1948. (Published by the Newcomen Society, 1948. Archives of the *Saturday Evening Post*, Indianapolis, IN).
10. S.S. McClure, *My Autobiography* (New York: Frederick A. Stokes Co., 1914), 149.
11. Ibid., 168.
12. Ibid., 210.
13. *McClure's*, May 1893, 94.
14. McClure, *My Autobiography*, 214.
15. Ibid., 225.
16. Quoted by Peter Lyon in *Success Story: The Life and Times of S.S. McClure* (New York: Charles Scribner's Sons, 1963), 129–130.
17. Peter Lyon, *Success Story: The Life and Times of S.S. McClure*, 245.
18. McClure, *My Autobiography*, 246.
19. For an account of this dispute with McClure, see John E. Semonche, "The *American*

Magazine of 1906–15: Principle vs. Profit," *Journalism Quarterly* 40 (1963): 36–44, 86.

20. For a detailed history of this period between 1905 and 1929, see Alan and Barbara Nourie, *American Mass Market Magazines* (New York: Greenwood Press, 1990), 247–251. This useful volume contains a collection of "micro-histories" of about 150 American magazines.

21. Schneirov, *The Dream of a New Social Order*, 117.

22. Advertisement from New York *Sun*, October 2, 1893, reproduced by Britt, *Forty Years—Forty Millions*, 39.

23. Ohmann, *Selling Culture: Magazines, Markets and Class at the Turn of the Century*, 25.

24. Dorey Schmidt, ed., *The American Magazine, 1890–1940* (Wilmington: Delaware Art Museum, 1979), 7.

25. Peter Haining, *The Classic Era of American Pulp Magazines* (Chicago: Chicago Review Press 2000), 9.

26. Peterson, *Magazines in the Twentieth Century*, 8.

27. Oswald Garrison Villard, *Dictionary of American Biography* Base Set. American Council of Learned Societies, 1928–1936. Reproduced in *Biography Resource Center* (Farmington Hills, MI: Gale, 2009).

28. Schneirov, *The Dream of a New Social Order*, 120.

29. Frank Luther Mott, "John Brisben Walker," *Dictionary of American Biography* Base Set American Council of Learned Societies, 1928–1936.

30. Karen Roggenkamp, "Dignified Sensationalism: *Cosmopolitan*, Elizabeth Bisland, and Trips Around the World," *American Periodicals* 17, 1 (2007): 26–40.

31. Schneirov, *The Dream of a New Social Order*, 87.

32. Frank Luther Mott, *A History of American Magazines 1885–1905, Vol. 4* (Cambridge Harvard University Press, 1968), 46.

33. Ibid., 487.

34. Talk by Huber Ulrich, director of public relations for The Curtis Publishing Company January 1955. *Saturday Evening Post* Archives, Indianapolis, IN.

35. Mary Ellen Zuckerman, *A History of Popular Women's Magazines in the United States 1792–1995* (Westport, CT: Greenwood Press, 1998), 7.

36. Ibid., 88.

37. Huber Ulrich, January 1955, 6. *Saturday Evening Post* Archives, Indianapolis, IN.

38. Huber Ulrich, January 1955, 10. *Saturday Evening Post* Archives, Indianapolis, IN.

39. Walter D. Fuller, "The Life and Times of Cyrus H.K. Curtis," Address to the Newcomer Society, New York, February 19, 1948. *Saturday Evening Post* Archives, Indianapolis, IN

40. *A Short History of the* Saturday Evening Post (Philadelphia: Curtis Publishing Company 1927). *Saturday Evening Post* Archives, Indianapolis, IN.

41. John Tebbel, *George Horace Lorimer and the* Saturday Evening Post (Garden City, NY Doubleday, 1948), 25.

42. Theodore Peterson, *Magazines in the Twentieth Century*, 136.

43. Ohmann, *Selling Culture: Magazines, Markets and Class at the Turn of the Century*, 83.

1900-1920

Pioneers Create a Prosperous Century

By 1900, magazines were booming with circulations growing rapidly. With the recession of the 1890s over, America's population and manufacturing economy expanded, and magazines benefited from new readers and advertisers. Three publishers—Bernarr Macfadden, William Randolph Hearst, and Condé Nast—created companies whose magazines led the way into the magazine century. Other historic magazines launched during the nineteenth century continued to grow, especially *Scientific American, Harper's, Atlantic Monthly,* and *National Geographic.* Some of today's influential political and religious magazines also had their origins during the first two decades of the century.

Bernarr Macfadden: *Physical Culture* and *True Romance*

Bernarr Macfadden (1868–1955) was the most colorful and controversial among the early magazine publishers of the century. He could be called the first "special interest" publisher. His health and fitness proselytizing projects included magazines, books, exercise machines, speaking tours, body-building contests, gyms and even health sanitariums. He wrote seventy-three books, mostly on health and fitness topics, and sponsored the country's first body-building competition in 1903.

Macfadden launched his first magazine, *Physical Culture*, in March 1899, which reached a circulation of 25,000 by January 1900. It published such diverse writers as Charles Eliot, the president of Harvard; John L. Sullivan, the heavyweight boxing champion; and Carrie Nation, the temperance movement opponent of alcohol and tobacco. Macfadden later created another genre with his confession and detective magazines. *True Story's* huge success spawned numerous confession and romance magazine competitors. At its peak in 1930, Macfadden Publications, Inc. was worth an estimated $30 million and published twenty-seven magazines.

"Perhaps more than any other individual, Macfadden bears responsibility for pioneering what has become the American obsession with diet, health and fitness," said a *Wall Street Journal* review of *Mr. America*, a 2009 biography of Macfadden.[1] The first issue of *Physical Culture*, which sold for a nickel, carried a cover image of a muscular young man identified as "Prof. B. Macfadden in classical poses." Page one summarized his philosophy:

- That weakness is a crime.
- That one has no more excuse for being weak than he can have for going hungry when food is at hand.
- That disease is not sent by divine providence, but is the result of the victim's own ignorance or carelessness.
- That [the editor's] great purpose in life is to preach the gospel of health, strength and the means of acquiring it....

Physical Culture was not the country's first health and fitness magazine. Eighty-five health magazines were started between 1830 and 1890, and "almost all of them offered dry, impersonal instruction in the proper denial of earthly pleasure."[2] Mark Adams, a Macfadden biographer, attributes *Physical Culture's* success to three elements: "He freely used celebrities, he sought women readers as well as men, and he seasoned every issue with a healthy dose of sex."[3]

Macfadden sprinkled the pages of the magazine with photos of scantily clad men and topless women fitness models. When a Pennsylvania YMCA director wrote to complain about its steamy photos and articles, Macfadden replied defiantly: "One of the principal causes of weakness and ugliness...is the lack of respect for the human body—the idea that it is something vulgar to be hid and despised. Why should we be ashamed of our bodies?"[4]

In 1903, Macfadden challenged readers to participate in America's first bodybuilding competition—his "*Physical Culture* Exhibition"—for which he offered a $1,000 first place prize to "the most perfect specimen of physical manhood." He later expanded the Madison Square Garden contest to include women. The first winner of the women's division was Emma Newkirk, and the first men's champion was Al

Treloar, who became physical education director at the Los Angeles Athletic Club in 1906, a position he held for forty-four years.

Macfadden sponsored and promoted the second *Physical Culture* Exhibition in 1905. On October 5, two days before its scheduled opening, New York vice squad officers raided his office where Macfadden was arrested on charges of circulating obscene pictures—namely the published photos of Emma Newkirk, winner of the 2003 contest. Macfadden remained defiant. After his release on $1,000 bail, he told the press: "The purpose of this exhibition…is to show how the spread of *Physical Culture* has improved the human body. Manifestly that cannot be done if the exhibitors are covered with clothing."[5] In a December editorial, Macfadden blasted Anthony Comstock, New York's chief vice officer, whom he called "the quintessence of prudery." Three months later, Macfadden was convicted in the federal district court in Trenton, N.J. He paid a $2,000 fine but escaped a two-year prison sentence when President William H. Taft granted clemency after a deluge of protests from *Physical Culture* readers.[6]

Macfadden was a master of "brand extension" before the term was invented. Today magazines search for ancillary products on which to stamp their brand and logo. Macfadden expanded the popularity of *Physical Culture* in creative ways with his body-building contests, exercise machines, books and gyms. Even his run-ins with the vice squad contributed to the magazine's success more than they hurt it.

On January 16, 1919, the eighteenth amendment to the Constitution, which authorized prohibition, went into effect. Congress passed the nineteenth amendment on June 4, which gave women the right to vote, and sent it to state legislatures for their eventual ratification. In May, the first issue of *True Story* was launched by Macfadden and became the smash hit of the 1920s that launched a new genre of magazines—the confession magazine. His innovative concept for the magazine was reader-written, first-person dramatic stories.

With cash prizes offered for the best stories, promotional ads invited readers to tell about their triumphs and failures in love and marriage, even suggesting topics like, "Why I remained an old maid." He advised contributors "Don't try to be literary. Write your story frankly and simply, just as you would talk it. Truth is stranger than fiction [and] usually far more interesting." Some later article titles reflect the editorial focus that generally remained unchanged: "I Was Anyone's Girlfriend," (1951), "After Last Night, Am I A Lesbian?"(1970), or "Surgeons Begged for my Dead Husband's Heart" (1969).

"We want stories only from the common people," Macfadden once said. "We've got to keep out 'writing writers' who want to make a business of it." He established a board of review of "everyday people" who read and gave their opinions on the 70,000 to 100,000 manuscripts submitted annually. He required contributors to sign

affidavits swearing their stories were true. Macfadden instructed editors to correct punctuation and grammar mistakes, but leave the rest of each story intact as submitted by the reader.[7] Macfadden re-discovered a time-tested principle of what good writers and editors have always known: A narrative about a true, dramatic experience with a plot and an outcome has great reader appeal, especially when told in first-person. If the story illustrated a moral principle that others could learn from, that made it even better.

The true story of how *True Story* was invented remains in dispute. One version attributes the idea to Mary Louise Macfadden, the third of his four wives and the one to whom he was married the longest. She said she suggested it to her husband in February 1918 while on a walk. "Let's get out a magazine called 'True Story,' written by its own readers in the first person. This has never been done before. I believe it will have a wide readership," she reportedly said. [8]

From its first issue, sales skyrocketed and tripled the revenue of Macfadden's company between 1918 and 1920. It achieved circulation figures close to two million by 1929, equaling the big-sellers like *Ladies' Home Journal* and the *Saturday Evening Post*. The magazine was so successful that he started others in the same genre: *True Romances, True Love and Romances,* and *True Experiences.* Over the next twenty years, Macfadden published dozens of magazines; some were one-shot affairs he published to scare off competitors. Some better-known Macfadden titles included *Liberty, Dance, Dream World, Ghost Story, Love Mirror, Master Detective, Movie Weekly, Muscle Builder, National Brain Power, Own Your Own Home, Photoplay, Radio and TV Mirror, Radio Mirror, Sports-Life,* and *True Detective Mysteries.*[9] After Macfadden's death, the company acquired two of its major rivals, *True Confessions* in 1963 and *Modern Romances* in 1978.

Like other wealthy publishers of the era, Macfadden entertained political aspirations from time to time. He ran unsuccessfully for the Republican nomination for president in 1932 and as a Republican candidate for the U.S. Senate in Florida in 1940. In 1948, he ran as a Democrat for governor of Florida and lost. He died in 1955 at the age of eighty-seven. His descendants and admirers have maintained a website (www.bernarrmacfadden.com) with stories and pictures about the colorful publisher.

William Randolph Hearst: *Cosmopolitan, Good Housekeeping*

William Randolph Hearst (1863–1951) was a magazine merchant—an entrepreneur who used his inherited wealth to build a media empire that included newspapers, magazines, radio and television stations, movie studios and book publishers

After seventeen years in the newspaper business, Hearst entered magazine publishing in 1903 with the founding of *Motor* magazine, which he modeled after the British publication *The Car* that he had read on his honeymoon. He later bought *Cosmopolitan* in 1905 and *Good Housekeeping* in 1911. By 1920, Hearst had acquired thirteen newspapers, five magazines in the U.S. and one in England. By 1930, he owned twenty-eight newspapers, thirteen magazines, and eight radio stations. Other magazines he had acquired by then included *Connoisseur, Harper's Bazaar, House Beautiful, Popular Mechanics,* and *Redbook.*

The son of a millionaire miner and rancher, young Hearst attended Harvard University where he was expelled twice, first for staging a noisy celebration of Grover Cleveland's election in 1884 and the second time in 1886 for playing pranks on faculty members. In 1880 his father acquired *The San Francisco Examiner* as payment for a gambling debt. The newspaper struggled for the next six years with marginal profits. "I am convinced," Hearst wrote to his father from Harvard in 1886, "that I could run a newspaper successfully. Now, if you should make over to me the *Examiner*—with enough money to carry out my schemes—I'll tell you what I would do...."[10]

The senior Hearst acceded to his son's wishes and turned the newspaper over to him. On March 4, 1887, the *Examiner* published its first issue under William Randolph Hearst, who was twenty-four years old. He invested in new printing technology, hired new writers and editors, and doubled its circulation within a year. The newspaper also developed a tradition for sensational stories. One author described Hearst employees as "diligent in their pursuit of shocking and titillating material to draw in more readers."[11] Hearst then purchased the *New York Journal* in 1895, launched the *Chicago American* in 1900, and acquired dailies in Boston (1904), Los Angeles (1904), Atlanta (1912), and San Francisco (1913). His colorful and controversial career, which included two terms as a Democratic member of Congress and nominee for president at the 1904 Democrat convention, is well documented in many sources. Hearst's career inspired the 1941 Orson Welles film *Citizen Kane*, a portrait of a media tycoon ruined by his own excesses.

Hearst Magazines, a unit of Hearst Corporation led today by Catherine Black, publishes fifteen magazines with 200 international editions. Table 1 tells the name of each of its current magazines, the date it was founded, and the date acquired by Hearst Corporation.

Cosmopolitan

The first magazine that Hearst purchased after launching *Motor* in 1903 was *Cosmopolitan* in 1905. Chapter two covered those years under John Brisbane Walker's ownership from 1888 to 1905. It began imitating the muckraking of

McClure's and in various articles attacked political corruption in Washington and antitrust abuses by wealthy corporation owners. Then it began emphasizing fiction, especially under editor Ray Long's leadership from 1918 to 1931. Poems and short stories, as well as some novels and novelettes by well-known authors, characterized its content up through the 1940s.

Table 1

Hearst Magazines
Year of founding with year of acquisition by Hearst

Cosmo Girl! (1999)
Cosmopolitan (founded 1886; acquired 1905)
Country Living (1978)
Esquire (1933; acquired 1986)
Food Network Magazine (2008)
Good Housekeeping (founded 1885; acquired 1911)
Harper's Bazaar (1867; acquired 1912)
House Beautiful (1896; acquired 1934)
Marie Claire (1994)
O, The Oprah Magazine (2000)
Popular Mechanics (founded 1902; acquired *1958)*
Redbook (1903; acquired 1982)
Seventeen (1944; acquired 2003)
Smart Money (1992—published jointly with *Wall Street Journal*)
Town & Country Travel (2003)
Veranda (1987)

Current as of January 2010

After World War II and during the 1950s, *Cosmopolitan* began publishing less fiction and more service and how-to articles aimed at the burgeoning population of post-war housewives. "What not to tell your husband," and "I was sure I was sterile," were characteristic titles of 1950s articles. But despite its attempt to remain relevant to postwar women, its circulation dropped drastically during the 1960s and its future was uncertain—until Helen Gurley Brown came along as editor.

Helen Gurley Brown, a newspaper columnist and author of the 1962 best-seller *Sex and the Single Girl*, interviewed with Hearst executives Richard Deems and Richard Berlin in 1965 and convinced them what she could do for *Cosmopolitan* if she were editor. She envisioned a new audience of young, career-oriented women and an editorial content focused on male-female relationships, self-improvement and inspirational articles that would help young women develop their potential. They gave her the job.

In her first editor's column in the July 1965 issue, she immediately set the new tone and addressed the magazine's new target audience of young, single women. Brown wrote:

Hello! I'm *Cosmopolitan*'s new editor. I've had the honor of meeting many of you before through my books and newspaper column. Now, honor of honors, I'll get to visit with you every month….The stories and articles in this issue were picked for one reason only. I thought they'd *interest* you…knowing that you're a grown-up girl, interested in whatever can give you a richer, more exciting, fun-filled, friend-filled man-loved kind of life! You also want to be inspired, entertained and sometimes whisked away into somebody *else's* world.[12]

"She always related to her audience on a personal level," wrote Brown biographer Jennifer Scanlon in *Bad Girls Go Everywhere*. Brown made "Each reader feel as though she were being addressed as an individual. She convincingly assured each reader…that the magazine was all about her."[13] Helen Gurley Brown brought unprecedented success in sales and readership for the magazine. She put the "Cosmo girl" on her first cover and every succeeding cover. "The Cosmo Girl" symbolized a lifestyle and the bright, energetic young woman who could make her place in the world.

"A million times a year I defend my covers," Brown admitted. "I like skin, I like pretty. I don't want to photograph the girl next door."[14] By 2000, *Cosmopolitan* had reached a circulation of 2,592,887, which ranked twentieth among all magazines.[15] Although Brown retired in 1996, her successors Bonnie Fuller and Kate White continued with her editorial tradition.

Good Housekeeping

Good Housekeeping was the second magazine that Hearst purchased in 1911, which was twenty-five years old at the time. It was founded by Clark W. Bryan, a Massachusetts newspaper publisher. The magazine was among the first to seek relationships with its readers by sponsoring contests, inviting readers to write in with questions, suggestions, stories and household advice, and paying them for their contributions. "Contributors had a real sense that the magazine was theirs, an enterprise they took part in, and area where they were respected as experts on the topics (home and housekeeping) they knew best," wrote Professor Mary Ellen Zuckerman, a historian of women's magazines.[16] The magazine also built the laboratory facilities that evolved into the Good Housekeeping Institute and the Good Housekeeping Seal of Approval.

One of its first contests offered a $250 prize for the best series of six articles on "How To Eat, Drink And Sleep As Christians Should." In the April 28, 1888, issue, the magazine made a $25 offer for "the best buffalo bug extinguishers, the best

bed bug finisher, the best moth eradicator and the best fly and flea exterminator."[17] Clark W. Bryan committed suicide in 1898 and the magazine then went through a series of owners before it was purchased by Hearst in 1911. By then *Good Housekeeping* was an attractive color magazine with a circulation of more than 300,000. Professor Mott attributed its early success to "general prosperity, more aggressive and informed management, the improved appearance of the magazine and a greater emphasis (beginning about 1904) on fiction by well-known writers." Another reason was its home service feature articles and *Good Housekeeping* Institute and Seal of Approval. In 1900, the magazine set up its institute to test various methods and practices to be recommended to women readers.

By the 1960s, *Good Housekeeping* was also recognized as one of the "Seven Sisters," which included *Ladies' Home Journal, McCall's* (no longer published), *Family Circle, Woman's Day, Redbook,* and *Better Homes & Gardens.* They were dubbed the "seven sisters" magazines because many of their young staff members graduated from one of the Seven Sister colleges—a group of prestigious women's colleges in the Northeast.[18] By the end of the 20th century, *Good Housekeeping* had reached a circulation of 4,558,524, which ranked seventh among all magazines.[19]

Popular Mechanics

Henry Haven Windsor, an Iowa minister's son who edited *Street Railway Review* from 1892 to 1902, launched *Popular Mechanics: An Illustrated Weekly Review of the Mechanical Press of the World* in 1902. Windsor, a visionary who saw the role of science in the developing industrial world, displayed a knack for interpreting complex mechanical information for the average reader. Starting with only five paid subscribers, he wrote the entire contents, sold a few ads and employed a staff of two during the first year. Its content focused on everything from simple home repairs to constructing home appliances and boats. Captivated by the 1903 Wright brothers' invention of the airplane, the magazine covered the evolving science of flight from its beginning. Besides covering aeronautical events, the magazine published features on how to build a glider and an airplane.[20]

Windsor continued as editor and publisher until his death in May of 1924, when he was succeeded by his son. Henry H. Windsor, Jr., served as editor and publisher until 1958 when the Hearst Corporation purchased the magazine.[21] By this time, the paid circulation exceeded a million. The magazines increased in popularity and averaged 300 pages per issue during the Great Depression. It taught readers how to save money. How-to articles on repairing a car, home appliances, building an inexpensive home, or a radio from recycled parts were frequently published during the 1930s. During the 1940s, it started publishing overseas editions in French, Spanish, Danish, Swedish, and German. Although the magazine had a

largely male audience, it always attracted some female readers with reviews and how-to articles on repairing home appliances, household and fashion items. After Hearst purchased the magazine in 1958, it moved the magazine's publishing operations from Chicago to New York in 1962. Its circulation peaked at 1.7 million in the 1970s. Dented by competition from proliferating computer magazines in the 1980s and rise of Internet technology in the 1990s, its circulation declined to 1.2 million readers by 2000.

Redbook

Redbook grew steadily from its founding in May 1903 to become one of the leading women's magazines and member of the elite "seven sisters." Originally called *The Red Book Illustrated*, it was launched by a group of four Chicago businessmen—Lewis M. Stumer, Abraham R. Stumer, Benjamin J. Rosenthal, and Louis Eckstein, owners of real estate properties, restaurants, and clothing stores. They recruited a reporter from the *Chicago Record*—Trumbell White—as its first editor, who served in that capacity until 1906. The magazine was designed as "invariably wholesome, invariably decent, invariably cheerful," said an editorial in the first issue. "Red is the color of cheerfulness, of brightness, or gayety. It is the color of the most brilliant display in nature, from sunsets to autumn foliage. Therefore THE RED BOOK."[22] Within two years, the magazine reached a circulation of more than 300,000.

The magazine reached a circulation of one million by 1939 and two million by 1950. It was sold to the McCall Corporation in 1929, publishers of *McCall's*, which owned it until 1975 when the Charter Company purchased it. Hearst Magazines purchased *Redbook* in 1982. By 2000 its circulation reached 2,269,605 paid subscribers, which ranked twenty-sixth among all consumer magazines.

From the late 1920s to the early 1950s, it was a general interest magazine of light fiction for men and women. According to Professors Kathleen Endres and Theresa Lueck, "*Red Book* was trying to convey the message that it offered something for everyone, and, indeed, it did....There was short fiction by talented writers such as Jack London, Sinclair Lewis, Edith Wharton and Hamlin Garland. Stories were about love, crime, mystery, politics, animals, adventure and history (especially the old West and the Civil War)."[23] During the 1950s, it published articles on racial prejudice, the dangers of nuclear weapons, and the damage caused by McCarthyism.

The magazine started repositioning its contents towards female readers during the mid 1950s, a focus that heightened after Robert Stein became editor in 1958. In 1965, Sey Chassler became editor and led the magazine through a seventeen-year tenure when circulation increased to nearly five million and the magazine earned many awards, including two National Magazine Awards. His *New York Times*

obituary said, "A strong advocate for women's rights, Mr. Chassler started an unusual effort in 1976 that led to the simultaneous publication of articles about the proposed equal rights amendment in thirty-six women's magazines. He did it again three years later with thirty-three magazines."[24]

The current focus on married women in their twenties and thirties began in the 1980s. "We try to appeal to the whole woman," said editor Annette Capone in 1985. "She's not just a housewife, and she's not just a career woman with kids."[25]

Condé Nast: *Vogue, House and Garden, Vanity Fair* and *Glamour*

As a publisher, Condé Nast (1873–1942) was in one sense a "missionary" of style and fashion whose biographer says of him: "Condé Nast's is a story of a man who had little personal glamour, yet who understood glamour, surrounded himself with it, and projected it to a world eager to pay for it."[26] He began his magazine empire when he purchased *Vogue* in 1909. Four years later he purchased *House and Garden*, which he transformed into a leading interior design authority. In 1914, he introduced *Vanity Fair*, a magazine that quickly set publishing standards in arts, politics, sports, and society. In 1939, he launched *Glamour*, the last magazine he would personally develop before he died in 1942. By 2010, Condé Nast Publications holdings included more than twenty magazines, including *Bon Appétit, Condé Nast Traveler, GQ, Lucky, Mademoiselle, The New Yorker, Redbook, Self, Seventeen, Wired,* and *YM.*

Condé Montrose Nast spent most of his early years in St. Louis. After earning a law degree from Washington University, he accepted his friend Robert Collier's offer in 1898 to move to New York and become advertising manager and later business manager at *Collier's Weekly*. During the next nine years, he led the magazine to unprecedented financial success and became a wealthy man. But he yearned to publish his own magazine.

In 1909 he bought *Vogue*, a small fashion and society magazine founded in 1892 by Arthur Turnure. He re-positioned its editorial mission with the goal of helping high-income women dress more fashionably. He published his first issue on June 24, 1909. In March 1911, he purchased part ownership of *House & Garden* and assumed total control in 1915. In 1913, *Vanity Fair*, originally *Dress & Vanity Fair*, was introduced with Frank Crowninshield as editor (1872–1947). By this time Condé Nast published magazines covering all aspects of affluent lifestyles: fashion, interior decorating, architecture, art, theater and literature.

Table 2

Condé Nast Publications
Year of founding with year of acquisition by CNP

Allure (1991)
Architectural Digest (1920; acquired 1993)
Bon Appétit (1955; acquired 1993)
Condé Nast Traveler (1987)
Details (founded 1982; acquired 1988)
Elegant Bride (founded as *Southern Bride*, 1988)
Glamour (1939)
Golf Digest (1950)
Golf World (1947)
GQ - Gentlemen's Quarterly (1957; acquired 1979)
House & Garden (1901; acquired 1915)
Lucky (2000)
Modern Bride (1949)
The New Yorker (founded 1925; acquired 1985)
Self (1979)
Vanity Fair (1913–1939; relaunched 1983)
Vogue (founded 1892; acquired 1909)
W Magazine (1971)
Wired (1993; acquired 1998)

Current as of January 2010

Nast's enduring contribution to magazine publishing was the concept of "class" or niche publications directed at particular groups of readers with common interests. Although special-interest magazines were already published, he was the first publisher to clearly define and re-position his magazines to particular groups of readers with special interests. "Every publisher must make up his mind whether he shall edit a publication for the whole heterogeneous reading population, or deliberately aim to attract some special segment of it," Nast wrote in an essay titled "Class Publications," which was published in the June 1913 issue of *Merchants and Manufacturers Journal*. In his prescience, Nast foresaw one of the most defining characteristics of magazines in the 20th. Nast went on to say that "class" publications could be aimed at:

> ...an automobile dealer, a stamp collector, an expert fisherman, a kindergarten teacher, an art student, a chicken fancier, a baseball fan, a clergyman, a soubrette [a female actor] and a suffragette....A class publication is nothing more nor less than a publication that looks for its circulation only to those having in common a certain characteristic marked enough to group them into a class. That common characteristic may be almost anything: religion, a particular line of business, a community of residence, common pursuit, or some common interest.[27]

Although Nast was the first publisher to articulate the concept of "class" or niche publications, most of his magazines were aimed at one particular class: the wealthy and affluent, especially women. He said the purpose of his magazines was to, "bait the editorial pages in such a way as to lift out of all the millions of Americans just the hundred thousand cultivated persons who can buy these quality goods."[28] Advertisers responded and paid top dollar to reach Nast's affluent readers. By 1926, *Vogue*, *Vanity Fair* and *House & Garden* ranked second, third and seventh among American magazines in total revenue even though their combined circulation was much further behind other leading magazines of the 1920s.

Edna Woolman Chase, who was editor-in-chief of *Vogue* from 1929 to 1952, described Nast's management style this way:

> The open door was Condé's policy. Anyone could push his head in. They could ask him a question, he'd take care of their problems….Condé liked roaming the office corridors and speaking to those who passed by. He might not be sure whether or not they were members of the organization, but they rarely knew it. He had a knack of making people feel he was interested in them.[29]

Just as Cyrus Curtis displayed a knack for spotting talent in young editors like Edward Bok and George Horace Lorimer, Condé Nast possessed the same knack for recognizing and promoting talented editors. His two best-known editors were Frank Crowninshield and Edna Woolman Chase.

Frank Crowninshield and *Vanity Fair*

After he purchased *Dress and Vanity Fair* in 1913, Condé Nast said part of its mission included the discussion of "all that is new and worthy in the fine arts and in books." To achieve that goal, he lured Frank Crowninshield (1872–1947) away from *Century* magazine, where he was the arts editor. Crowninshield's stated goal was to position *Vanity Fair* as a "magazine that is read by the people you meet at dinner parties" that covered topics that could inspire entertaining conversation, such as "parties, the arts, sports, theatre, humor, and so forth."

Vanity Fair's history can be traced to 1889 under different titles. However, the magazine's new identity began to emerge with Nast's inaugural September 1913 issue. "*Dress*" was dropped from the title four issues later and it became simply *Vanity Fair*. Crowninshield was editor from 1913 until 1936 when declining ad revenues forced Nast to close the magazine and merge its subscriber list with *Vogue*. The name "Vanity Fair" disappeared for the next forty-seven years until the company relaunched the title in 1983.

Frank Crowninshield started his editorial mission that remained consistent. *Vanity Fair* planned to present "the more entertaining aspects of modern American

life—to the theatre, to opera, art, literature, music, sport, humor and fashion."[30] He said it would include "the most interesting doings of the most interesting of the people who go to make *Vanity Fair* a 'very great Fair' indeed."[31]

Crowninshield made the magazine successful, especially during the 1920s, by creating an elegantly designed magazine that reproduced works of art by great artists with fiction and nonfiction by the best-known writers of the era. Carolyn Seebohm, who wrote a biography of Condé Nast, said that Crowninshield brought three great strengths to the magazine: "An extremely stylish and elegant layout; an eye for the artistic avant-garde; and some of the best writing produced anywhere in the world at that time."[32] Some of those writers included Thomas Burke, Robert C. Benchley, G.K. Chesterton, P. G. Wodehouse, Dorothy Parker, Aldous Huxley, Noel Coward, E.E. Cummings, Robert Sherwood and Edna St. Vincent Millay. Some of the artists included Pablo Picasso, Henri Matisse, Paul Gauguin, and Vincent Van Gogh and Jacob Epstein.[33]

Crowninshield was described by another biographer as "A tall, elegant, and urbane bachelor whose lapel was invariably adorned with a boutonniere. Crowninshield was exceptionally active in Manhattan social life as a toastmaster, party guest, cotillion leader, and after-dinner speaker."[34] He was also known as a kind editor who wrote such nice letters to contributors that they had trouble figuring out whether it was an acceptance or a rejection. He once told Paul Gallico: "My dear boy, this is superb! A little masterpiece! What color! What life! How beautifully you have phrased it! A veritable gem—why don't you take it around to *Harper's Bazaar?*"[35]

An interesting episode in the magazine's history occurred when Nast and Crowninshield fired Dorothy Parker (1893–1967) for writing an anti-Zeigfield follies review.[36] They were said to be fearful of the negative review's effect on advertisers. Shortly after that, Robert Benchley, who was the managing editor, and Robert Sherwood, a writer, resigned in protest. This episode was depicted in the 1994 movie, "Mrs. Parker and the Vicious Circle" about New York's famous Algonquin Roundtable of writers. All three, however, went on to become writers at *The New Yorker* and achieved even greater success as authors, poets and humorists.

Despite its many accolades, the first *Vanity Fair* assumed a prestige and a reputation that exceeded its financial success. It struggled along with high production costs and a modest circulation that never exceeded 100,000. According to one report, the magazine earned a profit in only one year of its existence.[37] *Vogue* editor Edna Woolman Chase said of the magazine, "In the twenty-three years of its life *Vanity Fair* achieved a circulation of about 90,000 of the most sophisticated, literate and art-conscious readers in America, but its annual figures were always in the red." She said part of the reason for its financial troubles was Crowninshield himself, "Who could never bring himself to care about advertising. Any aspect of it bored

him to death."[38]

Condé Nast announced the closing of the magazine with a press release dated December 31, 1936:

> Beginning with its March issue, *VANITY FAIR* will be combined with *VOGUE* and will be published under the title—"*VOGUE*, with which is combined *VANITY FAIR*." I have decided on the amalgamation of *VANITY FAIR* with *VOGUE*, its sister periodical for the reason that the lessening advertising patronage now accorded to periodicals like magazines so largely devoted to the spread of the arts…has made the publication of it, as a single publishing unit, unremunerative. It is for that reason that the magazine now closes its independent editorial career.[39]

Carolyn Seebohm, a Condé Nast biographer, says that Nast's original publishing vision also contributed to *Vanity Fair*'s financial failure. His belief in class publishing—fashion magazines for fashion readers, golfing magazines for golfers, and so forth—had become a publishing axiom by the middle thirties and was widely imitated. "*Vanity Fair*, however, was in the position of catering to a mixed, not altogether definable class…" she wrote.[40]

Edna Woolman Chase and *Vogue*

Edna Woolman Chase (1877–1957) was hired for a three-week temporary position at *Vogue* in 1895 addressing envelopes in the circulation department. She didn't retire from the magazine until 1952 at the age of seventy-five. The child of divorced parents, she was raised in modest circumstances by Quaker grandparents in Asbury Park, New Jersey. Her strong work ethic, honesty and sense of responsibility helped her to rise quickly through the ranks. After Condé Nast purchased the magazine, in 1909, he promoted Chase to assistant editor in 1914 and editor-in-chief in 1929.

In 1914, when World War I disrupted the Paris fashion shows, Chase proposed to Nast that *Vogue* sponsor the first-ever New York fashion show, which she called the "Fashion Fête." Uncertain of whether the social elites would participate, Nast and Chase agreed to donate proceeds to the Committee Of Mercy To Aid Women And Orphans Of The Allied Nations. After Mrs. Stuyvesant Fish, one of the leading ladies of New York society, accepted Chase's invitation to participate, the Fashion Fête became a big success. Chase later wrote, "The publicity that accrued to *Vogue* from the first Fashion Fête…was enormous. Our prestige and advertising soared, and we were, naturally, delighted. Like Bernarr Macfadden's body-building competition, this inaugural show extended *Vogue*'s brand identity and its popularity with the public.

The "church-state" conundrum—the need to keep editorial content free from

advertisers' influence—has plagued magazine publishers throughout the 20th century. It was a matter on which Nast enforced strict standards. In a 1942 memo to Mrs. Chase, Nast said:

> Vogue is made up of two distinct types of material: merchandise features and general articles. However worthily and beautifully the pages of the merchandise section may be edited and produced, it is the features of general character, occupying only about 25% of our space, that in an important way save Vogue from being classed as a merchandising catalogue type of magazine. It should, therefore, be the inexorable policy of the editors to keep these general articles *absolutely pure*.[41]

Three months later, he wrote another memo to her saying,

> Any article containing merchandise information should be presented frankly for what it is, without camouflage. This rule is of the utmost importance because once a merchandise features is introduced under the guise of a general article, the reader thereafter is led to distrust not only general articles but legitimate merchandise pages as well.[42]

Of all the magazines Condé Nast published prior to his death in 1942, *Vogue* was the most profitable whose earnings subsidized the less-successful *Vanity Fair*. Shortly before he died, Nast wrote Edna Chase a memo saying, "Edna, we have been a great team. I believe I have been a wide-awake and intelligent publisher, but I am the first to admit to myself and to acknowledge to the world, that without you I could never have built Vogue. We have built this great property together."[43]

Seventeen year's after Nast's death, Condé Nast Publications was purchased for $5 million in 1959 by newspaper magnate S.I. Newhouse, Sr. (1895–1979) as an anniversary present for his wife, Mitzi, who loved *Vogue*.[44] Newhouse expanded its magazine titles by purchasing Street & Smith Publications, the sports magazine publisher, in 1959. After Newhouse died in 1979, the magazine division, which included CNP, Street & Smith, and other units, was managed by his son S.I. ("Si") Newhouse, Jr. (1927-__) while his brother, Donald (1929-__), managed the newspaper and cable television operations. Chapter ten will discuss the expansion of Condé Nast during the 1980s.

Gilbert Grosvenor and *National Geographic*

National Geographic was started in 1888 as an academic publication of the National Geographic Society. For its first fifteen years, it was a dull, print-heavy publication edited for the society's members who had an academic interest in geography. Alexander Graham Bell (1847–1922), who was named president of the Society in 1897, held a different vision of the society that would appeal to anyone, not just aca-

demic geographers. That meant creating a magazine with a more popular, visual appeal to a general audience. The man he chose to do this was Gilbert Hovey Grosvenor (1875–1966), a school teacher who was twenty-three when he was hired as an assistant editor on a three-month trial basis. A year later Grosvenor married Bell's daughter, Elsie May.

Bell's and Grosvenor's vision for the magazine—a photo-oriented magazine that would popularize recent geographic findings and expeditions—clashed with the society's editorial committee who wanted to keep its narrow academic orientation. Fortunately, Grosvenor and Bell won out. After becoming editor-in-chief in 1903, Grosvenor led the *National Geographic* for the next fifty years as a pioneering photojournalism magazine. They created a set of editorial commandments for the magazine:

1. The first principle is absolute accuracy. Nothing must be printed which is not strictly factual.
2. Abundance of beautiful, instructive and artistic illustrations.
3. Everything printed in the magazine must have permanent value.
4. All personalities and notes of a trivial character are avoided.
5. Nothing of a partisan or controversial character is printed.

Grosvenor also created a set of writing rules to guide his editors and writers, which included:[45]

1. Avoid fuzzy language, which betrays fuzzy thinking.
2. Avoid urging a point of view. Our readers can be trusted to form their own opinions.
3. Avoid long words and phrases when short ones will do as well.
4. Avoid lazy phrases such as "is said to." Either it is a fact, or it is not. Find out.
5. Avoid pretentious language and foreign words without a translation.

In 1905, the *National Geographic* included an issue with eleven pages of photos about the Tibetan city of Lhasa taken by two Russian explorers, the first photos of that city ever published in an American magazine. In 1910, it published the first color photos in any magazine with a twenty-four photo series titled "Scenes in Korea and China." In the April 1913 issue, it was the first publication to publish articles and photos about the ancient Inca city of Machu Picchu, which had recently been discovered. From fewer than 1,000 subscribers when Grosvenor took over, it grew to 200,000 by 1913.

In 1951, Gilbert Grosvenor reflected on his long, successful career at *The National Geographic*. Referring to the huge reader response to the pictures of Lhasa

in 1905, he said, "The incident taught me that what I liked, the average man would like, that is, that I am a common average American. That was how the *National Geographic* started on its rather remarkable career of printing many pictures, and later more color pictures, than any other publications in the world."[46] When he retired in 1955, the magazine had more than two million subscribers.

Gilbert H. Grosvenor's son, Melville Bell Grosvenor (1901–1982) edited the magazine from 1957 to 1967. His grandson—Gilbert Melville Grosvenor (1931-___) edited the magazine from 1970 to 1980 and challenged one of its long-standing policies: "Nothing of a partisan or controversial character is printed." The younger Grosvenor and his succeeding editors in the 1980s and 1990s led the magazine into debates about chemical pollution, nuclear power, global warming, and human evolution.

In a 2007 survey of magazine journalism professors, *National Geographic* ranked first among the most influential magazines of the 20th century. *The New Yorker*, *Sports Illustrated*, *Newsweek*, and *Time*, which succeeding chapters will cover, were also among the top five.[47]

Gertrude Battles Lane and the *Woman's Home Companion*

The *Woman's Home Companion* was founded ten years before *Ladies' Home Journal*, beginning as the *Home Companion*, changing to the *Ladies Home Companion* in 1866, and *Woman's Home Companion* in 1897. Gertrude Battles Lane (1874–1941) was named editor in 1911 and held the position until 1940. During her twenty-nine years, the circulation grew from 727,000 to more than three and a half million, becoming the leader among women's magazines in the 1930s. She stated her editorial philosophy this way:

> In editing the *Woman's Home Companion*, I keep constantly in mind a picture of the housewife of today as I see her. She is not the woman who wants to do more housework, but the woman who wants to do less housework so that she will have time for other things. She is intelligent and clearheaded. I must tell her the truth. She is busy; I must not waste her time. She is forever seeking new ideas: I must keep her in touch with the best. Her horizon is ever extending, her interest broadening; the pages of the magazine must reflect the sanest and most constructive thought on the vital issues of the day.[48]

She edited the magazine throughout World War I, the roaring twenties, and the Great Depression. During the 1930s, Eleanor Roosevelt wrote a regular column and Presidents Taft, Wilson, Coolidge and Hoover wrote articles for her at one time or another. Although the magazine continued to grow and reached four million by 1950, it faced increased financial problems in the following years. After losing an estimated $3 million in 1956, the January 1957 issue was its last.

Other leading magazines of the era

Scientific American is the oldest continuously published magazine in America. Founded in 1845 by Rufus M. Porter as a one-page newsletter, it emphasized reports on new inventions and patents from the U.S. Patent Office in its early years. The magazine called itself, "The Advocate of Industry and Enterprise" and "Journal of Mechanical and other Improvements." The first issue displayed an engraving of "Improved Rail-Road Cars" on the cover with this commentary on the masthead:

> Each number will be furnished with from two to five original Engravings, many of them elegant, and illustrative of New Inventions, Scientific Principles, and Curious Works; and will contain, in high addition to the most interesting news of passing events, general notices of progress of Mechanical and other Scientific Improvements; American and Foreign. Improvements and Inventions; Catalogues of American Patents; Scientific Essays, illustrative of the principles of the sciences of Mechanics, Chemistry, and Architecture: useful information and instruction in various Arts and Trades.

Today *Scientific American* has a monthly U.S. circulation of 733,000 and publishes an additional eighteen foreign language editions around the globe.

Harper's is the second-oldest, continuously published magazine in America. A general-interest monthly of literature, politics, culture, finance, and the arts, it was launched as *Harper's New Monthly Magazine* in June 1850 by the New York book publisher Harper & Brothers. The same company also founded *Harper's Bazaar* magazine, and eventually became HarperCollins Publishing.

In the late 1960s, *Harper's* became one of the leaders in the "new journalism" movement under Willie Morris, who became editor-in-chief in 1967. The magazine declined in circulation and revenue after that and nearly went bankrupt. Two foundations, the John D. and Catherine T. MacArthur Foundation and the Atlantic Richfield Foundation, came along to rescue the magazine and establish it as an independent nonprofit entity.

The Atlantic was founded in Boston in 1857. Originally created as a literary and cultural commentary magazine, its current format is of a general editorial magazine. *The Atlantic* was the first to publish Julia Ward Howe's "Battle Hymn of the Republic" on February 1, 1862, and Martin Luther King, Jr.'s defense of civil disobedience in "Letter from Birmingham Jail" in August 1963.

Harper's, like its sister magazine, *The Atlantic*, has always been aimed at an educated elite, publishing articles on serious topics ranging from the economy to race relations, art and literature. As such, circulations were always modest and both magazines were forced into bankruptcy at least once.

Forbes was established in 1917 by B. C. Forbes, a financial columnist for the Hearst newspapers, and Walter Drey, the general manager of the *Magazine of Wall*

Street. B.C. Forbes became editor-in-chief, a position he held until his death in 1954, while Drey managed the company's business affairs. B.C. Forbes was later assisted by his two sons, Bruce Charles Forbes (1916–1964) and Malcolm Stevenson Forbes (1917–1990). The motto of Forbes magazine is "The Capitalist Tool."

Bruce Forbes took over after his father died, and he streamlined the magazine's management and improved its marketing techniques. During his leadership between 1954 and 1964, the magazine's circulation nearly doubled. When Malcolm Forbes took over, he undertook two strategic initiatives. He hired in-house editorial staff, instead of relying so heavily on freelancers, and started the first of the rankings articles for which Forbes became famous.

Forbes is perhaps best known for its many periodic lists and rankings of wealthiest individuals and largest companies. Since it takes considerable detective work to determine the actual wealth of an individual, *Forbes'* figures are regarded as nearly definitive. Some of these lists include the "200 Best Small Companies," "400 Best Big Companies," "Forbes 400" (a list of the richest people in the U.S.), "World's Richest People," "The World's 100 Most Powerful Women," and "The Celebrity 100."

After Malcolm Forbes died, his eldest son Malcolm Stevenson "Steve" Forbes Jr. (1947–) became president of the company and editor-in-chief of *Forbes* magazine. The company formerly published *American Heritage* and *Invention & Technology* magazines. Forbes suspended publication of these two magazines in May 2007, but they were later purchased by the American Heritage Publishing Company and have resumed publication in the spring of 2008.

Political and religious magazines

Political and religious magazines have traditionally faced difficulty in attracting major national advertisers. With modest circulations often less than 100,000, most of their advertisers consist of book publishers, schools and colleges, and special events and conferences of interest to their readers. Most corporate advertisers do not want to be identified with particular religious or political points of view for fear of alienating customers with different viewpoints. Consequently, with some exceptions, these magazines struggle along with modest subscription and ad revenue combined with support from wealthy benefactors, institutional sponsors and periodic appeals to readers for gifts and donations.

Three well-known political magazines with a generally liberal political orientation were started before 1920. *The New Republic* published its first issue on November 7, 1914, with founding editor Herbert Croly, who had financial backing from its original owners Dorothy Payne Whitney and her husband, Willard

Straight. It was purchased in 1974 by Harvard University faculty member Martin Peretz, who remains owner and editor-in-chief. *The Nation* was started on July 6, 1865, at the beginning of Reconstruction and has been published continuously since then. *The Progressive* was founded on January 9, 1909, by U.S. Senator Robert M. La Follette, Sr. of Wisconsin. First called *La Follette's Weekly*, its name was changed to *The Progressive* in 1929.

No conservative magazines still published today were started until 1946, when the Foundation for Economic Progress launched *The Freeman*. In 1955, William Buckley started *National Review*. Other conservative magazines such as *American Spectator* and *The Weekly Standard* were launched in the 1990s. Political parties and special interest groups all publish their own magazines, which are usually aimed at fund-raising and public relations more than substantive news reporting and analysis.

Three of the best-known independently published religious magazines are *Guideposts, The Christian Century* and *Christianity Today*. As the highest-circulation religious magazine, *Guideposts* reaches an interfaith audience of more than two million readers and will be covered in more detail in chapter six. *Christian Century* was started in 1908 by Charles Clayton Morrison and today the Chicago-based magazine reaches a mainline Protestant readership. *Christianity Today*, the largest magazine for an interdenominational Christian audience, was founded in 1958 by Billy Graham and other evangelical leaders. Christianity Today Inc., based in Carol Stream, Illinois, has expanded over the years and today publishes several other specialized titles such as *Leadership Journal, Books and Culture*, and *Church Finance Today*. The three major magazines published for Jewish audiences include *American Hebrew* (founded 1879), *American Israelite* (founded 1897), and *Reform Judaism* (founded 1911).

Standard directories list more than 3,000 titles of religious magazines currently published in the U.S., so the religious press has a significant impact on American culture. Most of them belong to one of four professional associations: the Associated Church Press, Evangelical Press Association, Catholic Press Association, and Jewish Press Association. Some promote the interests and beliefs of particular denominations and religious traditions, while others promote missions, social causes or theological perspectives cutting across denominational boundaries. Interested readers should consult *Popular Religious Magazines of the United States*, a book that presents a more comprehensive historical overview of religious publications than this one can achieve.[49]

The years between 1900 and 1920 saw the creation of companies that today dominate the consumer magazine market. Bernarr Macfadden's focus on health and fitness was a harbinger of a trend that continued to dominate the century. Condé Nast articulated and perfected the concept of niche audiences, while Hearst perfected mass marketing techniques with his expanding lists of titles. The industry's

heavy reliance on advertising revenue to subsidize publishing costs became entrenched. The 1920s were to see origins of three legendary publishing empires—Reader's Digest Association, Time Inc. and *The New Yorker*, to which we now turn. The war was over, America was at peace, so let the good times begin.

Notes

1. Geoffrey Norman, "Strong Circulation: How A Weight-Lifting and Diet Fanatic Built a Publishing Empire a Century Ago," *Wall Street Journal*, March 20, 2009, W10.
2. Mark Adams, *Mr. America: How Muscular Millionaire Bernarr Macfadden Transformed the Nation Through Sex, Salad, and the Ultimate Starvation Diet* (New York: HarperCollins: 2009), 43.
3. Ibid., 44.
4. Ibid., 46.
5. Ibid., 55.
6. James Young, "Bernarr Macfadden," *Dictionary of American Biography, Supplement 5: 1951–1955.* American Council of Learned Societies, 1977. Reproduced in *Biography Resource Center* (Farmington Hills, MI: Gale, 2009), http://galenet.galegroup.com/servlet/BioRC.
7. Theodore Peterson, *Magazines in the Twentieth Century* (Urbana-Champaign: University of Illinois Press, 1964), 299.
8. Quoted in Adams, *Mr. America*, 105.
9. William H. Taft, "Bernarr Macfadden: One of a Kind," *Journalism Quarterly* (Winter 1968): 627–633.
10. James F. O'Donnell, *100 Years of Making Communications History: The Story of the Hearst Corporation* (New York: Hearst Professional Magazines, 1987), 6.
11. Elizabeth Rourke, "The Hearst Corporation," *International Directory of Company Histories v. IV*, 625–627. See also O'Donnell, *100 Years of Making Communications History*.
12. Helen Gurley Brown, "Step into My Parlor," *Cosmopolitan*, July 1965, 4.
13. Jennifer Scanlon, *Bad Girls Go Everywhere: The Life of Helen Gurley Brown* (New York: Oxford University Press, 2009), 148–149.
14. Quoted in http://www.notablebiographies.com/Br-Ca/Brown-Helen-Gurley.html (accessed August 4, 2008).
15. Audit Bureau of Circulations figure as of December 31, 2000. Source: www.adage.com/datacenter (accessed August 4, 2008).
16. Mary Ellen Zuckerman, *A History of Popular Women's Magazines in the United States, 1792–1995* (Westport, CT: Greenwood Press, 1998), 205.
17. Frank Luther Mott, *A History of American Magazines 1905–1930* (Cambridge: Harvard University Press, 1968), 130.
18. Mary Ellen Zuckerman, *A History of Popular Women's Magazines in the United States.* The Seven Sisters colleges include: Barnard, Bryn Mawr, Mount Holyoke, Radcliffe, Smith, Vassar, and Wellesley.
19. Audit Bureau of Circulations figure as of December 31, 2000. Source: www.adage.com/dat-

acenter (accessed August 4, 2008).

20. Edward L. Throm, *Fifty Years of Popular Mechanics, 1902–1952* (New York: Simon and Schuster, 1951), ix–x. Cited in James L.C. Ford, *Magazines for Millions* (Carbondale: Southern Illinois University Press, 1969), 381.

21. "*Popular Mechanics* Magazine Purchased by Hearst Corporation," *Wall Street Journal*, November 21, 1958, 8.

22. "*Redbook*'s First Sixty Years," *Redbook*, May 1963, 76.

23. Kathleen L. Endres and Therese L. Lueck, *Women's Periodicals in the United States: Social and Political Issues* (Westport, CT: Greenwood Press, 1996), 299.

24. Robin Pogrebin, "Sey Chassler, 78, *Redbook*'s Editor in Chief" (obituary), *New York Times*, December 21, 1997.

25. Belinda J. Oliver, "*Redbook* Goes for the Jugular," *Magazine Age*, February 1985, 69.

26. Carolyn Seebohm, *The Man Who Was Vogue: The Life and Times of Condé Nast* (New York: The Viking Press, 1982), 13.

27. "Class Publications." Condé Montrose Nast Papers, Condé Nast Archives, Manuscript Collections, New York, NY.

28. *Time*, September 28, 1942, 51–52.

29. Edna Woolman Chase and Ilka Chase, *Always in Vogue* (Garden City, NY: Doubleday, 1954), 61.

30. *Vanity Fair*, May 1914, 19.

31. *Vanity Fair*, January 1914, 13.

32. Seebohm, *The Man Who Was Vogue*, 107.

33. *Vanity Fair* Editorial Career, undated. Condé Montrose Nast Papers, Condé Nast Archives, Manuscript Collections, New York, NY.

34. "Francis Welch Crowninshield." *Dictionary of American Biography, Supplement 4: 1946–1950*. American Council of Learned Societies, 1974. Reproduced in *Biography Resource Center* (Farmington Hills, MI: Gale, 2009), http://galenet.galegroup.com/servlet/BioRC.

35. "Frank Crowninshield, 75, Dies; Editor, Author and Bon Vivant," *New York Herald Tribune*, February 29, 1947.

36. Seebohm, *The Man Who Was Vogue*, 328.

37. *Newsweek*, January 4, 1936, 31.

38. Edna Woolman Chase and Ilka Chase, *Always in Vogue*, 286.

39. "Important announcement by the publisher of *Vogue* and *Vanity Fair*," December 31, 1936. Condé Montrose Nast Papers, Condé Nast Archives, Manuscript Collections, New York, NY.

40. Seebohm, *The Man Who Was Vogue*, 39.

41. Condé Nast to Edna Woolman Chase, "Purity of General Editorial Pages," March 26, 1942. Condé Montrose Nast Papers, Condé Nast Archives, Manuscript Collections, New York, NY.

42. Condé Nast to Edna Woolman Chase, "Merchandise Credits," May 11, 1942. Condé Montrose Nast Papers, Condé Nast Archives, Manuscript Collections, New York, NY.

43. Seebohm, *The Man Who Was Vogue*, 368.

44. Gigi Mahon, "S.I. Newhouse and Condé Nast; Taking Off the White Gloves," *The New York Times*, September 10, 1989.

45. The general guidelines and writing rules are quoted in Norberto Angeletti and Alberto Oliva, *Magazines That Make History: Their Origins, Development and Influence* (Gainesville: University Press of Florida, 2004), 241.
46. Angeletti and Oliva, *Magazines That Make History*, 251.
47. David E. Sumner, "Top American Consumer Magazines as Rated by Journalism Professors." Presented at the annual convention of the Association for Education in Journalism and Mass Communication, Washington, DC, August 10, 2007.
48. Mott, *A History of American Magazines 1905–1930*, 769.
49. P. Mark Fackler and Charles H. Lippy, eds., *Popular Religious Magazines of the United States* (Westport, CT: Greenwood Press, 1995).

The 1920s

Good Times, Great Magazines

The 1920s, sometimes called "the Jazz Age" and the "Roaring Twenties," were characterized by a robust economy, good times, and startups of some of the century's great magazines. The decade also marked the beginning of commercial radio, the invention of television, the first talking movie, first trans-Atlantic flight and even Mickey Mouse. It ended with the stock market crash and the beginning of the Great Depression, but not before *Reader's Digest*, *Time*, and *The New Yorker* were on their way to long-lasting success. H.L. Mencken achieved the height of his literary fame editing the satire magazine *American Mercury*. E.T. Meredith left his job as President Wilson's Secretary of Agriculture to return to Des Moines to build his publishing company and launch *Better Homes and Gardens*. *Saturday Evening Post* and *Good Housekeeping* continued their spectacular success and expanded their reach into American middle-class homes. It was, as they say, the best of times, which ended with the worst of times.

DeWitt and Lila Wallace and *Reader's Digest*

Reader's Digest, which published its first issue in February 1922, found its niche by providing practical and useful information at a time when most of its competitors were publishing fiction and essays. It had a simple, yet innovative editorial concept: condense and reprint the best articles from the country's leading magazines.

Table 1

Major Magazine Launches of the 1920s

Year	Magazine	Year	Magazine
1920	Architectural Digest	1923	Fruit, Garden and Home
	P G A Magazine		Reader's Digest
	Scott Stamp Monthly		Time
	Writer's Digest	1924	American Mercury
1921	Barron's		Commonweal
	Hunter's Horn		National Motorist Magazine
1922	American Gardener		Saturday Review
	Elks Magazine	1925	Arizona Highways
	Encompass		New Yorker (The)
	Foreign Affairs	1926	Camping Magazine
	German Shepherd Dog Review		Dance Magazine
	Harvard Business Review		New York Enquirer
	Magazine Antiques		Parents
	Outdoor America	1927	Flying
	Science News		Flying Models
	Ring: The Bible of Boxing	1929	Business Week
			Model Airplane News

DeWitt Wallace (1889–1981) and his fiancée, Lila Bell Acheson (1889–1984), started the magazine on a shoestring budget. The son of a Presbyterian minister and college president, Wallace worked in St. Paul, Minnesota, for a publisher of farm magazines and textbooks. Laid off from his job in 1921, he spent three months writing promotional circulars for his projected magazine. He borrowed $4,000 from his father and brothers and took his fiancée as a partner, who was also the daughter of a Presbyterian minister. They rented an office in Greenwich Village, clipped and condensed dozens of articles for their new magazine, and prepared circulars soliciting subscriptions. On their wedding day, October 15, 1921, they mailed thousands of circulars. When they returned home from their honeymoon in the Poconos, their mail included 1,500 charter subscriptions with $3 each.

The Wallaces created a formula that went on to become the "Four Commandments" of the magazine. They chose stories which met these standards:

1. Is it quotable? Is it something the reader will remember, ponder, and discuss?

2. Is it applicable? Does it come within the framework of most people's interests and conversation? Does it touch the individual's own concerns?
3. Is it of lasting interest? Will it still be of interest a year or two from now?
4. Is it positive? Does it offer the reader a solution or an optimistic and uplifting message?[1]

Lila Wallace wrote "A Word of Thanks" to charter subscribers in the first issue of February 1922, describing the *Digest's* approach: "These features will no doubt appeal particularly:

1. Thirty-one articles each month—one a day—condensed from leading periodicals;
2. Each article of enduring value and interest—today, next month, or year hence; such articles as one talks about and wishes to remember;
3. Compact format easy to carry in the pocket and to keep for permanent reference.
4. A most convenient means of keeping one's information account open..."

By 1951, the *Digest* was published in fifteen languages in forty-eight countries and had the highest circulation of any magazine in the world. On December 10 of that year, DeWitt and Lila Wallace appeared on the cover of *Time* magazine with the caption, "The DeWitt Wallace's, with scissors, paste and sunrises, 15,500,000 customers." The cover story called *Reader's Digest* "One of the greatest success stories in the history of journalism," and "by world circulation standards, DeWitt Wallace, the Digest's founder, owner and boss, is the most successful editor in history."

The *Time* story characterized the magazine's content with this breezy description: "In the *Digest's* world, things are usually getting better, faith moves mountains, prayer can cure cancer and poverty holds hidden blessings....Digest readers are left with a warm feeling about themselves, about life, and about the Digest."[2]

The magazine accepted no advertising and relied solely upon subscription revenue until 1955. While *Reader's Digest* originally relied entirely upon reprints from other magazines, it turned increasingly towards assigning its own original articles. It also began the controversial practice of paying authors to write articles for other magazines so that it could reprint them. The editors would approach another publication with a story idea and offer to pay the expenses and writer's fees in exchange for the right to reprint the story. Wallace's rationale for the practice was that a story's original appearance in a well-known and respected magazine brought a certain credibility and prestige. It also enabled him to maintain and market his magazine's purpose and title as a "digest."

Lila had the most influence over the magazine's design. After the magazine

started accepting advertising, it significantly increased its use of color and photographs. In 1957, she initiated the idea of putting a single illustration on the front and relegating the table of contents to the back cover. Her power over visual and artistic decisions was such that when Coca Cola offered the magazine $18 million for a back page cover ad, she calmly told her husband: "I bid nineteen million." They rejected the offer and the back cover remained pictorial.

Despite its popular success, the *Reader's Digest* was not always admired among intellectuals because of its conservative content, middle-class appeal, and lack of literary style. One of its frequent contributors, Louis Bromfield, told *Time* that the *Digest*'s main appeal was to "intellectual mediocrity" and that the magazine was so popular because "it requires no thought or perception."

Nevertheless, one of the *Digest*'s coups was discovering and publishing Alex Haley (1921–1992), the Pulitzer-Prize winning author of *Roots: The Saga of an American Family* and *The Autobiography of Malcolm X*. The *Digest* published its first Haley article, "The Harlem Nobody Knows" in June of 1954 and later, "Mr. Muhammed Speaks," which led to *The Autobiography of Malcolm X*. When Haley met Lila Wallace at a party, she told him, "If I can ever be helpful to you, let me know." Three years later, he wrote to her outlining his plans to trace his family history in Africa. The *Digest* offered him $1,000 a month plus travel expenses to do the research he could not have otherwise done. The result was *Roots*, a novel based loosely on his family's history. The book was published in thirty-seven languages, adapted into a television miniseries, and won the Pulitzer Prize in 1977. Of course, *Reader's Digest* also published a condensed version, and Haley remained there as a contributing editor until his death in 1992.[3]

Henry Luce, Briton Hadden, and *Time*

Time magazine made its mark in 1923 by summarizing the world's news in one convenient, easy-to-read magazine. Using a "digest" model similar to the *Reader's Digest*, its innovation came not in its content, but in the convenient way in which it packaged and delivered it. Whereas the *Digest* focused on service articles of practical interest, *Time* focused on news and current events.

Henry Robinson Luce (1898–1967) and Briton Hadden (1898–1929) were Yale classmates who decided while they were still in college that they wanted to start a news magazine. At Yale, Hadden was chairman of the *Yale News* and Luce its managing editor. They interrupted college in 1918 to enlist in the Student Army Training Corps at Camp Jackson, South Carolina. There they found time for long talks about the possibility of founding a new national weekly devoted to a concise and orderly presentation of the news. They returned to Yale and graduated with the class of 1920.[4]

After college, Luce became a reporter for the *Chicago Daily News* and Hadden worked for the *New York World*. By chance, they were both offered jobs on the *Baltimore News*. Reunited there, they resumed planning a weekly news magazine they tentatively called "Facts."

After less than a year in Baltimore, they quit their jobs and moved to New York with little money, plenty of ambition, and a typewritten dummy for their new magazine. Luce invented the term "news-magazine" in his prospectus. No magazine was published that resembled the modern weekly newsmagazine. At a time when New York City had seven daily newspapers, their prospectus argued that people were uninformed "because no publication has adapted itself to the time which busy men are able to spend on simply keeping informed." They proposed to collect facts on newsworthy subjects of general interest and give it to readers in short, quick-to-read doses. Luce later recalled that the name "Time" came to him while riding home on a subway one night and reading ads containing slogans such as "Time to Retire" and "Time for a Change."

They spent a year raising money and selling shares in their new venture, mostly to former Yale classmates or alumni. Mrs. William Harkness, the wealthy mother of a Yale friend, made the largest investment. They made their sales pitch and, without asking any questions, the kind lady wrote out a check for $20,000.[5] After raising $85,000—$15,000 short of their goal—they decided to proceed anyway. Time Inc. was incorporated on November 28, 1922. The first issue of "Time—The Weekly News-Magazine," contained thirty-two pages, sold for fifteen cents, and appeared on March 3, 1923. The partners had fulfilled their goal: reducing the world's news into twenty-two departments into a thirty-two page magazine that could be read in less than an hour.

The first issue contained no fanfare, no commentary or columns by the publishers. The only place that Luce and Hadden's named appeared was alongside other contributors and staff members in a small masthead on page twenty-three. Most pages contained four to eight short articles and no article in the entire issue contained a byline or was longer than a third of a page. Most of those original eighteen departments in that issue have remained a part of the magazine: National Affairs, Foreign News, Books, Art, The Theatre, Cinema, Music, Education, Religion, Medicine, Law, Science, Finance, Sport, Aeronautics, Crime, The Press, and Milestones.[6]

During the first six years, Hadden was editor-in-chief, while Luce was publisher and business manager. The founding partners complemented each other in both talent and temperament. Hadden was the mischievous extrovert and comedian—hard-partying, but brilliant wordsmith. Luce was the conservative, pragmatic intellectual who was voted "Most Brilliant" by his Yale classmates.

By January 1924, circulation climbed to 30,000. By the end of the year, it reached 70,000 and 250,000 in 1929. Ad revenues increased from $13,000 its first year to $414,000 in its fifth year when the magazine started making a profit. In 1925 Luce insisted that *Time*'s operations be moved to less-expensive facilities in Cleveland, Ohio, where national distribution was also easier. Hadden and most of the staff members opposed the move. Three years later, however, they returned after realizing that New York was a focal point for gathering national and international news. By this time, improved railroad transportation had also made national distribution easier.

Hadden was responsible for creating one of *Time*'s most enduring legacies: an acerbic, irreverent style of writing later dubbed by critics and fans alike as "Timestyle."

Using rhythmic effect, *Time*'s sentences sometimes began with participles or verbs and ended with nouns. Sometimes *Time* created new words that became an enduring part of the language, such as tycoon, socialite, pundit, kudos, guesstimate, male chauvinist, and televangelist. Other *Time* creations included: culturecrats, cinemactor, ecofreaks, and Californicate. *Time*'s executive editor Frank Norris was credited with naming "World War II" in 1939.

The magazine's "Timestyle" was studied by academics and parodied by satirists and critics. "Of all the journalistic phenomena of our age, the magazine *Time* is linguistically the most interesting," wrote one speech professor. "Here for the first time is a popular medium of information whose editors are using the language so freely and boldly as to suggest conscious experiment."[7] Another professor wrote that the "trademark of Timestyle" was its mixture of colloquial and highbrow words. "Our man from *Time* thinks nothing of combining the most ordinary words with the most highfalutin ones—even in the same sentence," she said.[8]

Hadden was stricken with a streptococcus infection in 1928 and died in 1929 at the age of thirty-one. Luce became editor and majority shareholder after buying out Hadden's portion of the estate. Soon thereafter, Luce started planning for the first of three magazines he was to create during his lifetime: *Fortune* (1930), *Life* (1936) and *Sports Illustrated* (1954).

Time started its "Man of the Year" tradition in 1927. During a light news week late in 1927, having neglected to put Charles A. Lindbergh on the cover the previous May when he made his famous flight, they came up with the "Man of the Year" idea to justify putting him on at year's end. Luce wrote in 1945:

> The whole thing began when the first week of 1928 was so dull. No one had done anything newsworthy enough to put his picture on *Time*'s cover, so somebody suggested we stop looking for a Man of the Week and pick a Man of the Year. This was an easy choice: Charles August Lindbergh.[9]

The choice became a national guessing game that became popular with readers and advertisers. Every president was chosen "Man of the Year" at least once except for Gerald Ford. Some choices stirred controversy since their criteria stated that the decision should be made on the basis of the person who had the "most influence" on world events—whether that influence was positive or negative. Consequently, Adolf Hitler was named "Man of the Year" for 1938, Josef Stalin in 1939 and 1942, and Iran's Ayatollah Khomeini in 1979.

Luce, a staunch Republican, gave *Time* a conservative tone under his leadership. "If everyone hasn't brains enough to know by now that I am a Presbyterian, a Republican and a capitalist, he should. I am biased in favor of God, the Republican Party, and free enterprise. Hadden and I invented *Time*. Therefore we had a right to say what it would be. We're not fooling anybody. Our readers know where we stand," he once said.[10]

No love was lost between Luce and President Roosevelt during his four terms in office. "The President detested both Luce and his wife, and the feeling was reciprocated. The Luce magazines were among the President's severest critics," wrote *Time* historian Robert Elson. [11]

Luce married Clare Boothe Brokaw on November 23, 1935, after divorcing his

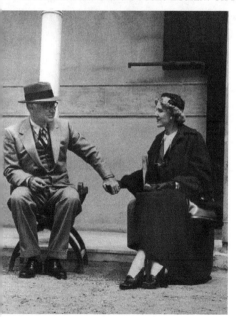

Time Inc. founder and publisher Henry R. Luce with his wife, Clare. Photo by Dmitri Kessel. Courtesy: Time Inc.

first wife about six weeks earlier. She had been associate editor of *Vogue* in 1930 and managing editor of *Vanity Fair* from 1930 to 1934.[12] Both were forceful, articulate and conservative in their politics. In the fall of 1942, Luce's wife, Clare Boothe Luce, won election to Congress from Connecticut and served two terms from 1943 to 1947. She was appointed ambassador to Italy by President Eisenhower in 1953 and held the position until 1956. Her position in national politics raised the dilemma of how Time Inc. magazines should cover the wife of their editor-in-chief. Eventually Luce called for a blackout on the coverage of his wife in all of the company's magazines.[13]

Luce's political views mellowed in later years, however. His successor, Hedle₁ Donovan, wrote in his memoirs, *Right Times, Right Places:* "His political outlook wa far more liberal than that of many self-made rich men, and his own Republicanism was of the 'Eastern progressive school' Harry was, in fact, pretty much of a politi cal independent most of the time, and tended to get very Republican only ever₁ fourth year."[14]

Although *Time* had strongly supported Republican candidates for presiden₁ throughout its history, the 1960 election marked a turning point in its partisanship Luce always slightly distrusted Richard Nixon and slightly admired John F. Kennedy Donovan wrote, "The attitude of the top *Time* editors reflected a lively journalis tic appetite of Kennedy as subject matter, an awareness of Luce's relatively toleran attitude toward this Democrat. Time Inc. was in some respects closer to th₁ Kennedy administration than to the Eisenhower administration it had champione₁ in two elections.[15]

Table 2

Year	Person	Year	Person
	Time's *Person of the Year*: 1927-2009		
1927	Charles Lindbergh	1969	Middle Class
1928	Walter Chrysler	1970	Willy Brandt
1929	Owen Young	1971	Pres. Richard Nixon
1930	Mohandas Gandhi	1972	Pres. Richard Nixon, Henry Kissinger
1931	Pierre Laval	1973	Judge John Sirica
1932	Pres. Franklin D. Roosevelt	1974	King Faisal of Saudi Arabia
1933	Hugh Johnson	1975	U.S. Women
1934	Pres. Franklin D. Roosevelt	1976	Pres. Jimmy Carter
1935	Haile Selassie of Ethiopia	1977	Anwar Sadat
1936	Wallis Simpson	1978	Teng Hsiao-ping
1937	Gen. and Mme. Chang Kai-Shek of China	1979	Ayatollah Khomeini
1938	Adolf Hitler	1980	Pres. Ronald Reagan
1939	Joseph Stalin	1981	Lech Walesa
1940	Winston Churchill	1982	The Computer
1941	Pres. Franklin D. Roosevelt	1983	Pres. Ronald Reagan, Yuri Andropov
1942	Joseph Stalin	1984	Peter Ueberroth
1943	Gen. George Marshall	1985	Deng Xiaoping
1944	Gen. Dwight D. Eisenhower	1986	Corazon Aquino
1945	Pres. Harry Truman	1987	Mikhail Gorbachev
1946	James F. Byrnes	1988	The Endangered Earth
1947	George Marshall	1989	Mikhail Gorbachev
1948	Pres. Harry S. Truman	1990	Pres. George Bush
1949	Winston Churchill	1991	Ted Turner
1950	G.I. Joe	1992	Pres. Bill Clinton
1951	Mohammed Mossadegh	1993	Nelson Mandela, F.W. De Klerk, Yitzhak Rabin, Yasser Arafat
1952	Queen Elizabeth II	1994	Pope John Paul II
1953	Konrad Adenauer	1995	Newt Gingrich
1954	John Foster Dulles	1996	David Ho
1955	Harlow H. Curtice	1997	Andy Grove
1956	Hungarian Patriot	1998	Pres. Bill Clinton, Kenneth Starr
1957	Nikita Khrushchev	1999	Jeff Bezos
1958	Charles De Gaulle	2000	Pres. George W. Bush
1959	Pres. Dwight D. Eisenhower	2001	Rudolph Giuliani
1960	U.S. Scientist	2002	The Whistleblowers
1961	Pres. John F. Kennedy	2003	The American Soldier
1962	Pope John XXIII	2004	Pres. George W. Bush
1963	Martin Luther King, Jr.	2005	Bono, Melinda and Bill Gates
1964	Pres. Lyndon Johnson	2006	You
1965	Gen. Wm. Westmoreland	2007	Vladimir Putin
1966	Young People	2008	Pres. Barack Obama
1967	Pres. Lyndon Johnson	2009	Ben Bernanke
1968	U.S. Astronauts		

Harold Ross and *The New Yorker*

The New Yorker, founded in 1925 by Harold Ross (1892–1951), established a niche for high-quality fiction, nonfiction, reviews, and cartoons, always appealing to a well-educated and sophisticated audience. Throughout its eighty-five year history, it has published most of America's best known authors and writers, winning more National Magazine Awards than any other magazine. Twenty-five books were written about the magazine between 1950 and 2006—about one every two years and more than any other magazine (see bibliography for a list). Harold Ross was an unlikely candidate to found such a magazine.

"As a poet is born, Ross was born a newspaperman," wrote *New Yorker* editor and writer James Thurber (1894–1961). Ross wrote for seven different newspapers before he was twenty-five, beginning with the *Salt Lake City Tribune* at the age of fourteen. Later he worked for newspapers in Sacramento, San Francisco, New Orleans, Panama and Atlanta, earning him the nicknames "the hobo" and "the wanderer" among some of his early associates.

In 1917 Ross enlisted in the Army's Railway Engineer Corps and was sent to Europe. Shortly after arriving, he volunteered to work at the *Stars and Stripes* newspaper in Paris, where journalism talent was in such short supply that he was promoted immediately to editor. Although he remained an Army private throughout his editorship, he established a reputation for editorial independence of *Stars and Stripes* as a serviceman's newspaper and didn't allow his military superiors to influence its content. In Paris, he also met and married Jane Grant, a former *New York Times* reporter and the first of his three wives.

After the war ended, she convinced him to go to New York, where he became the editor of *Judge*, the humor magazine, and then *American Legion Weekly*. During this time, he conceived the idea for a magazine that would combine humor, fiction, nonfiction and news about the arts and literature for a sophisticated audience. He became friends with Raoul Fleischmann, a wealthy heir of the bakery-empire family who became his business partner and chief investor. Ross wrote a prospectus in the fall of 1924 for prospective subscribers and investors, which stated:

> *The New Yorker* will be a reflection in word and picture of metropolitan life....Its general tenor will be one of gaiety, wit and satire, but it will be more than a jester. It will not be what is commonly called highbrow or radical. It will be what is commonly called sophisticated, in that it will assume a reasonable degree of enlightenment on the part of its readers.

The prospectus went on to describe its various departments and elements of content including the reporting of contemporary events and people of interest, reviews

of plays, books, cinema and musical performances, as well as some fiction and poetry and "...*The New Yorker* expects to be distinguished for its illustrations, which will include caricatures, sketches, cartoons and satirical drawings."

The most widely quoted sentence in Ross' prospectus is "*The New Yorker* will be the magazine which is not edited for the old lady in Dubuque," followed by, "It will not be concerned in what she is thinking about."[16]

The New Yorker's first year was not promising after circulation plummeted from an initial run of 15,000 copies in February to 2,700 in August. One biographer says of Fleischmann, "Within a few months he'd nearly wiped out his personal fortune." In his memoir, *The Years with Ross*, Thurber says, "*The New Yorker* was the outstanding flop of 1925, a year of memorable successes in literature, music, and entertainment, and the only flop that kept on going." He tells the story about Ross running into writer Dorothy Parker (1893–1967) at a New York restaurant.

"What happened?" Ross asked her. "I thought you were coming into the office to write a piece last week."

"Someone was using the pencil," she explained sorrowfully.

The indefatigable Ross never gave up, however, and the magazine earned its first profit in 1928. As its publisher and editor-in-chief, he led the magazine to stunning success for the next twenty-seven years until his death in 1952. Subscription and single copy sales rose every year except for two between 1925 and 1941—from 14,064 to 171,665. Advertising revenue rose every consecutive year between 1925 and 1934—from $36,000 to $2.5 million.[17]

Ross maintained a legendary separation between the magazine's editorial and advertising departments, even maintaining their offices on separate floors of the building. "I think it is essential that all members of the advertising staff be tactfully but firmly taught that they are in no wise to have direct contact with the members of the editorial staff or with he," he wrote in a memo to Raoul Fleischmann. He continued:

In my opinion this is most important. Unless stern measures are taken, my present efforts to keep the editorial department independent, uninfluenced, honest and—more important than all—slightly aloof, will be more or less defeated. I do not want any member of the staff to be conscious of the advertising or business problems of *The New Yorker*. If so, they will lose their spontaneity and verve and we will be just like all other magazines.[18]

Under Ross, *The New Yorker* published such writers as E.B. White and James Thurber and many series that later became best-selling books. The word "Profile," coined by staff writer James Kevin McGuinness, was a *New Yorker* invention. Today the word "profile" is universally used in journalism to refer to any biographical sketch

about a person, but it was *The New Yorker* that originated the term and first used it as the title for one of its regular features.

Harold Ross was not a great writer, but his exceptional talent was finding great writers and convincing them to write for his magazine. He was a charter member of the famed Algonquin Round Table, a group of writers, humorists, playwrights and screenwriters who met daily for drinks and card games at New York's Algonquin Hotel from 1919 to 1929. Other charter members included: Robert Benchley humorist and actor; Heywood Broun, columnist and sportswriter; Marc Connelly playwright; George S. Kaufman, playwright and director; Dorothy Parker, short story writer and screenwriter; Robert E. Sherwood, author and playwright; John Peter Toohey, publicist; and Alexander Woollcott, critic and journalist. Parker and other Algonquin members were the subjects of the 1994 movie, "Mrs. Parker and the Vicious Circle."

In its early years, especially, Ross was able to recruit from these and other great writers to contribute. James Thurber (1894–1961) worked as an editor, writer and cartoonist for the magazine from 1927 until his death. E.B. White (1899–1985) was a writer and editor for the magazine from 1925 until his death, in addition to writing well-known children's books. In 1929, Harold Ross tried to convince his friend Groucho Marx (1890–1977) to contribute. "If you would listen to me, you would write a lot and get a big reputation as a writer and plenty of publicity for the Marx Brothers which, God knows, they need," Ross told Marx.[19]

The New Yorker's first managing editor was Ralph Ingersoll (1900–1985) who played a substantial role in the magazine's early success. Henry Luce was able to lure Ingersoll away in 1930 to become the founding editor of *Fortune*. Harold Ross and Henry Luce were never friends, to say the least. On November 28, 1936, *The New Yorker* published "Time, Fortune, Life, Luce," which was a profile of Henry Luce written by Wolcott Gibbs using satirical "Timestyle."[20] The article made Luce so furious that he wrote an angry letter of protest to Ross. Ross responded with a five-page letter defending Gibbs' profile and said:

> You complained that there wasn't a single favorable word in the piece about you. It was generally felt that the total effect of the article and its being in existence at all was enormously favorable and that our listing of your remarkable growth…were practically heroic.

But then he added:

> I was astonished to realize the other night when I talked to you that you are apparently unconscious of the notorious reputation *Time* and *Fortune* have for crassness in description, for cruelty and scandal-mongering and insult. I say frankly…that you are in a hell of a position to ask anything of anybody.

After his signature, Ross included this typewritten slogan: "Small man...furious, mad ...no taste."[21]

After Ross's death in 1952, the second editor of *The New Yorker* was the equally legendary William Shawn (1907–1992), who was editor-in-chief from 1952 to 1987. Shawn started working for the magazine in 1933 until Ross promoted him to managing editor in 1939. He managed the magazine's coverage of World War II and in 1946, persuaded Ross to run John Hersey's story about the atomic bombing of Hiroshima as the entire contents of one issue.

Shawn's style differed drastically from that of Ross. Whereas Ross was the brash extrovert, often using profanity-laced language in dealing with writers, Shawn was quiet and reserved. Shawn was loved and admired by the writers who wrote for him. Brendan Gill described the gentle, yet determined way Shawn imposed his will upon writers:

> Questioning a comma, he will shake his head and say in his soft voice that he realizes perfectly well what a lot of time and thought have gone into the comma...but isn't there the possibility...that the sentence could be made to read infinitesimally more clearly if, say, instead of a comma a semicolon were to be inserted at just that point?

The New Yorker reached its greatest years under Shawn, and enjoyed a reputation many regarded as the most influential magazine in America. During the 1960s, it perfected the new "literary journalism" style, which chapter eight will report in more detail.

In 1985, the magazine was purchased by the Newhouse family and came under the Condé Nast family of magazines. In a controversial ouster, Si Newhouse replaced William Shawn with Robert Gottlieb, who had been editor-in-chief of Simon & Schuster and Alfred A. Knopf book publishers. This part of the story will continue in chapter ten.

Edwin T. Meredith and Meredith Corporation

Today the Meredith Corporation, based in Des Moines, Iowa, publishes twelve print magazines, fifty web sites and owns twelve television stations. Although the company had its origins in 1902 with the magazine *Successful Farming*, its flagship publication *Better Homes and Gardens* originated in 1922. Today *Better Homes and Gardens* ranks fourth in circulation, *Family Circle* ranks seventh and *Ladies' Home Journal* ranks ninth among all American magazines.

The grandfather of E.T. Meredith (1826–1928) gave him the controlling interest in his newspaper, the *Farmer's Tribune*, along with a note that said "Sink or swim." After leading the paper to profitability, Meredith sold it and began publishing a farm

service magazine called *Successful Farming* in 1902.

To attract national advertisers to *Successful Farming*, Meredith chartered a train dubbed the "Meredith Flyer" to bring 150 advertising and business executives to Iowa in 1914. He organized one trip in June and another in December. He wanted the business leaders to see for themselves the prosperous farms, businesses and families of the Midwest. Despite being in debt at the time, Meredith borrowed $10,000 to carry out this risky gamble. In Des Moines, the eastern executives met with merchants, business and civic leaders. In Ames, they met with Iowa State University professors and other state business leaders.[22]

Table 3

Meredith Corporation magazines
Year of founding with year of acquisition by Meredith
American Baby (founded 1938)
Better Homes and Gardens (founded 1922)
Family Circle (founded 1932; acquired 2005)
Fitness (founded 1983; acquired 2005)
Ladies Home Journal (founded 1883; acquired 1986)
Midwest Living (founded 1987)
More (founded 1998)
Parents (founded 1926; acquired 2005)
ReadyMade (founded 2001)
Ser Padres (founded 2005)
Siempre Mujer (founded 2005)
Successful Farming (founded 1902)
Traditional Home (founded 1989)
Wood (founded 1984)
Current as of January 2010

Meredith's gamble was a success, resulting in ads from dozens of well-known products, such as Wrigley's Gum, Edison Phonograph, and Metz automobiles. Within a year, *Successful Farming* boasted 600,000 in circulation and close to $2 million in annual advertising revenues.

"It was the forward thinking marketing ideas of Meredith that paved the way for the future success of *Better Homes and Gardens* and the rest of Meredith's operations…and formed a link with the New York advertising community from which the company benefited for decades to come," said Steve George, a former Meredith editor.[23]

Meredith made the unusual innovation of standing behind the quality and integrity of his advertisers. In the first issue of *Successful Farming*, Meredith

announced that he would repay any loss to paid subscribers sustained by trusting any deliberate swindler advertising in the magazine and that any such swindler would be publicly exposed. A few issues later, he promised that if the purchaser of any item advertised in *Successful Farming* found it to be less than represented, his money would be returned by the publisher. He refused to accept ads for patent medicine that was the backbone of most advertising revenues in those days. With these and other publications, he made noteworthy contributions to the cause of "truth in advertising."[24]

In 1912, the 200-employee company moved into the building at 1716 Locust Street in Des Moines, which remains its corporate headquarters. Since then, however, seven additions have been made to the building, including a $40 million campus addition completed in 1998.

Like Macfadden and Hearst, E.T. Meredith entertained political aspirations. Meredith ran unsuccessfully as the Democratic candidate for Iowa senator in 1914 and governor in 1916. President Woodrow Wilson appointed him Secretary of Agriculture in January 1920 where he served until March 1921 when the Harding administration took office. Meredith returned to Des Moines in 1921 and decided to focus on building his publishing company.

In 1922 the company purchased one magazine, *Dairy Farmer,* and launched another, *Fruit, Garden and Home.* Meredith tried to make *Dairy Farmer* a national success for five years before merging it with *Successful Farming.* In 1922, he started a magazine he named *Fruit, Garden and Home,* which, unlike *The New Yorker,* was written for the ladies of Dubuque. He changed its name to *Better Homes and Gardens* in August 1924 when it had half a million subscribers.

To capitalize on the success of *Better Homes and Gardens,* Meredith extended its brand with the *Better Homes and Gardens Cook Book* in 1930. The cookbook became one of the best-selling hardback books in America, with more than 29 million copies sold by its twelfth edition in 2003. It started selling *Better Homes and Gardens* garden tools at 2,000 Wal-Mart stores in 1994. It also built a national real estate service in 1978, which it sold in 1998.

During the 1980s and 1990s the company began to strengthen its niche in the home and family sector. The company launched an advertising campaign in 1993, which asserted, "If it has to do with home and family, it has to be in Meredith." The campaign featured black-and-white pictures of real families having fun together. By then, Meredith had purchased *Ladies' Home Journal* in 1986, launched *Midwest Living* in 1987 and *Traditional Home* in 1989. It went on to purchase *Family Circle* and *Fitness* in 2005 and launch *More,* a magazine for women over forty, in 1998.

Although Meredith did not purchase *Parents* until 2005, it was founded in 1926 by George J. Hecht (1895–1980). He also founded *Children's Digest, Baby Care, Humpty Dumpty* and the toy store chain F.A.O. Schwarz. At the time of *Parents*

'founding, he commented, "There are magazines devoted exclusively to the raising of cattle, hogs, dogs, flowers, and what not, not until now none on the most important work of the world—the rearing of children." Clara Savage Littledale (1891–1956) edited the magazine from 1926 until her death in 1956. Littledale relied on medical and scientific studies on children's health and nutrition and translated the information into practical, readable articles. She was a very accessible editor who gave advice to readers on the phone. Once a mother called to report that her son had not eaten breakfast that morning to which Littledale replied, "Well, try him on lunch." Under her guidance *Parents* became a far-reaching influence and was widely quoted in periodicals, books, and television programs. At the time of her death *Parents* was the most widely read publication in its niche with a circulation of 1,675,000.[25]

The years between 1920 and 1929 marked a period of unprecedented growth for the American economy and for American magazines. Magazines of this era, *Time, The New Yorker, Reader's Digest,* and *Better Homes & Gardens,* still represent some of America's largest and most influential titles.

After the stock market crashed on October 29, 1929, the market saw its largest descent in American history. Anyone who bought stocks in September 1929 and held onto them saw most of his or her adult life pass by before they returned to their September 1929 value. Although the 1930s brought difficult years for magazine publishers, they were not as difficult as one might predict. If Americans were out of work, then a magazine subscription remained an affordable means of entertainment and diversion.

Notes

1. Norberto Angeletti and Alberto Oliva, *Magazines That Make History: Their Origins, Development and Influence* (Gainesville: University Press of Florida, 2004), 299.
2. "The Press: The Common Touch," *Time,* December 10, 1951.
3. Angeletti and Oliva, *Magazines That Make History,* 311.
4. Frank Luther Mott, *A History of American Magazines, Volume V: Sketches of 21 Magazines 1921–1930* (Cambridge: Harvard University Press, 1968), 294.
5. Noel F. Busch, *Briton Hadden, a Biography of the Co-Founder of* Time (New York: Farrar, Straus and Company, 1949), 79.
6. *Time,* March 3, 1923.
7. Joseph J. Firebaugh, "The Vocabulary of *Time* Magazine," *American Speech* 56 (1981): 51–63.
8. Teresa M. Reed, "The Voice of *Time:* The Style of Narration in a Newsmagazine," *Written Communication* 8, 2 (April 1991): 240–258.
9. Publisher's Letter, January 1, 1945. Cited in internal memo: Sy Robinson to Julia Fay,

December 26, 1957. Time Inc. Archives.

10. John Kobler, *Luce: His Time, Life and Fortune* (Garden City, NY: Doubleday, 1968), 152.

11. Robert T. Elson, *The World of Time Inc. The Intimate History of a Publishing Enterprise. Volume Two 1941–1960* (New York: Atheneum, 1973), 72.

12. Ralph G. Martin, *Henry and Clare: An Intimate Portrait of the Luces* (New York: G.P. Putnam's Sons, 1990).

13. "Time-Warner," *International Directory of Company Histories*, Vol. 5 (Chicago: St. James Press, 1990): 673–676.

14. Hedley Donovan, *Right Places, Right Times. Forty Years in Journalism Not Counting My Paper Route* (New York: Henry Holt, 1989), 202.

15. Ibid., 152.

16. Ben Yagoda, *About Town:* The New Yorker *and the World It Made* (New York: Charles Scribner, 2000), 38.

17. Ibid., 97.

18. Ibid., 95.

19. Ibid., 17.

20. Wolcott Gibbs, "Time, Fortune, Life, Luce," *The New Yorker*, November 28, 1936, 20–25.

21. Harold Ross to Henry Luce, Nov. 23, 1936. New York: Condé Nast Archives, Box 4, Folder 26.

22. Kathi Ann Brown, *Meredith: The First 100 Years* (Des Moines, IA: Meredith Corporation, 2002), 22.

23. Steve George, letter to the author, April 3, 2009.

24. "Edwin Thomas Meredith," *Dictionary of American Biography Base Set*. American Council of Learned Societies, 1928–1936. Reproduced in *Biography Resource Center* (Farmington Hills, MI: Gale, 2009), http://galenet.galegroup.com/servlet/BioRC.

25. "Clara Savage Littledale," *Dictionary of American Biography, Supplement 6: 1956–1960*. American Council of Learned Societies, 1980. Reproduced in *Biography Resource Center* (Farmington Hills, MI: Gale, 2009), http://galenet.galegroup.com/servlet/BioRC.

The 1930s

More Readers, But Fewer Advertisers

Banks failed, companies went out of business and soup kitchens lines lengthened during the 1930s. With a population of 123 million the country's unemployment began at 16 percent in 1930 and soared to 25 percent by 1932. By 1938, it still hovered at 19 percent and never dipped below 10 percent until 1941. Nevertheless, many of today's successful magazines got their starts during the Great Depression. The biggest three success stories of the 1930s were *Fortune* (1930), *Esquire* (1933) and *Life* (1936). A number of other successful magazines were launched that are still published today: *Advertising Age, Family Circle, Glamour, Newsweek, Catholic Digest, Consumer Reports, U.S. News & World Report, Woman's Day,* and *Yankee.* Table 1 lists the best-known new magazines launched during this decade.

The percentage of magazines that increased their circulations during this decade is more surprising. According to Audit Bureau of Circulation figures, twenty-three of twenty-six continuously published magazines between 1930 and 1940 gained in circulation. *Fortune* and *Parents* tripled their circulation. *Harper's Bazaar, Redbook, Time* and *Popular Science* more than doubled their circulation. The average circulation gain for the twenty-six leading consumer magazines was 32.8 percent as shown in Table 2. *Atlantic Monthly, Harper's,* and *Scientific American* were the only magazines to lose circulation.

Table 1

Major Magazine Launches of the 1930s

Year	Magazine	Year	Magazine
1930	Fortune	1936	Consumer Reports
	Advertising Age		Opera News
	Hollywood Reporter		Life
1931	American Cowboy		Western Horseman
1932	Family Circle	1937	Popular Photography
1933	Esquire		Chronicle of the Horse
	Newsweek		Woman's Day
	U.S. News & World Report		Equestrian
1934	Bride's Magazine		American Artist
	Model Railroader		Look
1935	Babytalk	1938	American Baby
	Yankee	1939	Muscle & Fitness
1936	Catholic Digest		Salt Water Sportsman
	Ski Magazine		Glamour

Circulation growth doesn't mean magazine publishers faced an easy time. First, they faced increased competition from radio. Radio advertising revenue grew from $19 million in 1929 to $33 million in 1933 and climbed steadily throughout the Great Depression. Second, even though circulation grew, they faced increased production costs with declining ad revenue. As a result of the double-threat from radio competition and the economy, advertising revenue definitely suffered and many magazines went out of business (see Table 3). Companies such as Hearst and Condé Nast teetered on the brink of bankruptcy. Rising circulation combined with declining ad revenue posed a particularly difficult dilemma for magazines. While consumers could still afford magazines, many companies could not afford to buy advertisements, at least often as in the past. Since ad revenue now provided up to 50 percent publishing costs, magazines were stuck in the middle with increasing printing and production costs combined with declining advertising revenues.

For the Curtis magazines (*Saturday Evening Post* and *Ladies' Home Journal*), the dollar volume for advertising declined by 50 percent between 1929 and 1933. At the depth of the Great Depression, total debt for the Hearst Corporation was estimated at $147 million. A Hearst company history reports, "The Hearst organization was experiencing severe financial problems in the 1930s and by 1937 was almost bankrupt. Richard Berlin [vice president] was instrumental in saving Hearst's empire, negotiating with paper suppliers and banks for better terms. Hearst was forced to relinquish financial control of the company to an oversight committee, which sold or killed off unprofitable newspaper and magazines and liquated as many of Hearst's other assets as it could to pay off enormous debts."[1]

Table 2

Circulation of 26 Leading Magazines 1930 to 1940			
Magazine	1930 circulation	1940 circulation	Percent change
Atlantic Monthly	135,547	103,209	-23.9%
Better Homes & Gardens	1,377,079	2,063,652	49.9%
Business Week	72,846	112,418	54.3%
Cosmopolitan	1,726,623	1,764,974	2.2%
Field & Stream	137,799	256,886	86.4%
Forbes	75,074	80,941	7.8%
Fortune	31,758	135,362	326.2%
Good Housekeeping	1,709,775	2,342,768	37.0%
Harper's	136,195	112,113	-17.7%
Harper's Bazaar	97,075	210,337	116.7%
House Beautiful	105,374	207,763	97.2%
House & Garden	122,824	172,448	40.4%
Ladies Home Journal	2,481,620	3,385,948	36.4%
McCall's	2,467,248	3,108,151	26.0%
National Geographic	1,226,841	1,135,458	-7.4%
New Yorker (The)	97,165	148,335	52.7%
Parents	113,813	517,250	354.5%
Popular Mechanics	443,438	631,681	42.5%
Popular Science	288,394	623,854	116.3%
Redbook	561,187	1,254,454	123.5%
Saturday Evening Post	2,743,199	3,210,940	17.1%
Scientific American (The)	61,713	45,592	-26.1%
Time	282,230	751,121	166.1%
True Romances	505,793	696,078	37.6%
True Story	1,993,688	2,069,273	3.8%
Vogue	133,072	208,933	57.0%
Woman's Home Companion	2,501,606	3,370,193	34.7%
TOTAL	21,628,976	28,720,132	32.8%

Source: Audit Bureau of Circulations Archives, Schaumburg, Illinois.

By 1927, Condé Nast Publications had recorded its highest profits in its history and went public through a deal with Goldman and Sachs. Within months, the value of the stock doubled. By 1929, Condé Nast's estimated $16 million personal fortune was heavily invested in the stock market. He lost control of his company and his fortune in the crash of October 29 and never completely recovered. Goldman and

Sachs now held a controlling majority of the shares.[2] At one point, Condé Nast offered to sell his magazines to Henry Luce, an offer that Luce declined, saying "We didn't want to go into the fashion business. That wasn't our métier."[3]

Table 3

Depression-Era Magazines That Closed	
Magazine	Lifespan
Everybody's Magazine	(1899–1929)
Munsey's	(1889–1929)
McClure's	(1881–1929)
Century Illustrated Monthly	(1881–1930)
Smart Set	(1890–1930)
World's Work	(1900–1932)
Outlook	(1867–1932)
The Delineator	(1873–1937)
Literary Digest	(1890–1938)
Scribner's Magazine	(1887–1939)
Pictorial Review	(1899–1939)

In 1934 Nast convinced Lord Camrose, a wealthy English publisher and businessman, to purchase a controlling stake in the company. That move gave Condé Nast editorial, but not financial control, over his magazines again. He never regained financial control again, and at the time of his death, Nast's assets exceeded his debts by only a few thousand dollars.

Time Inc. and its magazines, *Time, Fortune,* and later *Life* grew during the Great Depression. The company's annual report for 1931 stated: "The progress of the year just passed cannot be summarized adequately by the simple statement that a new record consolidated net profit of $847,447 has resulted....Rather it is to be found in the fact that the appeal both of *Time* and of *Fortune* to their readers has increased to a marked degree during the year."[4] *Time* doubled its circulation between 1930 and 1940, while *Fortune* more than tripled its circulation. Part of their success lies in their emphasis on news and factual reporting during an era when factual information about the economy was in great demand. Magazines that suffered the most were those like Condé Nast's, which emphasized fashion and lifestyles of the affluent, and the general-interest magazines focusing on non-essential topics.

Even during this worst of times, reading offered Americans an affordable use of leisure time. If middle-class consumers couldn't afford vacations, golf or boats, most could afford a magazine. The "expansion of interests" theory (chapter one) also helps explain the growth. With the invention of "talkies," movies began to escalate in popularity. In 1927, Warner Brothers released *The Jazz Singer* starring Al Jolson, its first talking picture. In 1928, Walt Disney pioneered sound in an animated short film, *Steamboat Willie*, which helped turn Mickey Mouse into a national celebrity. Sound films were an immediate success and launched the careers of such movie icons as Clark Gable, Katharine Hepburn, Bette Davis, Fred Astaire, Ginger Rogers, Joan Crawford and Humphrey Bogart. At least sixteen movie-fan magazines were launched during this decade including: *Film Fun, Hollywood, La Film, Motion Pictures, Motion Picture Classic, Motion Picture Magazine, Movie Life, Movie Mirror, Modern Screen, Movie Story Magazine, Movies Magazine, Screen Book, Screen Play, Screenland, Screen Romances,* and *Silver Screen.*

But the growth of the motion pictures expanded the range of interests of the American people and magazines beyond these movie-fan magazines. In a 1940 speech, Condé Nast spoke about the impact of motion pictures during the 1930s:

> Now, within the past score of years, there has arisen an instrument that has generated an interest-arousing power, a publicity power, paralleling that of the newspapers. I mean the moving picture industry. Each week, in the United States, 85,000,000 entrances are bought to the moving pictures. Any power big enough to develop a concentration and universality of interest that will bring 85,000,000 people together weekly, evidently is an extraordinary power.[5]

Nast made this speech just a year after he launched *Glamour*, which he originally titled *Hollywood Glamour*. His purpose for Glamour was to create a fashion magazine that would show middle-class women how to dress more fashionably—like the Hollywood movie stars.

Fortune

With *Time* magazine's great success, Henry Luce was looking for a new challenge. As early as February 1929, he perceived the need of business leaders for factual news reporting about business. He presented a prospectus to the company's board of directors, describing the opportunity for such a magazine: "Business, the smartest, most universal of all American occupations, has no medium of expression except the financial pages of newspapers and the cheapest, least distinguished of magazines....We conceive that the failure of business magazines to realize the dignity and the beauty, the smartness and excitement of modern industry, leaves a

unique publishing opportunity." Luce's blueprint for *Fortune*, a title he had already chosen, concluded with these four points:

1. It will be as beautiful a magazine as exists in the United States. If possible, the undisputed most beautiful.
2. It will be authoritative to the last letter.
3. It will be brilliantly written. It will have *Time's* bursting-with-fact, economical objective merits, but the language will be smoother, more sophisticated.
4. It will attempt, subtly to "take a position," particularly as regards what may be called the ethics of business.

The first issue of *Fortune* hit the stands in February of 1930, four months after the dramatic crash of 1929. Single copies cost $1 at a time when the Sunday *New York Times* and many magazines cost five cents. *Fortune* was an oversized glossy magazine that used heavy paper stock and color photographs. The magazine became distinguished for its art and photography, especially in its early years.

Fortune developed a reputation for its social conscience with a team of notable writers. Luce wanted writers who went beyond the facts and figures of business and probed into the shadows of factories and personalities of men who ruled them. Notable writers that he recruited included James Agee (1909–1955), Archibald MacLeish (1892–1992), John Kenneth Galbraith (1908–2006), and Dwight MacDonald (1906–1982). Luce allowed MacLeish to work long enough each year to earn his expenses, then to leave to work on his poems and plays. He later earned Pulitzer Prizes for poetry and drama. Agee's epic chronicle of Great Depression sharecroppers, *Let Us Now Praise Famous Men*, began as a *Fortune* article.[6]

Luce discovered a young Margaret Bourke-White (1904–1971) as *Fortune's* first photographer and she went on to become one of the 20th century's most celebrated photojournalists. When assigned to document Depression-era America, she pioneered the photographic essay as a medium to examine social issues and human problems.

Fortune's circulation soared from 31,758 in 1931 to 113,963 by 1935 and 135,362 by the end of the decade—a remarkable 326 percent increase during the Great Depression. In 1955, the magazine pioneered its famous list of America's top companies, the "Fortune 500," which ranked companies according to annual revenue. Later it developed the "Fortune Global 500," "Fortune 100 Best Companies To Work For," and "Fortune America's Most Admired Companies."

Part of the reason for *Fortune's* success during the Depression could, in fact, be attributed to the economic dysfunction of the 1930s. The failure of so many American businesses created a void of information for those whose businesses

managed to survive. Business leaders needed facts about what was working, what wasn't working, who was succeeding and who was failing. Although never intended for the "man in the street," *Fortune* quickly found its niche among American business leaders and entrepreneurs and maintained that leadership role for decades to come.

The supermarket magazines: *Woman's Day* and *Family Circle*

Supermarkets have always given magazine publishers one of their best outlets for single copy sales. Two of today's best-known women magazines, *Woman's Day* and *Family Circle*, were first launched by grocery store chains in the 1930s and given away free to their store customers.

Before it was called "Woman's Day," the magazine originated in 1931 as a free A&P Grocery Store leaflet with menus and recipe planners designed to encourage customers to buy more food products. It was so successful that the company made plans to launch a full-scale magazine, which would also be free. It launched the first issue of *Woman's Day* in 1937, which included six pages of recipes and some feature articles. One article was titled "What To Do About Worry" and another asked "Is Football Worthwhile?" Its editorial mission appeared in the opening pages:

> Running a home and caring for a family successfully is one of the hardest jobs in the world. You have to be a combination politician, nurse, cook, maid-of-all-work, interior decorator, mind-reader, teacher, dressmaker, shopper and bookkeeper. You never have enough money to do all the things you want to do—and the job gets pretty tiresome at times. Maybe we can get together and help make this job easier.[7]

Immediate demand for the magazine was so strong that A&P realized that it could no longer afford to give it away. So the cover price was set at five cents, which remained in effect until 1952 when it was increased to seven cents. *Woman's Day* had a circulation of three million by 1944 and reached four million by 1958 when A&P sold the magazine to Fawcett Publications. After that the magazine went through several owners before it was purchased by Hachette Filipacchi, a French-owned company, in 1988.

Family Circle began in 1932 as a weekly tabloid sold in bulk to 1,275 supermarkets and distributed free to their customers. It was founded by Harry Evans, an out-of-work magazine editor, who had financial backing from Charles Merrill of Merrill, Lynch and Company. Evans envisioned a magazine for women that contained cooking and household tips, but whose main purpose was to help supermar-

kets sell more products. The formula worked, and the magazine grew steadily throughout the Great Depression. In September 1946, it became a monthly magazine with a five-cent cover price. In 1958, the publisher purchased a competing supermarket magazine, *Everywoman*, and changed its title to *Everywoman's Family Circle* until 1963 when it resumed its original title of *Family Circle*. After the merger, the magazine had a circulation of five million and access to 12,657 grocery stores in the U.S. and Canada.[8] Today the magazine is owned by the Meredith Corporation. Its four million subscribers give *Family Circle* the highest circulation of any of the major women's magazines and a seventh-place rank among all magazines.

Esquire

Esquire grew out of the trade magazine *Apparel Arts* and three advertising booklets, the *Observer, Club and Campus* and *Gentleman's Quarterly*, that were sold or given away in men's clothing stores. The booklets and trade magazine were published by the owners of a Chicago advertising agency, David Smart (1892–1952) and William Weintraub. Their idea for *Esquire* was to create an upscale magazine geared toward men's leisure and lifestyle interests and also sold in clothing stores. One of their young copywriters was Arnold Gingrich (1903–1976), who edited *Apparel Arts*, and whom they chose as *Esquire's* founding editor.

The three men worked for a year to create a colorful prototype for a new magazine that would combine fashion and humor with high-quality fiction and nonfiction from some of America's best writers. In a promotional booklet for prospective advertisers, they described the magazine this way:

> What more opportune occasion for…a new kind of magazine that will answer the question of what to do? What to eat, what to drink, what to wear, how to play, what to read …? That magazine is *Esquire*. It is, as the name implies, a magazine for men. To analyze its name more closely, Esquire means in the encyclopaedia and dictionary sense, that class just below knighthood—the cream of that great middle class between the nobility and the peasantry.[9]

In his memoir, *Nothing But People: The Early Days at Esquire*, Gingrich said they feared that the magazine they envisioned would be too expensive for most men:

> To our horror, by the time we had something that we all agreed was substantial enough …we saw that we had on our hands a magazine that must sell for fifty cents. This seemed prohibitively high at a time when magazines that were selling for a nickel, like *Saturday Evening Post, Collier's* and *Liberty*, were offering a really big editorial money's worth.

Nevertheless, even at that price, *Esquire* was a huge success as soon as it hit the streets on October 15, 1933. Of the 100,000 printed copies, they planned to sell 5,000 copies on newsstands and the remaining 95,000 in men's stores. After the newsstand copies sold out within a few hours, they scrambled to recall 95,000 from menswear stores so they could be re-shipped to newsstands. Although they planned for a quarterly magazine, the advertiser and customer demand for more *Esquire* was so strong that they assembled another issue in forty-five days and began publishing monthly issues after that.

Circulation soared under Gingrich and reached 550,000 by 1936 and 675,000 by 1937. An internal memo from Condé Nast cites the competition from *Esquire* as one reason for *Vanity Fair*'s declining ad revenue and eventual closing in 1936.

Gingrich was a friend of Ernest Hemingway and convinced him to write an article, "Hemingway on Fishing," for that first issue. Hemingway's byline and articles he wrote for the next three years were no doubt part of its success. His famous work, *The Snows of Kilimanjaro*, made its first appearance on the pages of *Esquire*. Gingrich's friendship with Hemingway also opened doors to recruiting more of Hemingway's writer-friends. "I found that the ability to say 'Ernest sent me' had the effect of 'Open Sesame,'" Gingrich said. Names of the famous writers who published in *Esquire* during the Gingrich years are too numerous to mention here, but included F. Scott Fitzgerald, H.L. Mencken, John Steinbeck, Ezra Pound, Flannery O'Connor, James Baldwin, William Styron, John Updike, William Faulkner, Dorothy Parker, Tennessee Williams and Robert Penn Warren.

Gingrich never avoided controversies. In 1936, he published the article, "Latins Are Lousy Lovers," which caused such an uproar in Cuba that its government banned and confiscated copies of the magazine. In the 1940s, *Esquire* took a turn toward appealing to more prurient male interests with "girlie" art by George Petty and Alberto Vargas, featuring their work in foldouts as "the Esquire girl." The U.S. Postmaster General, Frank Walker, canceled the magazine's second-class mailing privileges because he determined that the photos of the beautiful young women were obscene, lewd, and lascivious. *Esquire* challenged the ruling in a case that went to the Supreme Court three years later. In a 1946 ruling, Justice William O. Douglas stated that supporting the postmaster general would give the Post Office "a power of censorship abhorrent to our traditions."[10]

After a dispute with David Smart over a new publishing venture, Gingrich left *Esquire* in 1947. He returned as editor in 1952 and remained until 1958.

One of the promotional writers for *Esquire* in the late 1940s was Hugh Hefner, who stayed behind after the magazine moved to New York in 1950. Hefner took the lessons he learned at *Esquire* and went on in 1954 to create one of the most successful and controversial magazines of the century—*Playboy*.

Thomas Martyn and *Newsweek*

Newsweek was launched in 1932 by Thomas J.C. Martyn, who had started his journalism career as one of *Time*'s original staff members nine years earlier. An Oxford University graduate, Martyn was a Royal Air Force veteran who had lost a leg in World War I. Luce hired Martyn as foreign news editor without ever meeting or interviewing him on the recommendation from a mutual friend.[11] Martyn was on vacation from Oxford in Rome, visiting his friend, J. Franklin Carter, when a cable reached Carter inviting him to join *Time*'s original staff in New York. Carter had just accepted another job so he recommended his friend Martyn. Hadden and Luce cabled back to tell Martyn to come to New York immediately. Martyn was offered the job for $60 a week, making him the magazine's highest-paid staff member.

Martyn resigned in 1925 after a dispute with Luce over moving expenses when the magazine moved to Cleveland for a couple of years. Martyn went to work for *The New York Times*, which he quit after a few years to draw up a prospectus, recruit investors, and establish a competing newsmagazine.

Martyn's prospectus argued that some people believed "*Time* is too inaccurate, too superficial, too flippant and imitative" and promised a magazine "written in simple, unaffected English [in] a more significant format [with] a fundamentally sober attitude on all matters involving taste and ethics."[12]

He raised $2.25 million in startup capital from 120 individual investors. With a staff of twenty-two, he launched the magazine he called "News-Week" and guaranteed advertisers a minimum circulation of 50,000. When the first issue of *News-Week* was published on February 17, 1933, Martyn sent a copy to Henry Luce saying, "You will take some degree of satisfaction from the knowledge that a former *Time* man is competing with you...on the friendliest basis." Luce responded with a polite note offering "best wishes for a long and useful life" for the magazine.

The magazine lost money during its first four years. Martyn underestimated the money needed to start the magazine and ploughed through more than $2 million in four years before filing for bankruptcy. During the merger and reorganization in 1937, he sold his interests when *News-Week* was merged with *Today*, another unprofitable magazine. *Today*, with financial backing from Vincent Astor and Averill Harriman, had been launched in 1933 to popularize the New Deal under editor Raymond Moley, a former senior adviser to President Roosevelt. Astor, who became president of the new company, came from the wealthy American family of John Jacob Astor whose fortune was rooted in the fur trade and real estate holdings.

Malcolm Muir (1885–1979) became editor-in-chief of the new magazine and brought experience in publishing and sales acquired during his years as president

of McGraw-Hill. The editors adopted the slogan "the magazine of news significance," and a new era was launched. Muir changed the title to eliminate the hyphen and on October 4, 1937, *Newsweek* hit the newsstands with its redesigned title and features.

The early *Newsweek* had some successes. It appealed to readers who didn't like *Time*, which had already established a reputation for its opinionated slant on the news and sometimes irritating "*Time*style." David Halberstam (1934–2007) described *Newsweek* this way: "It had none of the brilliance or zest of *Time*, and none of the excesses of Luce. Its staff was considered better than the magazine, and many of the people there were dropouts from the Luce empire. It was a weak alternative for those who found *Time* simply too prejudiced; Newsweek was prejudiced too, but in a blander way."[13] Nevertheless, *Newsweek* grew and shared in the big circulation gains of all magazines in the fifties. Its circulation rose about 80 percent between 1950 and 1962 when its circulation was 1.5 million.

Newsweek found a new owner in 1961 when *The Washington Post* bought the magazine for about $9 million. The Astor Foundation, owners of *Newsweek,* had been looking for a buyer since the 1959 death of philanthropist Vincent Astor. Phil Graham, the *Post's* publisher, managed the magazine for only two years before he committed suicide in 1963. For many years, Phil Graham (1915–1963) had been a troubled man suffering from a manic-depressive illness.[14] The Washington Post Company was owned by his wife Katherine Graham's father, Eugene Meyer. When Phil Graham died, Katherine Graham (1917–2001) took over as publisher and owner. She infused the magazine with the talent and money it needed to compete with *Time.* The editorial budget, which was $3.4 million in 1960, increased to more than $10 million by the time the decade ended. Hundreds of thousands more was spent to improve its graphic design and production capabilities. Osborn Elliott (1924–2008), who was editor from 1961 to 1976, wrote, "We…set out after Henry Luce's *Time*; we figured it was vulnerable because of its set ways, its predictable politics, its snideness, and its cuteness of language."[15] By the late 1960s, it surpassed *Time* in revenue for a few years by appealing to a younger, liberal generation with ingenious slogans such as "the newsweekly that separates fact from fiction" and "the most quoted newsweekly."

David Lawrence and *U.S. News and World Report* (1933)

David Lawrence (1888–1974) launched *The United States Daily* as a daily newspaper in 1926. He re-launched it as a weekly, *The United States News*, on May 17, 1933, which was the forerunner of *U.S. News & World Report.* "The times were bad. A few

weeks before, all the banks had been closed and the gloom of the worst depression in American history surrounded us," Lawrence wrote.[16] The weekly newspaper grew to a circulation of 85,000 before Lawrence changed it to a magazine format on January 1, 1940. In May 1946, he founded *World Report* magazine to focus on international affairs and analysis. The magazine reached a circulation of 125,000 within a few weeks. Within eighteen months, however, he saw the advantages of combining the two weeklies.

The first issue of a magazine titled "*U.S. News & World Report*" was on March 19, 1948, which resulted from a merger between Lawrence's weekly newspaper *United States News* and his weekly magazine *World Report*. "By 1948, national and international affairs had become so interwoven…that we combined the two magazines into one called *U.S. News & World Report*," he wrote. "By that time, our publishing enterprise had met practically all of its financial problems, and we were out of the red and were making a good profit."[17] At the time of the merger, *World Report* reached a circulation of 125,000 and *United States News* reached 300,000 subscribers.

Lawrence claimed several innovations for the magazine. First was "spot analysis," which he described as "an attempt to relate the news to the life of the individual—to put into perspective what has happened and to project forward the consequences of the day-to-day headlines as indicating short-range or long-range trends."

Second was what Lawrence called the "pictogram." His friend and *New York Times* reporter Arthur Krock wrote in a *Reader's Digest* article, "Excellent charts, graphs and maps became a *U.S. News & World Report* trademark."

Third, lengthy "Q and A" interviews were a *U.S. News & World Report* innovation. Krock wrote, "One of his [Lawrence's] most successful ideas was the broad-ranging question-and-answer interview, each taped and edited from a lengthy round-table discussion conducted with *U.S. News* staff with a prominent figure. Information elicited from these interviews has often made front-page news."[18]

David Lawrence grew up in Buffalo, New York. Soon after enrolling at Princeton in 1906, he became the correspondent for seventeen newspapers in New York and Philadelphia and eventually for the Associated Press. While Lawrence was a student, Woodrow Wilson was president of Princeton and occasionally lectured in government and international affairs classes that Lawrence attended. Lawrence later said that Wilson influenced his views of life and politics and international affairs more than any other single individual. Lawrence subsequently covered the Wilson White House, where he enjoyed an access unequalled by other reporters.

Although David Lawrence became widely known as a conservative, he began his career as a Democrat and remained a registered Democrat until his death. He declined a job offer of $10,000 a year on the *New York Tribune* in 1916 because it

was a Republican newspaper where he did not feel he would fit in. "My articles would be at awkward variance with the editorial policy…," he told the publisher.[19]

Among all the presidents, Lawrence seemed to have been closest to Dwight Eisenhower and his papers contain some two dozen letters from the former Republican leader. Toward the end of his administration, Eisenhower wrote to Lawrence saying, "I cannot fail to send you this note to say you have an appreciative and admiring audience in the White House. I must add that this is a consistent sentiment, whatever the subject of your daily column."[20]

Lawrence turned over ownership of the magazine to its employees on June 30, 1962. He became chairman of the board and profit-sharing trust and continued as editor. A statement in the July 9 issue said, "All employees…with at least one year of service with the company—at present numbering 285 out of 435 employees—are members of the profit-sharing trust which now becomes the largest single holder of the company stock."[21]

He died on February 11, 1973, of a heart attack while vacationing in Florida. At the time of his death, *U.S. News* had a circulation of 1,940,000.

Sunset and *Yankee*

America currently has four major regional lifestyle magazines serving the West (*Sunset*), the South (*Southern Living*), the Midwest (*Midwest Living*) and the Northeast (*Yankee*). *Sunset* was established as a promotional magazine for the Southern Pacific Railroad in 1898. *Yankee,* serving New England readers, was established in 1935 followed by *Southern Living* in 1965 and *Midwest Living* in 1986.

The Sunset Route between New Orleans and San Francisco was the Southern Pacific Railroad's premiere route. The company created the magazine for customers to encourage more travel and tourism in the West, which still had a rough "wild West" image among most Easterners. In 1929, Lawrence W. Lane, a former *Better Homes and Gardens* advertising executive purchased the magazine and it remained in Lane family ownership until Time Inc. purchased it in 1990.

Yankee Magazine was founded in 1935 by Robb Sagendorph (1900–1970) with 613 charter subscribers, of which 600 turned out to be bogus names provided by a slippery subscription service. Based in Dublin, New Hampshire, it has remained in the Sagendorph family ownership through Yankee Publishing, Inc., one of the country's few remaining family-owned magazine publishers. The company also publishes *Old Farmer's Almanac,* which was first published in 1792 and remains the oldest continuously published periodical in the country. The company's mission statement says it keeps Robb Sagendorph's dream alive by publishing a magazine

that "expresses our great New England culture" and reflects the New England way of life today.[22]

Life

Life is the most famous magazine of the 20th century that is no longer published and also the one with the most deaths and resurrections. With the exception of *The New Yorker*, more books have been written about *Life* than any other magazine. Launched as a weekly magazine of photojournalism in 1936, it became one of the most read and widely celebrated magazines in the 1940s, 1950s, and 1960s. Faced with competition from television and declining ad revenue, Time Inc. closed it down the first time in 1969. Then the company revived it as a monthly feature magazine from 1972 until its second closing in 2000. Then it revived *Life* again as a weekend newspaper-supplement in October 2004. Competing against *Parade* and *USA Weekend*, it was distributed in more than 60 newspapers at its peak. Time Inc. closed the magazine for the third time in April 2007. It has, however, retained the Life.com website, where it provides daily news updates and millions of free photographs and cover images from *Life*'s archives. The company also continues to publish books of photography and photo collections using the *Life* brand.

Twenty years before television began its rise, *Life*'s phenomenal success came as a result of its pioneering achievements in photojournalism and ability to deliver pictures of world events to its readers. Although *National Geographic* was also a pioneering magazine of photography, *Life*'s emphasis on people and current events gave it a distinct niche.

"To see life, to see the world; to eyewitness great events; to watch the faces of the poor and the gestures of the proud," read *Life* magazine's purpose statement in founder Henry Luce's 1935 prospectus. It continued:

> To see strange things—machines, armies, multitudes, shadows in the jungle and on the moon; to see man's work—his paintings, towers and discoveries; to see things thousands of miles away, things hidden behind walls and within rooms, things dangerous to come to; the women that men love and many children; to see and to take pleasure in seeing; to see and be amazed; to see and be instructed....To see, and to show, is the mission now undertaken by a new kind of publication, THE SHOW-BOOK OF THE WORLD....

The first cover of *Life* magazine, dated November 23, 1936, displayed a Margaret Bourke-White photo of the Ft. Peck Dam in Montana built by the WPA. The first inside photo displayed a surgical-masked doctor in a crowded delivery room. With the caption "*Life* begins," the full-page photo presented a baby boy in the doctor's

gloved hand.[23] That baby was George Story who became a journalist and then a city manager before retiring to Hawaii. On April 4, 2000, only days after it was announced that *Life* would fold for the second time, George Story died at age sixty-three. "George was always so positive and he really enjoyed his fame as *Life's* baby," his widow said in the May 2000 issue of *Life*—its last as a monthly magazine.[24] From its first issue, sales far exceeded even Luce's expectations. His prospectus predicted that it would take two or three years to reach a "break-even circulation" of 500,000. Nevertheless, all 250,000 copies of the first issue sold out the first day. A dealer in Cleveland, who received 300 copies, telegraphed the publisher's circulation office: "*Life* sold out first hour. Could sell 5,000 more."[25] From Los Angeles came the word, "First issue of *Life* caused heaviest demand…of any publication ever known. Clean sellout. We lost thousands of sales and still a heavy demand." By the end of 1937, *Life's* circulation reached 1.5 million.

The idea for *Life* magazine is most often credited to Clare Boothe Luce (1903–1987). In 1931 when she was working for Condé Nast (before she married Luce), she wrote Nast a memo suggesting that he buy up the faltering *Life* (a previous magazine with a different owner, but the same name) and make it into a picture news magazine. Nast seriously considered the idea for several months and had his designers make up a dummy of such a magazine. But Nast was preoccupied with financial worries and never implemented the idea. But she never abandoned the idea and brought it to Luce's attention after they married in 1935.[26]

Clare Boothe Luce was *Vanity Fair's* managing editor from 1930 to 1933. In 1934 after leaving the magazine, she met Henry Luce, publisher of *Time* and *Fortune*. Although married, he soon divorced his wife and married Clare on November 23, 1935. After *Life* became a spectacular success in the late 1930s, Henry Luce was sued for plagiarism and $5 million by the Bruehl brothers, who had created another prospectus for a picture magazine similar to *Life*, which they had sent to Luce in 1932. Their lawsuit fell apart, Clare Boothe Luce later wrote, "when I produced my file, with the original prospectus for *Life*, which had been made some time before they made theirs."[27]

The first 522 issues of *Life* between 1936 and 1946 weighed 455 pounds—or almost a pound per issue. In December of 1946, Fred Griffith of Phoenix, Arizona, wrote in a letter to the editor that he had saved every copy of *Life* since its first issue, with his collection weighing 455 pounds. He went on to offer this breakdown by year:

1936–37: 50 lb.
1938: 46 lb.
1939: 40 lb.
1940: 48 lb.

1941: 51 lb.
1942: 54 lb.
1943: 48 lb.
1944: 42 lb.
1945: 41 lb.
1946: 45 lb. (minus six issues)

The only reason the weight declined between 1943 and 1945 was wartime paper restrictions. Circulation increased from 2.8 million copies in 1940 to 5.2 million by the end of the 1940s. As early as 1950, *Life* could boast that it reached one in five Americans and by 1961, that figure increased to two in five, according to the A.C. Nielsen Company.[28] Thirty-eight staff photographers of *Life* were shown in a 1960 photograph in *The World of Time Inc.* that included its original four full-time photographers in 1936: Peter Stackpole (1914–1997), Alfred Eisenstaedt (1898–1995), Margaret Bourke-White (1904–1971) and Thomas McAvoy (d 1966).

Life reached a circulation high in 1969—eight and a half million—when it took on one million *Saturday Evening Post* subscribers after the *Post* closed in February of that year. But it could never attract sufficient advertising revenues to offset the cheap subscription rates it had to offer to sustain that many readers. *Life's* revenue losses in the 1960s and early 1970s brought it to a staggering halt with its last weekly issue on December 29, 1972. In that issue, Vice Chairman Roy Larsen wrote, "As a magazine we tried to talk to you across all barriers and special interests. We didn't want to reach you as skiers, or teen-agers or car-owners, or TV-watchers, or single women, or suburbanites, or inhabitants of New York City, or blacks, or whites Instead, we wanted to talk to you as people, who share the common experience of humanity. I still believe that such talk is important to our country. I am sorry with all my heart that *Life* can no longer make that contribution."[29]

Re-launched as a monthly by Time Inc. in 1978, *Life* endured another twenty-two years, but never came close to the eight and a half million subscribers it enjoyed at its height. In 1980, it reported an average paid circulation of 1,364,800 to the Audit Bureau of Circulations. By 1994, it had reached a circulation of 1,614,700, which declined steadily until its last monthly issue.[30]

Condé Nast was a friend and admirer of Luce. In an internal company memo he attributed the success of *Time, Fortune and Life* magazines to the news value they brought to their readers.

Henry Luce has built up the soundest and most successful publishing business in the United States….Why has Luce been able to build up these properties in such a short time? The answer is that he has brought a keener sense of *News Values* to the publish-

ing of magazines than any other American publisher. Prior to the advent of Mr. Luce, news subjects were thought to be exclusively within the province of the daily newspaper. Luce thought differently and has ridden his publications into an extraordinary success by putting back of them the power that is found in the interest of human beings in the news of events and of their fellow human beings.[31]

Literary Digest and the 1936 election

The *Literary Digest*, the venerable magazine founded in 1890, was one of the country's most successful magazines during the first three decades of the century. Its circulation had increased from 63,000 in 1900 to 900,000 by 1919. Its editorial formula included articles about news events of the previous week compiled from various newspaper reports, documents and commentary. It created a reputation for impartiality by balancing each controversial topic with sources from opposing and independent viewpoints. In 1920, the *Literary Digest* was second only to the *Saturday Evening Post* with gross advertising revenue of over $12 million. According to Frank Luther Mott, its coverage of World War I "probably did more to establish it in a high place among American periodicals than anything else."

The magazine's greatest embarrassment, however, occurred in 1936 when its post card poll of readers incorrectly predicted that Alf Landon would defeat Franklin D. Roosevelt. Its polls had correctly predicted the outcomes of the 1916, 1920, 1924, 1928, and 1932 presidential elections. These polls were a lucrative source of publicity for the magazine. In each case, the winner was accurately identified and the Electoral College vote was almost exact—some papers suggested calling off the elections and using the *Digest* instead.[32] In *Literary Digest's* October 31 issue, based on more than 2,000,000 returned post cards, it predicted that Republican presidential candidate Alfred Landon would win 57 percent of the popular vote and 370 electoral votes. The flaw in its polling technique, which permanently changed polling techniques, was that it was not a randomly chosen poll of voters. The magazine's readers, who were generally affluent, did not include the masses of unemployed Americans.

The *Digest's* eventual failure in 1938 is often tied to this mistaken prediction. But the magazine had been declining in popularity and readership for several years. It reached its peak circulation in 1925 with 1.5 million readers, which declined to 1.4 million by 1930, 774,000 by 1935 and less than half of that by the time it closed. In February 1938, the *Digest* suspended publication. Time Inc. purchased the unfulfilled subscriptions of *Literary Digest* and gave its readers the choice of *Time* or *Life* subscriptions.

Consumer Reports

Consumer Reports remains as one of the few successful magazines of the 20th century that has never accepted advertising. Since its first issue in May 1936, its purpose has been to evaluate and recommend products and services to its readers based on independent testing by its own staff. As such, the publishers always believed that accepting any advertising would represent a conflict of interest and violate its editorial integrity. It has maintained that standard for more than seventy years while relying upon subscription revenue and donations from readers and foundations.

The magazine itself was preceded by the formation in 1933 of Consumers Research, a nonprofit research laboratory. After a strike by its employees, they organized Consumers Union, which Amherst College economics professor Colston Warne described in a 1936 speech, "Protecting Consumers' Rights," in which he said: "There is in New York City now a consumers' laboratory which tests products, and rates them as to their quality. It is owned and controlled by organized consumers. This laboratory is called the Consumers' Union." Warne was one the founders of Consumers Union and chaired its board from 1936 to 1979.

In May 1936, the first issue of *Consumers Union Reports* came out. It included articles that rated the quality of "Grade A" and "Grade B" milk, breakfast cereals, soap, and stockings. An article on credit unions explained their superiority to banks, while an article on Alka-Seltzer concluded that its claims "vanish like the gas bubbles in the air." The magazine changed its name three times before it settled on *Consumer Reports* in 1948.[33]

In 1940, Consumers Union Reports started asking its readers about their experiences with various products on its annual questionnaires, which has since become a tradition. In 1941, the organization built a soundproof room to test radios. In 1954 *Consumer Reports* presented the results of its tests on Westinghouse color television which had a retail price of $1,295. That year it was also the first known magazine to publish a series of reports on the tar and nicotine content of cigarette smoke and health hazards of smoking. At the time, most magazines published large numbers of cigarette advertisements, many of which depicted celebrities extolling the pleasures and even health benefits of smoking.

In 1974, *Consumer Reports* published a three-part series describing the widespread pollution of community water systems, with recommendations for cleaning them up and setting up citizen-action programs around the country. The series won the magazine's first National Magazine Award along with other awards. By 1992 the magazine had reached five million paid subscribers—the largest of any magazine that doesn't accept advertising.

Alice Thompson and *Glamour*

Glamour, which was launched under the title *Glamour of Hollywood* in 1939, was the last magazine that Condé Nast had a personal involvement in creating. Nast originated the concept in 1932 as *Hollywood Patterns*. Pattern magazines, in general, thrived during the 1930s when women could not afford ready-made manufactured clothing. Nast proposed a pattern magazine that gave women a cheaper line of patterns modeled on the clothing of Hollywood movie stars. *Hollywood Patterns* was so successful that Condé Nast turned it into the magazine *Glamour of Hollywood*, with Alice Thompson as its first editor in chief. The title was later shortened to *Glamour*.

When Nast announced the new magazine in February, he said, "Entertainment is Hollywood's business, but its byproduct and most powerful magnet is glamour.... Hollywood fashion designers and make-up artists have perfected the science of giving screen actresses their maximum of appeal. Recognizing Hollywood's importance as a disseminator of fashion, beauty and charm, *Glamour* has been created to interpret that fashion, beauty and charm in terms of the average woman's daily needs."

The magazine was an immediate success. By the eleventh issue, *Glamour* had achieved newsstand sales of 200,000 copies and 250,000 copies by April 1941—a remarkable achievement. Just a year before his death, Condé Nast had again proved his genius in creating magazines for a targeted niche.

Nevertheless, as the 1920s ended with a cataclysmic event that foreshadowed difficult times ahead, so did the 1930s. In September 1939, the German army invaded Poland, the nations of Western Europe went to war, and America was to follow three years later.

NOTES

1. James O'Donnell, *100 Years of Making Communications History: The Story of the Hearst Corporation* (New York: Hearst Professional Magazines, 1987), 53.
2. Condé Montrose Nast, 1873–1942, "Biographical Note." Condé Nast Archives Index, Manuscript Collections, New York, NY.
3. Robert T. Elson, *Time Inc. The Intimate History of a Publishing Enterprise: 1923–1941* (New York: Atheneum, 1968), 126.
4. Ibid., 154.
5. Carolyn Seebohm, *The Man Who Was Vogue: The Life and Times of Condé Nast* (New York: Viking Press, 1982).

6. Daniel Okrent, "Every Page Will Be a Work of Art" (introduction), in *Fortune: The Art o* *Covering Business* (New York: Time Inc., 1999), xii.
7. James Playsted Wood, *Magazines in the United States*, 3rd ed. (New York: The Ronald Pres Company, 1971), 295.
8. Theodore Peterson, *Magazines in the Twentieth Century* (Urbana-Champaign: Universit of Illinois Press, 1964), 283.
9. Arnold Gingrich, *Nothing But People—The Early Days at* Esquire, *A Personal Histor 1928–1958* (New York: Crown Publishers, 1971), 102.
10. Alan Nourie and Barbara Nourie, *American Mass Market Magazines* (New York Greenwood Press, 1990), 112.
11. Noel F. Bush, *Briton Hadden: A Biography of the Co-Founder of* Time (New York: Farra Straus and Company, 1949), 85–86.
12. Elson, *Time Inc. The Intimate History of a Publishing Enterprise: 1923–1941*, 169.
13. David Halberstam, *The Powers That Be* (New York: Alfred A. Knopf, 1979), 363.
14. For the most detailed description of Phil Graham and the events leading to his death, se David Halberstam's *The Powers That Be.*
15. Osborn Elliott, *The World of Oz* (New York: Viking Press, 1980), 33.
16. David Lawrence, "Our 30th Anniversary," *U.S. News & World Report*, May 27, 1963, 108
17. David Lawrence, "U.S. News and World Report: A Two-Way System of Communication. Speech to the Newcomen Society, Washington, DC, November 12, 1968. Published by th Newcomen Society in North America, 1969, 14.
18. Ibid.
19. D.L. to C.W. Gilbert, *New York Tribune*, November 22, 1916. David Lawrence Papers, Bo 64.
20. Dwight Eisenhower to D.L., July 31, 1959. Princeton University Archives and Speci Collections, David Lawrence Papers, Box 30.
21. "A Statement by U.S. News & World Report, Inc.," *U.S. News & World Report*, July 9, 196 4.
22. "A Brief History of *Yankee Magazine*," http://www.yankeemagazine.com/about/yankeehis tory.php.
23. *Life*, November 23, 1936.
24. *Life*, May 2000.
25. Loudon Wainwright, *The Great American Magazine: An Insider History of* Life (New Yor Alfred A. Knopf, 1986), 81.
26. George H. Douglas, *The Smart Magazines: 50 Years of Literary Revelry and High Jinks Vanity Fair, The New Yorker, Life, Esquire and the* Smart Set (Hamden, CT: Archo Books, 1991), 124.
27. Wainwright, *The Great American Magazine*, 323.
28. Peterson, *Magazines in the Twentieth Century*, 57.
29. *Life*, December 29, 1972.
30. *1999 Magazine Trend Report,* Audit Bureau of Circulations, Schaumburg, IL (Decemb 1999): 80.
31. Condé Nast, "Study No. 7 News Values." Internal memo dated July 17, 1940. Conc

Montrose Nast Papers, Condé Nast Archives, New York, NY.

32. *Literary Digest*, November 17, 1929, 9.

33. Glenn Anderson, "Consumer Reports," in Nourie and Nourie, 65.

The 1940s

Paper Shortages, Censorship— and More Magazines

World War II did not seem to dampen the continued expansion of American magazines throughout the decade. The war started on September 1, 1939, when Germany attacked Poland. The United States' involvement lasted from December 7, 1941, when Japan bombed Pearl Harbor, until 1945, when Germany surrendered on May 7, and Japan surrendered on August 15. American magazines unanimously supported the war effort during those four long years. It was "the Good War," the last war to find unanimous support from Americans.

During the war, men and women who served in the armed forces created a shortage of labor in the forestry industry. As a result, paper prices skyrocketed and Americans were asked to conserve paper so most of it could be used in the war effort. The government imposed paper rationing restrictions in 1943, which forced all magazine publishers to reduce the number of published pages. For example, Howard Black, who was in charge of advertising sales for Time Inc. announced a decision to limit *Time* to 104 pages of editorial and advertising matter and *Life* to 132. Time Inc. saved over 35,000 tons of paper through this and other efforts such as drastically reducing the number of complimentary subscriptions, shortening grace periods of expired subscribers before stopping delivery, and switching to lighter weight paper stock for its magazines.[1]

John H. Johnson, who was publisher of *Negro Digest* in April 1945, was cited for violating wartime paper restrictions and called to appear before an appeals

board in Washington. The notice he received in the mail read:

You are in violation of Regulation L-244. You are herby ordered to cease and desist publishing the magazine called *Negro Digest* until you reduce your paper usage to your allotted 7.43 tons per quarter.[2]

He was using twenty-five tons of paper per quarter to publish *Negro Digest* and admits he was violating the law, but didn't realize he was doing so. Basically the law prohibited any publisher from using more paper than he or she was using at the beginning of the war. Johnson's lawyer advised him to go to Washington and make an appeal to the board using the "extreme hardship" provision of the law and not to ignore the racial dimensions of the case. Johnson was one of twenty-five publishers or printers making on appeal on Tuesday, June 12, 1945. He told the board that limiting the magazine to the quota would not only work a hardship on the company, but on its employees and distributors who gave up other jobs to get into magazine publishing. He also cited its positive effect on improving race relations. "We have printed articles which have told something of the history and achievements of the Negro group in particular, and these have bolstered the morale of the men in service," he said.

The board approved the appeal—the only one it approved that day—and gave Johnson permission to continue using twenty-five tons.

Wartime censorship was equally tough for publishers. The First War Powers Act, which was approved on December 18, 1941, gave executive authority to the President for the prosecution of the war, including a censorship provision. The next day President Roosevelt signed Executive Order 8985, which established the Office of Censorship and gave its director the power to censor international communications in "his absolute discretion."[3] He appointed Byron Price, a long-time newspaper journalist and general manager of the Associated Press as its director, a position he held until the war ended.

Fortune was one of the primary victims of wartime censorship because so many industrial and manufacturing processes were classified as important military information. For example, on December 8, 1941, the deadline for its February 1942 issue an article on the American Locomotive Company had been voluntarily submitted to the War Department because it dealt with tank production. The War Department returned the article to the *Fortune* editors with so many deletions that they had no time for revision and it was sent to press as censored. The article began:

At CENSORED on the shores of Lake Erie in western New York stood an abandoned foundry. Its great steel rafters were gabled by six inches of dust; its floor was pocked with gaping holes where the core ovens once stood....That was eighteen months agoToday that same foundry, swept, painted, and whole of body, throbs with the clan-

gor of industrial creation. Within, 550 workmen at hammers and honers, wrenches and reamers, make the steel framework on which giant guns will roll into battle. It is the CENSORED arsenal of American Locomotive....What happened to the CEN-SORED foundry is roughly symbolic of what has happened to the entire locomotive industry in two years of wartime expansion.[4]

The Office of Censorship was terminated after Japan's surrender in August 1945. After the announcement about ending censorship, Byron Price was photographed posting a sign on his door that read, "Out of Business," while he told the press, "You have the thanks and appreciation of your government."

Outside of the war, the most notable magazine trend of the decade was the continued proliferation of special-interest and special-audience publishing companies. The decade began in 1940 with the launch of the military niche magazines, *Army Times* and *Marine Corps Times*, which are published today by Army Times Publishing Company, a subsidiary of the Gannett newspaper chain. Since then the company has added *Navy Times*, *Air Force Times*, *Defense News* and *Federal Times* to its titles. *Military Officer* magazine was launched in 1945 and is still published by the Military Officers Association of America.

The entrepreneurs of passion

Throughout the years many magazines have been started by people who knew little about publishing but were passionate about a subject and sharing that knowledge with others. This kind of passion created and sustains the magazine publishing business. Three of those "pioneers of passion" started their publishing empires during the 1940s: Jerome Irving Rodale (1898–1971), Robert Petersen (1927–2007), John H. Johnson (1918–2005).

Rodale started *Organic Gardening* and his company Rodale Inc. in 1942, which is today the leading publisher of health, fitness and outdoor sports magazines. Robert Petersen (1927–2007) launched *Hot Rod* magazine in 1943 and dozens of other auto enthusiast magazines.

Johnson (1918–2005) started *Negro Digest* in 1942, *Ebony* in 1945, and *Jet* in 1951. Johnson led the way in breaking publishing barriers for minorities and today Johnson Publishing is the world's largest African-American-owned publishing company.

John H. Johnson: *Negro Digest, Ebony* and *Jet*

John H. Johnson (1918–2005) is best known as the founder and publisher of *Ebony*, which became America's most successful magazine for a predominantly African-

American audience. *Ebony*, however, was preceded by *Negro Digest*, which he founded in 1942 and published until 1951. His most enduring successes were *Ebony* and *Jet*.

Table 1

	Major Magazines Launched During the 1940s		
Year	**Magazine**	**Year**	**Magazine**
1940	Army Times	1947	American Motorcyclist
	Marine Corps Times		Road & Track
1941	Gourmet		Palm Springs Life
	Parade		Air Force Times
	Sky & Telescope		Golf World
	Trailer Life		Kiplinger's Personal Finance Magazine
1942	Negro Digest	1948	American Quarter Horse Journal
	Organic Gardening		Diabetes Forecast
1943	Hot Rod Magazine		U.S. News & World Report
1944	Seventeen		Skiing
1945	Ebony		San Diego Magazine
	Military Officer	1949	Motor Trend
	Guideposts		American Heritage
1946	Pet Product News		Preservation
			Modern Bride

Johnson was born in rural Arkansas, the grandson of slaves. When he was six years old, his father died in a sawmill accident and Johnson was raised by his mother and stepfather. The family moved to Chicago in 1933 during the Great Depression. His leadership and journalism skills emerged in high school as president of the student council and editor of the school newspaper and yearbook.

While attending the University of Chicago, he worked as an assistant to Harry Pace, the president of Supreme Life Insurance Company, who took a special interest in mentoring the young Johnson. One of Johnson's duties was preparing a monthly digest of newspaper articles for Pace. That gave him the idea for a magazine that would focus on news and features of interest to Blacks. "There was an unwritten rule in the South in this period that a Black's picture could not appear in the press unless it was in connection with a crime. There was no consistent coverage of the human dimensions of Black Americans in northern newspapers and magazines," Johnson wrote in *Succeeding Against the Odds*.

So he went around asking colleagues and referrals to make a $1,000 investment in his proposed magazine. "I went from office to office in Black Chicago and was

told no and hell no," he said. He went to Roy Wilkins, who was editor of the national NAACP magazine, who told him, "Save your money, young man. Save your energy. Save yourself a lot of disappointment."[5] Although discouraged by everyone else, his mother supported his dream. After praying about it for three days, she gave him permission to use her furniture as collateral for a $500 loan. Johnson used the money to buy stamps. Harry Pace allowed him to use the 20,000-name mailing list, stationery, and mailing equipment owned by the insurance company. He wrote this letter to his potential subscribers:

Dear Mr. Brown:

A good friend of yours told me about you. He told me that you are a person who likes to keep abreast of local and national events.

He said you are the kind of person who will be interested in a magazine that will help you become more knowledgeable about your own people and about what they are doing to win greater recognition for you and other members of our race. Because of your position in the community and the recommendation I received, I would like to offer you a reduced rate on the magazine Negro Digest, which will be published in the next thirty days. Magazine subscriptions will sell for $3.00 a year, but in view of the recommendation we are offering a subscription to you for $2.00 if you send your check or money order by September 30.[6]

The first issue was published on November 1, 1942, and reached 50,000 paid subscribers within a year. While Johnson says the magazine was modeled after *Reader's Digest*, it had an important difference. "*Reader's Digest* tended to be upbeat, but *Negro Digest* spoke to an audience that was angry, disillusioned and disappointed. You couldn't digest that world without digesting the frustration and anger."

Three thousand subscribers responded and sent checks totaling $6,000. Johnson's 15 percent response rate is more than five times the normal response of two to three percent for publisher's direct mail solicitations. The next year, the magazine reached a watershed in its success after he persuaded Mrs. Eleanor Roosevelt to write an article for the magazine. "Our circulation jumped, almost overnight, from 50,000 to 100,000. After that we never looked back," he said.

The magazine met with great success by all measures, but it was soon eclipsed by that of *Ebony* in 1945. *Negro Digest* was suspended in 1951 but revived in 1961 as a literary quarterly. Its name was changed to *Black World* in May 1970 and continued under that name until its last issue in April of 1976.

Johnson says the idea for *Ebony* came initially from his two principal freelancers, Jay Jackson and Ben Burns, who had been "pestering" him to publish a new entertainment-oriented magazine they wanted to call "Jive." Johnson demurred at the idea, but told them, "I've been doing some crude market research, checking newsstands in the Black community, and dealers tell me that the only magazine selling

almost as much as *Negro Digest* in Black communities is *Life*. I think the time is ripe for a Black picture magazine," he told them.[7]

"In a world of despair," he wrote in *Succeeding Against the Odds*, "We wanted to give hope. In a world that said Blacks could do few things, we wanted to say they could do everything." He continued:

> We believed in 1945 that Black Americans needed positive images to fulfill their potential. People wanted to see themselves in photographs. White people wanted to see themselves in photographs, and Black people wanted to see themselves in photographs. We were dressing up for society balls, and we wanted to see that….We wanted to see Dr. Charles Drew and Ralph Bunche and Jackie Robinson and the other men and women who were building the campfires of tomorrow.[8]

Johnson's wife, Eunice, suggested the name "Ebony," which she explained to him means "fine black African wood."

Ebony's first print run of 25,000 copies sold out the first day and Johnson went back and printed another 25,000 copies. The articles emphasized the achievements of successful Black Americans, as well as dramatized problems and issues in race relations. Its circulation grew rapidly throughout the following decades. Within its first two years, the magazine's influence was noted by *Time, Newsweek, Life* and *Reader's Digest* that reprinted some of its articles or photographs.

During the heyday of confession and romance magazines in the 1950s, Johnson launched *Tan Confessions* and *Copper Romance*. These magazines were profitable for a few years, but reached their peak before the end of the decade and he closed them. He also started *Tan*, a women's service magazine in 1950. When pocket-sized magazines became popular during the early 1950s, he launched *Hue*, a pocket-sized feature magazine, that didn't last. The pocket-sized newsmagazine *Jet*, however, was immediately successful and has continued its success to this day. In its first issue, Johnson wrote:

> In the world today everything is moving at a faster clip. There is more news and far less time to read it. That's why we are introducing…JET, to give Blacks everywhere a weekly news magazine in handy, pocket-sized form. Each week we will bring you complete news coverage on happenings among Negroes all over the U.S.—in entertainment, politics, sports, social events as well as features on unusual personalities, places and events.[9]

In 1965 when *Ebony* celebrated its twentieth anniversary, *Ebony* was selling 900,000 copies a month and *Jet, Tan* and *Negro Digest* were selling a total of 2.3 million copies a month. By 2000, *Ebony's* circulation had reached two million.

In December of 1971 Johnson Publishing Company moved into its new eleven-

story headquarters on Michigan Avenue, which was the first black-owned building in Chicago's Loop. Building on his publishing success, Johnson expanded into other business ventures, including a cosmetics company, television and radio stations, and insurance. In 1974, he was elected chairman and chief executive officer of Supreme Life Insurance Company, the same company where he worked as assistant to Harry Pace. In 1982, Johnson became the first African-American to appear on the Forbes 400 list of wealthiest Americans. At the time of Mr. Johnson's death in 2005, both *Ebony* and *Jet* both ranked as circulation leaders among American magazines.

In 1972, the Magazine Publishers of America gave Johnson its "Publisher of the Year" award. President Bill Clinton awarded him the Presidential Medal of Freedom, the nation's highest civilian honor, on September 9, 1996.

Jerome Irving Rodale and Rodale Inc.

In 1942, Jerome Irving Rodale (1898–1971) started *Organic Farming and Gardening* magazine, today known as *Organic Gardening*, which taught its readers how to grow better food by cultivating healthier soil using natural techniques. The son of an immigrant grocer, he grew up on New York's lower east side. At the age of twenty-two, he changed his birth name from Cohen to Rodale because he felt that anti-Semitism could hurt his career. Originally an accountant, he and his brother started Rodale Manufacturing, which made electrical wiring devices. In 1940, he moved from New York to Emmaus, Pennsylvania, where he purchased a sixty-three acre farm so he could experiment with his ideas on the connection between soil and health.

Like the founder of many special interest magazines, Rodale didn't begin with an ambition of starting a "successful magazine" but rather a passion to share his ideas with a wider audience. His biographer wrote, "Just as J.I. believed that diseases of plants and animals could be avoided by sound farming practices, he increasingly came to believe that human diseases could be prevented by sound eating habits." Rodale told a group of Michigan organic gardeners in 1948, "There is a definite proven connection between the quality of our foods and our health."

Rodale had an eclectic background in manufacturing, printing and publishing. In 1942, the company was publishing several small magazines: *Fact Digest, Science Facts, War Digest* and *You Can't Eat That.* But wartime paper shortages made it difficult to start new magazines without shutting down existing ones. Nevertheless, he forged ahead and launched the first issue of *Organic Farming and Gardening* in May 1942.

He mailed 14,000 free copies to farmers with an invitation to subscribe, but only

received twelve paid subscribers in return. Undaunted and undiscouraged, he shifted gears and targeted a different niche—amateur gardeners—where he found success. With the proliferation of home-grown gardens that the government encouraged to grow to ensure a war-time food supply, Rodale found a receptive audience. Circulation grew steadily. In December 1942, he changed the name to *Organic Gardening and Farming* and a month later to simply *Organic Gardening*. A few months later, he sold his other magazines to focus exclusively on *Organic Gardening*.

The March 1943 issue, which sold for a cover price of twenty-five cents, included features on "The control of plant diseases," "Raising chickens by feeding earthworms," and "Are chemical fertilizers factors for undermining our health?" The cover included the slogan, "Help the War Effort. Use Only Home-Made Organic Fertilizers," at the bottom of the page.

By the end of the war, *Organic Gardening* had 30,000 subscribers. The war's end also brought an end to paper restrictions and gave Rodale resources to expand his publishing ventures. In 1945, he published his book, *Pay Dirt*, which promoted his beliefs about the benefits of organic gardening and farming. The book was a huge commercial success and brought national fame to J.I. Rodale. "It more or less made me 'Mr. Organic,'" he wrote. "I was considered the leader of the movement. I was called upon to speak all over the country, received important visitors at our farm, [and] had lunch with notables at the Colony Club on Park Avenue...."[10]

In the spring of 1950, Rodale Press began running ads in *Organic Gardening* soliciting subscriptions to *Prevention,* which J.I. Rodale called "a medical journal for the people." The magazine would tell readers how to prevent illness rather than waiting for the need to cure it.

By the time the first issue came out in June, it had already attracted 50,000 subscribers. All of the articles in the first issue focused on the raging polio epidemic. J.I. Rodale believed it was essential to base all of its articles on proven science. "When we began publishing...we decided on a policy. We would quote only from conservative M.D. sources. We would print no articles about chiropractic and osteopathy. We definitely would not print anything by naturopaths."[11]

As the company matured, J.I. Rodale gradually turned over more responsibilities to his son, Robert Rodale (1930–1990), who was named president of Rodale Press. For the next two decades, the company continued to grow with its book publishing division and two flagship magazines, *Organic Gardening* and *Prevention*. The only new launch during this time was *Compost Science: The Journal of Waste Recycling* in 1960.

By the 1970s, the organic movement began gaining traction among the public and Rodale Press rode the rising tide. From 1968 to 1971, *Organic Gardening and Farming*'s circulation grew from 400,000 to 720,000 while *Prevention*'s circulation grew from 520,000 to 920,000 in the same period. But 1971 also brought a sad and

tragic death to the company's founder.

On June 7, J.I. Rodale traveled to New York to do a taping for the Dick Cavett television show. Cavett introduced J.I. who came on stage as the band played, "Doing What Comes Naturally." After a few minutes of banter, Cavett asked J.I. about his age. "I'll be 73 in August," he said. "I am so healthy I expect to live to 101. I have no aches or pains. I'm full of energy."

Table 2

Rodale Inc. Magazines	
Founded	**Magazine**
1942	*Organic Gardening & Farming*
1964	*Bicycling* (acquired 1978)
1987	*Men's Health*
1985	*Mountain Bike* (acquired 1987)
2001	*Organic Style*
1950	*Prevention*
1966	*Runner's World* (acquired 1985)
1977	*Running Times*
2005	*Women's Health*
Current as of January 2010	

Two minutes later he had a heart attack and two physicians in the audience rushed to the stage to check his pulse; he had none. He was rushed to a nearby hospital and pronounced dead of cardiac arrest. The show never aired, however.

The day before he died, J.I. Rodale told his son, Bob, "Stick with a thing for a long time and you'll make it work." Bob Rodale continued to make Rodale work. A company history describes J.I. Rodale as "A man without many hobbies, aside from reading, writing and starting new business ventures." But Robert ("Bob") Rodale, "...from his childhood on the farm, had a genuine interest in and affection for the outdoors. And in the 1960s as he pursued sporting interests in his private life, he would weave them into Rodale's publications."[12]

During the next twenty years, the company saw its greatest expansion in the launch and acquisition of new magazines including the acquisition of *Bicycling* in 1978, *Runner's World* in 1985, and *Mountain Bike* in 1987. In 1987, the company launched *Men's Health*, which grew to almost two million subscribers and the nation's best-selling men's magazine. In 1999, Rodale Inc. was named one of *Fortune* magazine's "100 Best Companies to Work for in America."

Jerome Irving Rodale, founder of Rodale Inc., and son Robert Rodale. Photo courtesy: Rodale Family Archives

Like his father, Bob Rodale was also to meet an untimely death. On September 20, 1990, he was killed in a car accident in Russia. With the Soviet Union beginning to crumble, Bob Rodale saw an opportunity to expand more of the company's titles overseas. He made the trip to discuss plans to launch *Novii Fermer*, a farming magazine that would address the needs of new farmers in this post-Communist nation. A city bus, which had swerved out of traffic to avoid a military truck, crashed into the van carrying Bob Rodale, instantly killing him and two other passengers.

His wife, Ardath Rodale (1928–2009), became chairman and chief executive officer of the company, a position she held successfully for the next seventeen years

as the company continued to grow. On June 18, 2007, Ardath Rodale stepped down as chairman, and her daughter, Maria Rodale, was named chairman. That same year, thirteen Rodale books made *The New York Times* bestseller list, and the company acquired more than 5.3 million new customers. *Working Mother* named Rodale to its list of "Best 100 Companies for Working Mothers." Now in its third generation of family leadership, Rodale Inc. has been one of the most-admired family-owned publishing companies.

Robert E. Petersen and *Hot Rod*

Robert E. "Pete" Petersen (1926–2007) started *Hot Rod* magazine when he was sixteen years old and went on to build Petersen Publishing into an empire that in 1995 published thirty-four monthly or bi-monthly magazines. Petersen's magazines were built around a distinct niche: car enthusiasts, with titles like *Hot Rod, Motor Trend, Car Craft, 4-Wheel & Off-Road, Sport Truck, Circle Track, Rod & Custom, Chevy High Performance,* and *Hot Rod Jr.* As his company grew, however, he branched into wider areas of interest like *Guns & Ammo, Hunting* and *Handgun. Dirt Rider, Sport Rider, Motorcycle Cruiser,* and *Motorcyclist*–but still focused on his target demographic of young males with outdoor, sporting interests. While he sold the company and retired in 1997, most Petersen magazines are still published by other companies. Petersen, the son of a Los Angeles auto mechanic, put together the first issues of *Hot Rod* in his apartment and went around to races selling copies for twenty-five cents to fans. *Forbes* magazine says, "*Hot Rod* was the quintessential niche publication. It gave southern Californians a way to indulge their love affair with the internal combustion engine."[13]

The second magazine he launched was *Motor Trend* in 1949, which targeted an older, more affluent audience who was interested in sport and luxury cars. It gave *Hot Rod* readers a new Petersen magazine to "graduate" to as they grew older and more affluent. This ability of Petersen to hold onto maturing readers by launching new magazines became one of the strengths of the company.

Petersen and his company innovated in three ways. First, he located "niches within niches" of the company's most successful magazines and launched new magazines to cater to those sub-niches. Second, unlike most special interest magazines, he looked for writers who were experts in their field first and writers second. And third, as *Motor Trend* illustrated, he sought to create new magazines that would keep the same audience of core readers as they grew older and interests changed.

Hot Rod created a new niche of readers for *Chevy High Performance* and *Circle Track. Motor Trend* created an audience for *New Car Buyer's Guide,* while *Guns &*

Ammo became the parent magazine for *Handguns*. Petersen sought neither the huge circulations nor "prestige" demographics prized by most magazines. His magazines focused on interests of mostly male enthusiasts who enjoyed hobbies Petersen himself enjoyed, such as cars and guns.

The company focused on single copy and newsstand sales, avoiding the high costs of direct mail and subscription fulfillment. It streamlined production costs and maintained low overhead, which enabled it to make money on magazines with circulations as low as 100,000.

Not all Petersen magazines were successful. In 1975, he launched *Wheels Afield,* a recreational vehicle magazine that fell victim to the gas shortages of the 1970s. In 1977, he overestimated the short-lived citizens band radio craze by publishing *CB Life.* He also ventured into another niche with *Inspiration,* a mass-market religious magazine, which he folded after he conceded he became too "emotionally involved" with it. Other failures were *Go Cart, True Magazine,* and *Slot Car Racing.*

Petersen, however, was quick to recognize mistakes and cut his losses before ill-conceived titles incurred staggering losses. "The trick in business," he told *Forbes,* "is not to hang on when it's gone."

Petersen and his wife lost both their sons in a 1975 airplane accident. With no direct heirs, he used part of his fortune in 1994 to establish the Petersen Automotive Museum in Los Angeles (www.petersen.org). The museum's mission is to explore 100 years of automotive history and its impact on American culture. In 1997, he sold the company to a group headed by D. Claeys Bahrenburg, the former president of Hearst Magazines. The company went through two ownership changes in the next decade. Most former Petersen titles are now published by Source Interlink Companies, Inc. (www.sourceinterlink.com). Petersen died in 2007 at the age of eighty.

Other magazines of the 1940s

Walter Annenberg and *Seventeen*

Walter Annenberg (1908–2002) owned newspaper, television, radio and magazine properties, which at various times included *The Philadelphia Inquirer, Philadelphia Daily News, Daily Racing Form, Seventeen* magazine and *TV Guide.* Annenberg attended the Wharton School of Finance at the University of Pennsylvania from 1927 to 1928. He joined his father's company as a bookkeeping assistant in 1928. In 1920 his father, Moses Annenberg, moved his family from Milwaukee to Great Neck, Long Island, where he established his newspaper distribution business. He later purchased the *Daily Racing Form* and expanded it into seven racing papers

across the country. In 1936, he purchased *The Philadelphia Inquirer.* In 1939, Moses was indicted by a Chicago federal grand jury for income tax evasion. Walter and two other business associates were also indicted. Moses agreed to plead guilty, pay $9.5 million in back taxes and serve three years in prison. As part of the settlement, charges against Walter and other business associates were dropped. Moses died of a brain tumor 39 days after his release from prison in 1941.

As the only son in a family of eight, Walter was named heir to the newly named Triangle Corporation, which included the *Inquirer* and several other publications. His years as publisher of *The Philadelphia Enquirer* from 1942 to 1969 were sometimes controversial because of charges that he used the newspaper for personal vendettas against his enemies.

Annenberg noticed the growing buying power of young female consumers and saw the need for a magazine aimed at teen-aged girls. Therefore, he founded *Seventeen* in 1944 and named his sister Enid Haupt as editor. The magazine was a huge commercial success from the beginning and soon reached a million readers. *Seventeen's* success provided another example of the modern business model of connecting a "special audience" to a huge group of potential advertisers eager to reach that market with its products. Annenberg's second stroke of genius in sensing the market for a new magazine came in 1952, when he purchased a series of local television magazines, which he consolidated into *TV Guide.* The next chapter will tell more about *TV Guide.* In 1988, he sold *Seventeen* and *TV Guide* and remaining portions of Triangle Publications to Rupert Murdoch for $3.2 billion. Annenberg was known for his philanthropy and gave more than $2 billion to various causes, including $150 million to the Corporation for Public Broadcasting. His gifts established schools of communication at the University of Pennsylvania in 1962 and the University of Southern California in 1971. He died in 2002 at the age of 94.

Norman Vincent Peale and *Guideposts*

Norman Vincent Peale once asked a group of business executives how much they thought it would take to launch a new magazine. Most of them suggested millions of dollars. He asked them if they had ever heard of *Guideposts.* Most of them had. "We started it with $7,500" he told them. By the time *Guideposts* was launched in 1945, Peale was the nation's best-known Protestant leader, a syndicated columnist, host of a radio program and frequent speaker at business and professional meetings. His magazine advocated a practical, down-to-earth faith and sought to reach an audience that included Protestants and Catholics.

The Rev. Norman Vincent Peale (1898–1993) was author of thirty-two books and pastor of New York's Marble Collegiate Church from 1932 to 1984. Peale is best-known for his book, *The Power of Positive Thinking*, which was published in

1952, sold tens of millions of copies, and is still in print today. Titles of some of his other books reflect his self-help philosophy and editorial thrust for *Guideposts: The Art of Living* (1937), *A Guide to Confident Living* (1948), *Inspiring Messages for Daily Living* (1950), *Amazing Results of Positive Thinking* (1959), *The Tough-Minded Optimist* (1961) and *Enthusiasm Makes The Difference* (1967).

Peale's first job after graduating from college was as a staff reporter for the *Detroit Journal* where he considered becoming a journalist before deciding on seminary. He liked to tell the story of his editor Grove Patterson, who took a pencil and put a dot on a sheet of paper and asked Peale, "What is that?"

"A dot," the young Peale replied.

"No, it's a period—the greatest literary device known to man. Use as many as you can. And write in short, fast-moving sentences," said the editor.[14]

He saw *Guideposts,* which he launched with his wife Ruth Stafford Peale (1906–2008), as an extension of his ministry. Located in Pawling, N.Y., near the *Reader's Digest* headquarters, Peale was friends with its founders, Lila and DeWitt Wallace, and shared resources with the established magazine in several ways. *Guidepost's* first editor was Grace Perkins Oursler, a Roman Catholic and the wife of *Reader's Digest* editor Fulton Oursler.

Although the magazine's editorial formula slowly evolved, it remained consistent over the years. Editors invited readers to tell their first-person stories about how they achieved triumph over tragedy, sickness or failure through prayer, positive thinking, common sense, and faith. They looked for good stories with strong content, even when they came from amateur writers, and worked with writers to edit the story to the magazine's standards. A statement in each issue described its purpose: "*Guideposts* magazine, A Practical Guide to Successful Living, is a monthly inspirational, interfaith, nonprofit publication written by people from all walks of life. Its articles present tested methods for developing courage, strength and positive attitudes through faith in God."[15]

Subscriptions grew rapidly and reached two million by 1973. By 1984, it had four and a half million paid subscriptions, a million more than either *Time* or *Newsweek*. A Peale biographer wrote that the magazine "so far outstripped its competition that it had no competition in its field."[16]

Today Guideposts Associates, Inc. publishes five magazines. Other magazines include *Positive Thinking, Angels on Earth, PLUS: The Magazine for Positive Thinking,* and *Guideposts for Kids.*

Parade

Parade, a weekly Sunday supplement distributed in more than 400 newspapers in the United States, was founded in 1941 and went through two different owners

before its purchase by Condé Nast Publications in 1976. By one definition, it is the nation's most widely read magazine with a weekly circulation of thirty-two million copies. As a newspaper-distributed supplement, however, it lacks the circulation and revenue structure that require other magazines to play by different rules. First, it's sold to newspapers, not individual subscribers or single copy purchasers. Second, the magazine is printed on newsprint , which is of lesser quality than magazine paper. Unlike *Time* and *Newsweek*, which have a lag time of a few days, *Parade* goes to the printer three weeks before its publication date. The long lead time has led to some embarrassing incidents for the magazine. For example, the January 6, 2008, cover story on Benazir Bhutto asked if she was "America's Best Hope Against Al-Queda?" when the former prime minister of Pakistan was assassinated ten days earlier on December 27, 2007.

Nevertheless, the magazine has held itself to high standards throughout its seventy-year history and such embarrassments have been rare. "Joining the right writer to the right idea, *Parade* consistently provides its readers with quality stories," says its mission statement, which continues: "That quality itself is defined by three elements: clarity, authority and substance. Each article must be clear in design and content and well researched and written with a voice of authority. It must also have substance, telling readers something they didn't know before and giving them an opportunity to effect change."

Kiplinger's Personal Finance Magazine

Kiplinger's Personal Finance Magazine, launched in 1947 by W.M. Kiplinger (1891–1967), was the nation's first personal finance magazine. The magazine advised its readers on managing money, buying a car, choosing investments, insurance and health care, and saving for college, travel, and retirement. Founded as "Kiplinger Magazine: The Changing Times," it changed its name to "Changing Times: The Kiplinger Magazine" in 1949. It kept that name until 1991, when it became *Kiplinger's Personal Finance Magazine.* It relied solely on subscription and single-copy revenue until 1980 when it began carrying advertising. The company also publishes another monthly magazine, *Kiplinger's Retirement Report,* which it launched in 1993.

The magazines were preceded by a weekly newsletter, *The Kiplinger Letter,* which Kiplinger, a former Associated Press economics reporter, began publishing in 1923. *The Kiplinger Letter* created the telegraphic, short-paragraph style that was widely imitated during the newsletter publishing boom of the 20th century, which saw the creation of several thousand newsletters on specialized subjects. The company also publishes other specialized newsletters, including *The Kiplinger Tax Letter, The Kiplinger Agriculture Letter, The Kiplinger California Letter,* and *Kiplinger's*

Biofuels Market Alert. Today Kiplinger Washington Editors, Inc., is a privately held company managed by three generations of the Kiplinger family.

The New Yorker publishes "Hiroshima"

The New Yorker's coverage of World War II culminated with John Hersey's 31,000 word article, "Hiroshima," which was the only article published in the August 31, 1946, issue. Later published as a book, it graphically portrayed the atomic bomb's devastation of the Japanese city through stories from a Jesuit priest, a widowed seamstress, two doctors, a minister, and a young woman who worked in a factory. In 1999, a thirty-three member panel from New York University ranked *Hiroshima* first among the 100 most outstanding works of journalism in the 20th century.

William Shawn, who was managing editor of *The New Yorker* at the time, sent John Hersey (1914–1993) to Japan to write about the atomic bomb's devastation of that city. Shawn convinced editor Harold Ross to devote the whole issue to Hersey's account. At the bottom of the first page, they appended this note:

> "TO OUR READERS. *The New Yorker* this week devotes its entire editorial space to an article on the almost complete obliteration of a city by one atomic bomb, and what happened to the people of that city. It does so in the conviction that few of us have yet comprehended the all but incredible destructive power of this weapon, and that everyone might well take time to consider the terrible implications of its use.

That issue sold out on newsstands within hours and hundreds of reprint requests began pouring in immediately. The ABC Radio Network pre-empted regular programming to broadcast the article's full text in four half-hour segments. The book *Hiroshima* was published three months later and remained in print into the twenty-first century.[17]

In 1985 John Hersey returned to Hiroshima, where he wrote a follow-up, *Hiroshima: The Aftermath*, which *The New Yorker* published in its July 15, 1985, issue. Hersey also wrote several novels, including *A Bell for Adano*, which won a Pulitzer Prize and was made into a movie. He taught fiction and nonfiction writing courses for eighteen years at Yale University, his alma mater.

Whittaker Chambers and Alger Hiss

Whittaker Chambers, an editor and writer for *Time* between 1939 and 1948, attracted the national spotlight when, in a hearing before the House Un-American Activities Committee, he testified that state department official Alger Hiss (1904–1996) was an underground Communist who had participated in espionage

activities. Hiss vigorously fought the charges, but the controversy continued through two trials until 1950 when a Grand Jury convicted Hiss of perjury and sentenced him to five years in prison. Hiss had been a senior adviser to the Secretary of State, playing an important role in organizing the United Nations. In 1948 Hiss was president of the prestigious Carnegie Endowment for International Peace.

Whittaker Chambers (1901–1961), who grew up on Long Island and attended Columbia University, was an active member of the American Communist Party from 1924 to 1937. He publicly renounced the party and went into hiding for two years to protect himself and his family from repercussions. He also embraced Christianity and became a devout Quaker. He recounts in his memoir, *Witness,* how he was attracted to Communism and became a staff writer for the *Daily Worker* and then writer and editor of *New Masses*, a Communist-controlled literary monthly. He was also active in underground party activities and carried messages and stolen documents from American Communists to his Soviet superiors for them to transmit to Moscow. During the trials, Chambers implicated Alger Hiss as a fellow spy against the United States.

Chambers was honest about his past when hired by *Time* as a book reviewer in 1939. With a wife and two children to support, he worked hard and received several promotions and raises. According to an official company history, "His extraordinary writing skills and his appetite for hard work impressed his superiors [including Luce], and in 1944 he was promoted to the important role of foreign news chief."[18]

Nevertheless during his public testimonies and two trials against Hiss, public sentiment, as well as that of many *Time* staff members, ran against Chambers and proved an embarrassment to Time Inc. At the time, Hiss was a prominent public official and Chambers was an obscure magazine editor. He was also controversial among *Time*'s writers and foreign correspondents because his antipathy toward Communism resulted in charges of bias in his choosing and editing of stories. Consequently, he was pressured to resign.[19]

Chambers resigned from Time Inc. in 1948 and retired to his farm near Baltimore to write his autobiography, *Witness.* He offered the serial rights to the manuscript to *Life*, but Luce suggested to him that not *Life* but *Time* serialize the book. Ultimately Chambers sold the series to the *Saturday Evening Post.* Chambers later wrote Luce that he decided to take the *Post*'s offer, even though *Time* had offered to raise its bid, because he feared that in offering the book to Time Inc. he might embarrass the company, which he didn't want to do.

When *Witness* came out in book form in 1952, it became an immediate bestseller. *Time* gave it a long, favorable review, which said: "Its depth and penetration make *Witness* the best book about Communism ever written on this continent. It

ranks with the best books on the subject written anywhere."[20] Although Chambers died in 1961, he was posthumously awarded the country's highest civilian honor, the Medal of Freedom, by President Ronald Reagan on March 26, 1984. As the 1940s ended, the war was over and the United States was about to enter a new era of peacetime prosperity. Sales of television sets were expanding rapidly while new television stations were cropping up in cities across the country. American magazines had another challenge to face and overcome.

Notes

1. Robert T. Elson, *Time Inc. The Intimate History of a Publishing Enterprise: 1941–1960* (New York: Atheneum, 1973), 40–41.
2. John H. Johnson (with Lerone Bennett, Jr.), *Succeeding Against the Odds* (New York: Time-Warner Books, 1989), 145.
3. See Michael S. Sweeney, *Secrets of Victory: The Office of Censorship and the American Press and Radio in World War II* (Chapel Hill: The University of North Carolina Press, 2001).
4. "American Locomotive," *Fortune*, February 1942, 79–82. Cited in Elson, *Time Inc., The Intimate History of a Publishing Enterprise: 1941–1960*, 6–7.
5. Johnson, *Succeeding Against the Odds*, 115.
6. Ibid., 119.
7. Ibid., 153.
8. Ibid., 159.
9. Ibid., 207.
10. Daniel Gross, *Our Roots Grow Deep: The Story of Rodale* (Emmaus, PA: Rodale, Inc., 2008), 21.
11. Ibid., 81.
12. Ibid., 117.
13. Jerry Flint, "The Magazine Factory," *Forbes*, May 22, 1995, 160.
14. David E. Sumner, "Norman Vincent Peale: 90 and Still Writing," *Christian Writers Newsletter*, August 1988, 1.
15. Lawrence Thompson, "Guideposts," in *Popular Religious Magazines of the United States*, P. Mark Fackler and Charles H. Lippy, eds. (Westport, CT: Greenwood Press, 1995), 252.
16. The most complete history of *Guideposts* appears in chapter 4, "The Guideposts Story," in *God's Salesman Norman Vincent Peale and the Power of Positive Thinking* by Carol V.R. George (New York: Oxford University Press, 1993), 101–127.
17. "William Shawn." *The Scribner Encyclopedia of American Lives, Volume 3: 1991–1993* (New York: Charles Scribner's Sons, 2001). Reproduced in *Biography Resource Center* (Farmington Hills, MI: Gale, 2009), http://galenet.galegroup.com/servlet/BioRC.
18. FYI, March 26, 1984, p. 8, from the files of the Time Inc. Archives.
19. Besides *Witness* (1952), many of Chambers's letters and articles were posthumously published in *Cold Friday* (1964) and *Odyssey of a Friend* (1969), edited by William F. Buckley, Jr. A comprehensive biography of Chambers is Sam Tanenhaus, *Whittaker Chambers*

(1997). For details on the Hiss-Chambers case, see Allen Weinstein's *Perjury* (1978). Alger Hiss presents his defense in his book *In the Court of Public Opinion* (1957).

20. Elson, *Time Inc. The Intimate History of a Publishing Enterprise: 1941–1960*, 244.

The 1950s

Television Spurs Leisure Activities, Magazine Growth

After a decade of depression and a decade of war, Americans felt ready to relax and enjoy the good times. While the 1950s are usually depicted in the stereotypical image of the "Leave it to Beaver" TV family, the public's appetite for new types of magazines portrays a different image. June Cleaver might have been secretly reading the *National Enquirer*, while Wally and Beaver might have been upstairs looking at *Playboy* pictures and laughing at *Mad* cartoons.

In August of 1953, *Fortune* began an eleven-part series on "The Changing American Market" which predicted that the 1950s would see an amazing growth in the "moneyed middle-class" and the demand for leisure-time products and services. The *Fortune* series pointed out that Americans were spending $18 billion annually on "unmistakable leisure-recreational expenditures, on spectator amusements...domestic and foreign pleasure travel, boating, games and toys, certain books, magazines and newspapers."[1]

Five new magazines came out during the 1950s that symbolized the overall thrust of American magazines for the next fifty years: *TV Guide, Sports Illustrated, Playboy, Mad,* and *National Enquirer. TV Guide* rode the cresting wave of television's rise to dominance in the mass media marketplace and created a new generation of celebrities. The *National Enquirer* reported their marriages, affairs, and divorces, while *Playboy* set the stage for the sexual revolution to come a few years later. *Sports Illustrated* symbolized the sports and leisure pastime activities that post-war pros-

perity was to create for the growing middle-class. And *Mad* captured the adolescent fantasies and frivolities of their children. And all these magazines paved the way for hundreds more like them that were to reach the largest market of magazine readers in history.

Table 1

Major Magazines Launched During the 1950s		
Year	Title	Current Publisher
1952	*Mad*	DC Comics
1953	*TV Guide*	Opengate Capital
1953	*Playboy*	Playboy Enterprises, Inc.
1953	*San Francisco*	San Francisco Magazine
1953	*Car Craft*	Source Interlink
1953	*TV Guide*	Lionsgate TV Guide
1954	*Hemmings Motor News*	Hemmings Publishing
1954	*Sports Illustrated*	Time Inc.
1955	*Bon Appétit*	Conde Nast Publications Inc.
1955	*National Review*	National Review, Inc.
1955	*Guns Magazine*	Publisher's Development Corp.
1955	*Village Voice*	Village Voice Media Holdings LLC
1956	*Boating*	Bonnier Corporation
1956	*Car & Driver*	Hachette Filipacchi Media U.S., Inc.
1957	*National Enquirer*	American Media, Inc.
1958	*AARP: The Magazine*	American Association of Retired Persons
1958	*Christianity Today*	Christianity Today, Inc.
1958	*Autoweek*	Crain Communications, Inc.
1958	*Your Retirement Advisor*	Hearst Magazines
1958	*Guns & Ammo*	Intermedia Outdoors
1959	*Golf Magazine*	Time Inc.
Current as of January 2010		

The rise and fall of *TV Guide*

"The George Burns and Gracie Allen Show," "The Jack Benny Program," "Truth or Consequences" with Ralph Edwards and "You Bet Your Life" with Groucho Marx made their television debuts in 1950. These superstars switched from radio to television that year when, for the first time, TV ratings matched radio ratings. "If this television craze continues with the present level of programs, we are destined to have a nation of morons," Boston University president Daniel Marsh said that year.[2]

After his success with *Seventeen* in 1944, Walter Annenburg's second stroke of

genius came in sensing the market for a national television magazine. He came up with the idea of providing national news and features about network programs with regional editions offering individualized program schedules. In 1952, he purchased a series of local TV magazines, which he consolidated into *TV Guide*. The idea for using a print magazine to promote television programs originated five years earlier in New York with *TeleVision Guide*. This magazine was created by Herbert Muschel and Lee Wagner and first published on June 14, 1948. Similar magazines were published in Philadelphia and Chicago. Annenberg purchased all three magazines for more than $1 million each. Annenberg owned Triangle Publications, Inc., which then included *Seventeen*, the *Philadelphia Inquirer*, the *Philadelphia Daily News*, *Morning Telegraph*, and *Daily Racing Form*.

The first issue of *TV Guide* was published on April 3, 1953, with Lucille Ball and Desi Arnaz, stars of the popular "I Love Lucy" program, on the cover. The second carried a picture of Jack Webb, who played the Los Angeles cop in "Dragnet." Sales started at more than a million copies, but declined for the next few months until they picked up again in September. Annenberg remained undeterred and learned that sales would always decline in summer because of vacations and program reruns. Circulation began a steady growth after the first few slow months. By 1957, *Time* magazine called *TV Guide* "the most successful magazine started since the war." In a promotional ad, *TV Guide* proclaimed that it had the "Largest Circulation in Weekly Magazine History."[3]

Circulation reached 18.5 million by the early 1980s. By that time, it published 102 regional editions with printing plants in California, Ohio, Pennsylvania, South Carolina, Minnesota, Colorado, and Texas. Triangle Publications earned an estimated $1 million a week from the publication. However, with the growth of cable television guides and free newspaper program guides that began in the 1980s, *TV Guide* began a steady circulation decline that was never reversed.

In 1989, *TV Guide* was purchased by Rupert Murdoch's News America Publications for $3 billion. During the 1990s, *TV Guide* continued to lose readers and advertising as program schedules became freely available on the Internet. In 2005, the magazine cut its rate base and tried to reinvent itself as a celebrity and entertainment magazine focused on television. After losing $20 million in a year, the ailing magazine and its debts were sold in October 2008 to a private equity firm, OpenGate Capital, for the sum of one dollar. OpenGate managing partner Andrew Nikou told *Ad Age*, "The reason we acquired this business is simple. It needed additional investment. We're investing in this company to take it to the next stage."[4] *TV Guide* continues to be published and ended the 2008 year with a circulation of 3.2 million. Its circulation ranked fifteenth after it peaked at second highest among all magazines in the 1980s.

Henry Luce, Time Inc., and *Sports Illustrated*

By the early 1950s, Henry Luce and Time Inc. had not created a new magazine since *Life* in 1936. *Time, Fortune* and *Life* were highly successful, and the company had cash to spare. Luce and his staff wanted to start a new magazine, but weren't sure what kind. The company solicited suggestions from all of its employees. Robert Cowin, a young circulation executive, suggested a sports magazine. He had returned from a readership survey in Columbus, Ohio, which Time Inc. regarded as "the perfect microcosm of middle-class America." He was amazed at the number of women who reported that their husbands were not reading *Time*, but the sports section of the newspaper or some other sports periodical. Therefore, he typed a long memo to Daniel Longwell, Luce's senior advisor, and John Shaw Billings, his editorial director.

> There is one very broad field which is not adequately covered by any publication with a large national following—sports! I'm sure that Time Inc. with its facilities and appealing editorial "know how" could put out a sports publication so far above and ahead of anything being published today that the demand would be overwhelming. With the trend toward a shorter work week and more holidays, the number of people and the time they spend engaged in their favorite sporting activities is growing at an enormous rate. Why not cater to this obvious interest?[5]

Cowin never received a response to the memo, and his idea was ignored for three years. But the idea for a sports magazine kept percolating throughout the company. Henry Luce was well known for having no personal interest in sports. But he warmed up to the idea more and more as the conversation continued. In thinking over various projects, Luce said, "The compass needle always came back to sport."[6]

During 1953, the company set up an "experimental sports magazine project" to develop a sports magazine. With his analytic mind, Luce kept looking for a deeper, philosophical purpose for the magazine. He once asked a staff meeting, "What's the purpose of such a magazine? What's its justification?" He went on to answer his own question:

> Sport has aspects too, of creativity. Man is an animal that works, plays and prays. As a boy, I remember reading a book entitled *Four Things Men Live By*. These four things were Love, Work, Play, and Prayer. No important aspect of life should be devalued…. And sport has been devaluated….It does not get serious attention. The new magazine will be a reevaluation of sport—not an over-evaluation—to put it in its proper place as one of the great modes of expression.[7]

He began envisioning a weekly newsmagazine that would both report and critical-

ly examine the sports business, its celebrities, participants, and fans. It would be aimed at an educated audience who had the time and means to attend sporting events. But it would also cover participatory sports like tennis, fishing, golf, bowling and hunting.

The company purchased the rights to the name "Sports Illustrated" for $5,000 from Dell Publishing Company, which had published an unsuccessful magazine with the same title during the 1940s. After the company conducted more marketing and advertising research for a year, all signals were go. It had received 350,000 charter subscriptions from a successful direct mail solicitation. Vol. 1, No. 1 of *Sports Illustrated* was published on August 16, 1954.

Barron's magazine stressed the risk that Time Inc. was taking in launching a sports magazine. "There are today [1954] some 7,792 magazines in America, but of some 3,182 launched since the war only a handful have established themselves as institutions in their field. The rate of mortality here…is terrific." [8]

Sports Illustrated was indeed a gamble. It lost millions of dollars for ten consecutive years until turning its first profit in 1964. During those years, rumors continued inside and outside the company that the magazine would fold. After years of discouragement, some staff members resigned or were reassigned. Circulation grew, but the magazine was slow in attracting major advertisers. Advertisers were skittish about sports, which still had a low-brow, blue-collar image on Wall Street. Professional and collegiate athletics had not yet attained the national prestige and popularity that was created largely by television. An individual entrepreneur could never have sustained a money-losing magazine for ten years. But Time Inc. could use its profits from its other three magazines to sustain the venture. Once Henry Luce was sold on a sports magazine, he never backed down or wavered in his support.

Initially, the magazine covered an eclectic assortment of sports—big game hunting, yachting, horse racing, dog shows, and fishing, along with cooking, fashion, and travel—besides traditional team sports. The magazine began to succeed after André LaGuerre was named editor in 1960. LaGuerre, a Frenchman, narrowed the magazine's niche from trying to cover all sports to covering the major sports of football, baseball, basketball, and hockey.

Cover stories reflected the gradually narrowing focus on the magazine's content. Its first fifty-two issues included only nine cover stories about football, baseball, and basketball. Other cover stories in 1954 focused on duck hunting, game-hunting in Africa, bird-watching, gymnastics, skin diving, yachting, bullfighting, trout fishing and archery. By 1964, the number of cover stories on football, baseball or basketball had almost tripled to twenty-four. The 50th anniversary issue of *Sports Illustrated* included a tally of cover story topics between 1954 and 2004. Professional football ranked first in cover stories with 511, baseball second with 502,

and basketball third with 294.[9] Table 2 shows the top ten sports celebrities who appeared on the covers of *Sports Illustrated* during those first fifty years.

Table 2

Sports Celebrities on *Sports Illustrated*'s Covers 1954 to 2003			
Rank	Number of covers	Name Sport	
1	49	Michael Jordan	basketball
2	37	Muhammad Ali	boxing
3	22	Kareem Abdul-Jabbar	basketball
4	22	Magic Johnson	basketball
5	22	Jack Nicklaus	golf
6	15	Larry Bird	basketball
7	15	Pete Rose	baseball
8	14	Mike Tyson	boxing
9	14	Arnold Palmer	golf
10	14	Bill Walton	basketball

Source: *Sports Illustrated 50th Anniversary Issue, Nov. 10, 2003.*

Besides content, other factors contributed to the magazine's success, especially the increasing popularity of sports aided by the expansion in professional franchises and television. In the early 1950s, professional leagues were limited mostly to franchises in major eastern and a few western cities. Major league baseball attendance had been declining since its record high in 1948, pro football attendance averaged less than 30,000 per game, while pro basketball was described by one observer as a "small-time, penny ante sport because it attracted so many small-time penny ante

perators."[10]

Televised sports events, especially after color television arrived in the 1960s, created more fans for all three sports. ABC originated its long-running "Monday Night Football" series in 1970, which it broadcast until 2006 when ESPN took over the series. It was the second-longest-running prime time show on network television after "60 Minutes") and one of the highest-rated. Meanwhile, the pro leagues expanded their franchises into the South, Midwest and West. The introduction of the Boeing 707 in 1958, the first modern jet, made air travel increasingly abundant and affordable and contributed to the growing national popularity of sports at all levels.

Sports Illustrated's famous "Swimsuit Issue" was created by André LaGuerre, who edited the magazine from 1960 to 1974. Casting about for an idea to add pizazz to a slow-news January, LaGuerre summoned his assistant, Jules Campbell, and asked her, "How would you like to go to some beautiful place and put a pretty girl on the cover?"

She chose a beach shooting in Baja and Sue Peterson, an 18-year-old Los Angeles model, for the cover photo. The historic date for the first Swimsuit Issue was January 20, 1964. "That issue was a vast success and became an annual fixture: exotic settings all over the world, more and more pages, more and more expanses of girls, less and less bathing suit," wrote Hedley Donovan, Time Inc.'s editor-in-chief.[11]

The swimsuit issue and its ancillary products like calendars and videos accounted for 10 percent of the magazine's profits for the next twenty years. But they came at a cost of canceled subscriptions every time it appeared, and continued criticism from both conservative readers and feminists. Nevertheless, by 2000, *Sports Illustrated* had become a national institution, the only large-circulation title ever to win consecutive National Magazine Awards for general excellence. With three million subscribers, it was the second most profitable magazine in the world (behind *People*) and had earned more than a billion dollars in profits since 1984.

"*Sports Illustrated* is like Rolex, the Rolex of magazines," said tennis star Chris Evert two decades after the magazine named her its 1976 "Sportswoman of the Year." She continued: Nobody's ever topped it. I think it was always a thrill to be on the cover, or be featured there. I can still remember the headline of the first story they ever ran about me—'More Joan of Arc than Shirley Temple'—and I was like fifteen years old at the time. It was a big deal, and it still is."[12]

TV and the "decline" of general interest magazines

Television's role in stimulating the success of *TV Guide* seems obvious. Readers needed a guide to programming and *TV Guide* met that need. *Sports Illustrated*'s success

can be equally linked to the expansion and growth of professional sports and the number of television viewers. More than that, however, television probably helped the magazine industry continue to grow.

"Television was the best thing which could have happened to magazines as a field," said James B. Kobak in 1999. Kobak, author of *How to Start a Magazine and Publish It Profitably*, spent more than fifty years as a consultant to dozens of successful magazine launches and new ventures. He went on to say:

> Remember that magazines do not exist in and of themselves. They exist only because people have interests. Since World War II those interests have been expanding—and changing—primarily because of greater affluence, better education, more travel, technical advances and probably more than anything else, television, because it introduced so many subjects for people to become interested in.[13]

Kobak made a similar observation in a 1961 speech. "It's hard to say that circulation has been hurt when circulation has increased between 1950 and 1960 by 21 percent. It's hard to say that television has hurt advertising revenue when that's increased some 80 percent in that ten year period."[14]

Many believe that television caused the decline of the general interest magazines and rise of specialized magazines. While television produced a slight acceleration of these trends, general interest magazines had been declining and folding since the early 1900s, as noted in chapter one. Nineteen general interest magazines folded between 1900 and 1950: *Arena, Lippincott's Magazine, Leslie's Weekly, The Independent, The Dial, Everybody's Magazine, Munsey's, McClure's, Century Illustrated Monthly, Smart Set, World's Work, Outlook, The Delineator, Literary Digest, Scribner Magazine, Pictorial Review, North American Review, Forum,* and *Littell's Living Age* (see table in chapter one).

Four major general interest magazines folded between 1950 and 1970: *Collier's, Life, Look,* and *Saturday Evening Post.* Two of these were later re-launched (*Saturday Evening Post* in 1972 and *Life* in 1972). *Saturday Evening Post* is still successfully published as a bi-monthly. Three lesser-known magazines stopped publishing during the 1950s: *Woman's Home Companion* (1873–1957); *American Magazine* (1876–1956) and *Coronet* (1936–1961). These magazines, however, were all owned by Crowell-Collier Publishing, which closed the magazines for mangement reasons.

Some believe that television killed general interest magazines by siphoning away advertising dollars. In order to recover from this damage, the magazine industry adapted by shifting to niche-oriented magazines on specialized topics and made an eventual recovery. Competition from television was one factor among many in the decline in revenue at *Collier's, Life, Look,* and *Saturday Evening Post.* However, television competition did not seem to affect continued growth at *National*

Geographic, The New Yorker, Reader's Digest, Harper's, most women's magazines, or hundreds of special interest magazines launched during the 1950s.

In a 1956 *Journalism Quarterly* article, Leo Bogart wrote that both general interest and total magazine circulation grew between 1946 and 1954. "The salient fact is that in 1954 the circulation of ABC-measured [Audit Bureau of Circulations] magazines was more than a fourth higher than in 1946, when TV was not even a whisper in the bars and homes of the nation," he wrote. However, he concluded that magazines, "which for the most part appeal to specific segments of the market or to specific interest groups," made the biggest gains during this time. [15]

In the same journal, Christine and Robert Root analyzed magazine circulation trends between 1938 and 1963. They concluded: "Magazines of every type have made gains much faster than the population….Americans, in brief, are buying magazines more than before World War II." They did find that magazines dealing with fishing, hunting, mechanical hobbies, sports, travel and other leisure activities made the greatest gains. Newsmagazines, while gaining substantially, trailed behind other categories, and "the popular mass magazine has lagged behind all," they said. [16]

Benjamin Compaine focused on a growth of the special interest magazine in 1980 article. He said that television's exposure of the public to new ideas, places, and interests helped spur magazine growth: "Just as book publishers have learned that a successful movie spurs book sales, so magazine publishers have learned to take advantage of television. The popularity of television spectator sports has stimulated sales for magazines and fast-breaking news on television has created opportunities for deeper analysis and perspective from the newsmagazines," he explained. [17]

Television's share of mass media advertising revenue (compared with magazines, newspapers, and radio) increased from 5 percent in 1950 to 43 percent in 2000. Magazines' market share declined from 13 percent to 9 percent. [18] Newspaper and radio share of the ad market declined substantially more than that of magazines, however. These figures are shown in Table 2.

Even though magazines' share of the advertising market declined, their total advertising revenue increased every consecutive year between 1950 and 2000 except for two. That's because the advertising pie was getting bigger. Total spending on advertising grew substantially faster than the economy as a whole. Advertising growth exceeded total economic growth in the U.S. by 860 percent during these 50 years. Total spending on advertising grew from $3.3 billion to $137.9 billion for a growth rate of 4,179 percent. Gross domestic product grew from $294 billion to $9,817 billion for a growth rate of 3,319 percent. [19] Advertising was becoming a huge business as producers and manufacturers spent escalating amounts of money to reach a growing media audience. It was not so much that the magazine industry as a whole suffered; it was simply that the rules of the game had changed.

Table 3

Market Share of Total Advertising Revenue

Year	Magazines		Television		Newspapers		Radio		Total Ad Spending
	Millions of dollars	Percent share	Millions of dollars	Percent share	Millions of dollars	Percent share	Millions of dollars	Percent share	
1950	$415	12.7%	$171	5.2%	$2,076	63.5%	$605	18.5%	$3,267
1955	$729	13.5%	$1,025	19.0%	$3,088	57.3%	$545	10.1%	$5,387
1960	$941	13.6%	$1,590	23.0%	$3,703	53.5%	$692	10.0%	$6,926
1965	$1,199	13.2%	$2,515	27.7%	$4,457	49.0%	$917	10.1%	$9,088
1970	$1,323	11.1%	$3,596	30.0%	$5,745	48.0%	$1,308	10.9%	$11,972
1975	$1,465	8.5%	$5,263	30.7%	$8,442	49.2%	$1,980	11.5%	$17,150
1980	$3,149	9.5%	$11,469	34.6%	$14,794	44.7%	$3,702	11.2%	$33,114
1985	$5,155	8.9%	$21,022	36.3%	$25,170	43.5%	$6,490	11.2%	$57,837
1990	$6,803	8.8%	$29,073	37.8%	$32,281	42.0%	$8,726	11.3%	$76,883
1995	$8,580	9.1%	$37,828	40.2%	$36,317	38.6%	$11,388	12.1%	$94,113
2000	$12,370	8.8%	$57,172	41.5%	$49,050	34.8%	$19,295	13.7%	$137,887

Sources: *Statistical Abstract of the United States* (Annual, 1950–2000)

The circulation war between *Collier's, Life, Look,* and *Saturday Evening Post* that led to their demise is well-documented in several books and articles. To summarize the story: In order to constantly increase their circulation base and attract more advertisers, they kept offering cheaper and cheaper subscriptions. Cheap subscriptions produce "cheap readers" who don't become loyal readers and don't renew. Because of expensive promotional and direct mail costs, most magazines only break even on first-year subscribers and don't began to earn a profit until after they renew. These magazines couldn't keep up with increased printing and mailing costs for their cut-rate subscriptions, while advertisers balked at increased advertising rates for their inflated numbers.

For example, a 1972 study by the Association of National Advertisers found that *Life* sold an average of 80 percent of its subscriptions for less than the standard price.[20] Advertisers didn't buy the smoke-and-mirrors charade and began to withdraw. These three magazine companies engaged in name-calling, ads attacking each other, and unethical sales practices. Ernest Jones, president of a major advertising agency, criticized the "…deplorable trend of some portions of the magazine industry to wash their sordid linen in public…to carry their intramural bickering into the public's living rooms. Full page ads giving the lie to each other; finger-pointing and snide sharp-shooting; amused and sardonic comment in the public media….The public has neither the time, knowledge nor desire to determine what the fight is all about," he told a Magazine Publishers of America convention in 1962.[21]

Three lesser-known magazines, *American Magazine, Collier's,* and *Woman's Home Companion,* were closed in 1956 by their owner, Crowell-Collier Publishing Company. *Collier's* was established in 1888 by Peter Fenlon Collier. It was purchased by Crowell Publishing in 1934, which later merged to become Crowell-Collier Publishing in 1939. A feature magazine similar to *Life* and *Look,* its circulation had risen to 4.1 million by the time of its closure. Crowell Publishing acquired *Home Companion* in 1883 and changed the name to *Woman's Home Companion.* Its most influential editor was Gertrude Battles Lane, who edited the magazine from 1912 to 1941 (see chapter three). At one time during the 1940s, it was the leading women's magazine and had reached 4.3 million readers by 1953. *The American Magazine* was created in 1906 by muckraking journalists Ray Stannard Baker, Lincoln Steffens and Ida M. Tarbell who left *McClure's* after a dispute with its publisher S.S. McClure (see chapter two).

The decision to close these once-influential magazines was the result of a series of bad business decisions by the company's management. Although *Collier's* and *Woman's Home Companion* were losing money, *American Magazine* broke even

in 1955. One historian said that Collier-Crowell was "run by bankers, not by pub
lishers or men who understood the complexities of the publishing business
Unfortunately, these bankers did not surround themselves with knowledgeable
publishers."[22]

In 1956, Collier-Crowell received an attractive offer to buy Consolidated
Television and Radio Broadcasters, Inc., a group of Midwestern television and
radio stations. In order to raise the funds, the bankers that ran the company decid
ed they could save considerable money by closing the *American Magazine* and le
the readers choose *Collier's* or *Woman's Home Companion* to fulfill their subscriptions
In a complicated sequence of events, the deal to buy the broadcasting company fel
through. Collier-Crowell was faced with no other option than to close *Collier's* and
Woman's Home Companion. The last issue of *Collier's* was published January 4, 1957
while the January 1957 issue was the last for *Woman's Home Companion*.[23]

Population growth and economic expansion benefited magazine and televisio
expansion, especially between 1950 and 1975. Population grew by 42 percent dur
ing these 25 years from 152 million to 216 million. Economic expansion was big
enough to help launch television into American homes and also sustain the growth
of the magazine industry. During this time, per capita income increased from
$1,892 in 1950 to $7,343 in 1975.

The biggest victim of television was newspapers. Americans, who had relied
upon newspapers for current events, turned increasingly to television as their pri
mary source of news. Improved technology helped the radio industry by making
them increasingly smaller, cheaper, and portable. The competition of television
was offset by increased radio use in automobiles, recreational activities and travel
Magazines turned more and more to providing specialized content to targeted
audiences. Advertisers found that magazines could deliver these targeted audi
ences better than any of the other three media.

Other magazines

Four more magazines of note were launched during the 1950s, which set trends fo
the remainder of the century. *National Enquirer* is the "father" of tabloid journal
ism in America and spawned a generation of imitators. *Playboy* was a harbinger fo
the sexual revolution of the 1960s, not to mention hundreds of similar men's "skin
titles. *Mad* was the first humor magazine that reached mainstream success and influ
enced a generation of humor and comedy writers. In a more serious vein, when
William F. Buckley, Jr. launched *National Review* in 1958, he set in motion a con
servative resurgence that resulted in the election of Ronald Reagan and two mor
Republican presidents between 1980 and 2000. We turn now to those four maga
zines.

National Enquirer

In 1952, Generoso Pope, Jr. (1927–1988) purchased the ailing *New York Enquirer* for $75,000 and turned it into the *National Enquirer*, the pioneering tabloid magazine that spawned a generation of American imitators. The *New York Enquirer*, the city's only Sunday weekly, was founded in 1926 by William Griffith, a Hearst advertising executive. Pope was an M.I.T. engineering graduate who worked for two years as a CIA intelligence officer before purchasing the *Enquirer*. He was the son of Generoso Pope, Sr. (1891–1950), an Italian immigrant who built one of New York City's largest companies, the Colonial Sand and Stone Company, and *El Progresso Italo-Americano*, the oldest Italian-language newspaper in the U.S.

Generoso (Gene) Pope, Jr. dropped the "New York" in its title and renamed it "National Enquirer" in June 1957. The early years of the *National Enquirer* focused on "gore and blood" stories about accidents and crime. He told *Time* in 1972, "I noticed how auto accidents drew crowds and decided if it was blood that interested people, I'd give it to them."[24] For example, two stories in the July 15, 1962, issue were titled, "Pets are cruelly strangled for barbaric barbecues" and "How wrists were lashed by mom, then she was strangled by her foster parents." Pope once said, "It bothered the hell out of me running that kind of paper, but it was paying the bills and after all those lean years it was a good feeling to have some money in the bank."[25] One of his most famous adages was, "Don't bore your audience. Be brief."

Pope was an intriguing and complex man. He gave huge salaries to his staff members, sometimes helped with their hospital bills and other emergencies, and made frequent donations to local Florida charities. He wore a Timex watch, inexpensive clothes, drove an old car, and never sought the company of politicians or public celebrities. He never expressed any political views, if he had any. He could be very demanding and was notorious among staff members for firing anyone on the spot who crossed or offended him.

National Enquirer became the first general-interest magazine to sell at supermarket checkout stands in the late 1960s. In seeking women shoppers, it gradually turned from blood and gore to celebrity news and gossip, as well as medical breakthroughs, the occult and UFO's.

According to Steve Coz, who was editor in 1999, "Our readers tend to be women, forty-ish, with a couple of kids. They may or may not be divorced and live in a household making less than $50,000. The women finished high school and maybe a couple of years of college."[26] In 1970, Pope moved the headquarters from New York to Lantana, Florida, and later to nearby Boca Raton.

The magazine gained some credibility in the 1980s when it turned to investigative pieces about public figures. On June 2, 1987, it ran the cover story and printed a photo of presidential candidate Gary Hart sitting on the deck of a boat with

his mistress, Donna Rice, on his knee. Hart, a Colorado senator, lawyer, and Yale Divinity School alumnus, was the Democratic front-runner in the race to succeed Ronald Reagan. According to Iain Calder, who worked for the *Enquirer* from 1964 to 1996, "Our story was a death blow to his political career. He left the presidential race before we even hit the checkout racks."[27] Everette Dennis, former executive director of the Freedom Forum Media Studies Center at Columbia University, said later, "The *National Enquirer* earned its spurs with the Gary Hart story. It established them in a new way. The fact that it happened made it more acceptable for mainstream publications to look at the *National Enquirer* as a lead for news."[28]

The *National Enquirer* also reached another watershed with its eighteen months of investigative reporting about the O.J. Simpson murder case and trial. *New York Times* reporter David Margolick wrote on Oct. 24, 1994, "With accurate saturation reporting of the killings, evidence and legal maneuvering, the *National Enquirer* has become the bible of the O.J. Simpson case....Mainstream reporters may grumble about its checkbook journalism, laugh patronizingly at its hyperbole, talk vaguely about inaccuracies. But always, they look at it."[29]

Nicole Brown Simpson, ex-wife of the NFL football superstar, and friend Ron Goldman were murdered on June 13, 1994. While Simpson was acquitted of murder charges in one of the most controversial jury decisions in history, he lost a $33 million civil suit brought against him by Goldman's father, Fred Goldman. After combing through archival photos, the *Enquirer* published a photo of O.J. Simpson wearing Bruno Magli shoes in 1995 (which Simpson had denied ever owning) like those leaving bloody footprints at the murder scene of Nicole Simpson. Although it came too late for the criminal trial, Steve Coz, who was editor at the time, said the photo was crucial to the $33 million judgment against Simpson in the civil trial.[30]

In January of 1997, Ennis Cosby, the son of comedian Bill Cosby, was murdered in a bizarre robbery and killing that occurred while he was fixing a flat tire on a Los Angeles freeway. With Bill Cosby's permission, the *Enquirer* offered a $100,000 reward for information leading to the capture of the killer. "We solved the case. It was simple," said editor Iain Calder. "After we offered the reward, a witness contacted our office in Los Angeles and told us the whole story."[31] A Ukrainian immigrant named Mikail Markhasev was later convicted and sentenced to life without parole.

While the *National Enquirer* put bizarre, attention-getting headlines on its covers, the stories themselves were often tamer, fact-oriented, and less sensational than the covers. Calder was interviewed in 1996 by the *Yale Journal of Ethics* and asked, "Do you classify what the *Enquirer* does as journalism?"

"Certainly it is journalism. We are informing Americans of the kind of thing

Table 4

American Media Inc. Magazines
National Enquirer
Star
National Examiner
The Globe
Sun
Country Weekly
Fit Pregnancy
Flex
Mira!
Shape
Men's Fitness
Muscle & Fitness
Natural Health
Current as of January 2010

they want to know about. We are the number one weekly paper in America, and we have been for the last two and half decades. You only do that by being successful." He denied charges that the *Enquirer* "made up" stories. "Some tabloids have been known to do that kind of thing. The *Enquirer* does not do that, never did it, and I don't think ever will do it as long as I am around." Carol Burnett's successful libel lawsuit against the *Enquirer* (which will be discussed in chapter 9) casts doubt on that claim. It was, however, the only successful libel litigation among many filed against the *Enquirer*.

By 1969, circulation climbed to 1.2 million, which topped the *Reader's Digest* in single copy sales. Circulation reached 5.7 million at its peak in 1978 but gradually declined due to increased competition from similar tabloids like *Weekly World News*, *Star*, the *Globe*, and the *National Examiner*.

After Pope died in 1988, his heirs sold the company for $412.5 million to Boston Ventures, a group that included McFadden Holdings, a publisher of romance and trade magazines.[32] That linked *National Enquirer* back to Bernarr Macfadden (1868–1955), who launched a new genre of confession and romance magazines in 1919 with *True Story* (see chapter three). That group later re-organized itself as American Media, Inc. The new company bought the *Star* from Rupert Murdoch in 1990 and began purchasing and consolidating competing tabloid magazines. It

purchased Globe Communications, owner of the *Globe* and *National Examiner*, in 1999. David J. Pecker, the former president of Hachette Filipacchi Magazines became president of American Media Inc. (AMI) that same year.

Today AMI publishes six of the top fifteen best-selling weekly newsstand titles in the country. One is the Spanish-language *Mira!*, the best-selling celebrity magazine in the Hispanic market. The company made headlines in late 2001 after its headquarters building in Boca Raton, Florida, was victimized by an anthrax attack, and employees were forced to evacuate. Since then the corporate headquarters have moved back to New York City, but the magazines maintain their editorial offices in Boca Raton.

Mad magazine

Mad is a humor and satire magazine launched in 1952 by publisher William Gaines (1922–1992) and founding editor Harvey Kurtzman (1924–1993). Originally a comic book that spoofed other comic books, Kurtzman turned it into a magazine with issue #24 in July 1955. *Mad* became legendary for poking fun at popular culture, especially advertisements, TV programs, political figures and entertainment celebrities.

According to the *New York Times*, "*Mad*'s wacky brand of humor influenced everything from *The National Lampoon* to 'Saturday Night Live' to a recent issue of *Esquire* magazine." *Time* magazine said, "*Mad* was the first comic enterprise that got its effects almost entirely from parodying other kinds of popular entertainment ….To say that this became an influential manner in American comedy is to understate the case."

William Gaines was a comic book publisher who inherited EC Comics from his father, Max Gaines, after his death. Max Gaines (1894–1947) was himself a pioneering figure in the creation of the modern comic book. In 1933, he created the first four-color, saddle-stitched pamphlet, which became the standard format for modern-day comics. Max Gaines called his company "Educational Comics," but his son changed the name to "Entertaining Comics" after he took over. Between 1947 and 1952, the company was publishing nine successful comic books that were edited by his two senior editors, Harvey Kurtzman and Al Feldstein.

Kurtzman, who edited *Two-Fisted Tales* and *Frontline Combat*, asked Gaines one day why he wasn't making as much money as Feldstein. Gaines pointed out that Feldstein was turning out seven comic books to Kurtzman's two, but made him this proposition: "I tell you what, Harvey. I know you're a humorist. Why don't you put out a humor magazine? Just slip it in between your two war books and your income will go up 50 percent." Kurtzman started planning the humor magazine over the summer and published his first issue in August 1951. The rest is, well, *Mad* history.

ry, which is well documented in two excellent books: *The Mad World of William M. Gaines* (1972) by Frank Jacobs and *Completely Mad* by Maria Reidelbach (1991). Harvey Kurtzman left as editor in 1956 to start *Trump*, a *Playboy*-backed humor magazine that lasted for only two issues.[33] He was replaced by Al Feldstein, who edited the magazine until 1984. The magazine's circulation peaked at 2.8 million in 1974. When Feldstein retired in 1984, he was replaced by Nick Meglin and John Ficarra, who co-edited *Mad* for the next two decades. Founder and publisher William Gaines died in 1992, but by that time the magazine was owned by Time Warner. After Meglin retired in 2004, John Ficarra became editor and continues to edit the magazine today.

Alfred E. Neuman is *Mad*'s most famous cover celebrity. The fictional mascot made his debut on the March 1955 cover and has appeared in some form on more than 500 covers since then. The "What—Me Worry?" image of the teen-aged boy is distinguished by a grin, big ears and one eye slightly lower than the other. In 1956, *Mad* announced Neuman as a candidate for president, the first of an endless string of unsuccessful campaigns. His face has been portrayed as a carving on Mount Rushmore, a flower child, an organ grinder and even Uncle Sam on a recruiting poster ("Who Needs You?"). Although Kurtzman created the name of "Alfred E. Neuman," the image itself has unclear print origins dating back into the nineteenth century.[34] In 1966, Gaines won a copyright infringement lawsuit filed by a Vermont woman who claimed her husband had created the grinning kid in 1914. The U.S. District Court ruled that the Alfred E. Neuman image was in the public domain when *Mad* began using it.

Mad has been the defendant in several lawsuits throughout its six-decade history. In the summer of 1963, Al Feldstein was looking for a bonus piece to put in an annual supplement, "More Trash from Mad." Nick Meglin and Feldstein came up with the idea of "Sing Along with *Mad*," a twenty-page songbook of parody lyrics which the magazine said could be "sung to the tune of many popular songs." A group of music publishers that represented Irving Berlin, Richard Rodgers, Cole Porter and other songwriters filed a $25 million copyright infringement lawsuit claiming that the parody of their song lyrics violated copyright laws. The plaintiffs hoped to establish a legal precedent that only a song's composers retained the right to parody that song. The U.S. District Court ruled in favor of *Mad* on twenty-three songs, but in favor of the plaintiffs on two other songs, "Always" and "There's No Business Like Show Business," which it said did violate copyright. The plaintiffs appealed to the U.S. Court of Appeals, which ruled completely in favor of *Mad* on all twenty-five songs. After the U.S. Supreme Court refused to hear the case, the lower courts' decisions were allowed to stand.[35]

For almost fifty years, *Mad* maintained the distinction of being one of few popular consumer magazines to never carry advertising. Except for the cover, it was

printed mostly in black and white and newspaper stock. In 2001, it broke that tradition and began running paid advertising, which allowed for the introduction of color printing and improved paper stock. After its 500th issue in June 2009, amid widespread cutbacks at Time Warner, the magazine began a quarterly publishing schedule.

Hugh Hefner and *Playboy*

After graduating from the University of Illinois with a psychology degree in 1949, Hugh Hefner drifted through a series of "day jobs" while aspiring to become a professional cartoonist. After working as an advertising copy writer for a department store, he landed a job writing promotional copy at *Esquire* (which published photos of nude women during the late 1940s). But *Esquire* was preparing to move to New York City, and Hefner preferred to stay behind in the Windy City. In 1952, he found a job as sales and promotion manager for Publisher's Development Corporation that published *Modern Man, Art Photography* and *Modern Sunbathing*, all of which also included nude photos on their pages. Here he learned how to deal with newsstand dealers, distributors, and printers. His last job before *Playboy* was as circulation promotion manager for *Children's Activities*, a national children's magazine, where he learned more about circulation techniques. He achieved some local notoriety as a cartoonist when he published *That Towdlin' Town: A Rowdy Burlesque of Chicago Manners and Morals*, a book of satirical cartoons offering a risqué look at the Chicago social scene.[36]

Rebelling against the strict religious values of his parents, Hefner developed an individualist creed of self-expression and personal autonomy linked with sexual experimentation. From his previous experience, he knew there was a market for nude photos of women, but he conceived a magazine with a little more class and literary quality than those he had worked for. His original title for his new magazine was *Stag Party*. After the owner of *Stag* magazine threatened a copyright infringement lawsuit, he settled on "Playboy." He purchased the rights to several nude photos of Marilyn Monroe taken in 1949, which he made into the first *Playboy* centerfold. The first issue was published in early 1953 without a date because Hefner was uncertain whether sales would be successful enough to publish a second issue. The rest, as the cliché says, is history, which has also been well documented in two books: *Bunny, The Real Story of Playboy* by Russell Miller (1985) and *Mr. Playboy: Hugh Hefner and the American Dream* by Steven Watts (2008).

Two incidents in its later history brought notoriety to the magazine. Freelance journalist Gloria Steinem (1934-___) went undercover in 1963 to obtain a job at Chicago's Playboy Club and write her famous exposé, "I was a Playboy Bunny" for *Show*, an arts and culture magazine. In diary form, it detailed the grueling, under-

paid and harassing working conditions of the young women employed by Hefner. The article was published in Steinem's 1983 book of essays, *Outrageous Acts and Everyday Rebellions* and made into a television movie, "A Bunny's Tale," starring Kirstie Alley. The emerging women's movement of the 1960s and 1970s made *Playboy* an increasing target of feminist wrath. Campus demonstrations erupted, such as one at the University of Southern California where a group of women carried signs reading "We Won't Take *Playboy* Lying Down" and heckled a magazine spokesperson during a talk.[37]

Gloria Steinem became a leading feminist activist and one of the founding editors of *Ms.* magazine in 1972. Hefner and Steinem never met until they were brought together in 1998 for induction into the American Society of Magazine Editors' Hall of Fame. Hefner was honored for his publishing success with *Playboy* and Steinem was honored for her success with *Ms.*[38]

Playboy also became famous for its monthly feature, "The Playboy Interview," with entertainment, sports and political celebrities. The most-quoted interview came in November 1976 with Jimmy Carter (1924-__), who won the presidential election that year. Carter, who was a devout Baptist, was widely lampooned for his "I have lust in my heart" quote. What he actually said was, "I've looked on a lot of women with lust. I've committed adultery in my heart many times....This is something that God recognizes, that I will do and have done, and God forgives me for it." In a later interview, historian Douglas Brinkley told PBS, "Do not underestimate what a crisis that interview and the 'lust in my heart' caused Carter. It almost derailed the entire Carter campaign. They were in havoc over it."[39]

Playboy reached its peak circulation of 7.2 million in 1972, which declined by two thirds to 2.7 million by 2008. During the 1980s, video recorders and VHS tapes became widely available and could provide more of the nude reality that had made *Playboy* famous. During the 1990s, the Internet made such content even more readily accessible and free.

Hugh Hefner promoted his daughter Christie Hefner (1952-__) to president of Playboy Enterprises in 1982 and CEO and chairman of the board in 1988. She held that position for twenty-one years until she stepped down in early 2009.

William Buckley and *National Review*

William F. Buckley, Jr. (1925–2008) graduated from Yale University in 1950, where he was captain of the debate team and chairman of the *Yale Daily News*. The next year, he was thrust into national attention when he published *God and Man at Yale: The Superstitions of "Academic Freedom,"* a controversial book that criticized Yale for having strayed from its original religious and philosophical ideals. Buckley, a Roman Catholic, went on to achieve national fame as the author of more than fifty books,

the syndicated column "On the Right" published in 300 newspapers, and host of the PBS television program, "Firing Line" from 1966 to 1999. In 1955, he founded *National Review*, which had a more significant influence on the rise of American conservatism than any other single publication.

During the 1950s, the *New Republic* and *The Nation* were among eight weeklies advocating a left-of-center position on political issues. Although the moderate Republican Dwight Eisenhower (1890–1969), was elected president in 1952, conservatism had no strong voice among American magazines. *The Freeman* was the only conservative periodical, but its circulation was modest and it had never gained a significant voice in the public arena.

In his 1950 book, *The Liberal Imagination: Essays on Literature and Society*, Lionel Trilling (1905–1975) wrote:

> In the United States at this time liberalism is not only the dominant but even the sole intellectual tradition. For it is the plain fact that nowadays there are no conservative or reactionary ideas in general circulation...the conservative impulse and the reactionary impulse do not...express themselves in ideas but only...in irritable mental gestures which seek to resemble ideas.[40]

When three editors at *The Freeman* resigned in 1953 after an internal dispute, Buckley started planning his magazine that would bring together a diverse coalition of conservative thinkers and reach an audience of intellectuals and opinion makers. Buckley joined with Willi Schlamm, a former editor at *The Freeman*, to raise $300,000 to launch the magazine. He recruited a staff of writers and editors that included Whittaker Chambers, Garry Wills, Russell Kirk, James Burnham, Frank Meyer, L. Brent Bozell (Buckley's brother in law), and Willmoore Kendall (Buckley's former Yale professor).

Like most political opinion magazines, *National Review* carries little corporate advertising and has never earned a profit. Buckley said in 2005 that the magazine had lost about $25 million over fifty years.[41] Like similar political magazines, it stays afloat with donations from subscribers, foundations and various fundraisers.

Buckley remained as editor-in-chief until 1997, when he was succeeded by Richard Lowry, his hand-picked successor. Glenn Anderson wrote in *American Mass Market Magazines*, "Although never a physically splashy magazine, *National Review*'s polysyllabic verbal pyrotechnics remain one of its most characteristic features. Ronald Reagan once said that he'd spent 'many happy hours in my favorite chair, *National Review* in one hand, the dictionary in the other.'[42]

A decade of play and leisure

In conclusion, *TV Guide*, *Sports Illustrated*, *Playboy*, *Mad* and *National Review* both set the tone and reflected the tone of the 1950s. Although the decade was not quite

as conventional as widely assumed, the magazines of the decade reflected one of play and leisure. The 1960s were to see a different mood that dispelled the playful leisure of the 1950s. It was a decade full of conflict, controversy, sexual experimentation, social movements, and political movements. But it also thrust some of the 20th century's best writers and best writing to the forefront with a more in-depth style of writing dubbed "The New Journalism."

Notes

1. Michael MacCambridge, *The Franchise: A History of Sports Illustrated Magazine* (New York: Hyperion, 1997), 31.

2. Lois Gordon and Alan Gordon, *American Chronicle: Six Decades in American Life 1920–1980* (New York: Atheneum, 1987), 289.

3. James Playsted Wood, *Magazines in the United States,* 3rd ed. (New York: The Ronald Press Company, 1971), 289.

4. *New York Daily News,* October 16, 2008, www.nydailynews.com/money/2008/10/16/2008–10–16_tv_guide_sold_for_one_dollar.html (accessed November 14, 2009).

5. MacCambridge, *The Franchise,* 12–13.

6. Hedley Donovan, *Right Times, Right Places: Forty Years in Journalism Not Counting My Paper Route* (New York: Henry Holt, 1989), 340–341.

7. MacCambridge, *The Franchise,* 33.

8. Donovan, *Right Times, Right Places,* 351.

9. *Sports Illustrated, 50th Anniversary Issue 1954–2004,* November 10, 2003, 92–93.

10. MacCambridge, *The Franchise,* 23.

11. Donovan, *Right Times, Right Places,* 310.

12. MacCambridge, *The Franchise,* 6.

13. James B. Kobak, letter to the author, February 20, 1999.

14. Quoted in Theodore Peterson, *Magazines in the Twentieth Century* (Urbana-Champaign: University of Illinois Press, 1964), 24.

15. Leo Bogart, "Magazines Since the Rise of Television," *Journalism Quarterly* 33 (Spring 1956): 153–166.

16. Christine V. Root and Robert Root, "Magazines in the United States: Dying or Thriving?" *Journalism Quarterly* 47 (1964): 15–22.

17. Benjamin Compaine, "The Magazine Industry: Developing the Special Interest Audience," *Journal of Communication* 30, 2 (Spring 1980): 98–103.

18. *Statistical Abstract of the United States* (annual, 1955 to 2000). Washington, DC: Government Printing Office.

19. U.S. Bureau of Economic Analysis, May 26, 2005. Cited in *Time Almanac 2007* (Boston: Pearson Education, 2006), 600.

20. *Magazine Circulation and Rate Trends, 1940–1971.* New York: Association of National Advertisers, 1972. Cited in A.J. Van Zuilen, *The Life Cycle of Magazines; A Historical Study of the Decline and Fall of the General Interest Mass Audience Magazine in the United States During the Period 1946–1972* (Ulthorrn, The Netherlands: Graduate Union Press,

1977).

21. "Yesterday's Quote," *The New York Herald Tribune*, February 1, 1962, 35.
22. Van Zuilen, *The Life Cycle of Magazines*, 121.
23. See Paul C. Smith, "The Collier's Affair: A Rueful Memoir," *Esquire*, September 1964, 135. See also Smith's memoirs, *Personal File: An Autobiography* (New York: Appleton-Century, 1964).
24. Cited in Pat McGraw, "The First of the Worst: The Early Days of the *National Enquirer*." Presented at the Southeast Colloquium, March 2002, Association for Education in Journalism and Mass Communication, Little Rock, AR.
25. William Amlong, "Pope: The High Priest of Lowbrow," *Tropic, The Miami Herald Sunday Magazine*, January 14, 1973, 17–18, 30.
26. McGraw, "The First of the Worst."
27. Iain Calder, *The Untold Story: My 20 Years Running the* National Enquirer (New York: Miramax/Hyperion, 2004), 212.
28. Jack Vitek, *The Godfather of Tabloid: Generoso Pope Jr. and the* National Enquirer (Lexington: University Press of Kentucky, 2008), 244.
29. David Margolick, "The *Enquirer*: Required Reading in Simpson Case," *New York Times*, October 24, 1994 (accessed www.nyt.com, November 16, 2009).
30. Andrea Sachs, "Mud and the Mainstream," *Columbia Journalism Review* (May/June 1995). Cited in Vitek, *The Godfather of Tabloid*, 245.
31. Calder, *The Untold Story*, 303.
32. Vitek, *The Godfather of Tabloid*, 230.
33. Shirrel Rhoades, *A Complete History of American Comic Books* (New York: Peter Lang Publishing, Inc., 2008), 262.
34. John Ficarra, e-mail to David E. Sumner, November 10, 2009.
35. Frank Jacobs, *The Mad World of William M. Gaines* (Secaucus, NJ: Lyle Stuart, Inc., 1972), 221–223.
36. Steven Watts, *Mr. Playboy: Hugh Hefner and the American Dream* (New York: John Wiley & Sons, 2008), 52.
37. "*Playboy* Attacked by Student Feminists," *Daily Trojan*, April 9, 1970. Cited in Watts, *Mr. Playboy: Hugh Hefner and the American Dream*, 241.
38. Alex Kuczynski, "Bosom Foes Together Again," *The New York Times*, May 3, 1998, 1.
39. "Jimmy Carter," *The American Experience* (WGBH, Public Broadcasting System, 2002), http://www.pbs.org/wgbh/amex/carter/filmmore/index.html.
40. Lionel Trilling, *The Liberal Imagination: Essays on Literature and Society* (New York: Viking Press, 1950), ix.
41. Gary Shapiro, "An 'Encounter' with Conservative Publishing," *The New York Sun*, December 9, 2005.
42. Glenn Anderson, "National Review," in Alan Nourie and Barbara Nourie, eds., *American Mass Market Magazines* (New York: Greenwood Press, 1990), 296.

The 1960s

Social Change for Magazines and America

No other decade ushered in as many social changes as the 1960s. Tom Wolfe wrote in *The New Journalism,* "The Sixties was one of the most extraordinary decades in American history in terms of manners and morals. Manners and morals *were* the history of the Sixties." He continued:

> A hundred years from now when historians write about the 1960s in America (always assuming, to paraphrase [French writer] Céline, that the Chinese will still give a damn about American history), they won't write about it as the decade of the war in Vietnam or of space exploration or of political assassinations. . . . but as the decade when manners and morals, styles of living, attitudes toward the world changed the country more crucially than any political events.[1]

It was that kind of decade. While it saw the emerging civil rights movement, women's movement and gay rights movement, it also brought hippies, widespread sexual promiscuity, rock music, and drug use. A president, presidential candidate and civil rights leader were assassinated, while the whole decade saw violent demonstrations. The younger generation rejected traditional careers in favor of "meaning in life." Ray Kroc started McDonald's, the nation's first fast-food chain. The word "Negro" disappeared from public use to be replaced by "Black" and later "African-American." Married men and women hyphenated their last names, while women asked to be addressed as "Ms." instead of "Mrs." or "Miss."

Magazines led the way in covering these events with "the New Journalism," a form of writing that greatly affected the way that newspapers and magazines told their stories. Tom Wolfe (1931–) wrote in his book about the history of this movement:

> There were no manifestos, clubs, salons, cliques, not even a saloon where the faithful gathered since there was no faith and no creed. At the time, the mid-Sixties, one was aware only that all of a sudden there was some sort of artistic excitement in journalism, and that was a new thing in itself.[2]

Fewer new magazines were launched in the 1960s than in any preceding decade—at least well-known magazines still published today. The most successful new magazines of the decade were *Rolling Stone* in 1967, *The Advocate* in 1967 and *New York* in 1968. *Rolling Stone* and *New York* magazines were among the leaders in the New Journalism movement, while *The Advocate* was a gay rights newsmagazine.

Esquire led the pack in covering the 1960s. Many books have been written about many magazines, but only one magazine had three books written about one decade in its history: *Esquire*. The first was *Smiling through the Apocalypse: Esquire's History of the Sixties*, a 981-page book containing fifty-nine of its articles published between 1960 and 1969. The second book was *It Wasn't Pretty, Folks, But Didn't We Have Fun? Esquire in the Sixties*, a ten-year history of *Esquire* under its legendary editor Harold Hayes (1926–1989) by Carol Polsgrove, an Indiana University professor.[3] The third was *Covering the '60s: George Lois, The Esquire Era*, which contains full-page reproductions of seventy famous *Esquire* covers between 1962 and 1972 by art director and designer George Lois.

Under Hayes, *Esquire* was indeed at the forefront of the New Journalism. "*Esquire* did its part to break up the monochrome of fifties culture in the early sixties, ranging widely across the scene, acquiring an attitude: an irreverent, skeptical edge . . . ," Polsgrove wrote. The names of many *Esquire* writers during the 1960s are still widely known: Hunter Thompson, Norman Mailer, Tom Wolfe, Gay Talese, James Baldwin, Garry Wills, Gore Vidal, William F. Buckley, Jr., and Malcolm Muggeridge.

The simplest definition of New Journalism is "the use of fiction techniques in nonfiction reporting." The most commonly cited fiction techniques included scene-by-scene storytelling, character development, dialogue, monologue, and detailed description of characters and their environments. Their works were called "new" at the time because they departed from the traditional inverted pyramid, "Five-W" style of reporting. The unit of construction for these styles of stories was not the fact or piece of information, but the re-creation of a scene—much like in a movie. The purpose was not merely to convey facts and information, but give readers an emo-

tional impact by re-creating the feeling, ethos and mood of an event.

It was, however, a controversial movement criticized from inside and outside the journalism profession. Critics charged that the "new journalists" re-created (or made up) the dialogue and thoughts of their characters in a way that couldn't be verified. The new journalists replied that all of their quotes and dialogues were based on their interviews with sources. Critics charged that new journalists sometimes inserted themselves into their stories, wrote in first-person, and failed to write objectively. New journalists countered that a first-person interpretation of an event or a person sometimes gave a more accurate representation of "the truth" than traditional objective reporting.

From its origin to the current day, debate continues about whether these techniques were "new" or earlier authors in American history used the same techniques. What made it a "new" movement, however, was the large number of magazine and newspaper journalists who consciously used and defended the techniques. Gay Talese was among the first to do so. He was a *New York Times* reporter from 1955 to 1965 and started writing freelance articles for *Esquire* in 1960. He said in an interview with this author:

> In my college years, I used to read mostly fiction and I still do. It was the short story that caught my imagination as done by John O'Hara or Irwin Shaw, who were very popular short story writers. I was very interested in trying to bring to magazine writing or daily reporting if I could get the room to do it, some of these story-telling techniques. But never at the expense of verifiable factual reporting and using real names; never composite characters.[4]

Talese said in the same interview that he didn't like the term "New Journalism" because "a lot of people think of New Journalism as playing fast and loose with the facts, and I've always taken great care to be accurate."

Some accounts of the New Journalism stressed the newspaper backgrounds of some of its major authors, such as Tom Wolfe at the *New York Herald Tribune* and Gay Talese at the *New York Times*. Most of their best-known New Journalism books, however, first appeared as freelance work in magazines. It doesn't appear to have made a strong impact on newspapers until later. Most of the books by the well-known new journalists originated as magazine articles or a series of articles. Table 1 offers a list of some of the best-known books by New Journalism authors— books that are frequently cited in discussions about the New Journalism.

Although the New Journalism made an impact on many magazines, the ones most frequently cited as "carriers of the banner" were *Esquire, New York, The New Yorker, Harper's*, and *Rolling Stone*. Each one had a high-profile editor during the 1960s who made an impact on his magazine, his writers and the decade.

Table 1

Best-Known New Journalism Books, Authors and Originating Magazines		
1	*The Armies of the Night* (1971 Pulitzer Prize winner) First published in *Commentary, Harper's*	Norman Mailer
2	*In Cold Blood* First published in: *The New Yorker*	Truman Capote
3	*Electric Kool Aid Acid Test* First published in: *New York*	Tom Wolfe
4	*Slouching Towards Bethlehem* First published in: *Saturday Evening Post* and other magazines	Joan Didion
5	*The Kingdom and the Power* First published in: *Esquire, Harper's*	Gay Talese
6	*Honor Thy Father* First published in: *Esquire*	Gay Talese
7	*Fear and Loathing on the Campaign Trail '72* First published in: *Rolling Stone*	Hunter Thompson
8	*Kandy-Colored Tangerine-Flake Streamline Baby* First published in: *Esquire*	Tom Wolfe
9	*Fear and Loathing in Las Vegas* First published in: *Rolling Stone*	Hunter Thompson
10	*Dispatches* First published in: *Rolling Stone, Esquire*	Michael Herr
Source: Author's research		

Harold Hayes and *Esquire*

Harold Hayes is the magazine editor most frequently quoted and written about in this period. *Vanity Fair* published a 2007 article profiling *Esquire* during the 1960s under Harold Hayes, calling it "The *Esquire* Decade." "Hayes's *Esquire* would identify, analyze, and define the new decade's violent energies, ideas, morals, and conflicts—though always with an ironic and, occasionally, sardonic detachment that kept the magazine cool as the 60s grew increasingly hot," wrote Frank Digiacomo. He said the terms "point of view," "tone," "perspective," and "irreverence" were often used by Hayes with his writers. "These qualities distinguished *Esquire* from the jaunty suburban earnestness of *The New Yorker*, or its duller competitors *Harper's* and *The Atlantic*. They also gave the magazine urgency and a timeliness that month-

lies didn't ordinarily have," he wrote.[5]

Esquire's influence in the development of the New Journalism was the result of a happy coincidence. The magazine's fortunes sagged in the late 1950s and "it was obvious that we needed to once again establish ourselves as a unique magazine," said Hayes. "We decided to go to very good writers." There were at the same time such writers as Mailer, Gore Vidal, William Styron and James Baldwin who "wanted to express themselves in nonfiction on the issues of the day." Said Hayes, "We suited each other's purposes. For these writers, the move to *Esquire* was a step down critically; but a step up in terms of national exposure."

Clay Felker recalled that he and Hayes, while they worked together at *Esquire*, were deliberately attempting to create a new style of writing for the magazine. In an interview with this author, he said:

> I think *Esquire* was in the forefront [of the New Journalism] and then it was picked up by others. *New York* was an outgrowth of *Esquire* because I had been an editor at *Esquire* and learned these techniques. We started doing New Journalism in the 1950s. It was a conscious experiment in order to give us what marketing people call a "product difference." It had to be substantive and something other people couldn't do.[6]

As a pioneer of the New Journalism, Gay Talese was one of the first writers to apply the techniques of fiction to nonfiction in this period. Some of Talese's most famous articles appeared in *Esquire* during the Hayes era including his profile of singer Frank Sinatra ("Frank Sinatra Has a Cold"), prize fighter Floyd Patterson ("The Loser"), and "Honor Thy Father," a profile of mafia leader Joe Bonanno and his son. His first *Esquire* article appeared in December 1960. Talese recalled his dissatisfaction with the restraints put on daily reporting:

> . . . I found I was leaving the assignment each day, unable with the techniques available to me or permissible to the *New York Times*, to really tell, to report, all that I saw: to communicate through the techniques that were permitted by the archaic copy desk. So I don't know at what point I got into another form of journalism, more ambitious, more suspect. . . . I started with trying to use techniques of the short story writer in some of the *Esquire* pieces I did in the early sixties.[7]

Esquire's covers by George Lois were also legendary. They were provocative, funny, outrageous, and controversial. The May 1968 cover, while Richard Nixon was campaigning for his second bid for president, showed a large image of his face with four unidentified hands applying lip stick and makeup. The cover line was, "Nixon's Last Chance: This Time He'd Better Look Right!," an oblique reference to his droopy appearance in the televised 1960 debates with John F. Kennedy. After the issue was published, Hayes received a call from a member of Nixon's campaign staff who crit-

icized it, saying it was an "attack on Nixon's masculinity." He called Hayes "a lousy liberal" and hung up.[8]

Harold Hayes wrote in the September 1972 issue (shortly before both left) about why Lois was such a great designer. "His visual excellence springs from two sources. a) his belief that a picture is dependent on some accompanying statement in order to project an idea; b) his intuitive grasp of the idea to be rendered," Hayes wrote. Then he added, "What is left unaccounted for within these parameters may be summarized as talent."[9]

Clay Felker and *New York* magazine

Clay Felker (1925–2008) was an assistant editor along with Harold Hayes at *Esquire* until 1962 when Hayes was promoted to editor. Felker left soon after that to join the staff of the *New York Herald Tribune* as editor of its Sunday supplement *New York*. Five years later when the *Herald Tribune* folded, Felker found investors, raised funds and launched *New York* as an independent magazine (*New York* is a different magazine than *The New Yorker*.) Felker's promotion attracted 60,000 charter subscribers with an advertising campaign that promised "New York on $5 a Year" and offered chances to win 1,001 prizes, including dinner with Mayor John Lindsay at Gracie Mansion. He defined its editorial policy as "New York and good writing—that's what we are about. We want to be the weekly magazine that communicates the spirit and character of contemporary New York."[10] His original writers included Tom Wolfe (1931–), Gail Sheehy (1937–) and Gloria Steinem (1934–). Felker and Sheehy were married in 1984.

Felker said in a 1996 interview with this author, "I went over to the *Herald Tribune* and took those techniques with me onto the Sunday supplement called *New York* magazine," he said. "We had a cityside reporter, Tom Wolfe, who was assigned to [the magazine] to write one article a month. That's where Tom Wolfe came from; he was a city side rewrite person. Then the *Herald Tribune* folded up. I went out and raised money and started *New York* magazine as an independent publication."[11]

He later told the *New York Times*, "I had been experimenting along with several other editors in town with something that was then called the New Journalism and is now called Literary Journalism. These were people who could do that, using the traditional techniques of English literature in a different form—which I have always felt communicates not only the facts but the emotions."[12]

"I can't tell intelligent and accomplished writers how to think," Felker once said. Rather than prescribing subjects and guiding the writing, he encouraged his writers to "pinpoint important trends before they become universal."[13] Gloria Steinem has said of Felker, "Clay is a walking test area for ideas. He grasps them, makes them

grow, and doesn't care where they come from."[14]

Nora Ephron said of him: "I've never seen anything like him. If you tell him you're having a lobotomy tomorrow, he would say: 'Hmmm, lobotomy, lobotomy, what can I do with it?' He sees stories everywhere."[15]

"Radical Chic," a 20,000-word article by Tom Wolfe, is one of *New York's* most famous articles of the era. With detailed and sardonic mockery, Wolfe described a fund-raising party given by musical conductor Leonard Bernstein in his Park Avenue apartment, which was attended by rich liberals and Black Panthers, who received the evening's charitable proceeds. The June 1970 article outraged both the liberals and the Black Panthers, but the issue sold out.

When he died in 2008, the *New York Times* described Felker's successful editorial formula, which was imitated by dozens of city magazines launched in other cities during the next two decades:

> Mr. Felker came up with a distinctive format: a combination of long narrative articles and short, witty ones on consumer services. He embraced the New Journalism of the late '60s: the use of novelistic techniques to give reporting new layers of emotional depth … Meanwhile, what he called its "secret weapon," its service coverage—on where to eat, shop, drink and live—kept many readers coming back."[16]

William Shawn and *The New Yorker*

Ronald Weber in *The Literature of Fact* cites *The New Yorker* as the premier carrier of the New Journalism banner.[17] William Shawn (1907–1992), editor of *The New Yorker*, assigned and encouraged Truman Capote (1924–1984) to write *In Cold Blood: A True Account of a Multiple Murder and Its Consequences*, which originally appeared as a four-part series in September and October of 1965.[18] After the book was published in February 1966, it became New Journalism's first widely acclaimed bestseller. Capote's book sold out of its first printing of 100,000 copies within a few weeks. Columbia Pictures paid $1 million for film rights, and Book-of-the-Month Club featured it as a monthly selection. By 1983, the book had brought Capote an estimated $2 million in royalties on more than three million copies.[19] The original "In Cold Blood" movie came out in 1967 starring Robert Blake, Scott Wilson and John Forsythe; a TV remake came out in 1996. In 2008, "In Cold Blood" was chosen for the U.S. National Film Registry by the Library of Congress as being "culturally, historically, or aesthetically significant."

Truman Capote, who was born in New Orleans, wrote ten novels before producing his first nonfiction work. Although he became a brilliant and prolific author, he never attended college and obtained his first job with *The New Yorker* when he was seventeen. "The job wasn't very glamorous, just clipping newspapers and filing

cartoons," he once said. But it marked the beginning of his long association with the magazine that would serialize his best-known work and shape his writing style. The Public Broadcasting Service produced a 2006 documentary about Truman Capote in its "American Masters" series.

Another New Journalism author and Pulitzer Prize-winner, John McPhee (1931–), has been associated primarily with *The New Yorker*. His eclectic writing career, which covered many areas of interest, began at *Time* and led to a long association with *The New Yorker* beginning in 1965. Many of his twenty-nine books include material originally written for that magazine. His first book, *A Sense of Where You Are* (1965) profiled basketball star Bill Bradley, who later became a U.S. Senator from New Jersey and Democratic candidate for president in 2000. McPhee's book *Annals of the Former Worlds*, a geological history of North America, won the Pulitzer Prize for general nonfiction in 1999.

Willie Morris and *Harper's*

Harper's editor Willie Morris (1934–1999) has also been praised for his accomplishments in developing the new genre at *Harper's*. Morris graduated from the University of Texas and was editor of *The Daily Texan* before attending Oxford University as a Rhodes Scholar. He returned to the U.S. and became editor of *The Texas Observer*. His freelance articles for *Harper's* during that time impressed its editors so much that he was hired as an associate editor in 1963.

After working in this position four years, Morris was chosen editor of *Harper's* at the age of thirty-three in 1967, the youngest in the magazine's long history. During his four years as editor-in-chief, he revitalized the magazine by recruiting well-known writers and encouraging lengthy literary reporting and nonfiction. Willie Morris wrote fondly of his days at *Harper's* in his memoir *New York Days:*

> I believe we had succeeded in bringing together many of the nation's best writers who were dramatically reflecting the clashing American cultures of the time: the tensions and madness, the complexity and promise. We were pushing the language to its limits in a national journal that was iconoclastic and unpredictable and, I trust, edifying and entertaining.[20]

One of his accomplishments was recruiting the acclaimed novelist Norman Mailer (1923–2007) to write about his October 1967 march on the Pentagon. Part one, "The Steps of the Pentagon" about a public demonstration against the Vietnam War, first appeared in the March 1968 issue of *Harper's*. Part two, "The Battle of the Pentagon" was written for *Commentary* in April 1968. After being published as a book, *Armies of the Night* won both a National Book Award and the Pulitzer Prize

for nonfiction.[21]

In his account, Mailer gave readers a subjective account of one of the decade's largest public demonstrations against the Vietnam War. He used colorful and sometimes profane language, which Morris said, " . . . opened radical new ground in subject matter and in the uses of the language in popular national journals." Morris said that Mailer's 90,000-word article was the longest magazine article published in history. John Hersey's "Hiroshima" in *The New Yorker* (August 31, 1946) previously held that honor. But Morris also admitted that Mailer's article provoked controversy and more letters to the editor than any piece in the magazine's history. Most of them were hostile and asked for subscription cancellations, not because of Mailer's anti-war stance, but because of his profanity and use of language. Mailer spent days reading all of them and later came to Morris and said, "All these people sitting all over America writing these letters. They're carrying on a conversation with a magazine as if a magazine itself were a human being."[22]

Morris resigned in 1967 under pressure from *Harper's* owners due to declining advertising sales and sometimes controversial content. He returned to his native Mississippi, where he taught writing classes at the University of Mississippi and wrote and published twenty books before his death in 1999.

Jann Wenner and *Rolling Stone*

Rolling Stone, which became the country's best-known rock music magazine, was started in 1967 by Jann Wenner (1946–). *Rolling Stone* was essentially a rock music fan magazine during its first few years, but became a home of literary nonfiction in the 1970s. After Wenner hired John Burks as managing editor, *Rolling Stone* took on a new journalistic weight and began publishing some of the best writers of the era.

Wenner grew up in the affluent Marin County suburbs of San Francisco, where his father, Ed Wenner, owned a successful baby formula company. At the age of twelve, his parents sent him to the Chadwick School in Los Angeles, which had a reputation as "an orphanage of rich kids."[23] A National Merit Scholar finalist, Wenner decided to attend the University of California at Berkeley, where he majored in English for two years before dropping out. At the Berkeley campus, his journalism talents began to flourish. In February 1966, he began writing "Something's Happening," a music column for the *Daily Californian,* using the pseudonym "Mr. Jones." In his weekly columns, Mr. Jones reviewed local rock bands, sang the psychedelic praises of acid, quoted Bob Dylan, Mick Jagger and the Beatles.[24]

In the summer of 1967, students were protesting the war in Vietnam, doing

drugs, making love, and listening to the Beatles, who had declared a year earlier that they were "more popular than Jesus." San Francisco was filled with an influx of white middle-class youth seeking to break their ties with family and tradition. And the Berkeley campus was a national focal point for everything that was happening during the 1960s.

In these surroundings, Wenner started *Rolling Stone* with $7,500 and the help of Ralph Gleason, a popular music critic for the *San Francisco Chronicle*, who had befriended the younger Wenner. Gleason played a substantial role in giving Wenner his start. Gleason had started a local magazine called *Sunday Ramparts* and gave Wenner his first full-time job as entertainment editor. However, the magazine folded in May 1967. Wenner found a job as a mail carrier and lived in his mother's basement with his girlfriend. When Wenner proposed the idea to Gleason, he said, "Hey groovy; let's do it." The summer gave Wenner and Gleason time to find investors and plan the content for their new magazine. They chose the name "Rolling Stone" from the title of a song by blues singer Muddy Waters and the old proverb, "A rolling stone gathers no moss." In the first issue published October 18, 1967, the twenty-one-year-old Wenner wrote:

> You're probably wondering what we are trying to do. It's hard to say; sort of a magazine and sort of a newspaper....*Rolling Stone* is not just about music, but also about the things and attitudes that the music embraces....To describe it any further would be difficult without sounding like bullshit, and bullshit is like gathering moss.[25]

Hunter S. Thompson (1937–2005) became the magazine's best-known writer during its early years and a pop culture icon. He started his career as a sports writer for a small Florida newspaper. He later wrote as a Caribbean correspondent for *Time, New York Herald Tribune* and the *National Observer*. However, he achieved notoriety among the 1960s generation as national affairs editor for *Rolling Stone* from 1970 to 1984, where many of his articles appeared. Thompson, the self-acclaimed "Duke of gonzo journalism," wrote a series of pieces on the 1972 presidential campaign for *Rolling Stone*. These later became part of his third book, *Fear and Loathing on the Campaign Trail, 1972*. His other well-known book by a similar title, *Fear and Loathing in Las Vegas*, also originally appeared in the pages of *Rolling Stone*.

Why did these magazines and their editors so influence the promotion and proliferation of the New Journalism? The New Journalism developed because of a convergence of four historical factors: a) the historical events of the 1960s, especially the Vietnam war, the civil rights movement, the women's movement, and the hippie-drug counterculture—all of which provided ample subject matter to write about; b) a group of innovative, risk-taking editors at the magazines discussed in this chapter; c) a group of creative, risk-taking editors and writers; and d) the rise of tele-

vision and its influence on the competitive media marketplace. Among all of these factors influencing the development of the New Journalism, Gay Talese said in a 1996 interview with this author that the competitive influence of television was most significant:

> What television took away from places like the *New York Times* was the belief in getting there first with the facts. Journalism changed when television established itself as getting there first. The wire service mentality—just get the facts and tell the story straight—well how could you do that and sell newspapers if people had already got a sense of it through television, even a more visual sense in less time.[26]

Felker said that television stimulated writers to move beyond the facts and offer news in an emotional and interpretive context:

> What New Journalism did was to recognize that there was new competition for print. That competition was television. That brought the news to people quicker than a daily newspaper or a national newsmagazine. And so what you had to do was give another interpretation. You had to present the news in a more emotional, interpretive conceptual context. And also it had to be more dramatic and emotional so that the reader not only got the intellectual argument behind it, but the reader was connected emotionally to the story.[27]

Echoing Tom Wolfe's quote at the beginning of this chapter, Clay Felker also said that the change in values that occurred during the 1960s were more significant than the events and movements of the decade: "A lot of new ideas came out of the 1960s. Attitudes were changing; values were changing. It wasn't just about drugs, civil rights, and antiwar movement, although that's a very important part of it. Everything was changing in terms of values."[28]

The Advocate

From its meager origins in 1967, *The Advocate* grew to become the largest magazine aimed at gay and lesbian readers. It evolved out of the newsletter "PRIDE" published by the Los Angeles gay activist group "Personal Rights in Defense and Education" that orchestrated rallies and protests against police brutality. When PRIDE was struggling financially, Bill Rau and Richard Mitch purchased it from the group for $1and turned it into a commercial newspaper, *The Los Angeles Advocate*, which published its first issue in September 1967. In his book, *Unspeakable: The Rise of the Gay and Lesbian Press in America*, Streitmatter says, "The *Los Angeles Advocate* became the genre's first true newspaper, destined to evolve into the largest publication in the history of the gay press."[29]

News stories were the original focus for the twelve-page monthly. "All of our

resources were directed toward what the straight press wouldn't print, and what gay people needed to know about what was happening in the world," Mitch told the *Wall Street Journal*.[30] Although it focused on hard news, it also published columns, editorials, book and film reviews and events calendars.

In 1969 Mitch and Rau renamed it *The Advocate* and began national distribution. By 1974, they were printing 40,000 copies per issue. It attracted the attention of David Goodstein, a wealthy investment banker, who purchased it for $1 million in 1974 and turned it into a full-color magazine. Goodstein, who had been fired from an executive position with a San Francisco bank because of his sexual orientation, wanted to create a magazine that would promote the gay rights movement. But he also wanted to reposition it from a news publication to a cultural and lifestyle magazine for an affluent gay audience. Not long before he died in 1985, he said, "The first thing I wanted to do was make it lively and change over from the newspaper concept to a magazine concept. In the age of television, the old news concept doesn't work, journalistically." He invested $3 million of his own money in the magazine before it started earning a profit in 1979. The magazine attracted critics from within the movement, who charged that it was more interested in attracting advertisers than in advocating for gay rights and equality.[31] After Goodstein's death, the magazine changed ownerships through a series of mergers and acquisitions, and is published today by LPI Media.

The Advocate was only one of hundreds of successful LGBT magazines, which have sectored into more niche audiences. *Echelon* is targeted for LGBT business professionals. *Gay Parent* was first launched online in September 1998. After an enthusiastic response from readers, a bimonthly print edition was started in November 1998. *Out*, a "popular lifestyle magazine that celebrates the spirit of gay culture, including fashion and style, trends, society, and the arts," was founded by Michael Goff in 1992. *HIV Plus*, which offers medical information and lifestyle resources, is distributed mainly to AIDS service organizations, community-based groups, physicians' offices, pharmacies, and other qualifying agencies. The Los Angeles-based magazine was founded by Anne-Christine d'Adesky in 1998. *Our Own Voices: A Directory of Lesbian and Gay Periodicals*, lists 2,678 periodicals published for LGBT audiences in the U.S. between 1890 and 1990.[32] Rodger Streitmatter's book, *Unspeakable: The Rise of the Gay and Lesbian Press in America*, offers the best historical overview of 20th century LGBT periodicals and is recommended for further reading.

Southern Living

Launched in 1966, *Southern Living* was never part of the New Journalism movement, but it was financially the most successful new magazine of the 1960s.

Professor Sam Riley, who wrote many books about the magazine industry, called *Southern Living*, "The unquestioned leader among regional magazines in both the South and the nation."[33] Its circulation at the end of 2008 was 2.8 million, which ranked in the "top 25" among all magazines and the leader among regional magazines. *Sunset*, which serves California and the western region, is second among regional magazines with a 1.8 million readership. Today, both magazines are published by the Southern Progress Corporation of Birmingham, Alabama, which was purchased by Time Inc. in 1985.

Southern Living was launched in February 1966 by the Progressive Farmer Company, which later became Southern Progress Corporation. The *Progressive Farmer* magazine was started in 1886 and is still published today, but was sold in 2006 to DTN, a company specializing in information services for the agricultural and refined fuel industries.

The title "Southern Living" originated in 1963 as a department in *Progressive Farmer*. However, its parent company recognized that its readers were leaving the farms, moving to cities and that demand for the farm magazine would likely decline. Small family-owned farms were disappearing in the South as in the rest of the country. Like most regional and city magazines, *Southern Living* focused on positive topics and encouraged readers to enjoy their lifestyles.

In his introduction in the first issue, company president Eugene Butler said the new magazine would be a family-oriented magazine for men and women who wanted to improve their homes, enjoy good food, participate in their communities, and learn more about their region's recreational and travel destinations. Its pages told readers how to cook, fix up their house, improve their garden, and find a good vacation destination.

The magazine has been remarkably successful. During its first decade, ad pages spurted from 268 to 1,265 and revenues grew from half a million to fourteen million dollars. In a 1977 article, *Forbes* declared *Southern Living*, "the most profitable magazine in the United States," noting that it had earned twice the profits of *Playboy* or *The New Yorker*.[34] In 1974, Emory O. Cunningham, the magazine's founding publisher, was given the Henry Johnson Fisher Lifetime Achievement Award by the Magazine Publishers of America.

In 1985 Time Inc. purchased *Southern Living* and its parent company, Southern Progress Corporation, for $480 million, the most ever paid for a magazine company until that time. However, the company kept its publishing headquarters in Birmingham. Southern Progress also publishes four other magazines. *Cooking Light*, which was founded in 1987, offers readers "delicious ways to eat smart, be fit, and live well." Each issue includes at least 100 original recipes. *Health*, which focuses on women's health, was purchased by Time Inc. in 1991 after the closure of its original owner, Family Media. *Coastal Living*, which was launched in 1997, is a

lifestyle magazine aimed at readers who live on the coasts: Atlantic, Pacific or Gulf. Its mission is to "spotlight topics within sight, sound, taste, touch, or smell of salt water." *Sunset*, a lifestyle magazine for West Coast readers founded in 1898, was purchased by Time Inc. in 1990 and reorganized as part of its Southern Progress division in 2001.

Roy Reiman and Reiman Publications

If *Southern Living* was an exception to the prevailing 1960s ethos, Roy Reiman and the dozen magazines he created completely defied it. *Taste of Home* and his other magazines were devoted to cooking, country crafts, rural lifestyles and traditional values. His first magazine, *Farm Building News*, was started in 1967 and followed by *Country Woman* (1970), *Farm & Ranch Living* (1978), *Country* (1987), *Reminisce* (1991), *Taste of Home* (1992), *Taste of Home Health & Fitness Cooking* (1993), *Birds & Blooms* (1995), *Backyard Living* (2004), *Cooking for Two* (2005) and *Taste of Home Simple and Delicious* (2006). By the end of the century, six of his magazines were in the top 100 in circulation and *Taste of Home* was the best-selling food magazine. His company, based in Greendale, Wisconsin, produced more than $300 million in revenue—and none of the magazines carried advertising. In an exception to the prevailing business model of the 20th century, all relied on circulation revenue.

"The [Reiman] magazines present a singular model in important ways. They are ad-free and eighty percent of content is submitted by readers," said Professor Sheila Webb of Western Washington University. In her 2006 study of Reiman Publications, Webb reported that editors asked readers to submit stories and recipes, participate in contests, advertise for pen pals, win a prize, complete polls, compete for prizes, send in favorite photos, share jokes, tell about a most embarrassing moment or describe a favorite country character. Each day Reiman received 400 to 500 e-mail messages and several hundred letters from readers. "The response is impressive," she wrote. "A winning cookie recipe was one of 34,000 entries." 35

Reiman's success attracted the attention of the Reader's Digest Association, Inc., which purchased the company in 2002 for $760 million. In 2007, the company announced that it was dropping the Reiman name and that it would now be known as "RDA Milwaukee."

The torch passes at Time Inc.

Henry R. Luce died at his Phoenix home on February 28, 1967, of heart problems. At the height of his Time Inc. empire, Luce was one of the most powerful and influential men in America. The German newsmagazine *Der Spiegel* said of him in 1961: "No one man has, over the last two decades, more incisively shaped the image of

America as seen by the rest of the world, and the American's image of the world, than *Time* and *Life* editor Henry Robinson Luce. . . . Winston Churchill counted him among the seven most powerful men in the United States." In 1998, the U.S. Postal Service issued a stamp honoring Luce on the 100th anniversary of his birthday. The stamp was No. 57 of the Postal Service's Great Americans series, honoring men and women who helped shape the nation's history. The Public Broadcasting System produced a 2004 documentary about his life in its "American Masters" biography series.

In 1959, after recovering from his first heart attack, Henry Luce prepared to pass the title of editor-in-chief to Hedley Donovan (1914–1990), who was the managing editor of *Fortune*. Although Luce did not fully retire until 1964, he began a management reorganization that put a new generation of Time Inc. managers in control. Donovan became the new editor-in-chief of Time Inc. The top position at each of the company's magazines—including *Time*—were always given the title "managing editor."

Donovan tells the story of his 1959 meeting with Luce (who was known by "Harry" to his colleagues) at his home.

> At my usual leave-taking hour, Harry said in a somewhat apologetic way that he had to bring up something "rather personal." He wondered if I would be interested, "not right away, in a few years or so," in being the next editor-in-chief of Time Inc. . . . I said I didn't think he should commit himself just then. In a few years, someone else could emerge who would look like a better choice. "You'll do," he said in a not-unfriendly way.[36]

In his memor, *Right Times, Right Places*, Donovan described Luce's intellectual curiosity. "In all our thousands of hours of dialogue, I saw the workings of his nonstop curiosity and his almost infallible instinct for converting his own intellectual itchiness into effective journalism." He said that Luce had become arguably, "The most influential private citizen in the United States. It was hard to think of any American who had been a continually important man for so long. Luce had become a major national figure by the middle 1930s, when Eisenhower was an unknown major, Kennedy a schoolboy, and Johnson a minor bureaucrat in a New Deal agency.[37]

During his tenure, Donovan changed the reputation of *Time* magazine from its traditionally conservative tone under Luce to a more neutral stance. The *Time* staff was divided over Vietnam and reflected an ambivalence that enabled rival *Newsweek* to take the lead in reporting on the war. While the New York editorial staff was primarily "hawkish," its reporters, especially its Vietnam correspondents, were increasingly critical of the war. By early 1968, *Time* began to call for a change in U.S. policy and softening of U.S. objectives in Vietnam. Lyndon Johnson later

told friends, "Hedley Donovan betrayed me," a betrayal he ranked with the turning of Walter Cronkite in costing him the war. In a March 1968 cover story, *Time* lamented that "the history of the war is all too painfully graven in false optimism…raised by officials armed with gleaming statistics and Pollyanna rhetoric."

In 1973 as the Watergate episode began to unfold, *Time* published the first editorial in its history, which called on President Richard Nixon to resign. "He has irredeemably lost his moral authority, the confidence of most of the country, and therefore his ability to govern effectively," the editorial said.[38]

After retiring in 1979 Donovan became a senior adviser to President Jimmy Carter. Donovan published his first book, *Roosevelt to Reagan: A Reporter's Encounter with Nine Presidents*, in 1985. He published his memoir, *Right Times, Right Places: Forty Years in Journalism*, in 1989.

In 1969, the U.S. put Neil Armstrong, Buzz Aldrin, and Michael Collins on the moon. More than 400,000 attended the Woodstock Rock Festival. A year earlier, Martin Luther King Jr. and Robert Kennedy were assassinated. Stokely Carmichael (1941–1998) and other black power movement leaders had replaced King as dominant voices in the civil rights movement. On November 15, 1969, hundreds of thousands of demonstrators assembled on the Washington Mall to protest the Vietnam War. When the headlines of the 1970s did not bring better news, Americans began turning inward to pursue their personal interests.

Notes

1. Tom Wolfe, *The New Journalism* (New York: Harper and Row, 1973), 29.
2. Ibid., 23.
3. Carol Polsgrove, *It Wasn't Pretty, Folks, But Didn't We Have Fun? Esquire in the Sixties* (New York: W.W. Norton, 1995).
4. Gay Talese, telephone interview with the author, May 16, 1996.
5. Frank Digiacomo, "The *Esquire* Decade," *Vanity Fair,* January 2007 http://www.vanityfair.com/culture/features/2007/01/esquire200701?currentPage=1.
6. Clay Felker, telephone interview with the author, April 1, 1996.
7. Ronald Weber, *The Reporter as Artist: A Look at the New Journalism Controversy* (New York: Hastings House, 1974), 68–69.
8. George Lois, *Covering the '60s: George Lois, The Esquire Era* (New York: Monacelli Press 1996), 32.
9. *Esquire*, September 1972, quoted in Lois, *Covering the '60s*, vi.
10. "*New York Magazine* Appears Again in the Spring," *Editor and Publisher*, November 1967, 13.
11. Clay Felker, telephone interview with the author, April 1, 1996.
12. Deirdre Carmody, "He Created Magazines by Marrying New Journalism to Consum

erism," *The New York Times*, April 9, 1995, Sec. 4, 1.

13. Everette Dennis and William L. Rivers, *Other Voices: The New Journalism in America* (San Francisco: Canfield Press, 1974), 42.

14. Ibid.

15. *Contemporary Authors Online*, Gale, 2009. Reproduced in *Biography Resource Center* (Farmington Hills, MI: Gale, 2009), http://galenet.galegroup.com/servlet/BioRC.

16. Deirdre Carmody, "Clay Felker, Magazine Pioneer, Dies at 82," *The New York Times*, July 2, 2008.

17. Ronald Weber, *The Literature of Fact: Literary Nonfiction in American Writing* (Athens: Ohio University Press, 1980), 111.

18. John Hollowell, *Fact and Fiction: The New Journalism and the Nonfiction Novel* (Chapel Hill: University of North Carolina Press, 1977), 38–39.

19. *Contemporary Authors*, Vol. 18 (Detroit: Gale Research Company, 1986): 81–88.

20. Willie Morris, *New York Days* (Boston: Little, Brown and Company, 1993), 340.

21. Hollowell, *Fact and Fiction*, 39.

22. Morris, *New York Days*, 221–222.

23. Robert Draper, Rolling Stone Magazine: *The Uncensored History* (New York: Doubleday, 1990), 36.

24. Ibid., 47.

25. Ibid., 69.

26. Gay Talese, telephone interview with the author, May 16, 1996.

27. Clay Felker, telephone interview with the author, April 1, 1996.

28. Ibid.

29. Rodger Streitmatter, *Unspeakable: The Rise of the Gay and Lesbian Press in America* (Boston: Faber and Faber, 1995), 83.

30. Stephen J. Sansweet, "A Homosexual Paper, *The Advocate* Widens Readership, Influence," *Wall Street Journal*, November 3, 1975. Cited in Streitmatter, *Unspeakable*, 88.

31. Rodger Streitmatter, *Unspeakable*, 186.

32. Alan V. Miller, *Our Own Voices: A Directory of Gay and Lesbian Periodicals, 1890–1990* (Toronto: Canadian Gay Archives, 1990).

33. Sam Riley, *Magazines of the American South* (New York: Greenwood Press, 1986), 239.

34. "The Most Profitable Magazine in the U.S.," *Forbes*, June 15, 1977, 30–31. Cited in Riley, *Magazines of the American South*, 240.

35. Sheila M. Webb, "The Narrative of Core Traditional Values in Reiman Magazines," *Journalism and Mass Communication Quarterly* 83, 4 (Winter 2006): 865–882.

36. Hedley Donovan, *Right Places, Right Times: Forty Years in Journalism Not Counting My Paper Route* (New York: Henry Holt and Company, 1989), 164.

37. Ibid., 157, 161.

38. "To Our Readers: An Editorial: The President Should Resign," *Time*, November 12, 1973, www.time.com/time/magazine/article/0,9171,944643,00.html.

The 1970s

Magazines and "The Me Decade"

The 1970s did not bring much good news to Americans. The decade began with the shocking deaths of four Kent State University students after the Ohio National Guard opened fire on their war protest demonstration. After more than 50,000 soldiers lost their lives in Vietnam, the nation had to accept peace without victory in losing its first war. Not long after bringing the troops home, Richard Nixon became the first American president to resign in shame after his implication in the Watergate burglary cover-up. Between 1976 and 1980, Americans coped with spiraling inflation, increasing unemployment, gas rationing, and long lines at gas pumps. The "misery index" (inflation rate plus the unemployment rate) reached 25 percent in 1979 and became a widely quoted figure on the evening news. If all of this wasn't enough, the decade ended with Americans watching daily news reports about the grim takeover of the American embassy in Tehran from November 4, 1979, to January 20, 1981, where sixty-four Americans were held hostage for 444 days.

The 1970s became widely known as "The Me Decade." Titles of new magazine launches during the 1970s illustrated that Americans wanted to escape the problems and focus on themselves, their own interests, goals, and leisure-time activities. Tom Wolfe coined the term "The Me Decade" in a 1976 cover story by the same title for *New York* magazine. Calling it the "the greatest age of individualism in American history," his article analyzed how Americans' preoccupation with themselves had affected everything from leisure activities to sexual habits and even religious beliefs. He characterized the attitude of the decade as, "Let's talk about Me.... Let's find the Real Me.... Let's get rid of all the hypocrisies and false modesties that obscure the Real Me...."[1]

Table 1

	Major Magazine Launches of the 1970s		
Year	**Magazine**	**Year**	**Magazine**
1970	*Essence*	1975	*Fine Woodworking*
	Sail		*Soap Opera Digest*
	Smithsonian		*Truckin'*
	Country Woman		*Gray's Sporting Journal*
	Mother Earth News		*In-Fisherman*
	Black Enterprise		*Endless Vacation*
	Dog Fancy		*Columbus Monthly*
	Spin		*Yoga Journal*
1971	*Shutterbug*	1976	*Nascar Winston Cup Scene*
	Trailer Boats		*American Handgunner*
	Easyriders		*New Jersey Monthly*
	Minneapolis St. Paul Magazine		*Outside*
	European Car		*Wine Spectator*
	Model Retailer		*Mother Jones*
	Bowhunter		*Entrepreneur*
	Dirt Bike		*Robb Report*
	W Magazine		*Horse Illustrated*
	Connecticut Magazine		*Wilson Quarterly (The)*
	Chicago Reader	1977	*US Weekly*
	Chesapeake Bay Magazine		*Southern Accents*
	Natural Health & Fitness		*Equus*
	Travel and Leisure		*Petersen's 4 Wheel & Off-Road*
1972	*Money*		*Rod & Custom Magazine*
	Petersen's Photographic		*Running Times*
	Street Rodder		*Woodworker's Journal*
	MS.		*Florida Design*
1973	*American Hockey Magazine*		*Riverfront Times*
	Canoe & Kayak		*American Angler*
	Practical Horseman		*Deer & Deer Hunting*
	Super Chevy		*Indianapolis Monthly*
	Old-House Journal		*Weekly World News*
	American Hunter	1978	*Art & Antiques*
	Astronomy		*Low Rider*
	Petersen's Hunting		*Farm & Ranching Living*
	Motorcross Action Magazine		*Low Rider*
	Texas Monthly		*Traditional Home*
	Cosmopolitan En Espanol		*Country Living*
	Absolute Sound		*Working Mother*
	Backpacker		*Food & Wine*
1974	*Woodenboat*	1979	*Computer Shopper*
	People		*Cruise Travel*
	Relix		*Boating World*
	Orange Coast		*This Old House*
	High Times		*Photo Techniques*
	Rider		*North American Hunter*
	Cruising World		*Country Home*
	Vegetarian Times		*Scale Auto*
			Hispanic Business

More than twice as many magazines were launched during this decade than any preceding decade; about 95 percent of them reflected this self-preoccupation. Many were small magazines of limited circulation that reached a target audience of enthusiasts in a particular avocation or leisure activity: i.e., *Canoe & Kayak, Fly Rod & Reel, Dog Fancy, Yoga Journal, Wine Spectator*, or *Food & Wine*. Maybe they could be called the "escapist genre." If the evening news was too depressing, Americans could always find diversion in a magazine.

History has many dimensions, however, and these magazines do not tell the whole story of the 1970s. There were serious issues and serious magazines to deal with them. The women's movement gained momentum. The Supreme Court ruled in 1973 that employment ads could not specify gender. The glass ceiling rose higher as more women entered the executive ranks of companies. Some Protestant and Jewish groups began ordaining women. The Civil Rights Act of 1964 and the Voting Rights Act of 1965 brought desired results as more African-Americans entered the mainstream of American life. Not all social ills had been solved, by any means, but a few of the new magazines launched during the decade reflected the changes that were taking place.

Black Enterprise and *Essence* served the growing number of black professionals, both men and women. *Ms.* magazine, which both reflected and shaped the emerging women's movement, served women seeking to redefine their role in the workplace, home, and in society. It was joined later by competitors such as *Savvy, New Woman, Working Woman* and *Working Mother*. *Vegetarian Times* was the first of a large number of health or fitness-oriented magazines launched between 1970 and 2000. *Smithsonian* defied conventional wisdom by becoming the most successful general interest magazine launched since the 1930s.

Ms.

The women's movement had been gaining momentum since the early 1960s. Betty Friedan's book, *The Feminine Mystique* (1963) is often cited as the first major document of the women's movement. Friedan (1921–2006) attacked traditional views of women's "proper role" and argued that being a housewife and mother was not sufficiently rewarding for many women. In 1966, Friedan joined with other feminists to create the National Organization for Women (NOW), which was to become the most influential feminist organization. "The time has come," asserted the NOW founders, "to confront with concrete action the conditions which now prevent women from enjoying the equality of opportunity and freedom of choice which is their right as individual Americans and human beings."

Ms. was founded in 1972 by a group of women that included Pat Carbine, a

senior editor at *Life*, and Gloria Steinem, a columnist for *New York* magazine. The convinced Clay Felker, the publisher of *New York*, to give *Ms.* its debut by publish ing a small premier issue inserted into the December 15, 1971, issue. This *Ms.* debu generated an astonishing 26,000 subscription orders and over 20,000 reader letter within weeks. The first issue of the free-standing *Ms.* was published in sprin 1972, and its 300,000 copies sold out in eight days. By 1974, circulation had rise to 400,000 and topped half a million by the end of the decade.[2] *Ms.* had struck chord.

Ms. claimed a number of "firsts," including being the first magazine that:

- featured prominent American women demanding the repeal of abortio laws
- advocated and called for passage of the Equal Rights Amendment
- rated presidential candidates on women's issues
- spotlighted domestic violence and sexual harassment on the cover
- featured feminist protest of pornography, including pornographic men magazines
- rejected advertisements it considered sexist
- exposed the pressure from advertisers on women's magazines for favorabl coverage and ad placement.

For example, *Ms.* accepted cigarette advertising, a policy that its readers sometime criticized. The editors went through lengthy conversations with the Philip Morri Company about a possible ad in its Virginia Slims "You've Come a Long Way, Baby campaign. Ultimately they turned down the $80,000 in ad revenue because they con sidered the campaign too sexist, not because it encouraged smoking.

From 1978 to 1987, *Ms.* was published as a nonprofit magazine through th *Ms.* Foundation for Education and Communication. Faced with declining ad rev enue and circulation, it was sold in 1987 to an Australian company headed by pub lisher Sandra Yates and editor Anne Summers. Although they redesigned an enlarged the magazine, it lost popularity with many readers who felt the new edi tors diluted its feminist message and made it resemble a traditional women's mag azine.

During the next fifteen years, the magazine went through four different own ers. In 1989, the magazine was sold to Dale Lang, owner of Lang Communication which published *Working Woman* and *Working Mother*. Lang invited well-know feminist author Robin Morgan to become editor. Before accepting the job, she tol Lang her "outrageous demands." She said:

> It must be completely free of all advertising. It must be editorially autonomous from
> Lang Communications. And I want to make it international, with a minimum of six

pages of international news in each issue. I want to do in-depth investigative journalism, and to name names. And I want to bring back world class fiction and poetry.[3]

To Morgan's surprise, Lang agreed to all of her demands, and she took the job. She invited Gloria Steinem to come back on board as a consulting editor. Although it had to charge higher subscription and cover prices, the "remodeled" magazine regained its popularity with women readers. The first few issues sold out quickly on the newsstand and within a year the number of paid subscribers topped 250,000.

In its premiere issue as an ad-free magazine, Gloria Steinem explained the pressures faced by *Ms.* and other women's magazines in her famous exposé, "Sex, Lies and Advertising." She cited example after example of incidents where an advertiser pressured women's magazine editors to give favorable coverage to its products or placement of its ads. She quoted Sey Chessler, former editor of *Redbook,* who told her, "Advertisers want to know two things: What are you going to charge me? What else are you going to do for me? It's a holdup….I also think advertisers do this to women's magazines especially…."[4]

The ad-free years at *Ms.* lasted only until 1996 when the magazine was sold to a group of investors, Liberty Media for Women. Then it changed hands once more. On December 31, 2001, the Feminist Majority Foundation, led by president Eleanor Smeal, became the owner. The group was a consortium of feminists that included former editors Marcia Gillespie and Gloria Steinem, as well as other businesswomen and philanthropists. *Ms.* operations are now located at the Feminist Majority Foundation offices in Los Angeles and Arlington, Virginia.

The conundrum faced by *Ms.* during its musical chair series of owners was not its message, which always had an enthusiastic base of women readers. The primary problem was finding and sustaining a financial base of support. The magazine's "ad-less" business model between 1989 and 1996 was laudable in its goals, but difficult to maintain for a long time. As noted in chapter three, magazines with *any* political point of view always had difficulty attracting national advertisers. Nevertheless, *Ms.* continued to be an award-winning magazine recognized nationally and internationally as the media expert on issues relating to women's rights, and the status of women in America.

The women of *Newsweek*

When *Newsweek* published a cover story titled "Women in Revolt" in March 1970, it became the first newsmagazine to write a major story on the women's liberation movement. Ironically, it also became the first magazine to have a sex discrimination lawsuit filed against it. That same month forty-six women at *Newsweek* filed a complaint with the Equal Employment Opportunity Commission claiming dis-

crimination in hiring and promotion. Editor Osborne Elliott admitted, "The frustration of these women was fueled by the fact that there was only one woman writer at *Newsweek* at the time and she was judged too junior for the assignment, so a freelancer, Helen Dudar, the wife of one of *Newsweek's* writers, Peter Goldman, was hired to write the cover story."[5]

On the same day the "Women in Revolt" cover story was published, a letter from the women of *Newsweek* landed on the desk of its publisher Katharine Graham (1917–2001), stating:

> Women have rarely been hired as, or promoted to, the positions of reporter, writer, or editor; they are systematically by-passed in the selection of bureau correspondents and are routinely given lower titles and pay....Incredibly, *Newsweek* was unwilling to work with any woman on staff to write this week's cover story on the women's liberation movement.[6]

The magazine resolved the complaint by promising to hire more women as writers and promote more to editor's positions. However, two years later fifty women employees filed another complaint against *Newsweek* with the EEOC. They said that the earlier complaint against *Newsweek* had produced only "token alterations" in promotion and hiring. They pointed out that only five of the magazine's forty-one writers and twelve of its seventy-one correspondents were women.[7] They reached an agreement in June 1973 with *Newsweek's* management promising that at least one third of its writers and reporters would be women by December 31 1974. They also agreed that "at least one woman will have been made a senior editor in charge of one of the seven major editorial divisions" by December 31, 1975.

Newsweek had always employed women as researchers, its lowest editorial position, but never promoted them to higher positions. Among the women who worked as *Newsweek* researchers in the early 1970s were syndicated columnist Ellen Goodman (1941–), author and film producer Nora Ephron (1941–), and author and financial columnist Jane Bryant Quinn (1939–).

Essence

Starting with *Ladies' Home Journal* in 1879, at least a dozen women's magazines had achieved great mass market success. There had never been a magazine targeted for African-American women, however. Four black men—Edward Lewis, Clarence Smith, Cecil Hollingsworth, and Jonathan Blount—saw the niche for such a magazine and raised the money to launch *Essence* in 1970. As Lewis put it, *Essence* sought to "make Black women feel good about themselves."[8] Several banks and Playboy Enterprises backed the business, while *Good Housekeeping's* John Mack Carter gave

xpert advice. Carter (1928–) earned the distinction as the only person to ever serve
s editor-in-chief of three major women's magazines: *McCall's* (1962–1965), *Ladies'*
Home Journal (1965–1974), and *Good Housekeeping* (1975–1994).
Twenty-five years later, the *New York Times* wrote, "*Essence* magazine has
become the pre-eminent voice for black women. Its circulation passed one million
ast year. And, after years of wooing luxury markets, the magazine now includes
mong its advertisers Chanel, Giorgio, Cadillac, and Estee Lauder."[9] While the
magazine published regular features on beauty, fashion and culture, it also addressed
erious issues such as AIDS in the black community, abortion, interracial marriage,
ape and incest, and blacks and IQ tests.

Marcia Gillespie (1944-___) edited the magazine from 1972 to 1980 and
stablished its successful formula of service articles on fashion, beauty and family
ombined with probing analysis of social and political issues facing black women.
Gillespie told *Time*: "I wanted to show what black women really are: beautiful, coura-
geous and incredibly vital people."[10] Gillespie published profiles of African-American
elebrities and told everyday African-American success stories.[11] Gillespie also later
erved as editor-in-chief of *Ms.* from 1993 to 2001.

Susan L. Taylor (1946-___) was named the editor-in-chief of *Essence* in 1981
by publisher Edward Lewis. She led the magazine through the nineteen years of
xpansion and growth between 1981 and 2000. She started doing freelance work
n 1971, then became full-time fashion and beauty editor and worked her way up
from there.

Taylor became best known for her inspirational articles in her monthly column,
In the Spirit." Drawing upon the spiritual foundation she inherited from her par-
nts, she encouraged black women to believe in themselves, to focus on their
trengths and make a positive difference in their world. "We try to deliver the strate-
gic information and the inspiration to help black women make a triumph of their
ives," Taylor told the *Los Angeles Times*. In 1993 Taylor published a collection of her
olumns and some new ones, for her best-selling book, *In the Spirit: The Inspirational*
Writings of Susan L. Taylor.

Taylor never went to college, a missing credential that sometimes haunted
her. She grew up in Harlem and later Queens as the daughter of immigrants from
he West Indies. The publisher was criticized for naming her the editor by other
Essence employees who had graduated from prestigious women's colleges. Therefore,
Taylor started taking night classes at Fordham University in the 1980s and earned
her B.A. in 1991. After writing *In the Spirit*, she went on to publish two more books:
Lessons in Living and *Confirmation: The Spiritual Wisdom That Has Shaped Our*
Lives (with Khephra Burns). In 2002, she was named to the Magazine Hall of Fame
by the American Society of Magazine Editors.

Earl G. Graves and *Black Enterprise*

Earl G. Graves (1935–) is the founder and publisher of *Black Enterprise*, a maga
zine that focuses on issues, advice and news for black-owned business owners
which he launched in 1970. Graves grew up in Brooklyn with parents who emigrat
ed to the U.S. from Barbados. After graduating with an economics major from
Morgan State University, he served as a captain in the Army Green Berets for two
years. He then worked as a narcotics agent for the Treasury Department. Later he
got involved with politics, working for the Johnson-Humphrey ticket in the 1964
presidential campaign and Robert F. Kennedy's New York senate race. In 1966
Robert Kennedy hired him as an administrative assistant to plan and supervise the
senator's events. Graves was later present at the scene of Kennedy's assassination on
June 5, 1968.[12] After Kennedy's death, he was offered a Ford Foundation fellow
ship to study economic development in Caribbean countries.

Graves knew that the time was right to plan, develop, and produce a monthl
periodical devoted to news, commentary, and articles for African-American entre
preneurs and business executives. He borrowed $150,000 from the Chas
Manhattan Bank, which, in turn, bought 25 percent of the company as equity.[13]

In 1997, Graves published his best-seller *How to Succeed in Business Withou
Being White*. The book told many anecdotes and stories about the early years at the
magazine where he had to overcome resistance to sell advertising to major corpo
rate advertisers. In the foreword, Robert L. Crandall, chairman and CEO a
American Airlines, says he first met Graves in 1973. He wrote: "Businesses at tha
time—including American Airlines—had not fully recognized the buying powe
and emerging economic clout of the black community. Earl did a great job in con
vincing us that *Black Enterprise* represented a real opportunity for American to bet
ter position itself with an important, growing segment of the market."[14]

During the next thirty years, Graves received more than sixty honorary degree
and numerous awards for his business success and civic contributions. He wa
named by *Fortune* in 2002 as one of the fifty most powerful and influential African
Americans in corporate America.

Time Inc. and *People*

On March 4, 1974, *People* hit the newsstands with a cover featuring actress Mi
Farrow, who was starring in the movie, "The Great Gatsby." Contents included arti
cles about Marina Oswald, wife of Kennedy assassin Lee Harvey Oswald; a stor
about author and exiled Russian dissident Alexander Solzhenitsyn; and a profile c
socialite Gloria Vanderbilt speaking about "a fourth marriage that really works."

Founding editor Richard B. Stolley (1928–) wrote in this issue, "*People* is a magazine whose title fits it perfectly. There is nothing abstract about the name. *People* is what we are all about." *People* was an immediate hit. That first issue sold 978,000 copies. "Within eighteen months we were making money, which was very quick, and within two years we had paid back the initial investment, which I think was about $40 million," said Stolley in an interview with this author.[15] The book *Magazines That Make History* said that by February 1978, *People* had become "the most successful magazine in the history of modern American journalism by climbing, in only three years, to ninth place in advertising history."[16] By 1991, it became the nation's most profitable magazine—a position it still retains.

"This was the beginning of the 'Me Decade,'" Richard Stolley said in explaining the magazine's success. "We found out that people in the news were quite willing to talk to us about themselves. They'd talk about a lot of personal things—their sex lives, their money, their families, religion. They'd talk about things that a few years earlier wouldn't even have been brought up."[17]

Richard Stolley, founding editor, People. *Photo by Alfred Eisenstadt. Courtesy of Time Inc. Archives*

"I think *People*'s success came from three places," said Joe Treen (1943–2009), who was its executive editor for twelve years. "It offered much more than just celebrity gossip, fashion stories and 'eye candy' photos. It had news, human interest, social issues, etc.—stories you do not get in the magazine's competition. No doubt newsstand buyers picked up the magazine because some celebrity was on the cover. But once they got inside, they very much related to the whole range of stories, including those that do not involve celebrities at all.

"Second, the magazine was very well-reported. It simply had more information than its competitors. And the information was accurate. Nothing was made up or padded or piped. Third, *People* had surprisingly high integrity. The magazine was copiously fact-checked. It operated under Time Inc.'s tough conflict of interest and code of ethics policies. In other words, a *People* story may seem frothy and gossipy but the reporting took place under the same kinds of rules at *The New York Times* or the *Washington Post*," said Mr. Treen.[18]

Hedley Donovan (1914–1990), who succeeded Henry Luce as editor-in-chief

at Time Inc., said of the magazine: "Like *Sports Illustrated, People* benefited from TV. Some of its subject matter was created by TV, and *People* could deal more candidly than TV with the personalities of the entertainment world. The magazine also benefited from the change in national mores that made many celebrities willing to discuss their personal lives with a frankness that would have been unthinkable only a few years earlier."[19]

During his years as founding editor, Richard Stolley developed a formula for best-selling cover stories. In one of the most famous quotes of magazine history, he said:

- ~ "Young is better than old.
- ~ Pretty is better than ugly.
- ~ Rich is better than poor.
- ~ TV is better than music.
- ~ Music is better than movies.
- ~ Movies are better than sports.
- ~ And anything is better than politics."

Stolley admitted, however, that these weren't his only considerations. "The face had to be recognizable to 80 percent of the American people. There had to be a reason for the person being on the cover. There had to be something happening in the person's life the week it was out there. And then there was this X factor. There had to be something about the person you wanted to know."[20]

In the book *Inside People*, Judy Kessler summed up the magazine's editorial philosophy which has remained unchanged: "To revisit familiar personalities and tell something about them you didn't know before, and to present unfamiliar people in an interesting, provocative way." [21]

Other magazines fight for celebrity coverage

The success found by *People* and *National Enquirer* spawned numerous imitators during the 1970s. Even the prestigious *New York Times* fought to get in on the celebrity market when it launched *Us Weekly* in 1977. The magazine lost money before turning its first profit in 1980. After the *Times* sold the magazine in 1981 to Macfadden Holdings, publisher of *True Confessions* and *Photoplay*, its circulation climbed to 1.1 million by 1983. Its editor Peter Kaplan proclaimed that *Us* intended to displace *People* as "the most popular magazine of America's pop culture."[22] He never achieved that goal before *Us* was sold to *Rolling Stone* publisher Jann

Table 2

Celebrities with the Most *People* Covers (1974 to 2002)	
Princess Diana	52
Julia Roberts	16
Elizabeth Taylor	14
Sarah Ferguson	13
Michael Jackson	13
Cher	13
John F. Kennedy, Jr.	12
Prince William	12
Madonna	11
John Travolta	9
Source: *People* Magazine 2002 and *Magazines That Make History* (University Press of Florida, 2004)	

Wenner in 1985. Wenner temporarily relinquished his duties at *Rolling Stone* to become editor-in-chief of *Us,* saying he planned to make it "Smarter, hipper, with high quality journalism." Wenner told *New York* magazine, "Call it what you want— gossip journalism, celebrity journalism, human-interest journalism. By any name, this has become the dominant theme of American journalism over the last five years."[23] The magazine is still owned by Wenner, who has brought it a measure of success. *Us* magazine was named "Magazine of the Year" by *Advertising Age* in 2004 and "Top Performer of the Decade 1996–2006" by Cappell's Circulation Report.[24]

Another tabloid, *Star,* was founded by Australian publisher Rupert Murdoch in 1974 to compete with the *National Enquirer.* In 1990 Murdoch sold *Star* to the *Enquirer.* Generoso Pope, Jr. launched *Weekly World News* in 1979 to supplement

the *National Enquirer*, which had reached phenomenal circulation success. After building a new color printing plant for the *Enquirer*, the entrepreneurial Pope had a creative idea. He would start a second weekly from scratch using the *Enquirer*'s old monochrome presses. So he hired a new publisher and editors to start *Weekly World News*, which was to be a down-scale version of the *Enquirer* printed on black-and-white newsprint. One editor said, "It was going to be, like, bizarre news. Someone actually said it would be like a bizarre, wild *Time* magazine."[25] Pope subscribed to 200 magazines or newspapers from around the country and hired researchers to scour and clip the wackiest and most bizarre stories to rewrite for the *Weekly World News*. With its small staff and low production costs, it turned into a cash cow for many years and generated millions in new revenue for Pope. Circulation peaked at 1.2 million during the 1980s and declined to less than 100,000 in 2007 when American Media Inc. stopped publishing the print edition. *Weekly World News* was sold in 2008 to Bat Boy L.L.C. which continues to publish it as an online magazine.

Jack Vitek, author of *The Godfather of Tabloid*, sums up the burgeoning tabloid market during the late 1970s:

> Together *Weekly World News* and the *Enquirer* covered what was to be the full spectrum of supermarket tabloid journalism. The *News* soon spawned an imitator, the *Sun*, another Mike Rosenbloom clone, which became third in his lineup with the *Globe* and *Examiner*. The *Enquirer*, *Globe* and *Star* competed for celebrity gossip and scandal, while the *Sun* and *News* worked the wackiest and weirdest terrain, with the *Examiner* falling somewhere in between.

All of these tabloids are now owned by American Media, Inc. Although their combined circulation reached its peak in the 1970s and early 1980s, their influence on American journalism cannot be understated. Numerous authors have written about the ironic "melding" of tabloid journalism with mainstream journalism. Mainstream newspapers and magazines have become more sensational and celebrity-focused, while the tabloids have become more fact-based in their reporting. Their success has contributed to their own decline after an increasing number of mainstream newspapers and magazines imitated their style and reporting techniques. Chapter eleven will explore this theme in greater detail.

Magazines fight legal battles

Magazines are infrequently the defendants in libel and copyright infringement lawsuits for three reasons. First, while most newspaper reporters have only twenty-four hours to gather and verify their facts, magazine writers start researching and

preparing articles weeks and months in advance. Magazine articles go through several layers of editing, especially at major magazines that have resources for fact-checking departments. Second, while copyright infringement or plagiarism may or may not occur frequently (no one knows), the legal costs and financial stakes discourage litigation. Magazines pay freelance writers at most a few thousand dollars for their articles, and the costs and risks of litigation can far exceed that figure.

The third reason that magazines are infrequently sued for libel is that magazines write mostly about "public figures" for whom the legal standard is considerably higher than for private citizens. While a private citizen must only prove "negligence" (meaning a simple reporting mistake) to bring successful libel litigation, celebrities and public figures must prove "actual malice." That means that the plaintiff must prove that the publication published a false item "knowing that it was false or with reckless disregard for whether it was true or false."

Five significant libel or copyright infringement lawsuits were filed against magazines between 1963 and 1984, and magazines lost four of them. Three of them occurred during the 1970s, but all five are discussed here to maintain continuity.[26]

Carol Burnett vs. *National Enquirer*

The *National Enquirer* published a sixty-seven word story in its March 2, 1976, issue that resulted in one of the few successful libel lawsuits ever won by a public figure. Entitled, "Carol Burnett and Henry K. in Row," the item read:

> In a Washington restaurant, a boisterous Carol Burnett had a loud argument with another diner, Henry Kissinger. Then she traipsed around the place offering everyone a bit of her dessert. But Carol really raised eyebrows when she accidentally knocked a glass of wine over one diner and started giggling instead of apologizing. The guy was not amused and "accidentally" spilled a glass of water over Carol's dress.[27]

Carol Burnett's family had a history of alcoholism, and she was personally angered by the story's implication of public drunkenness. Shortly after the item ran, Burnett's lawyers contacted the *Enquirer* to say the item was false and threatened litigation. The *Enquirer* conducted an internal investigation and could not corroborate its sources for the story. Therefore, it published a retraction, which read:

> An item in this column on March 2 erroneously reported that Carol Burnett had an argument with Henry Kissinger at a Washington restaurant and became boisterous, disturbing other guests. We understand these events did not occur, and we are very sorry for any embarrassment our report may have caused Miss Burnett.[28]

Nevertheless, Carol Burnett (1933–) sued. The case was widely publicized in

the media with *The New York Times* carrying twenty-five stories about it. The California trial was carried on national television. The *Enquirer's* lawyers argued that there was no actual malice on its part and that, as a news publication, it was protected from false statements that it had neither time nor opportunity to ascertain. Trial arguments revolved around whether the *Enquirer* was entitled to legal protection given to a "news publication" or whether it was a magazine. Under California statute, if a newspaper published a retraction on a story it learned was false, then the plaintiff had no right to punitive damages. However, the court ruled it was, indeed, a magazine, saying:

> By the same token the *National Enquirer* is designated as a magazine or periodical in eight mass media directories....its classification as a newspaper was changed to that of a magazine by the Audit Bureau of Circulations. It does not subscribe to the Associated Press or United Press International news services. According to a statement by its Senior Editor it is not a newspaper and its content is based on a consistent formula of "how to" stories, celebrity or medical or personal improvement stories, gossip items and TV column items, together with material from certain other subjects.[29]

The jury ruled in favor of Ms. Burnett and awarded her $300,000 in general damages and $1,300,000 in punitive damages. A judge quickly cut it in half and an appeals court reduced it again. Both parties settled for a sum they agreed to keep secret. She had made her point, however. She used the proceeds to establish the Carol Burnett Fund for Responsible Journalism at the University of Hawaii, "to support teaching and research designed to further high standards of ethics and professionalism in journalism, and for awards to outstanding students who have demonstrated a strong sense of journalistic responsibility and integrity."[30]

Harper & Row vs. Nation Enterprises

In 1979, Harper & Row published *A Time to Heal: The Autobiography of Gerald R. Ford*, written by the former president who held office from 1974 to 1976. Before the book went on sale, *The Nation* obtained a purloined copy of the manuscript and published a 300-word excerpt about Ford's account of his controversial decision to pardon Richard Nixon. The excerpt was quoted within a 2,256-word article about Ford written by *Nation* editor Victor Navasky and published in the April 3, 1979, issue.[31] *The Nation*, which was founded in 1865, is a magazine of liberal political opinion. *Time* had previously paid Harper & Row $12,500 for the exclusive right to print excerpts before its official publication. After *The Nation* published its excerpt, *Time* canceled its agreement with Harper & Row, which the contract permitted if any material was first published elsewhere.

Harper & Row filed a lawsuit against *The Nation* for copyright infringement. *The Nation* asserted as its defense that Ford was a public figure and his reasons for the pardon were of "vital public interest." Victor Navasky wrote in his memoir *A Matter of Opinion,* of his rationale:

> I had a belief that the public, rather than public figures, should own the news about public figures; that while it was proper for President Ford to copyright and make a profit from his memoirs, the inflated price—Ford and Betty got $1 million for their book contracts—came from the news values in the memoirs, which is not copyrightable....So we published the article.[32]

The Nation's lawyers argued that since Gerald Ford was a public figure, his statements surrounding the Nixon pardon contained news value that qualified for the "fair use" privilege permitted by the copyright law. Nevertheless, a federal trial judge ruled in favor of Harper & Row and awarded damages. The Second Circuit Court of Appeals reversed the decision and ruled that the memoirs were protected by the fair use privilege. Harper & Row appealed this ruling to the Supreme Court, which upheld the original court's decision. In an opinion by Justice O'Connor, the court noted that the right of first publication is a particularly strong right, and held that there was no "public figure" exception to copyright protection, asserting that "the promise of copyright would be an empty one if it could be avoided merely by dubbing the infringement a fair use 'news report' of the book." In applying the four tests of fair use, O'Connor pointed out that the purpose of *The Nation*'s use of the material was commercial (scooping a competitor) and that actual damage to Harper & Row occurred because *Time* canceled its $25,000 contract.[33]

Time Inc. vs. Firestone

In its December 22, 1967, issue *Time* magazine published a paragraph in its "Milestones" department that resulted in a significant decision distinguishing between public figures and private figures in libel cases. The full text read:

> Divorced. By Russell A. Firestone Jr., 41, heir to the tire fortune: Mary Alice Sullivan Firestone, 32, his third wife; a onetime Palm Beach schoolteacher; on grounds of extreme cruelty and adultery; after six years of marriage, one son; in West Palm Beach, Fla. The 17-month intermittent trial produced enough testimony of extramarital adventures on both sides, said the judge, "to make Dr. Freud's hair curl."

Mary Firestone filed suit in a Florida state court seeking $100,000 in libel damages because of *Time*'s statement that the divorce was granted because of her "extreme cruelty and adultery" and allegations of extramarital affairs. Although cruelty and

adultery were discussed in the trial, they were not the reasons the divorce was granted. *Time* argued that Mary Firestone was a public figure and could not recover damages based on the *New York Times Company v. Sullivan* decision, which protected media from liability except in cases of actual malice. In a series of appeals, a state court and the Florida Supreme Court ruled that Firestone was not a public figure. Therefore, she was entitled to damages from Time Inc. In a 1976 decision, the Supreme Court upheld the lower court rulings in a five-to-three decision.[34]

Curtis Publishing Company vs. Butts

Thirteen years earlier, the *Saturday Evening Post* published a story that accused two prominent football coaches of collaborating to fix the outcome of the game. "The Story of a College Football Fix" was published in its March 23, 1963, issue. At the time, Wally Butts was the athletic director and former head coach of the University of Georgia football team, and Paul "Bear" Bryant was the legendary University of Alabama coach whose teams won seven national championships. The writer's primary source was George Burnett, an Atlanta insurance salesman who, while dialing a public relations firm, claimed he was accidentally cut into a telephone conversation between Butts and Bryant. Burnett made notes of the conversation during which he alleged that Butts revealed Georgia's game plans and named specific players and plays.

In separate lawsuits, Butts and Bryant sued for $10 million each in compensatory and punitive damages. Both coaches acknowledged that the conversation occurred on September 13, 1962, but said it was limited to general football talk and didn't include any specific play details that could "fix" the outcome of the upcoming game. Alabama won the game 35–0 on September 22. Trial testimony revealed that the *Post* editors did not corroborate Burnett's allegations with any other sources, and that the *Post* paid Burnett $5,000 for his information. Players from both teams testified that the article contained false statements and quotations they never made. However, Burnett also testified that he never made statements attributed to him about a "rigged" or "fixed game" or that Butts and Bryant were "corrupt men." He also testified that Frank Graham, Jr., who wrote the article, never asked to see his notes on the conversation, and that the *Post* published the article without his ever having the chance to verify its accuracy.[35]

On August 20, 1963, the jury returned a verdict in favor of Butts and a libel judgment of $60,000 in actual damages and $3 million in punitive damages against Curtis Publishing. Although the judge later reduced this amount to $460,000, he said, "The article was clearly defamatory and extremely so...." Paul Bryant settled his separate libel case before it went to trial. He noted in his autobiography, *Bear,* that he probably could have won his case, but the entire episode was painful and

excruciating, and he was ready to put it behind him.[36] Former *Post* managing editor Otto Friedrich wrote about this settlement:

> One immediate result [of the Butts decision] was that Curtis, having lost in Georgia, where the terrain was relatively favorable, lost its nerve at the prospect of fighting the same battle in Alabama. It agreed to settle with Bear Bryant by a tax-free check of $300,000.[37]

Masson vs. *New Yorker*

In December 1983, Janet Malcolm, a freelance writer for *The New Yorker*, wrote a two-part series about Jeffrey Masson, a Freud scholar and director of the Freud Archives in London.[38] Masson sued Malcolm and *The New Yorker* for libel, claiming that she fabricated quotations he did not make. Masson claimed that the unflattering profile portrayed him as "unscholarly, irresponsible, vain, [and] lacking in personal honesty and moral integrity."

Masson claimed he never made what came to be dubbed the "sex, women, and fun" and the "intellectual gigolo" quotations. *The New Yorker* article quoted him as saying, "Maresfield Gardens [home of the Freud Archives] would have been a center of scholarship, but it would also have been a place of sex, women, fun. It would have been like the change in The Wizard of Oz from a black and white into color." [sic] Masson claimed he never said "a place of sex, women, fun." He also claimed never saying, "I was like the intellectual gigolo—you get your pleasure out of him, but you don't take him out in public."[39]

Malcolm claimed all quotes were based on forty hours of interviews with Masson she had taped or taken notes on. Malcolm testified that although she rearranged or altered his exact words, she was attempting "to present Masson's speech in logical, rational order so he would sound like a logical, rational person."[40] This complicated case lasted almost twelve years in a ping-pong series of seven court decisions, reversals, and appeals. It went to the Supreme Court, which remanded it back to lower courts after it made a further interpretation of the "actual malice" standard in the instance of altered quotations. After *The New Yorker* had been dismissed as a defendant, the case ended in 1996 when a San Francisco jury found that Janet Malcolm did not libel psychoanalyst Jeffrey Masson in her 1983 profile.[41]

The case was historic because it dealt with the degree that a writer can rewrite or rearrange quotes given by a source and still maintain accuracy as to that source's original intent and meaning. It relates to the central issue that made "The New Journalism" controversial during the 1960s. Kathy Roberts Forde explores this case and its legal and historic context in her excellent book, *Literary Journalism on Trial: Masson v. New Yorker and The First Amendment*.

Postscript

The end of *Life* and *Saturday Evening Post* as weekly magazines occurred during the late 1960s and early 1970s. Several books have been written about the circulation wars and internal management battles at both magazines during this era. Books about *Life* include: *That Was the Life* by Dora Jane Hamblin (1977), *The Great American Magazine: An Insider History of Life* by Loudon Wainwright (1986), *Life's America: Family and Nation in Postwar Photojournalism* by Wendy Kozol (1994), and *Looking at Life Magazine* edited by Erika Doss (2001). Three top editors or executives at the *Post* wrote their own accounts of these final years: *Decline and Fall* by Otto Friedrich (1970); *The Curtis-Culligan Story* by Matthew Culligan (1970); and *The Curtis Affair* by Martin Ackerman (1970). An account of the business decline of *Saturday Evening Post* was also published and used as a case study at the Harvard Business School.[42]

In May of 1970, the Curtis trustees sold the 700,000 shares of Curtis stock they had controlled since 1933 to Beurt SerVaas, a millionaire industrialist from Indianapolis, who took over as president and principal stockholder. "I came into this company to preside over its death, but instead I decided I could save it," he said. He told the *New York Times:*

> Toward the end the Post became worldly and sophisticated and hard-nosed in an attempt to rejuvenate itself, but it failed and what we intend to do now should make everyone happy. We're not going to print any more exposés or muckraking articles; we're going to concentrate on writing about those institutions and mores in contemporary America that are good for America.[43]

The venerable *Saturday Evening Post,* which has a lineage dating back to Benjamin Franklin's *Pennsylvania Gazette* in 1729, continues publication as a successful bimonthly magazine. Franklin's *Pennsylvania Gazette* became the *Saturday Evening Post* in 1821.[44] Its current publisher is Joan SerVaas, Beurt SerVaas' daughter, and editor-in-chief is Stephen George, a former editor at Rodale and Meredith. The magazine underwent a repositioning of its content in 2008 to return to its original mission of celebrating the best in American life and culture.

With America's renewed economic growth and expansion, the 1980s became known as a decade of affluence and greed. Magazines enjoyed the fruits of prosperity with steady growth. But they also became even more focused on celebrities while their editors and writers tried to figure out how to use their new PCs and Macs.

Notes

1. Tom Wolfe, "The 'Me' Decade and the Third Great Awakening," *New York*, August 23,

1976, http://nymag.com/news/features/45938 (accessed November 13, 2009).

2. Mary Ellen Zuckerman, *A History of Popular Women's Magazines in the United States,
 1792–1995* (Westport, CT: Greenwood Press, 1998), 227.

3. Robin Morgan, "*Ms.*—And I Have To Tell You It Feels Like Journalism." 1992 Meredith
 Lecture, School of Journalism and Mass Communication, Drake University (published
 April 1992), 16.

4. Gloria Steinem, "Sex, Lies, and Advertising," reprinted in *Moving Beyond Words* (New York:
 Simon and Schuster, 1994), 161.

5. Osborn Elliott, *The World of Oz* (New York: The Viking Press, 1980), 425.

6. Ibid., 146.

7. "Job Bias at *Newsweek* Charged by 50 Women in Complaints to EEOC," *Wall Street
 Journal*, May 17, 1972.

8. Zuckerman, *A History of Popular Women's Magazines*, 229.

9. Deirdre Carmody, "An Enduring Voice for Black Women," *The New York Times*, January
 23, 1995, D1.

10. "Marcia Ann Gillespie." *Notable Black American Women*, Book 3. Gale Group, 2002.
 Reproduced in *Biography Resource Center* (Farmington Hills, MI: Gale, 2009),
 http://galenet.galegroup.com/servlet/BioRC.

11. Ibid.

12. Sam G. Riley, "Earl Gilbert Graves," *African Americans in the Media Today* (Westport, CT:
 Greenwood Press, 2007), 156.

13. "Earl Graves," African-American Registry, www.aaregistry.com (accessed November 16,
 2009).

14. Earl G. Graves, *How To Succeed in Business Without Being White: Straight Talk on Making
 It in America* (New York: Harper Business, 1997), xix.

15. Richard Stolley, telephone interview with the author, February 17, 2005.

16. Norberto Angeletti and Alberto Oliva, *Magazines That Make History: Their Origins,
 Development and Influence* (Gainesville: University Press of Florida, 2004), 381.

17. Ibid., 376.

18. Joe Treen, e-mail to author, February 1, 2006.

19. Hedley Donovan, *Right Places, Right Times: Forty Years in Journalism Not Counting My Paper
 Route* (New York: Henry Holt and Company, 1989), 300.

20. Judy Kessler, *Inside People: The Stories Behind the Stories* (New York: Villard Books, 1994),
 11.

21. Ibid., xix.

22. Philip H. Dougherty, "*Us* Delays Plans To Go Weekly," *The New York Times*, January 10,
 1983, D8.

23. Edwin Diamond, "Celebrating Celebrity," *New York*, May 13, 1984, 22.

24. Media kit, Us Magazine, www.usmagazine.com (accessed November 18, 2009).

25. Jack Vitek, *The Godfather of Tabloid: Generoso Pope, Jr. and the* National Enquirer (Lexington:
 University Press of Kentucky, 2008), 191.

26. For more examples of legal cases involving magazines, see Chapter 11, "Magazine
 Legalities: Understanding the Law," in Sammye Johnson and Patricia Prijatel, *The
 Magazine from Cover to Cover*, 2nd ed. (New York: Oxford University Press, 2007),
 318–353.

27. Iain Calder, *The Untold Story: My 20 Years Running the* National Enquirer (New York: Miramax/Hyperion, 2004), 166.
28. Ibid., 167.
29. *Burnett* v. *National Enquirer*, 193 Cal. Reporter 206 (Cal. Ct. Appl. 1983).
30. University of Hawaii, School of Communications, http://www2.hawaii.edu/~tbrislin/cbfund.html (accessed November 20, 2009).
31. Victor Navasky, *A Matter of Opinion* (New York: Farrar, Straus and Giroux, 2005), 219.
32. Ibid., 220.
33. 471 U.S. 539 (1985).
34. *Time Inc.* v. *Firestone*, 424 U.S. 448, 1 Media L. Rep.1665 (1976).
35. Paul Bryant with John Underwood, *Bear: The Hard Life & Good Times of Alabama's Coach Bryant* (Chicago: Triumph Books, 1974). See pp. 212–226 for Bryant's account of these events.
36. Ibid., 224–225.
37. Otto Friedrich, *Decline and Fall: The Struggle for Power at a Great American Magazine,* The Saturday Evening Post (New York: Harper & Row, 1969), 44.
38. Janet Malcolm, "The Annals of Scholarship: Trouble in the Archives—Part I," *New Yorker*, December 5, 1983, 59–152, and "Part II," December 12, 1983, 60–119.
39. Kathy Roberts Forde, *Literary Journalism on Trial: Masson v.* The New Yorker *and the First Amendment* (Amherst: University of Massachusetts Press, 2008), 225.
40. Janet Gross, "At Libel Trial, Speaking Style Becomes the Focus," *The New York Times*, May 19, 1993, A16.
41. Ibid., 1–2.
42. John M. Wynne, *The Saturday Evening Post—Revised* (Boston: HBS Case Services, 1972). Retrieved at *Saturday Evening Post* archives, Indianapolis, IN.
43. *The New York Times*, November 6, 1970. Cited in Wynne, *The Saturday Evening Post— Revised.*
44. John Tebbel, *George Horace Lorimer and the* Saturday Evening Post (Garden City, NY: Doubleday, 1948), 17.

The 1980s

Computers and Celebrities Dominate the Decade

Computers and celebrity editors seemed to dominate the 1980s. The personal computer began revolutionizing magazine production techniques while celebrities increasingly dominated their content—both as editors and as subject matter. In 1981, IBM introduced its long-awaited personal computer that used the operating system developed by a fledgling company by the name of "Microsoft." In 1982, you could pay $40 an hour to read the *Harvard Business Review* online— if you had access to a mainframe computer. With a dazzling Super Bowl advertisement in 1984, Apple introduced its Macintosh computer. *TV Guide* later named it the "Greatest Commercial" of the century.

In 1984, Condé Nast introduced thirty-year-old Tina Brown as the editor of its recently revived-from-the-dead *Vanity Fair.* The Oxford-educated Brown was known as the "wunderkind of British magazines" after four successful years as editor in turning around *The Tatler,* a British magazine the company had recently published. Along with fame and good looks, she brought her penchant for publicity and controversy to *Vanity Fair, The New Yorker,* and then to *Talk.* A few years later, Condé Nast chose her headline-grabbing British colleague, Anna Wintour, to edit *Vogue.* Not long after that, Martha Stewart came along to launch *Martha Stewart Living* with Time Inc.

The revolution in magazine production

Before page-design software, magazine copy was typeset on machines costing

$25,000 and up, and page layout and paste-up was done by hand using hot wax machines. Page-design software for computers revolutionized this cumbersome production process. The first page design software was PageMaker, which was introduced in 1985 by Aldus Corporation. QuarkXPress, which was introduced in 1988, dominated the market until the end of the century. Aldus Corporation merged with Adobe Systems in 1994 and Adobe introduced In Design in 1999, which has since become the market leader.

Before the mid-1980s, magazines able to afford expensive equipment did production in-house while others farmed it out to production companies. After editors finished editing articles, they sent them to the production department, which keyboarded the copy into a typesetting machine. The layout staff ran it through a hot wax machine before doing "paste-up." Every single article was manually positioned on the page by cutting and pasting the copy to make it fit. Black and white photos had to be sent separately to the printer to create a "halftone." After the halftone was created, it was positioned on the page with hot wax the same as editorial copy. Color photos had to be sent out to companies that created four-color separations that could cost hundreds of dollars per photo. Black lines, boxes and frames were created on the layout pages using plastic production tape. After the "camera-ready pages" (or "mechanicals") were created, the magazine went to the printer. Printers used giant cameras to create negatives of the pages, which were then used to create the metal printing plates that were attached to the web presses.

"The late 1980s began the desktop publishing era," said Shirrel Rhoades, a former publishing executive at Scholastic, Inc., *Reader's Digest, Ladies' Home Journal*, and *Redbook*. "Suddenly I didn't have to have a big production department; suddenly I didn't have to do paste-up or impositions. I didn't have to have typographers or linotype machines. I could have some computer guy sitting there with a computer designing pages right there on his screen."[1]

The new technology drastically reduced production costs and attracted an influx of new magazines and entrepreneurial publishers. "Pre-press departments disappeared. To some degree, companies that did color separations disappeared. It changed the whole magazine industry during that period of time," said Rhoades. By the end of the 1990s, page designers could do everything on computers costing maybe $1,000 that fifteen years earlier cost more than $25,000. Like slide rulers, hot wax machines and paste-up tape became quaint relics of another era.

The rise and fall of computer magazines

Dozens of computer magazines were launched in the early 1980s and dozens were out of business by the end of the 1990s. There were special magazines for every niche and brand of computer, which included names like Commodore, Zenith, Texas

Instruments, Motorola, Atari, and Kaypro. Computer magazines told readers how to choose and buy computers, buy and use various kinds of software, and do things on their computers. As computers became common and people became sophisticated in how to use them, computer magazines saw a subsequent fall that was almost inevitable. By the end of the 1990s, whatever "how-to" information anyone needed was easily available online and probably free.

"There were 128 computer magazines being published in 1983," said Shirred Rhoades, who helped launch *Family Computing* for Scholastic, Inc., the largest publisher of educational magazines for children. He said, "Dick Robinson, the chairman of Scholastic, went to a consumer electronics show, and he saw this new thing called a personal computer. He had always viewed the *Scholastic* market as creating products for students, teachers, and parents. But we didn't have a lot of products for parents. He got the idea that a computer magazine would be great because parents could subscribe to this magazine and help their kids do their homework on their computers. So we launched *Family Computing*."

They published the magazine for four years, but the market was changing so rapidly that they had to reposition its content for a changing audience. "As the market grew, the education computer market seemed to take a dip. At the same time, the home office became the big thing. People found they could bring work home and could emulate on their computers the same spreadsheet or software from the office. So we repositioned *Family Computing* to become *Home Office Computing*," said Rhoades.[2]

BYTE, the first non-trade magazine in the computing field, was launched in 1975 and was among a wave of periodicals for early computer hobbyists. Another early computer magazine was *Computer Shopper*, which was launched in 1979 and published in print format until it folded in 2009. During its peak in the early 1990s, *Computer Shopper* issues were frequently more than 800 pages. *PC Magazine* was launched in 1982 and positioned itself as the leading information source for PC-related products. It peaked at 400 pages from the 1980s through the mid-1990s and folded in 2009. Both *Computer Shopper* and *PC Magazine* are still published regularly in online editions.

Steve Jobs (1955–) and Apple Computers introduced their Macintosh line in 1984, which spurred another series of magazines such as *Macworld, MacAddict, MacLife, Magazine, MacUser* and *Macintouch*. Apple introduced the Macintosh in a Super Bowl commercial that concluded with the line, "On January 24, 1984, Apple will introduce the MacIntosh computer and you will see why 1984 will not be like '1984.'" In 1999, *TV Guide* ranked it first in the "50 Greatest Commercials of All Time."[3]

After fallout and mergers in this segment, only *Macworld* remained in print format. The magazine is published by Mac Publishing, L.L.C., a subsidiary of the

International Data Group and not related to the Apple computer company. However, the magazine's successful niche in the market is partly due to Apple's innovative products, which enabled the magazine to use the tagline, "the Apple, Mac, iPod, and iPhone Experts" on its cover.

After the fallout of computer manufacturers, it was coming down to PCs and Apples by the mid-1980s, said Shirrel Rhoades. "The PC was the business computer, and the Apple computer was the graphic designer computer. Apple was more intuitive and designers liked it, and PCs were more appealing to the engineers and people who wanted logical analytical approaches," he said.

Continued innovation in hardware and software for both platforms made them almost identical. "Today the two are pretty well-blended. You can run PC programs on the Apple and PC has the Windows interface that emulates an Apple-like environment. But back then, that was the division of the marketplace," said Rhoades (1942–).

The rise of city and regional magazines

Inspired by the success of *New York* in 1968 and *Texas Monthly* in 1973, city and regional magazines became the fastest-growing sectors of the magazine industry during the next two decades. A 1982 study of city and regional magazines found that thirty-eight of them were launched between 1970 and 1979. The same study found that they grew in circulation an average of 32.8 percent between 1976 and 1980 with gains ranging from two percent to more than 100 percent. City magazines in Baltimore, Boston, Houston, Nashville and San Diego more than doubled their circulations during these five years.[4]

"Metropolitan or city magazines provide the only medium which has the capability of establishing the 'identity and flavor' of a market. No other medium…has the opportunity of position, through both editorial and design, to capture the true 'picture,'" according to Charles G. Meyst, former editor of *Richmond Lifestyle* in the study cited above.

Texas Monthly was launched in 1973 by Texas native Michael Levy after he sold advertising for *Philadelphia* magazine for a year. He returned to Texas to attend the University of Texas Law School and conceived the idea for the magazine while he was a law student. "The concept of a regional magazine, at that time, wasn't a known commodity," he told the *Dallas Morning News* ten years later. "We had no marketing studies. That would be like Alexander Graham Bell doing a marketing survey on the telephone. How could he do that if nobody had ever seen one?" During the next thirty-five years, it went on to win ten National Magazine Awards, including four for "General Excellence," more than any other city or regional magazine.

Texas Monthly is also one of a few successful magazines aimed at a statewide

audience. Out of about ninety city-regional magazines, only fifteen are published or aimed at a statewide readership. Magazines published for urban area audiences have been much more successful than statewide magazines. The reasons are both economic and cultural. Few national companies based in a particular state want to reach readers within that state only. Companies producing nationally distributed products and services want to advertise in national magazines. However, city magazines can attract local restaurants, entertainment venues, doctors, lawyers and other professionals that want to reach readers and potential customers within driving distances. States that are smaller in geographic area can also attract a group of advertisers of culinary and entertainment venues within driving distance of most readers.

The second reason there are few successful statewide magazines has to do with cultural identity. A successful magazine needs a large audience that shares common characteristics and interests. While residents of a large city share interests in entertainment, sports or recreational venues, the same cannot be said for residents of an entire state. Residents of northern and southern California, for example, might as well live in different states. One of the reasons for *Texas Monthly*'s early success was the cultural identity shared by Texans. However, the magazine's current mission statement reflects its desire to serve the state's increasingly diverse audience:

> *Texas Monthly* has always taken as its premise that Texas began as a distinctive place and remains so. In the last decade, however, as waves of New Yorkers and Californians and the like have moved to Texas, attracted by a strong economy and vibrant lifestyle, the state has evolved and so has the mission of the magazine. For the natives, *Texas Monthly* functions as a reminder of what once was, a record of their proud heritage. For the transplants, *Texas Monthly* is part textbook and part guidebook, a journalistic road map of the state, its history, and its people.[5]

Texas Monthly has been owned since 1998 by Emmis Communications, which is based in Indianapolis, Indiana. The company was founded in 1979 as Emmis Broadcasting by Jeff Smulyan. The company currently owns twenty-seven radio stations in several major cities as well as in Hungary, Slovakia, and Bulgaria. Smulyan entered the magazine business when he purchased *Indianapolis Monthly* in 1988, *Atlanta Monthly* in 1993, *Cincinnati Magazine* in 1997, *Texas Monthly* in 1998, *Los Angeles* in 2000, and *Orange Coast* (Orange County, California) in 2007.

Until the 1980s, three major regions of the country—Northeast (*Yankee*), South (*Southern Living*), and West (*Sunset*)—had their own magazines. The only region lacking its own magazine was the Midwest. Meredith Corporation based in Des Moines, Iowa, saw the need and launched *Midwest Living* in 1987. The magazine has since grown steadily to its current circulation of more than 900,000.

Table 1

Major Magazine Launches of the 1980s			
Year	Magazine	Year	Magazine
1980	Fine Homebuilding	1986	Triathlete
	Discover		Automobile Magazine
	Home & Away		Air & Space/Smithsonian
	Guitar World		North Shore Magazine
	Phoenix Home & Garden		Child
	Arthritis Today		Midwest Living
1981	Computer Gaming World		American Snowmobiler
	Islands		Inside Triathlon
	Metropolis		Mountain Bike Action
	Woman's World		Electronic House
1982	PC Magazine		Private Clubs Magazine
	Victorian Homes		Dogs USA
	Vintage Motorsport		Veterinary Practice News
	Circle Track		Caribbean Travel & Life
	Dirt Rider		Sport Fishing
	Bridal Guide	1987	Perfect Vision
	Playbill		Cooking Light
	FineScale Modeler		Country
	North American Whitetail		Birder's World
	PC World		Classic Toy Trains
	Details		Handguns
	Bird Talk		Inc.
	Garden Design		Men's Health
	Marlin		Veranda
1983	Romantic Homes		Premiere
	VW Trends		Conde Nast Traveler
	Fitness		Birds USA
	Guitar One		Wild Bird
	Flex Magazine		Parenting
1984	Utne Reader	1988	Golf For Women
	Wood		Fine Gardening
	Garden Railways		Muscle Mustangs & Fast Fords
	Artist's Magazine		Sport Truck
	Country Sampler		Sister 2 Sister
	Star Magazine		North American Fisherman
1985	Travel America		New York Press
	Outdoor Photographer		Car Audio and Electronics
	American Woodworker		PC Gamer
	Vim & Vigor		Shooting Sportsman, The
	Wildfowl		Elegant Bride (Southern Bride)
	Elle	1989	Soap Opera Weekly
	Men's Fitness		Movieline's Hollywood Life
	Departures		Gamepro
	Radio Control Car Action		Teacher Magazine
1986	Electronic Gaming Monthly		Auto Restorer
	Videomaker		First For Women

S.I. Newhouse, Jr. shakes up the 1980s

Newspaper magnate S.I. Newhouse purchased Condé Nast Publications in 1959. After he died in 1979, the magazine division, which included Condé Nast and other units, was managed by S.I. ("Si") Newhouse, Jr. (1927-___) while his brother, Donald (1930-___), managed the company's newspaper and cable television operations. Si Newhouse went on to become one of the principal magazine "movers and shakers" of the next thirty years.

Under Si Newhouse's leadership, Condé Nast continued its robust expansion into magazines by launching and buying titles aimed at readers with affluent lifestyles. In 1979, the company launched *Self*, the first Condé Nast launch since *Glamour* in 1939. In 1981, Newhouse purchased *Gentlemen's Quarterly* (GQ) from Esquire, Inc. In 1983, he purchased *Gourmet*, an epicurean magazine started in 1941, although he closed the magazine in 2009. In 1983, he re-launched *Vanity Fair* with great success. In 1986, he paid $25 million for Citibank's *Signature*, which went to its Diners Club cardholders, and remade it into *Condé Nast Traveler*, a travel magazine aimed at affluent travelers. Under his direction, the company started *Details* in 1988 and *Allure* in 1991. In 1993, it purchased *Bon Appétit* and *Architectural Digest*. It purchased *Wired*, a magazine focused on technology and society, in 1993.

"Si Newhouse has shaken up the company his father left behind, snapping up old magazines, starting new ones, refashioning those he already owns, hiring and firing at a sometimes dizzying pace," wrote one newspaper reporter. Newhouse is known as a quiet and reserved publisher who "speaks softly but carries a big stick." He was the subject of a critical biography, *Newhouse: All the Glitter, Power, and Glory of America's Richest Media Empire and the Secretive Man Behind It*, which was published in 1994.

Si Newhouse stirred up controversy when he purchased *The New Yorker* in 1985, the venerable magazine with a storied history dating back to its 1928 founding by Harold Ross. Since Ross's death, the magazine had been independently owned as a public company with Peter Fleischmann, son of Ross's financial backer Raoul Fleischmann, as its principal shareholder. The story of the behind-the-scenes maneuvering that resulted in Newhouse's takeover is told in the 1988 book, *The Last Days of The New Yorker*, by Gigi Mahon, as well as the 1994 biography *Newhouse* by Thomas Maier.

The prestige of the magazine suffered serious damage in the summer of 1984 after writer Alastair Reed admitted that he had occasionally created composite quotes and fabricated anecdotes for his articles. The Scottish-born writer made these admissions while giving a guest lecture to a Yale University class. The story was later picked up by the *Wall Street Journal, New York Times, Newsweek,* and other major

publications. Before the controversy subsided, the magazine was forced to publish a joint memo from the publisher and the editor stating that its high editorial standards would never again be breached. "We do not permit composites. We do not rearrange events. We do not create conversations," the memo read.[6]

On March 6, 1985, Newhouse completed the deal to pay $143 million for 87 percent of the shares of The New Yorker, Inc. stock that he didn't already own. While no one called it a "hostile takeover," the deal looked, acted and quacked like a duck. Newhouse's takeover was made possible because Peter Fleischmann, the majority shareholder, still owned only 25 percent of the shares. Board members Philip Messinger and William Reik owned a combined 27 percent of the company's shares and were unhappy with Fleischmann's management. Their willingness to sell and their unhappiness with Fleischmann put pressure on him to go along with the deal.

The acquisition was unanimously and vocally opposed by the magazine's 200 employees. "New Yorker employees were...appalled. As news of the finality of it spread, they reacted with anger, sadness, disbelief. They talked of leaving," wrote Mahon.[7] But, of course, they had no power to stop it. William Shawn (1907–1992), who had been editor since 1951 and managing editor since 1939, cooperated with the takeover and for two years tried to play the difficult role of mediator between Newhouse and the staff. Newhouse had promised Shawn and the staff that he would allow the seventy-eight-year-old Shawn to name his own successor. In 1987, however, Newhouse abruptly fired Shawn (another controversial move that outraged the staff) and named Robert Gottlieb (1930–) as his successor. Gottlieb had previously been editor-in-chief of Alfred Knopf, a book publishing company owned by Newhouse.

Newhouse made another controversial move by dismissing Grace Mirabella (1929–) as editor of *Vogue* and replacing her with Anna Wintour (1949–). Mirabella had spent thirty-one years at *Vogue*, seventeen of them as editor. During the years she was editor, *Vogue*'s circulation increased from 400,000 to 1.2 million. Mirabella discovered she had been fired after a friend heard Liz Smith, a New York gossip columnist, report it on the New York local television program, "Live at Five." Thomas Maier began his biography of Newhouse with this anecdote about Mirabella's dismissal. Newhouse said about his dismissal of Mirabella, "The way it was handled was graceless—without making a pun. The P.R. of it got all bitched up. So fine. But it wasn't a spur of the moment decision."[8] Grace Mirabella went on to start her own magazine, *Mirabella*, in 1989 with financial backing from Rupert Murdoch. *Mirabella* lasted for eleven years until it folded in 2000.

Shortly after purchasing *The New Yorker*, Newhouse named Steven Florio (1949–2007) as publisher of *The New Yorker*. Known for his brash and aggressive style, he was later promoted to president of Condé Nast magazines and given over-

sight of all sixteen of the company's magazines that reached thirty million readers. In announcing his death at the age of fifty-eight, *The New York Times* credited Florio with much of the company's recent success.

For 10 years, until 2004, Mr. Florio led Condé Nast….It was a period of great change in the magazine industry, with many companies downsizing because of the growth of the Internet. Still, under Mr. Florio's leadership, Condé Nast expanded from a relatively small company to the second-largest magazine publisher in the country, mostly by concentrating on magazines aimed at wealthy consumers of luxury goods and by aggressively focusing on selling advertising in them.9

The celebrity editors: Tina Brown, Anna Wintour and Martha Stewart

At the age of twenty-six, Tina Brown (1953–) was chosen editor of *The Tatler*, a moribund British magazine with a history dating back to 1709. Written for British society's elite, the magazine faced a circulation that had dwindled to 11,000 by the time she took the job. She brought wit, humor and satire to the magazine by poking fun at the same audience who read the magazine. "*Tatler*'s circulation, after its initial dip, actually tripled," wrote Judy Bachrach, a biographer of Tina Brown. "Even one of Tina's most obdurate critics was forced to conclude that mocking the upper classes seemed to have a remarkably salutary effect on its victims…Tina, even her enemies had to admit, did the most amazing things for the old magazine. In fact, she saved it," Bachrach wrote.10

After Brown had edited *The Tatler* for three years and increased its circulation from 11,000 to 35,000, Si Newhouse bought the magazine for Condé Nast on April 2, 1982. Bernard Leser, who was president of Condé Nast at the time, was quoted as saying, "We would never have bought *The Tatler* had it not been for Tina. I was absolutely convinced she was potentially one of the greatest editors one could have."11 By this time, however, Brown was becoming bored and looking for bigger challenges. A year earlier, she had married Harold Evans (1928–) who was editor of *The Sunday Times* (of London) from 1967 to 1981. After Rupert Murdoch purchased *The Sunday Times* in 1980, Evans edited the newspaper for another year before resigning over differences with Murdoch. On January 1, 1982, eight months after Newhouse purchased *The Tatler*, Brown announced her resignation as editor.

Si Newhouse was distraught over the resignation and wanted to find jobs for both Brown and Evans within his company. Although he had re-launched *Vanity Fair* with the March 1983 issue, he was not happy with the first two editors. The magazine remained unprofitable despite the $20 million the company had spent on it. Condé Nast's UK chairman, Bernard Leser, told his boss, "Si, I think Tina is very hot property. I think she's absolutely right for *Vanity Fair*."12

They found a place for Tina Brown as the new editor-in-chief of *Vanity Fair*. She began duties on January 1, 1984, as the third editor in the revived magazine's ten-month history. Her husband, Harold Evans, came with her, but did not start working for Condé Nast until 1986 when he was named as founding editor of *Condé Nast Traveler*. During the intervening two years, he was editor-in-chief of The Atlantic Monthly Press and editorial director of *U.S. News and World Report*.

At *Vanity Fair* and later *The New Yorker*, Brown became well known for spending lavish sums of money on writers, artists, and designers. She paid *Vanity Fair* writers up to $25,000 for lengthy articles and awarded $100,000-a-year contracts to her best writers. Staff members were given lavish expense accounts with trips to parties and events throughout the world. She bought them exotic Christmas and birthday gifts. One executive later said, "To spend one thousand dollars on a gift for an employee was not unusual. We don't have any checks here, as in checks and balances."[13] An admiring Si Newhouse, one of America's wealthiest men, was willing to accommodate her every wish. But it paid off.

By the end of her first four years as editor, circulation increased by 63 percent and advertising pages had tripled. By 1992, circulation had increased from 274,000 to more than a million with more than $1 million in profits. "It [*Vanity Fair*] was a perpetual underperformer when Tina took it over, and over time she turned it into the most talked-about magazine on the newsstand, with solid circulation and tons of advertising pages," wrote Cathie Black, president of Hearst Magazines, in her book *Basic Black*. She continued:

> Tina has established herself as not only a gifted editor, but as a heat-seeking missile with an uncanny knack for generating buzz. She—and by extension the magazines she edited—exuded an air of elegance, intelligence, and wit. She always managed to draw the brightest stars of the day into her orbit.[14]

Tina Brown put the best-known celebrities on *Vanity Fair* covers and paved the way for "celebrity journalism" that other mainstream magazines would follow. "The success of each month's issue rose or fell on the heat of the cover story and its inside features. As a result, *Vanity Fair* became the most stylish practitioner of the celebrity interview, underlying the American media's increasing reliance on Hollywood for news..." wrote Newhouse biographer Thomas Maier. He continued:

> Punchy photos with pithy headlines and familiar faces were needed to convince impulse buyers in the supermarkets to grab the latest issue. To attract a crowd into the show tent, to gain the needed circulation to justify the maximum possible advertising rates, celebrities on the cover became necessary, preferably blonde, beautiful and with a new blockbuster movie.[15]

The most controversial cover published by Brown was the August 1991 issue fea-

turing the nude and seven-months-pregnant actor Demi Moore in a shot taken by famed photographer Annie Leibowitz. "Tina was fascinated with the nature of celebrity in America. She took one class system and brought it to another system," said *Vanity Fair* writer Lynn Hirschberg. "I think Tina just understood the times. She recognized we had moved into a star system, and you either played to the star system or you lost it," said Tom Hedley, a former *Esquire* managing editor.[16]

Following her success at *Vanity Fair*, Newhouse chose Brown as the editor of *The New Yorker* after Robert Gottlieb retired. The magazine never made a profit during Gottlieb's five years as editor. Newhouse hoped that Brown would create the same dramatic turnaround at *The New Yorker* as she had at *Vanity Fair* and *The Tatler*. She did make many changes. She introduced a more modern layout with less type and more color and photography to the editorial pages. She also increased the coverage of current events and reduced the length of articles that often exceeded 10,000 words. She introduced the first letters-to-the-editor page in the magazine's history and added author bylines to the "Talk of the Town" pieces.

Under her direction, *The New Yorker* increased its circulation by a third to more than 800,000, but many of those subscriptions came at deeply discounted rates. Advertising revenue did not keep up with increased production costs, and the magazine continued to lose money—an estimated $10 million a year under both Gottlieb and Brown. Brown continued spending lavish amounts on writers with a reported $30 million a year editorial budget. Since Condé Nast is a privately owned company, precise figures on the magazine's revenues are not available. But the failure to make *The New Yorker* profitable put more pressure on Brown and the staff and made her once-amicable relationship with Newhouse increasingly strained. Brown's star-power was wearing thin. On July 8, 1998, she announced her resignation. Newhouse's fascination and admiration for Brown apparently had limits, and a sixteen-year professional relationship between the two ended. In 1999, she went on to become founding editor of the new magazine *Talk*, a Hollywood gossip and celebrity magazine jointly funded by Miramax and Hearst in 1999. This venture folded after two years.

After Brown left, David Remnick (1958–) was named editor of *The New Yorker*. With his strong credentials as a writer and reporter, he brought the magazine greater financial and literary success. He began as a staff writer at the magazine in 1992 after ten years as a reporter and Moscow correspondent for *The Washington Post*. He won a Pulitzer Prize in 1994 for his book *Lenin's Tomb: The Last Days of the Soviet Empire*.

Anna Wintour and *Vogue*

Anna Wintour (1949–) was named the editor of *Vogue* in 1988 after Newhouse fired

long-time editor Grace Mirabella. He felt that *Vogue* needed a fresh face and new momentum to meet its increased competition from the upstart *Elle*. The British editor had served her apprenticeship with Condé Nast as a successful editor of the British edition of *Vogue* and *House & Garden*. "She's perceived as a glamour girl," one *House & Garden* editor told *Newsweek*. "She's British, beautiful and wears only Chanel. She travels in a swell circle, and that's the crowd Condé Nast cares about."[17]

Wintour had begun her fashion magazine career in the U.S. during the 1970s as a fashion editor for *Harper's Bazaar*, *Savvy*, and *New York*. Former *New York* editor Edward Kosner lavished praise on her work in his memoir: "For her fashion issues, she'd present me with meticulous storyboards in which every page and spread was sketched out in precise detail with scouting Polaroids attached of the clothes to be shown….For the first time, *New York* had fashion pages more striking and innovative than those in *Fashions of the Times* or even *Vogue* itself. Over the next two years, Anna did extraordinary work."[18]

During the first ten years she was editor, circulation tripled from 373,000 to 1.2 million.[19] The September 2004 issue of *Vogue* boasted a record 832 pages, reportedly the largest issue of a monthly magazine ever published until then. She also helped introduce three spinoff titles: *Teen Vogue*, *Vogue Living* and *Men's Vogue*.

Wintour gained unsought public fame as the alleged inspiration for the Miranda Priestly character, the editor of a New York fashion magazine portrayed in the movie and novel titled *The Devil Wears Prada*. The 2003 book was written by Lauren Weisberger, who worked as a personal assistant to Wintour for a year. Although the book portrayed "Miranda Priestly" as a capricious and tyrannical editor, it brought Wintour increased name recognition and may have even boosted *Vogue*'s success. She was named "Magazine Editor of the Year" in 2006 by *Advertising Age*, citing the magazine's continued growth in circulation and advertising revenue.

"I learned many years ago to remain completely focused on what I do and not worry about what's being said or what's being written," Ms. Wintour said. "The most important thing is that you work with people you respect, and hopefully they respect you. You do the best job that you possibly can, and then you go home and have dinner with your kids and play with your dog."[20]

"The editor of *Vogue* has always been a celebrity; Anna is more so," said Si Newhouse. The Condé Nast philosophy, according to Newhouse, is to let the editors run free. "We try to hire people with intelligence and energy," he said. "Then they start to edit, and the magazine comes out in ways that are a total surprise to everyone. I didn't know what Tina was going to do. Nobody knew that when Anna came to *Vogue* she was going to have a girl in a Lacroix cross and blue jeans on the cover. We feel almost that whichever way it goes, as long as it doesn't do something absolutely screwy, you can build a magazine around the direction an editor takes."[2]

Martha Stewart and *Martha Stewart Living*

Martha Stewart published a series of books during the 1980s that established her name: *Entertaining* (1982), *Martha Stewart's Quick Cook* (1983), *Martha Stewart's Hors D'oeuvres* (1984), *Martha Stewart's Pies & Tarts* (1985), *Weddings* (1987), *The Wedding Planner* (1988), *Martha Stewart's Quick Cook Menus* (1988), *Martha Stewart's Christmas* (1989), and many others. She also wrote dozens of newspaper columns, magazine articles and other pieces on homemaking, and made numerous television appearances on programs such as "The Oprah Winfrey Show" and "Larry King Live." After all of this, a Martha Stewart magazine could not be far behind.

In 1990 Stewart signed with Time Inc. to develop a new magazine, *Martha Stewart Living*, for which she would be editor-in-chief. The first issue was published in late 1990 with an initial rate base of 250,000. In 1993, she began a weekly half-hour service program based on her magazine, which was quickly expanded to a full hour, and later to a daily format, with half-hour episodes on weekends. Stewart also became a frequent contributor to CBS's "The Early Show" and starred in several prime-time holiday specials on CBS Television. One biographer noted that by 1993, "Martha Stewart was the editor of one of the most closely watched—and rapidly growing—magazines in America. She was the author of ten books, the star of her hit TV show and six videotapes, and a regular guest on Oprah, the David Letterman Show, and Today. She was a one-person media conglomerate, the largest cottage industry in America."

After the magazine achieved success, Stewart wanted to free herself from Time Inc. and form her own company. Christopher Bryan, who wrote a biography of Stewart, said, "She was making demands on Time Warner that were perceived as so unreasonable and outrageous as to invite the Time side to let her leave simply to be done with her."[22] In a deal with terms that remained private, Stewart purchased rights to publish *Martha Stewart Living* and a series of spin-off books called "The Best of Martha Stewart Living." The new company would be called "Martha Stewart Living Omnimedia, LLC." *The New York Times* reported that she paid Time Warner at least $85 million to close the deal. By the end of 2008, *Martha Stewart Living* had grown to more than two million readers and ranked thirty-fifth in circulation among all magazines.

Mortimer Zuckerman buys *U.S. News and World Report*

On June 11, 1984, the board of directors signed an agreement to sell the employee-owned *U.S. News & World Report* to Mortimer B. Zuckerman (1937–), who paid

$163 million to stockholders and $13 million in notes to senior executives to make up for deferred compensation.[23] That came to about $3,000 a share for 56,000 shares. Industry analyst John Morton called the selling price "pretty stiff" based on the company's $3.2 million earnings the previous year. Zuckerman also owned *The Atlantic Monthly*, which he purchased in 1980 and sold in 1999. He has also owned the *New York Daily News* since 1993.

Zuckerman grew up in Montreal as the son of a tobacco and candy wholesaler. After earning degrees from Harvard, McGill, and the Wharton School of Business, he went to work for a prestigious Boston real estate firm. Here he displayed an amazing knack for stitching together real-estate deals and became a multi-millionaire by the age of 30. By 1985, Zuckerman owned and managed seventy-one buildings in Washington, Boston, New York, and California.

Zuckerman first became involved with *U.S. News and World Report* as a developer in 1981—three years before he purchased the company. The employee-owned company wanted to develop its four acres of prime land in Washington as a long-term investment and chose Zuckerman as a 50–50 joint venture partner. When the board decided to put the magazine up for bids, Zuckerman won out over such media giants as Gannett, the newspaper chain, and Gruner + Jahr, the German publisher that owned several U.S. magazines.

In a *USA Today* interview, Zuckerman said, "We expect to stay a very serious and straightforward newsweekly with a conservative perspective on its editorial page. This is what the magazine has been and this is what we expect to continue. This is its franchise, its history, and its voice." Distinguishing the magazine from its competitors, Zuckerman added,

> I see *Time* and *Newsweek* as almost Tweedledee and Tweedledum—they are really almost imitating each other very frequently. We try to be a different magazine. We have twice as much space devoted to business, financial, economic reporting and personal financial services—sort of the business-news-that-you-can-use kind of thing. We have a slightly older, better educated, more conservative, more affluent audience, an audience that is more in the way of professionals and managers, a lot of business people.[24]

One popular innovation at *U.S. News* was its annual rankings of colleges and universities, which began in 1983. The fall of 1987 marked the publication of its annual book, *America's Best Colleges*. The magazine's college rankings "cause bitter rivalries among colleges and universities, which feel an effect in the number of applications each time the institutions rise or fall on the list," wrote *New York Times* reporter Alex Kuczynski. Among the controversial criteria the magazine uses in its rankings include a survey of college presidents and amount of alumni giving. Nevertheless, the list spawned a profitable side business for the magazine. The annual

1 "best colleges" issue in September typically sold more than 50,000 copies—
about 40 percent more than typical newsstand sales.[25]
While all three newsmagazines have declined in circulation since 1990, the drop
at U.S. News & World Report has been the steepest. It lost 800,000 readers since its
1989 peak of 2.6 million while its share of the newsmagazine market declined from
25 to 22 percent. In November 2008, Zuckerman announced that he was reducing
the frequency of the magazine to monthly. At the time U.S. News averaged 1.8 mil-
lion circulation per issue, compared with 2.7 million for Newsweek and 3.4 million
for Time.

Time Inc. Merges with Warner Communications

Time Inc.'s magazine launch of TV-Cable Week in 1983—its first since People in
1974—was an abysmal failure. The company spent $100 million on the ill-fated ven-
ture. "Everybody noticed that the haughtiest magazine publishing company in the
world had the biggest magazine flop of the century," wrote Richard Clurman in To
the End of Time: The Seduction and Conquest of a Media Empire.[26] Top executives felt
they had never been able to successfully capitalize on the television revolution and
that the company remained too print-dominated. Led by Dick Munro, Nick
Nicholas, and Gerald Levin, the company paid $14 billion to acquire Warner
Communications in 1989. It was the largest corporate merger in American histo-
ry, which created the world's largest entertainment and media conglomerate. They
saw the merger as a way of "synergizing" their products with the cable television
operations, television stations, and movie production companies owned by Warner.
Warner's electronic empire would offer new ways to promote and expand Time's
print products.

The merger was controversial from the beginning. "Warner and Time were as
different from each other—in their people and their products—as the scrappy old
Brooklyn Dodgers and the haughty old New York Yankees. Different leagues, dif-
ferent managers, different fans—same hometown," wrote Richard Clurman in To
the End of Time.[27] Clurman argued that Warner's flamboyant chief executive,
Steven Ross, engineered the merger on unequal terms in a way that benefited him
and the company he had built over the past two decades.

Nevertheless, the merger did not directly affect the company's magazine pub-
lishing business, which continued to expand with the launch of Entertainment
Weekly and Martha Stewart Living in 1990. The print magazine division continued
to use the corporate name of "Time Inc." while the company itself became known
as "Time Warner." In 2000, it became "AOL Time Warner" in another controver-
sial merger with America Online. That marriage didn't work out too well, so it

divorced AOL and returned to using the name "Time Warner" in 2003.

By 1990, American magazines had reached their highest combined circulation in history. In 1991 they celebrated their 250th anniversary in America. Andrew Bradford published the first issue of his magazine, *American Magazine or a Monthly View of the Political State of the British Colonies*, on February 13, 1741. Three days later, Benjamin Franklin published his magazine, *The General Magazine and Historical Chronicle for All the British Plantations*. Neither Bradford nor Franklin could have imagined what magazines would look like 250 years later.

Notes

1. Interview with the author, Indianapolis, IN, July 7, 2009.
2. Ibid.
3. Barbara Vancheri, "Perfect Pitches: *TV Guide* Salutes 50 Best Commercials," *Pittsburg Post-Gazette*, June 30, 1999, http://www.post-gazette.com/tv/19990630tvland2.asp.
4. Alan D. Fletcher and Bruce G. VandenBergh, "Numbers Grow, Problems Remain for City Magazines," *Journalism Quarterly* 59, 2 (Summer 1982): 313–317.
5. www.texasmonthly.com/about.
6. Thomas Maier, *Newhouse: All the Glitter, Power, and Glory of America's Richest Media Empire and the Secretive Man Behind It* (New York: St. Martin's Press, 1994), 268.
7. Gigi Mahon, *The Last Days of* The New Yorker (New York: McGraw-Hill, 1988), 173.
8. Maier, *Newhouse: All the Glitter, Power, and Glory of America's Richest Media Empire*, 3.
9. Dennis Hevesi, "Steven T. Florio, Executive Who Expanded Condé Nast, Dies at 58," *The New York Times*, December 28, 2007, http://www.nytimes.com/2007/12/28/business/media /28florio.html.
10. Judy Bachrach, *Tina and Harry Come to America: Tina Brown, Harry Evans and the Uses Power* (New York: The Free Press, 2001), 82.
11. Ibid., 122.
12. Ibid., 127.
13. Ibid., 162.
14. Cathie Black, *Basic Black: The Essential Guide for Getting Ahead at Work (and in Life)* (New York: Crown Business Publishers, 2007), 158, 163.
15. Maier, *Newhouse: All the Glitter, Power, and Glory of America's Richest Media Empire*, 253.
16. Bachrach, *Tina and Harry Come to America*, 214–215.
17. *Contemporary Authors Online*, Gale, 2009. Reproduced in *Biography Resource Center* (Farmington Hills, MI: Gale, 2009), http://galenet.galegroup.com/servlet/BioCCAREER.
18. Edward Kosner, *It's News to Me: The Making and Unmaking of an Editor* (New York: Thunder's Mouth Press, 2006).
19. *Magazine Trend Report*, 1990, 1995, 2000 editions (Schaumburg, IL: Audit Bureau of Circulations).
20. "Magazine Editor of the Year: Anna Wintour," http://www.designtaxi.com

/news.php?id=5290 (accessed December 8, 2009).

21. Gigi Mahon, "S.I. Newhouse and Condé Nast; Taking Off the White Gloves," *The New York Times*, September 10, 1989.

22. Christopher Byron, *Martha Inc. The Incredible Story of* Martha Stewart Living Omnimedia (New York: John Wiley & Sons, 2002), 266.

23. Gwen Kinkead, "Media's New Mogul," *Fortune*, October 14, 1985, 196.

24. "TV Too Simple-Minded for Magazine Readers," *USA Today*, June 14, 1985, 13A.

25. Alex Kuczynski, "'Best' List for Colleges by U.S. News Is Under Fire," *The New York Times*, August 20, 2001, B1.

26. Richard M. Clurman, *To the End of Time: The Seduction and Conquest of a Media Empire* (New York: Simon & Schuster, 1992), 26.

27. Ibid.

The 1990s

New Media, New Magazines, New Controversies, New Problems

In a *Vanity Fair* article, writer David Kamp labeled the 1990s "The Tabloid Decade," saying, "The tabloidification of American life—of the news, of the culture, of human behavior—is such a sweeping phenomenon that it can't be dismissed as merely a jokey footnote to the history of the 1990s." The crystallizing event of the 1990s, he said, was the O.J. Simpson saga—"A prolonged Hollywood Babylon spectacle that confirmed the prevailing national interest in sex, death, celebrity and televised car chases." Besides the O.J. saga, the decade witnessed the Clarence Thomas-Anita Hill saga, the Pee-wee Herman saga, the JonBenet saga, the Tonya Harding saga; the Lorena Bobbitt saga, the Gennifer Flowers saga, the Monica Lewinsky saga, the list goes on. Magazines were in the thick of it all.

Time became more embroiled in the O.J. saga than it anticipated. Former football star O.J. Simpson was charged with the murder of his ex-wife, Nicole Brown Simpson, and her friend Ron Goldman in 1994. After a widely televised slow-speed pursuit, police arrested Simpson and released his mug shot to the media. Both *Time* and *Newsweek* published the Simpson mug shot on their next week's covers. *Time,* however, digitally altered the photo to darken the lines and images in a way that gave Simpson a more sinister-like appearance. Since *Time* and *Newsweek* used the same photo, differences in the two covers were immediately obvious to readers. *Time*'s cover produced an outcry of criticism. Civil rights leaders criticized the altered photo for its racist implications. Journalists criticized it because it was a news photo that was digitally manipulated. In the next issue, *Time*'s managing editor James R. Gaines expressed his naiveté at the outcry:

I have looked at thousands of covers over the years and chosen hundreds. I have never

been so wrong about how one would be received. In the storm of controversy over this cover, several of the country's major news organizations and leading black journalists charged that we had darkened Simpson's face in a racist and legally prejudicial attempt to make him look more sinister and guilty, to portray him as "some kind of animal," as the N.A.A.C.P.'s Benjamin Chavis put it.

While Gaines did not apologize for the altered photo, he did admit, "If there wa anything wrong with the cover, in my view, it was that it was not immediately appar ent that this was a photo-illustration rather than an unaltered photograph; to know that, a reader had to turn to our contents page or see the original mug shot on th opening page of the story."[1]

At the other end of the decade, a controversy at *The New Republic* became th subject of the movie "Shattered Glass," not to mention thousands of journalism ethics discussions. Adam L. Penenburg, a writer for Forbes.com, broke the story tha Stephen Glass, a writer at *The New Republic*, had fabricated "Hack Heaven," a story published in its May 18, 1998, issue. The story told how Ian Restil, a 15-year-old computer hacker, broke into the databases of a big software firm, "Jukt Micronics," and then demanded money, porn magazines and a sports car from the company. I was all fiction. Penenburg explained, "After investigating the claims made in th story, Forbes Digital Tool could not find any trace of the characters or companie or governmental agencies mentioned." Forbes presented its findings to Charle Lane, the editor of *The New Republic*. After firing Glass, Lane later investigated and confirmed that Glass had fabricated twenty-seven stories appearing in *The Nev Republic* over the previous eighteen months.

It was a tough decade for these and other magazines. Among the forty lead ing magazines in terms of circulation, about half gained readers while the other hal lost readers. Their combined circulations, however, declined from 137 million to 12 million. The biggest losers were the newsmagazines, the leading women's magazine and top-tier circulation titles like *TV Guide*, *Reader's Digest*, and *National Geographic* The newsmagazines were especially hard-hit. Between 1990 and 2000, combined circulations of *Time*, *Newsweek*, and *U.S. News & World Report* declined from 9. million to 9.2 million—a five percent decline. The most spectacular gains were mad by *Men's Health*, *Parenting*, *Martha Stewart Living*, *Entertainment Weekly*, *Shape Cooking Light*, *The New Yorker*, and *Vanity Fair*. These magazines more than dou bled their circulation during the 1990s, led by *Men's Health*, which tripled its cir culation.

In discussing "the tabloid decade," *Vanity Fair* writer David Kamp did not mean that tabloid magazines had taken over the magazine marketplace. To the contrary all of them lost circulation. His point, like that of many other authors, is tha tabloid news values of sex, sensationalism and celebrity had significantly influence mainstream magazines and other media. A newsweekly could no longer publish jus

a plain mug shot. It had to be digitally enhanced. Editors at a prestigious magazine of political opinion were so entertained by a charming writer's sensational tales that they never bothered to fact-check them.

In 1991, *People* became the most profitable magazine in America, a position it has held ever since. In a book about the magazine, Judy Kessler wrote: "1991 was a very good year. Not only did the magazine's advertising and circulation reach all-time highs but *People* surpassed *Time* in advertising revenue for the first time, producing an estimated $69 million in ad revenues in the first quarter of the year alone. *People* had just become the number-one magazine in ad revenues in the entire magazine industry."[2] Meanwhile, combined circulations of *Cosmopolitan*, *Entertainment Weekly*, and *People* rose from 6.6 million to 8.5 million—a stunning thirty percent increase.[3]

In 1994, President Bill Clinton participated in a forum broadcast on MTV. The forum included a group of high school and college students. Toward the end of the forum, the students were given a chance to ask the president some quick informal questions. Laetitia Thompson, a junior at Churchill High School in Potomac, Maryland, asked, "Mr. President, the world's dying to know: Is it boxers or briefs?" The line got a big laugh, but so did the President's reply: "Usually briefs."

Kamp described this as another defining moment of the decade. It was a "tabloid decade," he said, first, because a teenager felt it was perfectly appropriate to ask a President of the United States about his underwear preference and, second, because he gave a response. Maybe Thompson got the idea from *Cosmopolitan*, which actually published an article titled, "Cosmo Peeks Inside His Pants—Find Out What His Choice Of Underwear Says About Him."[4]

In 1997, *Time* named Steve Coz, editor of the *National Enquirer*, as one of its "25 most influential Americans." *Time* described Coz, a "cum laude" Harvard graduate, as "one of a new breed of editors who are making the tabs more influential...pursuing the stories that end up on the evening news." Coz told *Time*, "Every single network, every single magazine in America has gone more celebrity. That's the *Enquirer's* influence, whether you like it or don't like it."[5] Carl Sessions Stepp, a senior editor at *American Journalism Review*, echoed his sentiments. "Almost as fast as you can say O.J. or JonBenet, the supermarket tabloids are tanking, finding themselves out-tabloided and out-sleazed by the mainstream press they once sneered at."[6]

The "Enthusiast" publishers and their magazines

Mixed gains and "tabloidification" among leading consumer magazines overshadowed a hidden segment that was healthy and growing—the "enthusiast" magazines. By the 1990s, more than a dozen companies had emerged that published hundreds

of magazines tailored for narrow recreational and leisure interests. Circulations of their small magazines—often less than 100,000—cannot be known because they are not publicly available. Most of them are not large enough to have a membership in the Audit Bureau of Circulations, which charges expensive fees to verify circulation figures and make them available to potential advertisers. Only about 15 percent of the estimated 6,000 consumer magazines belong to the Audit Bureau.

These "enthusiast" companies publish a combined 400 magazines (see table 1). Some of them have been around for dozens of years, while others resulted from recent mergers and acquisitions of existing companies. Many "enthusiast" magazines formerly owned by Petersen Publishing (described in chapter six) are now published by one of these companies. Two companies in this sector—Bonnier Corporation and Bauer Publishing—are European companies that purchased existing companies and magazines in the United States.

Table 1

"Enthusiast" Publishers			
Hobbies, crafts, lifestyle, and leisure pursuits			
Name of company	No. of magazines	Types of Magazines and Areas of Content	Headquarters
Affinity Group, Inc.	27	Boating, camping, recreational vehicles, power sports	Laguna Hills, California
Bauer Publishing	10	Women's, teen, entertainment	Englewood Cliffs, New Jersey
Bonnier Corporation	51	Boating, yachting, flying, outdoor sports	Winter Park, Florida
Bowtie Inc.	70	Cats, dogs, horses and other pets	Laguna Hills, Calif. and other cities
DRG Publishing	7	Home crafts, sewing, quilting, nostalgia	Berne, Indiana
F&W Publications	34	Writing, creative arts & crafts, hobbies, collecting	Cincinnati, Ohio
Hoffman Media	10	Women's lifestyle, cooking, needlework and sewing	Birmingham, Alabama
Intermedia Outdoors Publishing Group	30	Hunting, fishing, outdoor sports	New York and other cities
Kalmbach Publishing	15	Collecting, model trains & toys, bird-watching, writing	Waukesha, Wisconsin
North American Media Group	12	Hunting, fishing, gardening, cooking	Minnetonka, Minnesota
Ogden Publications	10	Rural lifestyle, farm memorabilia and environmental sustainability	Topeka, Kansas
New Track Media	15	Sewing, quilting, scrapbooking, woodworking	Cincinnati, Ohio Cambridge, Mass. and other cities
Source Interlink Media	85	Cars, trucks, motorcycles, skateboarding, horses	New York, Chicago, Los Angeles, and other cities
Stampington Publishing	32	Home crafts, quilting, sewing, scrapbooking,	Laguna Hills, California

Author's caveat: Publishers constantly buy, sell, launch and close magazines as well as merge with one another. This information is accurate as of January 2010.

Bonnier's American operations originated with *WaterSki* magazine in Winter Park, Florida. A longtime competitive water skier, Terry Snow graduated from the University of Florida with a finance degree and moved to Winter Park—the epicenter of water skiing—to launch *WaterSki* in 1977. Snow expanded his company, World Publications, during the 1980s and 1990s by launching *WindSurfing, Sport Fishing, Sport Diver, WakeBoarding*, and acquired fifteen other titles. The Bonnier Group, a family-owned company based in Stockholm, Sweden, purchased World Publications in 2006 and combined its twenty magazines with eighteen it purchased from Time Inc. in 2007 to form Bonnier Corporation. In June 2009, it purchased *Popular Photography, Flying, Boating, Sound & Vision* and *American Photo* from Hachette Filipacchi Media U.S., bringing its total to more than fifty magazines. Terry Snow remained as the chief executive officer of Bonnier Corporation in Winter Park, Florida.

Samir Husni (aka "Mr. Magazine"), a professor of journalism at the University of Mississippi, has published an annual directory of new magazine launches since 1986. His research confirmed the two 1990s trends already noted—the dominance of "sex," "celebrity" and "enthusiast" magazines. Among the top-ranking sectors of launches tracked by Husni, the "enthusiast" category included "sports" magazines (1st place with 783 new magazines) and "crafts, games, hobbies" magazines (3rd place with 564 new magazines). The sex and celebrities categories included the "Sex" sector (2nd place with 652 new magazines) and "Media Personalities" sector (4th place with 545 magazines).

Husni explains, however, that the survival rate for new magazine launches is small. "Only 38 percent survive beyond the first year, 30 percent beyond the second year, and by year five, only 18 percent of new magazines are still in business," he said in an interview with this author.[7] Nevertheless, these numbers give an indication of consumer interest and demand.

Notable Launches of the 1990s

George

The magazine launch that attracted the most media attention in 1995 was *George*, which was named after America's first president. The co-founders of the magazine were John F. Kennedy, Jr. (1960–1999) and his partner Michael Berman, who owned a New York public relations firm. Kennedy, who became its editor-in-chief, envisioned a magazine that married politics and celebrity culture in such a way to attract readers who weren't seriously interested in politics. He did not want a magazine read only by political professionals, junkies and partisans of one party or the

Table 2

New Magazine Launches by Sector, 1992 to 2000

Rank	Sector	1992	1993	1994	1995	1996	1997	1998	1999	2000	TOTAL
1st	Sports	40	84	67	80	111	103	124	95	79	783
2nd	Sex	97	95	44	79	51	110	82	48	46	652
3rd	Crafts, Games, Hobbies	65	65	83	72	42	46	67	59	65	564
4th	Media Personalities	33	22	30	43	33	61	127	108	88	545
5th	Special Interest	60	38	35	25	85	36	55	49	44	427
6th	Computers	18	31	41	48	53	40	54	43	39	367
7th	Home & Home Service	20	45	35	44	39	28	29	39	53	332
8th	Epicurean	23	30	45	33	58	28	31	26	31	305
9th	Metropolitan/Regional/State	26	18	17	48	31	22	43	27	47	279
10th	Automotive	17	24	33	35	28	33	40	38	27	275
	Total Launches (includes these top 10 and 37 other sectors)	679	789	822	837	931	849	1065	864	873	

Source: Samir Husni, *The Magazine Guide* (Annual, 1992-2006, Nautilus Publishing) and www.mrmagazine.com. Published with permission.

other. The former president's son felt that most Americans had become political-ly indifferent and that his magazine could bridge the gap with rank-and-file Americans. According to one biographer, Kennedy sought and hired editors who were not politically savvy. "The theory was that if a politically illiterate editor found a story interesting, so would other readers who were interested in politics but weren't junkies," Richard Blow wrote in *American Son*.[8]

After graduating from New York University Law School, Kennedy worked as a prosecutor in the New York district attorney's office for four years. He yearned for a bigger challenge, however, something that would test his entrepreneurial aspira-tions. Kennedy and Berman shopped around for publishers with their idea before attracting the attention of David Pecker, who was then the president of Hachette Filipacchi Media U.S. The company is owned by the French conglomerate, Lagardere Group, and publishes other magazines in the U.S. such as *Elle, Woman's Day, Road & Track* and *Flying*. Pecker was impressed with their idea and agreed to invest $20 million in launching *George* over the next five years.

They launched *George* with the September 1995 issue and the tagline, "Not Just Politics As Usual." Kennedy's biographer wrote, "His decision to become a maga-zine editor was neither widely understood nor widely applauded. According to, well, almost everybody, John F. Kennedy, Jr., should have never founded a magazine, cer-tainly not one that put movie stars on its covers. Editing *George* was said to trivial-ize John."[9]

Each issue contained an editor's column and interviews written by Kennedy. In his July 1997 column, for example, he wrote about his visit with Mother Teresa (1910–1997) just a couple of months before she died.

> Within minutes of our having met, she commandeered me to drive her to the airport, where she was to receive a shipment of donated clothing from New Delhi. "You see," she said, "I ask everyone for help all the time. I ask, and I ask, and just when they think they've done enough and are fed up with me, I ask for more. She grinned, adding, "I have no shame." It was thrilling to help her....The three days I spent in her presence was the strongest evidence this struggling Catholic has ever had that God exists.[10]

George sought out writers with diverse views, publishing such contributors as Ann Coulter, Al Franken, Norman Mailer and Naomi Wolf. Gerry Dickinson, a read-er from Mt. Pleasant, S.C., wrote a letter-to-the-editor saying, "If Kennedy con-tinues to publish an unbiased and thought-provoking magazine that is not afraid to tackle tough issues, conservatives like me will keep buying *George*. I congratu-late him on his good work."[11]

Nevertheless, *George* struggled to attract advertisers and earn a profit. After Kennedy was killed in a tragic air crash with his wife and sister-in-law on July 16,

1999, the magazine was bought out by Hachette Filipacchi Media and continued publishing for over a year with Frank Lalli as editor-in-chief. Citing weak advertising support, the company announced in January 2001 that it was closing the magazine with the March issue.

In 2005, the *Media Industry Newsletter* in its annual publication *MIN Magazine*, asked Professor Samir Husni to identity the "Hottest Magazine Launches of the Past 20 Years." Husni chose these magazines listed in Table Three, citing them as "Not necessarily the first in their space, but unique in their own way and laden with good ideas and great execution."[12]

Table 3

Samir Husni's "Hottest Magazine Launches" of the Past 20 Years (1985-2005)		
Magazine	**Publisher**	**Year**
Elle (U.S.)	Hachette Filipacchi Media U.S.	1985
Men's Health	Rodale Publishing	1986
Midwest Living	Meredith Corporation	1986
Cooking Light	Southern Progress-Time Inc	1987
Country	Reiman Pubs. (now Reader's Digest)	1987
Parenting	Time Inc.	1987
Traditional Home	Meredith Corporation	1989
Entertainment Weekly	Time Inc.	1990
Martha Stewart Living	Time Inc./Martha Stewart Living Omnimedia	1990
Wizard	Wizard Entertainment	1991
Wired	Condé Nast	1992
Country Weekly	American Media	1994
In Style	Time Inc.	1994
People En Espanol	Time Inc.	1996
Maxim (U.S.)	Dennis Publishing	1997
ESPN: The Magazine	Disney/Hearst	1998
More	Meredith Corporation	1998
CosmoGirl!	Hearst Magazines	1999
Lucky	Condé Nast	2000
O, The Oprah Magazine	Hearst Magazines	2000
Real Simple	Time Inc.	2000
InTouch	Bauer	2003
Source: Samir Husni; published with permission		

O, The Oprah Magazine

O, The Oprah Magazine, was launched jointly in May 2000 by Hearst Magazines and Oprah's company, Harpo Productions. Cathie Black, Hearst Magazines president, and Ellen Levine, editor of *Good Housekeeping*, traveled to Chicago in January 1999 to make a presentation and convince Oprah to launch her own magazine. Although Winfrey had been invited by other companies to publish a magazine, Oprah was impressed with Black and Levine's presentation and accepted their offer. It immediately became the most successful magazine launch in history, according to Black. After two press runs, the initial May-June issue sold out of 1.6 million copies on newsstands. Two months later, the magazine increased its frequency from bimonthly to monthly and raised its rate base from 500,000 to 900,000. Black said, "While most magazines take at least five years to become profitable, *O* turned a profit from its very first issue. *Adweek* named *O* the 'Startup of the Year' and *Advertising Age* named it 'Best Magazine of the Year' and 'Best Launch of the Year.' It has become Hearst's second most profitable magazine—even though we split the profits with Oprah fifty-fifty."[13]

New titles from Time Inc.

Fifteen years after its successful launch of *People*, Time Inc. entered the fray again by starting more magazines during the 1990s than it did during the years of Henry Luce. After the failure of *TV-Cable Week* a few years earlier, success came with the launch of *Sports Illustrated for Kids* (1989), *Entertainment Weekly* (1990), *Martha Stewart Living* (1990), *InStyle* (1994), *People En Espanol* (1996), and *Real Simple* (2000). Time Inc. gave substantial credit for these launches to Ann Moore.[14] After earning a Harvard M.B.A., Moore started her career at Time Inc. in 1978 as a financial analyst. She rose through the ranks to become the founding publisher of *Sports Illustrated for Kids*, publisher of *People*, and executive vice president of Time Inc. In 2002, she was named chairman and chief executive officer. *Business Week* (a Time Inc. competitor) said of her, "Moore made her bones in the nineties by coaxing additional hundreds of millions in profit out of a *People* franchise many thought had peaked. She is the first woman to run what was long an extraordinarily old-boy company."[15] Under her leadership, *People's* ad sales more than doubled from $345 million in 1991 to $714 million in 2002.

In 2008, Ann Moore and Martha Stewart were honored by the Magazine Publishers of America and its affiliate the American Society of Magazine Editors. Moore received the Henry John Fisher Lifetime Achievement Award. In announcing the award, MPA president Nina Link noted her accomplishments: "Throughout

her career, Ann has shown extraordinary management skills and entrepreneurial drive in developing new magazines and expanding the footprint of many of the industry's flagship brands. Ann has transformed Time Inc. not just by successfully launching more titles than company founder Henry Luce, but also by overseeing her company's transition to digital platforms."[16]

Martha Stewart was named to the Magazine Hall of Fame by the American Society of Magazine Editors. Sid Holt, chief executive of ASME, said of her, "With the launch of *Martha Stewart Living* in 1991, Stewart created an entirely new magazine category. Her creativity and passion burst from the pages of each of her magazines, from *Martha Stewart Living* and *Martha Stewart Weddings* to *Everyday Food* and *Body+Soul*. Her high standards and impeccable attention to detail make her an inspiration for magazine editors and designers of every generation."[17]

Stewart's prison sentence did not deter her success and may have even enhanced it. In July 2004, she was sentenced to five months in a West Virginia federal prison for insider trading and lying to investigators about her sale of ImClone Systems stock just before its price plunged in 2001. Her former broker at Merrill Lynch was also sentenced to a five-month prison term. Revenues and ad sales at Martha Stewart Living Omnimedia declined by more than 50 percent that year, but bounced back after her release in March 2005.

"Turning a jail sentence into a public-relations asset is no mean feat, but Stewart has done it," wrote *Slate* columnist Henry Blodget. "Based on reports from prison, she has embraced her fate and tackled her one glaring weakness: her reputation as a snooty, rich, ice queen. The groundswell of enthusiasm about her 'comeback' has already carried the stock of Martha Stewart Living Omnimedia from $8 to nearly $34, and, judging from recent commentary, her public approval rating has surged as well," he wrote.[18]

As noted earlier, the combined circulations of *Time, Newsweek*, and *U.S. News & World Report* declined from 9.7 million to 9.2 million—a five percent decline. However two newsweeklies—*The Week* and *The Economist*—achieved notable circulation and ad revenue success. Founded in 1843, *The Economist* is a British-owned magazine edited in London. Its North American edition accounts for more than 50 percent of its 1.4 million circulation and grew substantially during the 1990s. It has defied conventional wisdom about the need for more pictures and lighter stories. *The Economist*'s focus is world news, politics and business, but it also published sections on science, technology, books, and the arts. Writing in *The Atlantic*, Michael Hirschorn said, "*The Economist* has been growing consistently and powerfully for years, tracking in near mirror-image reverse the decline of its U.S. rivals….It sells more than 75,000 copies a week on U.S. newsstands for $6.99 at a time when we're told information wants to be free and newsstands are disappearing." Hirschorn attributed the magazine's success to its penchant analysis of international news by

saying, "*The Economist* prides itself on cleverly distilling the world into a reasonably compact survey."[19]

Although not launched until 2001, *The Week* has achieved a steadily increasing circulation during succeeding years. "*The Week* curates over a thousand media sources from around the world to offer a true global and balanced perspective on the issues today—all in a concise, readable package," is the way the magazine bills itself. It is owned by Felix Dennis, the British publisher who also started a U.S. edition of *Maxim* in 1997 with great success. "A success in Britain, the American version of *The Week* has posted double-digit growth in the last eight reporting periods of the Audit Bureau of Circulations. It has hit a nerve, coming at a time when the familiar American newsweeklies are struggling to maintain their footprint," David Carr wrote in *The New York Times*. He quoted publisher Felix Dennis as saying, "*The Week* is going to be a huge global brand....If Henry Luce were to come back from the dead and was offered any magazine as a reward for coming back from the dead, I think he'd say he'd take *The Week*, because his first idea was doing exactly what this magazine does. His original idea was offering readers a précis of what was happening around the world in a given week."[20]

Dennis is correct about Luce's original purpose. *Time*'s original prospectus written in 1992 by Henry Luce and Briton Hadden said:

> From virtually every magazine and newspaper of note in the world, *Time* collects all available information on all subjects of importance and general interest. The essence of all this information is reduced to approximately 100 short articles, none of which are over 400 words in length.[21]

While *Time* had morphed into a different kind of magazine with a declining circulation, *The Week* had succeeded by using its original editorial formula.

The Sweepstakes controversies

Publishers Clearing House was founded in 1953 by Harold and LuEsther Mertz and their daughter, Joyce Mertz-Gilmore. With direct mailings offering huge numbers of discounted magazine subscription offers, the company became the largest magazine circulation agency in the industry. Most publishers participated in its annual sweepstakes promotions that offered cheap magazine subscriptions along with the chance to win millions of dollars in prize money. The advantage to publishers was the chance to attract new subscribers and build their advertising rate base without spending money on their own direct mail campaigns. The disadvantage was that PCH returned only a small percentage of already-discounted subscription revenue to the publishers. Most publishers, therefore, lost money on first-year sub-

scribers and had to hope for a couple of renewals before they could expect to earn a profit from PCH customers.

In the late 1990s, Publishers Clearing House, a Long Island, New York, company, was sued in separate actions by twenty-three state attorneys general alleging the sweepstakes giant used deceptive tactics to lure consumers into purchasing magazine subscriptions. In August 2000, PCH signed an agreement with these attorneys general to pay $18 million in restitution, some to be returned to 15,000 consumers who spent more than $2,500 each trying to win the sweepstakes. Among other stipulations, the company also agreed to:

- Include with their mailings a fact sheet that stated odds of winning, deadlines, prize values and quantities.
- Refrain from printing "You Are a Winner" on mailings unless the consumer had actually won.
- Send "No Purchase Necessary" notes to consumers spending $1,000 or more a year.
- Refrain from using a simulated check unless the face of the document clearly stated it was not a check.
- Avoid stating that any mailings originated from a federal or state government or other official entity.[22]

PCH agreed to pay an additional $34 million in fines, penalties and restitution one and a half years later in a comprehensive settlement resulting from a wave of consumer protection lawsuits by attorneys general from twenty-six other states. Although the largest, Publishers Clearing House was not the only sweepstakes promoter that was sued. Reader's Digest Association, Inc. had also been promoting its own sweepstakes for years. In a 2001 agreement with thirty-one states, RDA Inc. agreed to pay more than $6 million to settle charges that its sweepstakes promotions were also misleading. About $4 million of the settlement went to 7,500 "high-activity" customers who spent more than $2,500 annually between 1998 and 2000, according to California Attorney General Bill Lockyer. The company also paid $2 million in attorneys' fees and investigation costs. It was the fifth in a series of settlements with major sweepstakes houses since 1999, when the state attorneys general held public hearings on sweepstakes competitions. Besides PCH, other companies that reached settlements included American Express Publishing Corp., Time Inc., and U.S. Sales Corporation.[23]

In responding to these complaints, the Magazine Publishers of America adopted a statement on "Ethical Business Practices for Sweepstakes Promotions." The guidelines called for easy-to-find "No Purchase Necessary" statements and clear disclosure of all sweepstakes terms and conditions. Publishers Clearing House, Reader's

Digest and other sweepstakes promotions are still offered every year by these companies. In 2008, PCH expanded its promotions to more youthful channels such as Twitter and iPhone. These new offers sought to attract young customers into PCH's world as part of an overall effort to collect information on Web users, show them advertisements and use the registration information for mailing lists.

The expanding Internet

On August 6, 1991, Tim Berners-Lee, who invented the World Wide Web software, announced the invention from his research lab in Geneva, Switzerland. In a message to a newsgroup, he wrote, "The WWW project merges the techniques of information retrieval and hypertext to make an easy but powerful global information system....To follow a link, a reader clicks with a mouse. To search and index, a reader gives keywords or other search criteria. These are the only operations necessary to access the entire world of data."[24] That was the understatement of the decade.

Nearly twenty years later, no other technological advancement has affected the magazine industry more than the Internet and its World Wide Web component. It has provided new revenue platforms, a more effective means of marketing and subscription management, as well as the digitization of content to reduce the expense and time of shipping materials and repurposing content.

Launched in March 1993, *Wired* led the way into this revolution. With a goal of reporting how technology affects culture and the economy, the magazine was founded by American journalist Louis Rossetto and his partner Jane Metcalfe. Since only about a million and a half Americans were connected to the Internet at the time, they anticipated that *Wired* might sell a few thousand copies every month. The magazine sold 150,000 monthly copies by the fourth issue and 500,000 by the time Condé Nast Publishing purchased it in 1999. "We want to reflect what's going on in the world today and that means looking at the technological revolution that's unfolding before us. It's kind of like being strapped to the front of a rocket," Rossetto said less than a year after its launch. In naming it among the "20 Hottest Magazine Launches of the Last 20 Years," Samir Husni said, "*Wired* made it a point to meet the flash and excitement of the Internet boom with even more flash and excitement—there would be no dry, technology trade-magazine jargon for this publication."[25]

In 2009, the trade magazine *Mediaweek* chose *Wired* as the "Magazine of the Decade." *AdWeek* wrote that *Wired* deserved the honor. "Under the aegis of deep-pocketed Condé Nast and visionary editor Chris 'Long Tail' Anderson, *Wired* survived the storm by capturing a broader readership with an editorial mix spanning technology, business, science, entertainment and culture—in essence becoming the

chronicler of the technology surge that's changed all our lives this decade," she wrote.[26]

The Internet's effect on magazines

Fueled by headlines about newspaper closings and declining circulations, the conventional wisdom is that magazines are headed in the same direction. But the Internet's effect on magazines has been partly positive and partly negative—and not nearly as negative as on newspapers. The most damaging effect from Internet competition has been on print media that sell "commodity content," meaning news stories and factual information that doesn't vary substantially from one medium to another. Newspapers carry wire stories from AP and Reuters that are substantially identical. Most of these same newspapers put these same stories on their websites—for free. Therefore, if a reader's main interest is national and international news, why buy a newspaper or a newsmagazine?

Since 1992, each of the three major newsweeklies—*Time, Newsweek,* and *U.S. News & World Report*—went through several transformations of their digital and online versions. Each one stumbled along the way and sometimes failed. *Newsweek* was the first to experiment with "the new media" by offering a CD-ROM version of its magazine in 1992. In 1993, each magazine established an online edition in partnership with a service provider: *Time* with America Online, *Newsweek* with Prodigy, and *U.S. News & World Report* with CompuServe. By 1993, Prodigy carried two million subscribers, CompuServe had 1.5 million, and America Online was up to 500,000. By the end of 1993, about 100 magazines had signed up with online computer services and were joining at the rate of two or three a week.

Before each magazine had its own website, Time Inc. began its ambitious effort to put all of its magazines online at its "Pathfinder" site in October 1994. If users wanted to read an article from *Time* or *People,* they had to go first to Pathfinder.com. Pathfinder's editor James Kinsella told the trade magazine *Folio,* "The reason we came up with the name 'Pathfinder' is to help people find a path. It's really about personal empowerment." On the contrary, however, it was confusing to users. Pathfinder lost millions of dollars in its two-year history before the company terminated the effort and gave each of its magazines its own site.

During the early days of magazine websites, no one really knew what they were doing. Most magazines simply dumped their weekly or monthly content into their site. Many tried failing efforts to attract paid subscribers to their online sites. Many ended up with a "curtain" model—offering some free content, but enticing readers with discount print subscriptions to get free access to the complete website and its archives.

Richard Stengel managed Time.com in the 1990s and turned it into a profitable

venture before he was promoted to managing editor of the print magazine. He saw the website as a brand extension of its print version. "The mission statement of all 'magazine-dot-com's' is one that's unwritten and that is: 'Don't embarrass the mother-ship,'" he said in an interview with this author. "One of the things you have to be aware of is that you are part of the brand. It's a way of getting people familiar with your content, with your style, with the way you think and do things—and ultimately get people to subscribe."[27]

The history of the roller-coaster 1990s and how magazines faced the Internet challenge cannot be adequately summarized here. Readers interested in more details should read John Motavelli's *Bamboozled at the Revolution: How Big Media Lost Billions in the Battle for the Internet*. Motavalli examined how many media companies, especially Time Inc., spent hundreds of millions of dollars in efforts to capture an Internet audience. "The great media empires…simply did not know how to deal with the Internet, which constituted a direct attack on the domination they had enjoyed for so long," he wrote.[28]

Nevertheless, after the fall of many Internet content sites in the early 2000s, a powerful cultural attachment to magazines has endured. Magazines gave their readers a unique tactile, visual and sensory experience. Readers could flip through the pages, pause to admire a beautiful photo or laugh at a cartoon. Web content has not replaced magazines as once predicted; instead, it has evolved to extend the presence and depth of a magazine's content. It has extended the availability of magazine information to new audiences and has given publishers a more efficient means of subscription management.

William Kerr, the former CEO of Meredith Corporation—America's second-largest publishing company—said, "The Internet is your friend. Once viewed as a threat, the Internet is a medium that magazines are using as a growth catalyst on many fronts." Kerr continued: "For our editors, it allows us a more frequent dialogue with readers. For our marketers, it provides another source of potential revenue generation. For our circulation professionals, it provides a low-cost alternative for generating magazine subscriptions. And it is growing at a phenomenal rate."[29]

The London-based Federation of the International Periodical Press (FIPP) conducted surveys of magazine publishers in 2003, 2005, and 2007 about objectives and success with their websites. Out of twelve possible objectives for magazine websites, the surveyed publishers named four as consistently the most important:

- To create new revenue streams and profits in the long term
- To expand the print audience by creating an online audience of new readers
- To use the website to attract new readers for the print products
- To build a community around the magazine brand[30]

The most positive effect of the Internet for many magazines has been as a successful vehicle for attracting new print subscribers. Some magazines reported up to 20 percent of new print subscriptions originating from their websites. Lori Dorr, circulation director at *The New Republic*, said the magazine found many advantages for its website. "From the print perspective, we have tried to stress the immediacy that the Internet allows," she told *Folio*. "Having the digital versions of the magazine available for new subscribers allows them to engage in the product instantly, rather than having to wait four weeks for the print copy to show up. "That's a huge benefit for a print subscriber when you compare it to a traditional print mechanism."[31]

Cathie Black, president of Hearst Magazines, said in a 2009 interview with this author that Hearst magazines used the Internet to attract new subscribers and

Cathleen P. Black, President, Hearst Magazines. Credit: Hearst Magazines

reduce fulfillment costs. "We have sold in calendar 2009 close to three million subscriptions via the Internet," she said. "It's a powerful source of circulation for us and very economical. We're not spending a lot of money on direct mail. From a processing standpoint, if we can train a generation of magazine readers…to handle all of their subscription queries, billing questions, changes of addresses and payments online, that's going to be very significant from a cost standpoint."[32]

The Pew Project for Excellence in Journalism publishes an annual report titled, "The State of the News Media" that includes newspapers, magazines, online media, radio and television (www.stateofthemedia.org). In looking at trends among magazines since the early 1990s, especially news magazines, it saw five major trends.[33]

- The news agenda has gotten softer and more oriented to lifestyle rather than traditional hard news.
- The overall number of magazines is growing, but mostly in niche service magazines such as child care, travel or bicycling.
- The largest publishers are heavily invested in pop culture and entertainment magazines, which have seen large growth in the last decade.
- Coverage in *Time*, *Newsweek* and *U.S. News & World Report* is edging

into lighter areas such as pop culture, health and service. The news-magazines are becoming less specialized experts in anything and more a lighter version on every topic.

- The vast majority of the high-profile magazines—everything from *Time* to *Esquire* to *Vanity Fair*—are owned by one of three big media companies [Time Inc., Hearst, and Condé Nast].

The Pew report concluded by saying, "Overall, the magazine industry is healthy, but its landscape is very different than it was even ten years ago, let alone twenty." That was, indeed, the state of the magazine industry in 2000.

Notes

1. James R. Gaines, "To Our Readers," *Time*, July 4, 1994, http://www.time.com/time/magazine/article/0,9171,981052-1,00.html.
2. Judy Kessler, *Inside* People: *The Stories Behind the Stories* (New York: Villard Books, 1994), 253.
3. All quoted circulation figures are taken from Audit Bureau of Circulations reports and *Magazine Trend Handbooks* (Schaumburg, IL: *Magazine Trend Handbook*, annual, 1990–2000).
4. Jennifer Benjamin, "*Cosmo* Peeks Inside His Pants," www.cosmopolitan.com/sex-love/tips-moves/what-underwear-says-about-him (undated; accessed December 9, 2009).
5. "25 Most Influential Americans," *Time*, April 21, 1997, 50.
6. Carl Sesssions Step, "Treasure Trove of Tabloid Tales" (book review), *American Journalism Review*, March 2001, 69.
7. Samir Husni, e-mail to the author, December 16, 2009.
8. Richard Blow, *American Son: A Portrait of John F. Kennedy, Jr.* (New York: Henry Holt & Co., 2002), 34.
9. Ibid., 4.
10. John F. Kennedy, Jr., "A Mother Like No Other," *George*, July 1997, 22.
11. Letters to the editor, *George*, July 1997, 30.
12. Samir Husni, "Hottest Magazine Launches of the Past 20 Years," *MIN Magazine 2005*, 66 (published by Access Intelligence, L.L.C.; accessed at www.minonline.com, December 15, 2009).
13. Cathie Black, "Make Your Moment Count: *O, The Oprah Magazine*," in *Basic Black: The Essential Guide for Getting Ahead at Work (and in Life)* (New York: Crown Publishing, 2007), 101–102.
14. "Ann S. Moore," company biography, http://www.timewarner.com/corp/management/executives_by_business/time_inc/.
15. Jon Fine, "Edgy Days at the Top of Time Inc.," BusinessWeek.com, February 12, 2007 (accessed December 15, 2009).
16. Magazine Publishers of America (www.magazine.org), Press Release, November 28, 2008.
17. Ibid.

18. Henry Blodget, "What Martha Learned in Prison," Slate.com, March 3, 2005 (accessed December 15, 2009).
19. Michael Hirschorn, "The Newsweekly's Last Stand," *The Atlantic*, July–August 2009, http://www.theatlantic.com/doc/200907/news-magazines.
20. David Carr, "A Magazine Challenges the Big Boys," *The New York Times*, November 26, 2007.
21. Briton Hadden and Henry Luce, "TIME: The Weekly News-Magazine, 1922 Prospectus." Time Inc. Archives, New York.
22. "Spitzer Announces Landmark Settlement with Publishers Clearing House," New York State Office of the Attorney General, August 22, 2000,www.oag.state.ny.us/media_center/2000/aug/aug22a_00.html.
23. "Reader's Digest Pays $6 Million to Settle Sweepstakes Complaints," Consumeraffairs.com, March 9, 2001, www.consumeraffairs.com/news/digest.html#ixzz0ZoLQbBCK.
24. Tim Berners-Lee to Alt.hypertext newsgroup, August 6, 1991. Archived at: http://groups.google.com/groups?selm=6487%40cernvax.cern.ch (accessed September 20, 2002).
25. Samir Husni, "Hottest Magazine Launches of the Past 20 Years," *MIN Magazine 2005*, 74 (published by Access Intelligence, L.L.C., www.minonline.com; accessed December 15, 2009).
26. Lucia Moses, "Magazine of the Decade," www.bestofthe2000s.com/magazine-of-the-decade.html (accessed December 29, 2009).
27. Richard Stengel, interview with the author, New York City, June 13, 2002.
28. John Motavelli, *Bamboozled at the Revolution: How Big Media Lost Billions in the Battle for the Internet* (New York: Viking Penguin Group, 2002), xiii.
29. William T. Kerr, "Five Themes That Will Shape Our Business," *Magazine World* [published by the Federation of the International Periodical Press], October 2005, 21.
30. Guy Consterdine, "Routes to Success for Consumer Magazine Website," 3rd ed. (London: Federation of the International Periodical Press, 2007).
31. Bill Mickey, "*The New Republic* Boosts Subs and Service Through the Web," *Folio: The Magazine for Magazine Management*, August 1, 2005, http:www.foliomag.com.
32. Cathie Black, telephone interview with the author, December 7, 2009.
33. "The State of the News Media," The Pew Project for Excellence in Journalism, http://www.stateofthemedia.org/2004/narrative_magazines_intro.asp?cat=1&media=7.

Post-2000

A Look Back, a Look Forward

Most headlines about the print media since 2000 have reported about the closings of well-known newspapers and steadily declining circulations of others. Many have assumed that magazines shared the same fate. However, the general health of the magazine industry remains significantly greater than that of daily newspapers. First, because of the "commodity content" of newspapers, breaking news can be easily found on the Internet, but readers can't as easily find the convenient package of specialized features and service information that characterize magazines. Second, a one-year subscription to most magazines still costs less than $25 while one-year newspaper subscriptions cost $200 or more. While it's too soon to write the history of magazines since 2000, their success and staying power have been much greater than that of newspapers.

First, the bad news

Magazine circulations have declined and many magazines have closed since 2000. According to numbers available when this book went to press, 367 magazines shut down in 2009 and 64 went online-only. In 2008, 526 magazines ceased publication and in 2007, 573 shut down.[1] However, the total number of 1,466 shutdowns is smaller than the 1,837 new magazine startups, according to Professor Samir ("Mr. Magazine") Husni. He estimated that 1,837 magazines were launched in the same three-year period between 2007 and 2009.

Table 1

Magazine Closings by Major Publishers Since 2005	
Magazine	**Publisher**
Best Life	Rodale
Blender	Alpha Media Group
Business 2.0	Time Inc.
Cookie	Condé Nast
Cosmo Girl	Hearst Corporation
Cottage Living	Time Inc.
Country Home	Meredith
Domino	Condé Nast
Electronic Gaming Monthly	Ziff Davis
Elegant Bride	Condé Nast
Golf for Women	Condé Nast
Gourmet	Condé Nast
Green Guide	National Geographic
Hallmark Magazine	Hallmark Greeting Cards
Home	Hachette Filipacchi
House & Garden	Condé Nast
Men's Vogue	Condé Nast
Metropolitan Home	Hachette Filipacchi
Modern Bride	Condé Nast
National Geographic Adventure	National Geographic
Nickelodeon	Viacom
O at Home	Hearst Corporation
PC Magazine	Ziff-Davis
Playgirl	Blue Horizon Media
Portfolio	Condé Nast
Quick & Simple	Hearst Magazines
Southern Accents	Time Inc.
Sports Illustrated Latino	Time Inc.
Travel & Leisure Golf	American Express
Trump Magazine	Trump Entertainment
Sources: www.magazinedeathpool.com and other media reports	

Home and lifestyle magazines, also known as "shelter magazines," have been hardest-hit by the recession that began in 2007. About 25 percent of the closed magazines listed in Table 2 were shelter magazines: *Country Home, Country Living, Domino, Home, House & Garden, Metropolitan Home, O at Home,* and *Southern Accents.* While advertising revenue for most magazines declined by about 25 percent between 2007 and 2009, advertising in the shelter magazines declined by about 40 percent. The dwindling shelter magazine market mirrors the decline in home sales and decline in consumer spending on home improvements and redecorating.[2]

The "Grim Reaper," a blogger who started the "Magazine Death Pool" site (www.magazinedeathpool.com) in February 2006, tracks the closings of magazines and predicts which ones will be next. Although he maintains public anonymity, he gave an interview to *Publishing Executive* stating five reasons why he believes magazines are forced to close down. He says magazines most susceptible to failure are those that:

- outlived their usefulness or relevancy, especially those in the line of fire of what's popular on the Web.
- were caught in the crosshairs of the faltering economy.
- were created for advertisers, not for an audience.
- did not have a smart and profitable digital strategy.
- relied too heavily on advertisers in trouble or under the gun (i.e. automobiles, liquor).

He told *Publishing Executive* that in the first two cases, "There was really not much fault to be given. The times changed. The way people consumed their media changed. The Web began to own certain areas, like gossip, personal finance and sports, so magazines were becoming more vulnerable....The titles which have the best odds of surviving are the ones that are read for the big splashy ads, like *Vogue, Elle,* the bridal books. People buy those magazines for their lush spreads and ads. They cannot be reproduced on the Web or read comfortably on a mobile phone...yet," the Grim Reaper said.[3]

One of the most newsworthy closings of the decade was that of the 124-year-old women's magazine *McCall's.* The magazine changed its name to *Rosie* in April 2001 after TV entertainer Rosie O'Donnell and its publisher, Gruner + Jahr USA, invested $10 million each to launch the joint venture. O'Donnell quit the magazine in September 2002 following a dispute over editorial control with the publisher. The last issue was published in December 2002, which brought to a close the long and

celebrated history of *McCall's* as one of the leading women's magazines. In October the company sued O'Donnell for $100 million in damages in New York State Superior Court claiming that she had breached "duties of good faith and fair dealing and of fiduciary duty." She countersued for $125 million, saying that Gruner + Jahr broke its contract with her by cutting her out of key editorial decisions. In November 2003, a Manhattan judge ruled that there was no winner in the ugly court battle between entertainer Rosie O'Donnell and Gruner + Jahr USA, saying neither side would collect any damages.

Declining circulations

The circulation of fifty leading consumer magazines (Table 2) reveals that their total circulation declined by 6 percent between 2000 and 2009. Among those fifty magazines, thirty-two gained circulation while only eighteen lost circulation during those years. There were fourteen magazines with circulation losses exceeding 10 percent

~ *Seventeen*
~ *Field & Stream*
~ *Popular Science*
~ *Newsweek*
~ *Martha Stewart Living*
~ *Time*
~ *Guideposts*
~ *Family Circle*
~ *Playboy*
~ *Ebony*
~ *U.S. News & World Report*
~ *Reader's Digest*
~ *National Geographic*
~ *TV Guide*

Most of these fourteen magazines leaned toward "general interest," aiming at a readership that is both male and female of varying ages. Only one (*Seventeen*) focused on readers who are predominantly of one gender and one age. None of them are "special interest" or "enthusiast" magazines that focused on one particular hobby, avocation or leisure pursuit. The highest percentage of losses were incurred by just three magazines: *Reader's Digest, National Geographic* and *TV Guide*. Combined circulation losses at those magazines totaled more than fifteen million.

Table 2

Magazine	Dec. 1990	Dec. 2000	Jun. 2009	2000–2009 Change
Average Paid Circulation of 50 Leading Consumer Magazines 1990–2009				
Economist (The)	N.A.	333,200	810,821	143.3%
US Weekly	N.A.	827,634	1,945,831	135.1%
Everyday with Rachel Ray*	not published	922,600	1,815,462	96.8%
ESPN: The Magazine	not published	1,175,526	2,059,269	75.2%
Parenting	561,700	1,460,041	2,185,237	49.7%
Wired	not published	507,816	743,476	46.4%
New Yorker	618,400	850,081	1,049,942	23.5%
Cooking Light	897,600	1,453,558	1,772,029	21.9%
Rolling Stone	1,202,100	1,254,148	1,476,399	17.7%
AARP: The Magazine	22,437,200	20,963,870	24,554,819	17.1%
Entertainment Weekly**	726,100	1,520,463	1,779,537	17.0%
Men's Health	436,900	1,629,568	1,859,643	14.1%
Cosmopolitan	2,657,800	2,592,887	2,905,436	12.1%
Southern Living	2,318,200	2,537,485	2,840,241	11.9%
Family Fun	not published	1,938,400	2,161,343	11.5%
Glamour	2,183,500	2,147,263	2,389,915	11.3%
O, The Oprah Magazine	not published	2,162,668	2,397,697	10.9%
Vogue	1,217,900	1,174,183	1,298,480	10.6%
Prevention	3,023,900	3,008,136	3,312,624	10.1%
Parents	1,747,600	2,004,929	2,205,343	10.0%
InStyle	not published	1,584,691	1,738,787	9.7%
Vanity Fair	769,400	1,050,684	1,151,377	9.6%
Bon Appetit	1,384,300	1,280,105	1,352,658	5.7%
Real Simple	not published	1,900,700	1,976,821	4.0%
Shape	693,900	1,618,130	1,676,323	3.6%
Maxim	not published	2,458,150	2,537,130	3.2%
People	3,183,000	3,552,287	3,615,858	1.8%
Good Housekeeping	5,128,800	4,558,524	4,630,397	1.6%
Sports Illustrated	3,361,100	3,205,241	3,252,298	1.5%
Money	1,935,400	1,906,352	1,915,970	0.5%
Better Homes & Gardens	8,005,100	7,617,985	7,634,197	0.2%
Smithsonian	2,265,300	2,051,045	2,024,733	-1.3%
Redbook	3,927,200	2,269,605	2,223,195	-2.0%
Popular Mechanics	1,642,100	1,238,681	1,207,203	-2.5%
Ladies' Home Journal	5,012,100	4,101,550	3,842,791	-6.3%
Woman's Day	4,697,500	4,244,383	3,933,990	-7.3%
Seventeen	2,265,300	2,374,803	2,080,208	-12.4%
Field & Stream	2,011,300	1,752,937	1,514,497	-13.6%

Table 2 *continued*

Magazine	Dec. 1990	Dec. 2000	Jun. 2009	2000-2009 Change
Popular Science	1,814,000	1,554,698	1,320,314	-15.1%
Newsweek	3,219,600	3,144,695	2,646,613	-15.8%
Martha Stewart Living	555,500	2,436,422	2,030,844	-16.6%
Time	4,173,700	4,056,150	3,372,240	-16.9%
Guideposts	N.A.	2,590,323	2,072,211	-20.0%
Family Circle	5,287,400	5,002,042	3,932,510	-21.4%
Playboy	3,462,200	3,211,393	2,453,266	-23.6%
Ebony	1,849,100	1,728,986	1,301,760	-24.7%
U.S. News & World Report	2,315,500	2,070,511	1,365,652	-34.0%
Reader's Digest	16,330,700	12,566,047	8,158,652	-35.1%
National Geographic	10,186,300	7,828,642	4,708,307	-39.9%
TV Guide	15,720,700	9,948,792	2,934,969	-70.5%
TOTALS		155,369,010	146,169,315	Average decline-5.9%

*Launched 2005; data is for December 2006; **Launched 1991*
Source: Audit Bureau of Circulations

TV Guide, as explained in chapter 7, has faced considerable competition from free newspaper and online program guides. While the Reader's Digest Association, Inc. filed for bankruptcy in 2009, the company's financial woes extended far beyond its flagship title. Its purchase of twelve magazines from Reiman Publications for $760 million in 2002 made up a third of its debt, which reached $2.2 billion when the company filed for bankruptcy. As of 2008, the *Reader's Digest* magazine and its fifty international versions comprised only 16 percent of the company's total revenue.[4]

Except for the *Reader's Digest*, *National Geographic* and *TV Guide*, the remaining forty-seven magazines grew 4.3 percent in circulation from 2000 to 2009. Twenty-one of those magazines had double-digit percentage circulation gains. Those that gained readers focused mostly on celebrities, cooking, lifestyle, sports, health, or entertainment. Three of the titles—*The Economist, The New Yorker*, and *Wired*—focused on news or serious nonfiction features. Overall, these trends reflected the continued segmentation of the magazine market and decline of general interest magazines that began early in the 20th century. They also reflected the "popularization of content" theory discussed in the first chapter. As magazines grew to reach larger circulations, the intellectual level of their content declined. With few exceptions, such as *The Economist, The New Yorker*, and *Wired*, magazines ceased being a public forum of ideas and began focusing on celebrities and highly individualized lifestyle pursuits.

The good news

Whatever the economy was doing, there was never a shortage of publishers and entrepreneurs launching new magazines, some of them highly successful. Professor

Samir Husni tracked the following number of new magazine launches since 2000, which is reported in Table 3. Three of the most successful launches since 2005 have been *Everyday with Rachael Ray* (Reader's Digest Association), *Women's Health* (Rodale) and *Food Network Magazine* (Hearst). All three achieved astonishing circulation gains during their first two or three years of publication and all were named as "Launch of the Year" by the trade magazines *Advertising Age* or *AdWeek*. Another successful launch was *The Wall Street Journal Magazine*. Launched in September 2008 by its parent newspaper, the company announced in December 2009 that it would increase the magazine's frequency from four to six issues per year and that its expected circulation would be 1.5 million by March 2010. The magazine's advertising revenue also increased steadily throughout 2009. "The magazine has a well-established track record of moving products for our advertisers, even in the worst economic times," Michael Rooney, chief revenue officer of *The Wall Street Journal*, said in a statement.[5]

Table 3

New Magazine Launches 2000–2009

Year	Magazine Launches
2000	873
2001	702
2002	745
2003	949
2004	1007
2005	1013
2006	897
2007	502
2008	685
2009	650 (Jan.– Nov.)

Source: www.mrmagazine.com
Published with permission

The digital future of magazines

By 2010, popular use of the Internet was more than fifteen years old, and many magazines had found acceptable strategies and business models for their online sites. As the decade ended, three new technologies had further complicated how magazine brands connected with their readers—social media, mobile phones, and a new generation of tablet readers such as Apple's iPad. More consumers turned to Twitter, Facebook and other social media services to get their information instead of using Web sites. And more consumers used mobile devices such as BlackBerry, iPhone and iPad to access the Web and e-mail. The 2008 "Future of the Internet III" study sponsored by the Pew Research Center surveyed 600 Internet experts about the role of technology in the year 2020. More than 85 percent of these experts predicted that the combination of portability and affordability will turn mobile devices into the leading Internet gateway by the year 2020.

A 2010 Columbia Journalism Review survey of 665 consumer magazines found that 32 percent earned a profit from their websites, 31 percent lost money, and 28 percent were unsure or didn't separate print from online revenue. Sixty-eight percent said that advertising provided their largest revenue source, while 13 percent reported subscriptions to the print edition or online-only content as the most significant. More than half of the magazines offered all of their print content online for free. Sixty-five percent of profitable websites offered all of the magazine's print content for free online. Most magazine websites used social media sites to interact with readers. Seventy-five percent used Facebook, Twitter, or both and 64 percent published blogs.

"For all the talk about putting content behind a paywall, the survey makes free that the free content, supported by advertising, remains the dominant business model," said the survey's author Victor Navasky, who is chairman of the Columbia Journalism Review and Delacorte Professor of Magazine Journalism.[6]

As the decade drew to a close, publishers and entrepreneurs were experimenting with new technology and business models that offered innovative ways to deliver magazine content to readers. In 2008, Time Inc. launched *Maghound.com*, an online subscription service that allowed readers to choose multiple print magazine subscriptions for a single monthly fee. It allowed consumers to choose from more than three hundred magazines for a monthly fee of $4.95 for three, $7.95 for five, $9.95 for seven, and $1 each for eight or more. The three hundred choices included all of Time Inc.'s 120 titles as well as those from other major competitors. Unlike traditional subscription programs, Maghound offered consumers greater flexibility without long-term contracts. Subscribers could switch their magazine choices any time they wanted to cancel one and try another. They could also cancel their Maghound service at any time without waiting for a one-year subscription to expire.

Maggwire.com was another innovative service launched in 2009 by Ryan Klenovich, Steve DeWald, and Jian Chai. These three young entrepreneurs quit their jobs at Deutsche Bank in New York City to launch the service dubbed by some "Itunes for magazines." Maggwire allowed subscribers to pay a fee ranging from 1.5 to 50 cents for an article or purchase a monthly subscription for a particular category of information, such as politics, movies or sports, culled from more than six hundred magazines. Maggwire paid magazines 75 percent of that revenue and kept 25 percent. Ryan Klenovich, chief executive officer at Maggwire, said, "We are saving people time because we are learning what people are interested in and bringing them only those articles."[7]

In June 2009, Ann Moore, chairman and CEO of Time Inc., announced in memo to employees that she had named John Squires, the company's executive vice president, to a new role developing a business model and digital media strategy

While print magazines are not going away, and while we have built vibrant web-
sites with over 26 million unique visitors and 750 million page views each month,
's increasingly clear that finding the right digital business model is crucial for the
future of our business. We need to develop a strategy for the portable digital world
and to refine our views on paid content," the memo stated.[8]

As the year progressed, Squires created an alliance of major publishers that
included Time Inc., Condé Nast, Hearst, Meredith and The News Corporation.
Named "Next Issue Media," the alliance's common goal was to create digital mag-
zine models that could work across multiple platforms such as the iPhone, iPad,
BlackBerry or the next generation of color tablet readers similar to Amazon's
Kindle. These platforms would allow users to browse through full-color magazine
ages. Demonstration videos of full-issue digital magazines on a tablet platform were
circulated online in 2009 by Time Inc. (*Sports Illustrated*), Condé Nast (*Wired*) and
Bonnier Corporation.

"For the consumer, this digital initiative will provide access to an extraordinary
election of engaging content products, all customized for easy download on the
device of their choice, including smartphones, e-readers and laptops," said Squires
n the announcement. "It will be an attractive, cost-efficient, consumer-focused dig-
al reading environment that will enable publishers to derive revenue from content
and advertising sales as well as from print subscriptions."[9]

Hearst has announced its Skiff e-reader. The device, which debuted at the
Consumer Electronics Show in Las Vegas in January 2010, is a quarter-inch thick
with an 11.5-inch screen. The Skiff Reader features an installed e-reader service and
access to a digital store where consumers can wirelessly buy their newspaper and
magazine content.

Apple announced its long-awaited iPad at a special event in San Francisco on
January 27, 2010. "We want to kick off 2010 by introducing a truly magical and rev-
olutionary product today," Apple CEO Steve Jobs told the crowd.[10] The entry-level
9.7 inch touch screen device came with a MSRP of $499 for entry-level models and
up to $829 for models with 3G wireless capacity, which will also carry an addition-
al monthly subscription fee. The device is capable of providing full-color delivery
of magazine and newspaper content. Full-color magazine spreads similar to print
editions would be available on the iPad as well as competing models in the next gen-
eration of mobile devices. One of the iPad's limitations is that it can run only one
application or program at a time. About three weeks later, Condé Nast announced
that it would publish iPad versions of *GQ*, *Vanity Fair*, and *Wired* magazines. Other
companies such as Microsoft, Lenovo, and Hewlett-Packard have next-generation
able computers in the pipeline capable of making full-color magazine reading
accessible almost anywhere.

Concluding thoughts

The "expansion of interests" theory explained in chapter one offered a credible wa
of explaining magazine growth in the 20th century. Anecdotal and statistical evi
dence suggested that radios, motion pictures and television offered brief exposur
to topics that could be more fully explored only in magazines. The expansion of radi
and motion pictures during the 1930s may help explain why most magazines grev
in circulation during the Great Depression.

The theory, however, does not appear to hold up for the Internet and relate
mobile devices in suggesting continued growth for print magazines in circulatio
and revenue. First, the exponential growth of Web sites may indeed expand the rang
of interests of consumers, but they don't necessarily look to a print magazine to lear
more about those interests. They may simply look for another website for mo
information. Websites and blogs, however, can even more narrowly segment the con
tent of increasingly narrow interests. The second reason that the "expansion of inter
ests" theory breaks down is simply the glut and overload of information that th
Internet has provided. The exploding popularity of Facebook, Twitter, iPhone an
iPad applications has given consumers uninterrupted access to information when
ever they feel inclined to use it. The expanding use of social media may have als
contributed to the "popularization of content" and decreased interest in the mo
serious intellectual content offered by magazines.

On the other hand, the next generation of e-readers will likely bring neither th
salvation nor the demise of print magazines. The question remains whether con
sumers will pay $500 and more for an iPad and similar devices plus $300 a year fo
wireless access to read magazines that cost $20 or $25 for a year's subscriptio
Similar speculation and hype also surrounded the CD-ROM versions introduce
by magazines in the early 1990s, which turned out to be an invention that solve
a problem no one had.

The magazine industry in the United States has grown steadily for more tha
250 years and any kind of change will come slowly. The number of magazines pub
lished and the circulation of some magazines may decline. Some magazines will hav
to adapt, restructure and downsize. Some more may close. But print magazines w
likely remain for generations to come. The portability, affordability and accessibi
ity of a print magazine cannot be replaced by any digital mobile device. Televisic
forced changes in some segments of the magazine industry, but Americans' lo
affair with magazines continued to grow. This love affair will not likely end.

Thirty-one leading consumer magazines gained in circulation between 2000 ar
2009. Magazines that have been most successful since 2000 have offered conte
geared to very specialized and personal interests. Their content, as well as the

graphic presentation and convenience, could not be easily "commoditized" or duplicated on a website.

It's not just the raw information that magazines give their readers, but the emotional bond they create that makes them unique among mass media. Professor Husni of the University of Mississippi called magazines the "comfort media." "Magazines reinforce the positive things that make you feel good about yourself," he said in an interview with this author. "You will never see a magazine that makes you feel bad about yourself. Magazines were always positive agents of information as opposed to newspaper and TV, who were the bad news carriers."[11]

Cathie Black, president of Hearst Magazines, agreed with Husni. "The connectivity that a reader feels with his or her magazine is one of the very unique and special attributes of a magazine. We hear that over and over. A magazine also may in fact become a respite, a retreat; a place to be yourself, be inspired, aspire to be; and give you creative ideas about your home, your clothing, your life," she told this author.[12]

Maria Rodale, chairman and CEO of Rodale, Inc. echoed the same sentiments in her blog. "The Internet is a technology that enables people to go out in SEARCH of things," she wrote. "I'm all for that and love it to pieces. But sometimes, I just want things to FIND me. Sometimes, I am just tired of looking and typing and seeking, and I just want to sit on my comfortable couch and be surprised when I turn the page. That's why I believe magazines won't die."[13]

Notes

1. Cited in Matthew Flam, "367 Magazines Shuttered in 2009," *Crain's New York*, December 11, 2009, http://www.crainsnewyork.com/article/20091211/FREE/912119988.
2. Toni Fitzgerald, "Hachette shutters *Metropolitan Home*; Monthly is just the latest shelter title to close," http://www.medialifemagazine.com.
3. "Delighting in a Magazine's Death? A Q&A with the blogger behind MagazineDeathPool.com," *Publishing Executive*, July 2008, http://www.pubexec.com/index.php?controllerName=article&contextId=113873.
4. Lauren Streib, "Will *Reader's Digest* Survive Bankruptcy?" Forbes.com, August 17, 2009, http://www.forbes.com/2009/08/17/readers-digest-bankruptcy-business-media-readers-digest.html.
5. Chandra Johnson-Greene, "*The Wall Street Journal* Increases Circulation, Frequency of WSJ Magazine," Audiencedevelopment.com, December 18, 2009, www.audiencedevelopment.com/2009/.
6. Victor Navasky with Evan Lerner, *Magazines and Their Web Sites: A Columbia Journalism Review Survey and Report* (New York: Columbia University Graduate School of Journalism, March 2010), 42.

7. Daniel Lee, "Web Service Tries to Help Magazines Turn the Page," *Indianapolis Sta* November 15, 2009, B1.
8. "Ann Moore to Time Inc. Employees," June 16, 2009, www.foliomag.com/2009/time-in ceo-gives-evp-squires-special-summer-assignment.
9. Bill Mickey, "Publisher Group Officially Announces Digital Content Joint Venture AudienceDevelopment.com, December 8, 2009, www.audiencedevelopment.com/2009
10. Yukari Iwatani Kane, "Steve Jobs Takes Gamble on New iPad," *Wall Street Journal,* Januai 28, 2010, B1.
11. Mickey, "Publisher Group Officially Announces Digital Content Joint Venture."
12. Cathie Black, telephone interview with the author, November 30, 2009.
13. Maria Rodale, "Why Magazines Won't Die," December 9, 2009, http://www.mariasfarn countrykitchen.com/2009/12/page/2/.

SUGGESTED READING

A Bibliography of American Magazine History

General Histories

Abrahamson, David, *Magazine Made America. The Cultural Transformation of the Postwar Periodical.* Creskill, NJ: Hampton Press, 1996.

Angeletti, Norberto and Alberto Oliva. *Magazines That Make History: Their Origins, Development and Influence.* Gainesville: The University Press of Florida, 2004.

Clear, Richard E. with David T. Alexander. *Old Magazines: Identification & Value Guide.* Paducah, KY: Collector Books, 2003.

Compaine, Benjamin. *Consumer Magazines at the Crossroads: A Study of General and Special Interest Magazines.* White Plains, NY: Knowledge Industry Publications, 1974.

Douglas, George H. *The Smart Magazines: 50 Years of Literary Revelry and High Jinks at* Vanity Fair, The New Yorker, Life, Esquire *and the* Smart Set. Hamdon, CT: Archon Books, 1991.

Endres, Kathleen L. and Lueck, Therese L. eds. *Women's Periodicals in the United States: Social and Political Issues.* Westport, CT: Greenwood Press, 1996.

Endres, Kathleen L. and Lueck, Therese L. eds. *Women's Periodicals in the United States: Consumer Magazines.* Westport, CT: Greenwood Press, 1995.

Fackler, P. Mark and Charles H. Lippy, eds. *Popular Religious Magazines of the United States.* Westport, CT: Greenwood Press, 1995.

Ford, James L.C. *Magazines for Millions: The Story of Specialized Publications.* Carbondale: Southern Illinois Press, 1969.

Haining, Peter. *The Classic Era of American Pulp Magazines.* Chicago: Chicago Review Press, 2000.

Hudson, Robert V. *Mass Media: A Chronological Encyclopedia of Television, Radio, Motion Pictures, Magazines, Newspapers and Books in the United States.* New York and London: Garland Publishing, 1987.

Humphreys, Nancy K. *American Women's Magazines: An Annotated Historical Guide.* New York: Garland, 1989.

Janello, Amy, and Brennon Jones. *The American Magazine.* New York: Harry Abrahams and Magazine Publishers of America, 1991.

Kitch, Carolyn. *The Girl on the Magazine Cover: The Origins of Visual Stereotypes in American Mass Media.* Chapel Hill: University of North Carolina Press, 2001.

Mott, Frank Luther. *A History of American Magazines 1905–1930.* Cambridge: Harvard University Press, 1968.

Nourie, Alan and Barbara Nourie. *American Mass Market Magazines.* New York: Greenwood Press, 1990.

Ohmann, Richard. *Selling Culture: Magazines, Markets, and Class at the Turn of the Century.* London and New York: Verso Press, 1996.

Peterson, Theodore. *Magazines in the Twentieth Century.* Urbana: University of Illinois Press, 1964.

Riley, Sam, ed. *American Magazine Journalists, 1900–1960.* Detroit: Gale Research, 1990, 1994.

Riley, Sam. *Magazines of the American South.* New York: Greenwood Press, 1986.

Streitmatter, Rodger. *Sex Sells! The Media's Journey from Repression to Obsession.* Boulder, CO: Westview Press, 2004.

Streitmatter, Rodger. *Unspeakable: The Rise of the Gay and Lesbian Press in America.* Boston: Faber and Faber, 1995.

Taft, William. *American Magazines for the 1980s.* New York: Communication Arts Books, Hastings House Publishers, 1982.

Tebbel, John. *The American Magazine: A Compact History.* New York: Hawthorn Books, 1969.

Tebbel, John and Mary Ellen Zuckerman. *The Magazine in America 1741–1990.* New York: Oxford University Press, 1991.

Van Zuilen, A.J. *The Life Cycle of Magazines; A Historical Study of the Decline and Fall of the General Interest Mass Audience Magazines in the United States During the Period 1946–1972.* Ulthorrn, The Netherlands: Graduate Union Press, 1977.

Walker, Nancy A. *Shaping Our Mothers' World: American Women's Magazines.* Jackson: University Press of Mississippi, 2000.

Walker, Nancy A. *Women's Magazines, 1940–1960: Gender Roles and the Popular Press.* New York: Bedford/St. Martin's, 1998.

Wood, James Playsted. *Magazines in the United State, 2nd ed.* New York: Ronald Press, 1970.

Zuckerman, Mary Ellen. *A History of Popular Women's Magazines in the United Stats, 1792–1995.* Westport, CT: Greenwood Press, 1998.

Individual Magazines and Magazine Publishers

CONDÉ NAST

A Brief History of The Condé Nast Publications. New York: Condé Nast Publications, 1993.

Bachrach, Judy. *Tina and Harry Come to America: Tina Brown, Harry Evans and the Uses of Power*

New York: The Free Press, 2001.

elsenthal, Carol. *Citizen Newhouse: Portrait of a Media Merchant.* New York: Seven Stories Press, 1998.

Maier, Thomas. *Newhouse: All the Glitter, Power, & Glory of America's Richest Media Empire & the Secretive Man Behind It.* New York: Johnson Books, 1997.

Oppenheimer, Jerrry. *Front Row, Anna Wintour: The Cool Life and Hot Times of Vogue's Editor in Chief.* New York: St. Martin's Press, 2005.

eebohm, Carolyn. *The Man Who Was Vogue: The Life and Times of Condé Nast.* New York: Viking Press, 1982.

CURTIS and *SATURDAY EVENING POST*

ackerman, Martin. *The Curtis Affair.* Los Angeles: Nash Publishing, 1970.

ok, Edward William. *The Americanization of Edward Bok: The Autobiography of a Dutch Boy Fifty Years After.* New York: Charles Scribner's Sons, 1921.

ok, Edward. *A Man from Maine.* New York: Charles Scribner's Sons, 1923. (Bok's account of the life of his father-in-law, Cyrus H.K. Curtis)

ohn, Jan. *Creating America; George Horace Lorimer and the* Saturday Evening Post. Pittsburgh: University of Pittsburgh Press, 1989.

ulligan, Matthew. *The Curtis-Culligan Story; from Cyrus to Horace, to Joe.* New York: Crown Publishers, 1970.

riedrich, Otto. *Decline and Fall of the* Saturday Evening Post. New York: Harper and Row, 1970.

uller, Walter Dean. *The Life and Times of Cyrus H.K. Curtis, 1850–1933.* New York: Newcomen Society Address, 1948.

oulden, Joseph C. *The Curtis Caper.* New York: Putnam, 1965.

teinberg, Salme Harju. *Reformer in the Marketplace: Edward Bok and the* Ladies' Home Journal. Baton Rouge: Louisiana State University Press, 1979.

ebbel, John. *George Horace Lorimer and the Saturday Evening Post.* Garden City, NY: Doubleday and Co., 1948.

Wood, James Playsted. *The Curtis Magazines.* New York: Ronald Press, 1971.

EBONY

ohnson, John H. *Succeeding Against the Odds.* New York: Armistad, 1992.

ESQUIRE

ingrich, Arnold. *Nothing but the People: The Early Days at* Esquire *1928–1958.* New York: Crown Publishers, 1971.

ois, George. *Covering the 60s: The* Esquire *Era.* New York: Monacelli Press, 1996.

olsgrove, Carol. *It Wasn't Pretty Folks, But Didn't We Have Fun?* Esquire *in the 1960s.* New York: W.W. Norton, 1995.

FORTUNE—See *Time* and Time Inc.

GEORGE

Blow, Richard. *American Son: A Portrait of John F. Kennedy, Jr.* New York: St. Martin's, 2002.

GUIDEPOSTS

George, Carol V.R. *God's Salesman: Norman Vincent Peale and the Power of Positive Thinking.* New York: Oxford University Press, 1993.

HARPER'S

Morris, Willie. *New York Days.* Boston: Little, Brown and Company, 1993.

HEARST

Black, Cathie. *Basic Black: The Essential Guide for Getting Ahead at Work (and in Life).* New York: Crown Business Books, 2007.

Brown, Helen Gurley. *I'm Wild Again: Snippets from My Life and a Few Brazen Thoughts.* New York: St. Martin's Press, 2000.

Carlson, Oliver. *Hearst, Lord of San Simeon* (Westport: Greenwood Press, 1970).

Chaney, Lindsay. *The Hearsts: Family and Empire The Later Years.* New York: Simon and Schuster, 1981.

Hearst, William Randolph Jr., and Jack Casserly, *The Hearsts: Father and Son.* Toronto: Key Porter Books, 1991.

O'Donnell, James F. *100 Years of Making Communications History: The Story of The Hearst Corporation.* New York, Hearst Professional Magazines, 1987.

Older, Fremon, Mrs. *William Randolph Hearst, American.* New York: Books for Libraries Press, 1972.

Procter, Ben. *William Randolph Hearst: The Early Years, 1863–1910.* New York: Oxford University Press, 1998.

Scanlon, Jennifer. *Bad Girls Go Everywhere: The Life of Helen Gurley Brown.* New York: Oxford University Press, 2009.

Swanberg, W.A. *Citizen Hearst: A Biography of William Randolph Hearst.* New York: Scribner Sons, 1961.

Tebbel, John. *The Life and Good Times of William Randolph Hearst.* New York: Dutton, 1952.

LIFE—See *Time* and Time Inc.

MAD

Jacobs, Frank. *The Mad World of William Gaines*. Secaucus, NJ: Lyle Stuart, Inc., 1972.

MARTHA STEWART LIVING OMNIMEDIA

Byron, Christopher. *Martha Inc. The Incredible Story of* Martha Stewart Living *Omnimedia*. New York: John Wiley & Sons, 2002.

MEREDITH

Brown, Kathi Ann. *Meredith: The First 100 Years*. Des Moines: Meredith Books, 2002.
Meredith Publishing Co. *Edwin T. Meredith, 1876–1928. A Memorial Volume*. Des Moines, Iowa: Meredith Publishing, 1931.

MACFADDEN

Adams, Mark. *Mr. America: How Muscular Millionaire Bernarr Macfadden Transformed the Nation Through Sex, Salad, and the Ultimate Starvation Diet*. New York: HarperCollins, 2009.
Oursler, Fulton, *The True Story of Bernarr Macfadden*. New York: Copeland Publishing, 1929.
Wood, Clement, *Bernard Macfadden*, New York, Holt Publishing, 1953.

McCLURE'S

Baker, Ray Stannard. *American Chronicle*. New York: Scribner's, 1945.
Brady, Kathleen. *Ida Tarbell: Portrait of a Muckraker*. New York: Seaview/Putnam, 1984.
Lyon, Peter. *Success Story: The Life and Times of S.S. McClure*. New York: Scribner, 1963.
Steffens, Joseph Lincoln. *Autobiography of Lincoln Steffens*. New York: Harcourt Brace, 1931.
Wilson, Harold S. *McClure's Magazine and the Muckrakers*. Princeton: Princeton University Press, 1970.

MUNSEY'S

Britt, George. *Forty Years—Forty Millions: The Career of Frank A. Munsey*. New York: Farrar and Rinehart, 1935.

THE NATION

Navasky, Victor. *A Matter of Opinion*. New York: Farrar Straus and Giroux, 2005.

NATIONAL GEOGRAPHIC

Bryan, C.D.B. *The National Geographic Society: 100 Years of Adventure and Discovery*. New York: Harry N. Abrams, 1987.

Canby, Thomas Y. *From Botswane to the Bering Sea: My Thirty Years with* National Geographic. Washington, DC: Island Press/Shearwater, 1998.

Grosvenor, Gilbert. *The National Geographic Society and Its Magazine.* Washington, D.C.: National Geographic Society, 1957.

NATIONAL ENQUIRER

Bird, S. Elizabeth. *For Enquiring Minds: A Cultural Study of Supermarket Tabloids.* Knoxville: University of Tennessee Press, 1992.

Calder, Iain. *The Untold Story: My 20 Years of Running the* National Enquirer. New York: Hyperion, 2004.

Moskowitz-Mateu, Lysa and David LaFontaine. *Poison Pen: Tabloid Reporters Tell All Their Shocking Secrets.* Los Angeles: Dove Books, 1996.

Vitek, Jack. *The Godfather: Generoso Pope Jr. and the* National Enquirer. Lexington: University Press of Kentucky, 2008.

NEWSWEEK

Elliott, Osborn. *The World of Oz.* New York: The Viking Press, 1980.

Felsenthal, Carol. *Power, Privilege and the Post: The Katharine Graham Story.* New York: Seven Stories Press, 1993.

Halberstam, David. *The Powers That Be.* New York: Knopf, 1979.

Kosner, Edward. *It's News to Me: The Making and Unmaking of an Editor.* New York: Thunder's Mouth Press, 2006.

THE NEW YORKER

Adler, Renata. *Gone: The Last Days of the* New Yorker. New York: Simon & Schuster, 1999.

Forde, Kathy Roberts. *Literary Journalism on Trial: Masson v.* New Yorker *and the First Amendment.* Amherst: University of Massachusetts Press, 2008.

Gill, Brendan. *Here at the* New Yorker. New York: Random House, 1975.

Grant, Jane C. *Ross, The* New Yorker *and Me.* New York: Reynal, 1968.

Kramer, Dale. *Ross and the* New Yorker. Garden City, NY: Doubleday and Co, 1951.

Kunkel, Thomas. *Genius in Disguise: Harold Ross of The* New Yorker. New York: Random House, 1995.

Thurber, James. *The Years with Ross.* Boston: Little Brown, 1959.

Ross, Lillian. *Here but Not Here: A Love Story.* New York: Random House, 1998.

Vehta, Med. *Remembering Mr. Shawn's* New Yorker*: The Invisible Art of Editing.* New York: Overlook Press, 1998.

Yagoda, Ben. *About Town: The* New Yorker *and the World It Made.* New York: Scribner, 2000.

PEOPLE—See *Time* and Time Inc.

PLAYBOY

Miller, Russell. *Bunny, The Real Story of* Playboy. New York: Holt, Rinehart and Winston, 1985.

Watts, Steven. *Mr. Playboy: Hugh Hefner and the American Dream.* New York: Wiley, 2008.

THE PROGRESSIVE

Lueders, Bill. *An Enemy of the State: The Life of Erwin Knoll.* Monroe, Maine; Common Courage Press, 1996.

READER'S DIGEST

Bainbridge, John. *Little Wonder, or, The* Reader's Digest *and How It Grew.* New York: Reynal & Hitchcock, 1946.

Canning, Peter. *American Dreamers: The Wallaces and* Reader's Digest*: An Insider's Story.* New York: Simon and Schuster, 1996.

Heidenry, John. *Theirs Was the Kingdom: Lila and DeWitt Wallace and the Story of* Reader's Digest. New York: W.W. Norton, 1993.

January, Brendan. *DeWitt and Lila Wallace: Charity for All.* New York: Children's Press, 1998.

Wood, James Playsted. *Of Lasting Interest: The Story of the* Reader's Digest. New York: Doubleday and Co., 1958.

RODALE

Gross, Daniel. *Our Roots Grow Deep: The Story of Rodale.* Emmaus, PA: Rodale, 2008.

ROLLING STONE

Draper, Robert. Rolling Stone Magazine: *The Uncensored History.* New York: Doubleday, 1990.

SPORTS ILLUSTRATED—See *Time* and Time Inc.

TIME and TIME INC.

Baughman, James L. *Henry Luce and the Rise of the American News Media.* Boston: Twayne Publishing, 1987.

Byron, Christopher H. *The Fanciest Dive: What Happened When the Media Empire of* Time/ Life *Leaped Without Looking into the Age of High Tech.* New York: W.W. Norton, 1986.

Clurman, Richard. *To the End of Time: The Seduction and Conquest of a Media Empire*. New York: Simon & Schuster, 1992.

Covering History: Time Magazine *Covers, 1923–1997*. New York: Time Inc., 1998.

Elson, Robert. *Time Inc.: The Intimate History of a Publishing Enterprise—1923–1941*. New York: Athenaeum, 1968.

———. *The World of Time Inc.: The Intimate History of a Publishing Enterprise—1941–1960*. New York: Athenaeum, 1973.

Griffith, Thomas. *Harry and Teddy: The Turbulent Friendship of Press Lord Henry R. Luce and His Favorite Reporter, Theodore H. White*. New York: Random House, 1995.

Herzstein, Robert E. *Henry R. Luce: A Political Portrait of the Man Who Created The American Century*. New York: Charles Scribner's Sons, 1994.

Herzstein, Robert E. *Henry R. Luce,* Time, *and the American Crusade in Asia*. New York: Cambridge University Press, 2005.

Kobler, John. *Luce: His* Time, Life *and* Fortune. New York: Doubleday and Co, 1968.

Kronenberger, Louis. *No Whippings, No Gold Watches: The Saga of a Writer and His Jobs*. Boston: Little, Brown & Company, 1965.

Landers, James, *The Man Time Forgot: A Tale of Genius, Betrayal, and the Creation of* Time Magazine.

Martin, Ralph G. *Henry and Clare: An Intimate Portrait of the Luces*. New York: G.P. Putnam's Sons, 1990.

Prendergast, Curtis with Geoffrey Colvin. *The World of Time Inc.: The Intimate History of a Changing Enterprise—1960–1980*. New York, Athenaeum, 1986.

Swanberg, W.A. *Luce and His Empire*. New York: Charles Scribner's Sons, 1972.

FORTUNE

Fortune: The Art of Covering Business. New York: Time Inc. 1999. (with historical essay by Daniel Okrent)

LIFE

Doss, Erika, ed. *Looking at* Life Magazine. Washington and London: Smithsonian Institution Press, 2001.

Hamblin, Dorothy. *That Was The Life: The Upstairs, Downstairs Behind-The-Doors Story Of America's Favorite Magazine*. New York: W.W. Norton, 1977.

Wainright, Loudon. *The Great American Magazine: An Inside History of* Life. New York: Ballantine Books, 1986.

Kunhardt, Phillip, Jr. Life: *The First 50 Years, 1936–1986*. Boston: Little, Brown and Company, 1986.

PEOPLE

Kessler, Judy. *Inside* People: *The Stories Behind the Stories*. New York: Villard Books, 1994.

SPORTS ILLUSTRATED

Sports Illustrated, *The Anniversary Book: 1954–2004*. New York: Sports Illustrated Books, 2004.

Fleder, Rob. *Fifty Years of Great Writing:* Sports Illustrated *1954–2004*. New York: Sports Illustrated Books, 2004.

MacCambridge, Michael. *The Franchise: A History of* Sports Illustrated. New York: Hyperion Books, 1997.

TV GUIDE

Altschuler, Glenn C., and David I. Grossvogel. *Changing Channels: America in* TV Guide. Champaign, IL: University of Illinois Press, 1992.

Cooney, John. *The Annenbergs: The Salvaging of a Tainted Dynasty*. New York: Simon and Schuster, 1982.

Harris, Jay S. ed. TV Guide: *The First 25 Years*. New York: Simon and Schuster, 1978.

Laswell, Mark. TV Guide: *Fifty Years of Television*. New York: Crown Publishing Group, 2002.

Index

Mediating American History

SERIES EDITOR: DAVID COPELAND

Realizing the important role that the media have played in American history, this series provides a venue for a diverse range of works that deal with the mass media and its relationship to society. This new series is aimed at both scholars and students. New book proposals are welcomed.

For additional information about this series or for the submission of manuscripts, please contact:

> Mary Savigar, Acquisitions Editor
> Peter Lang Publishing, Inc.
> 29 Broadway, 18th floor
> New York, New York 10006
> Mary.Savigar@plang.com

To order other books in this series, please contact our Customer Service Department:

> (800) 770-LANG (within the U.S.)
> (212) 647-7706 (outside the U.S.)
> (212) 647-7707 FAX

Or browse by series:

WWW.PETERLANG.COM